W9-AVR-503

Troubleshooting and Repairing Camcorders

I would like to dedicate this book to my brothers and sisters:
Carl, Cecil, Thelma, Edgar, Walter, Lena, Hubert, Charles, and Janet.

Troubleshooting and Repairing Camcorders

2nd edition

Homer L. Davidson

McGraw-Hill

New York San Francisco Washington, D.C. Auckland Bogotá
Caracas Lisbon London Madrid Mexico City Milan
Montreal New Delhi San Juan Singapore
Sydney Tokyo Toronto

McGraw-Hill

A Division of The **McGraw·Hill** *Companies*

©1996 by The McGraw-Hill Companies, Inc.

pbk 1 2 3 4 5 6 7 8 9 DOC/DOC 9 0 0 9 8 7 6
hc 1 2 3 4 5 6 7 8 9 DOC/DOC 9 0 0 9 8 7 6

Library of Congress Cataloging-in-Publication Data
Davidson, Homer L.
 Troubleshooting and repairing camcorders / by Homer L. Davidson
 —2nd. ed.
 p. cm.
 Includes index.
 ISBN 0-07-015759-6 ISBN 0-07-015760-X (pbk.)
 1. Camcorders—Maintenance and repair. I. Title.
TR882.D28 1996
778.59'93—dc20
 96-12519
 CIP

Acquisitions editor: Roland S. Phelps
Editorial team: Anita McCormick, Book Editor
 David M. McCandless, Managing Editor
 Lori Flaherty, Executive Editor
Production team: Katherine G. Brown, Director
 Rose McFarland, Desktop Operator
 Nancy K. Mickley, Proofreading
 Jenniver M. Secula, Indexer
Design team: Jaclyn J. Boone, Designer
 Katherine Lukaszewicz, Associate Designer
 015760X
 EL3

Contents

Introduction *xiii*

1 Camcorder and video cassette formats *1*
New features *2*
Beta *2*
VHS *3*
VHS-C *3*
8 millimeter *5*
Video cassette problems *6*
Camcorder features *7*
Power requirements *12*
Hookups *12*
New weights *12*
Block diagram *14*
The camera section *19*
Digital signal process *20*
VTR or VCR section *25*
Audio tracks on tape *25*
Service notes *30*

2 Tips and techniques *33*
Service precautions *33*
Electrostatic-sensitive devices *34*
Soldering techniques *36*
Types of chip ICs *36*
Removing the IC chip *36*
Tools for IC replacement *37*
Installing IC chips *38*
Service data *38*
Voltage measurements *39*

Signal paths *39*
Component connections *41*
Connections *41*
IC chip precautions *41*
Surface-mounted components *44*
Types of chips *44*
Leadless transistor chips *44*
Digital transistor chips *45*
Leadless resistor chips *46*
Chip tantalum capacitors and filters *50*
Removing the part *53*
Installing small SMD components *53*
Test points *54*
Cleaning *54*
Lubrication *58*
Test equipment *61*

3 The camera section *65*
VHS/VHS-C camera circuits *65*
Pickups *66*
CCD pickups *66*
MOS pickups *69*
Canon ES1000 process board *71*
Signal processing circuits *75*
Luminance signal processing *77*
Chroma processing circuits *80*
Automatic iris control (AIC) *83*
Automatic white balance *85*
Automatic focus control *87*
The electronic viewfinder *91*
Troubleshooting EVF circuits *95*

4 Video circuits *99*
Video signal input/output circuits *99*
Head-switching circuits *102*
Operation in the record mode *104*
Samsung video record circuits *105*
Operation in the play mode *108*

Pentax PV-C850A *111*
Sony CCD/M8E/M8U rotary transformer and video head *119*
RCA CPR100 luminance record process circuit *120*
Chroma signal recording circuits *120*
Samsung Y & C record circuit *123*
Luminance playback processing circuits *124*
Realistic 150 *124*
Luminance playback process circuits *125*
Chroma signal playback circuits *128*
Conclusion *132*

5 System control *137*

System control circuits *139*
Function switch key input circuits *143*
Power control circuits *148*
Samsung battery terminal circuits *148*
Samsung function switches *148*
Canon ES1000 power supply PCB *150*
Realistic 150 (VHS-C) *152*
Samsung power supply sources *155*
Canon power off/on sequence *156*
On-screen display circuits *160*
Canon ES1000 video light *162*
Samsung remote control module *163*

6 Trouble detection and servo circuits *167*

Tape-end sensor *167*
Take-up reel detection circuits *172*
Dew sensor *173*
Canon ES1000 dew condensation circuit *175*
Sony CCD-M8E/M8U 8-mm dew detection circuit *175*
Cylinder lock circuits *176*
Mode switch *178*
Loading motor drive circuits *181*
Capstan motor drive circuits *184*
Servo circuits *185*
Servo control signals *192*
Conclusion *199*

7 Motor circuits *201*

Loading motors *201*
Loading motor removal *204*
Capstan motors *208*
Drum motors *217*
Drum motor removal *225*
Autofocus motors *228*
Autofocus motor removal *231*
Iris motor drives *233*
Zoom motors *237*
Conclusion *239*

8 Audio circuits *241*

External microphone jack *256*
Earphone jack *256*
Audio control heads *258*
Audio output jacks *260*

9 Mechanical tape operations *263*

General head description *264*
Mechanical operations *267*
Loading and drive mechanisms *282*
Samsung timing gear assembly *290*
Pentax PV-C850A 8-mm main brake drive mechanism *291*
RCA 8-mm idler gear/T-reel base operation *292*
Conclusion *296*

10 Remove and replace *299*

Write it down *299*
Too many screws *301*
Cassette cover removal *303*
Case removal *305*
VCR section removal *307*
Camera section removal *310*
Circuit board removal *313*
Microphone removal *316*
Electronic viewfinder removal *320*
Pickup tube assembly removal *325*

Auto focus and power zoom assembly *326*
Tape transport mechanism removal *326*
Video head removal *327*
Other transport parts removal *331*

11 Mechanical adjustments *349*

Important precautions *349*
Test equipment *349*
Preliminary adjustment steps *350*
Tape interchange ability adjustment *361*
Audio/control (A/C) head adjustment *362*
Reel table height adjustments *368*
Back tension adjustment *370*
Other adjustments *373*
Conclusion *378*

12 Electrical adjustments *381*

List of maintenance tools and test equipment *381*
Reflection of wall charts *384*
Tools and fixtures *386*
Camera setup *387*
Camcorder breakdown *388*
Power supply adjustments *389*
Servo adjustments *394*
CCD drive section *400*
Camera adjustments *404*
Electronic viewfinder (EVF) adjustments *415*
Adjustment notes *421*

13 Troubleshooting the camcorder *423*

Before troubleshooting *424*
Voltage measurements *424*
Scope waveforms *427*
Common failures *428*
RCA PRO845 power/loss switch inoperative chart *432*
Troubleshooting the various circuits *433*
No voltage to camera circuits *434*
Checking sensors *435*

No auto focus *437*
No power zoom operation *440*
Iris control circuits *441*
Capstan does not rotate *442*
Does not eject or load *443*
Cylinder of drum motor does not operate *446*
Poor rotation of drum motor *447*
Sensors not working *447*
Detectors not working *448*
Improper white balance *451*
No on-screen display *451*
No video monitor *454*
No video recording *454*
No record chroma *456*
No color playback *456*
No video playback *459*
No picture in playback mode *459*
No record chroma *462*
Sound does not operate *462*
No audio playback *466*
Noisy and jittery picture *466*
Horizontal jitter in picture *466*
White balance drifts *468*
No EVF raster *470*
No EVF horizontal deflection *471*
No EVF vertical deflection *473*
No EVF or weak video *474*
Infrared indicator *474*
Servo/system control waveforms *475*

14 Power supplies *477*
ac power supply *477*
Battery charging *480*
Battery detection circuits *481*
ac adapter/charger circuit adjustments *484*
Other battery connections *485*
Troubleshooting the power adapter *487*
Keeps blowing fuses *488*

Voltage tests *488*
Random transistor and diode tests *489*
Checking ICs and other components *490*
Lithium batteries *491*
Battery will not charge *491*

Appendices
A Abbreviations *493*
B Camcorder manufacturers *501*

Glossary *505*
Index *517*
About the author *525*

Introduction

SERVICING A CAMCORDER IS JUST AS EXCITING AS USING IT
to take those memorable pictures. Troubleshooting the camcorder
might be a new experience for some technicians. Without the ser-
vice literature and schematic, you have one strike against you
when attempting tough-dog repairs. Remember, the camcorder is
nothing more than a camera and a video cassette recorder in one
small package.

Today, the camcorder has become smaller in size, with a surge of 8
mm and VHS-C camcorders now being sold. Like any electronic
and mechanical device, the camcorder can break down. Likewise,
if the camcorder is roughly treated, more repairs are required.
Troubleshooting and repairing camcorders has opened up another
new product in the field of consumer electronics. Primarily, this
book was written for the electronic technician; however, the be-
ginning, intermediate, and experienced electronic student can
also learn from each chapter. This second edition of *Trou-
bleshooting and Repairing Camcorders* includes the new cir-
cuits and components found in today's camcorder.

This book contains 14 chapters, with an appendix of abbrevia-
tions, one of camcorder manufacturers, and a glossary of terms.
There are many full and partial schematics to help you learn and
locate the various symptoms. Photos of various camcorder compo-
nents illustrate the various problems. Chapter 1 begins with the
various camcorder cassette formats. Service tips and techniques
are provided in Chapter 2. Chapter 3 provides information and ser-
vice data of the camera section. How the video circuits operate
and are serviced is found in Chapter 4. The troublesome system
control section is located in Chapter 5. Chapter 6 describes how
the trouble detection and servo circuits are serviced. Various mo-
tor circuits, how they operate, and how to repair them are covered
in Chapter 7. The audio circuits are described in Chapter 8. Chap-
ters 9, 10, and 11 describe the mechanical operations, removal and
replacement, and mechanical adjustments of the various compo-

nents. The electrical adjustments are given in Chapter 12. Chapter 13 tells you how to troubleshoot, isolate, and repair the various sections of the camcorder. Last but not least, Chapter 14 covers servicing the power supply and battery charger adapter.

Servicing the camcorder requires good eyes and a steady hand. Troubleshooting the camcorder requires a lot of patience and dedicated workmanship. Repairing the camcorder can require several minutes of removing several PC boards to get at the defective part (but then this is what the successful electronic technicians are made of).

Besides correct test equipment, the schematic diagram and service literature is a must-have item. Many manufacturers have special test equipment and jigs to provide quicker service of the camcorder. More than 11 different camcorder manufacturers have provided valuable service literature and schematics for this book. Time is the electronic technician's most valuable and precious commodity, and you can save a lot of valuable service time by having the correct schematic diagram. These camcorder manufacturers have provided the required service information, and this book could never have been written without their help.

Like today's compact disc player, the camcorder is loaded with special components such as SMD components, integrated (IC) processors, Main Mi-Com processors, CCD and MOS image devices, and special optical components. Most of these parts must be obtained from the camcorder manufacturer. Always replace special components with the original part number. Simply locate the defective component listed in the manufacturer's service literature.

Like the VCR, the camcorder might change the attitude and daily repair procedure of the electronic technician, but it can be a new learning experience and a lot of fun. All electronic products that arrive on the scene might seem different at first, but each day it becomes a lot easier. If you are servicing VCR machines, repairing the camcorder is in your corner, so to speak. Servicing the camcorder opens up a new servicing field for the electronic technician.

The following table lists the makes, models, and formats of the units discussed in this book.

Make	Model	Format
Canon	ES1000	8 mm
	VME2NA	8 mm
General Electric*	9-9605	VHS
Mitsubishi	HS-C2OU	VHS-C
Minolta	C-3300	VHS-C
Olympus	VX-801	8 mm
Pentax	PV-C850A	8 mm
Radio Shack	Realistic 150	VHS-C
RCA*	CPR100	VHS-C
	CPR300	VHS
	PRO845	8 mm
Samsung	SCX854	8 mm
Sony	CCD-M8E/M8U	8 mm
Zenith	VM6150	VHS-C

*Thomson Consumer Electronics

Camcorder and video cassette formats

CAMCORDERS ARE NOTHING MORE THAN A COMBINATION electronic camera and video recorder in one package (see figure 1-1). The tools commonly found on the electronic technician's bench are all that is required to service the VCR section. Many of the same tools needed to repair the VCR recorder are required. Besides those tools found on the service bench, a good vectorscope, color monitor, lighting equipment, reflection charts, and a light meter will be needed. A lot of camcorder maintenance can be performed by using just the reflection charts and dual-trace oscilloscope for electronic adjustments.

When video cameras were first used with color TV sets, the instant picture was seen directly on the TV screen or monitor. With camcorders, the scene can be recorded, played back at once, or viewed at a later date. Some camcorders have playback features, while the smaller units record only. Like the VCR, there are several different camcorder tape formats to service.

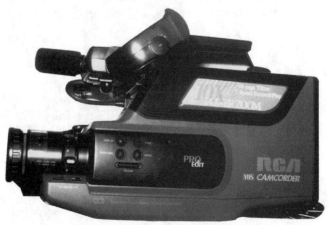

■ **1-1** *The RCA VHS camcorder with Pro-Edit and power zoom.*

New features

Besides more total pixels (270 k to 570 k) added to the CCD unit, image stabilization, automatic focus, fuzzy logic, and greater zoom operation with 10-to-1 or 12-to-1 power are found in many new camcorders. Image stabilization helps the picture to remain steady, even if your hands are not. The area of white balance has improved greatly in the new camcorders. No longer are the video pictures tinged blue, brown, or green.

The word *lux* refers to light. And in the camcorder, it means the amount of light needed to get a normal picture. Today, the camcorder requires less light, supplies better resolution, and produces brighter colors. Most new camcorders have a flying erase head, with less glitches and noises picked up. Several new camcorder models have a color electronic viewfinder instead of black and white, and have video lights built right into the camcorder. Even with all these added features, camcorders have become smaller and weigh less.

The smaller camcorder, VHS-C and 8-mm, have taken hold in the past five years. The 8-mm camcorder now accounts for 35 to 40 percent of camcorders sold. These camcorders are light in weight— around 3 lbs, and can record up to 3 hours of tape.

A new camcorder developed by Hitachi will be one-third the size and weight of the present camcorders. The camcorder is so small that it can fit in the palm of your hand. This means there will be no video tape or a servo section to record and play back the tape. A method of compressing and flash memory of chips makes it possible to record up to 30 minutes of video. Of course, the small camcorder is a few years away, and will probably be quite expensive at first.

Beta

The Beta camcorder matches up with the Beta VCR machines. They cannot be plugged into a VHS recorder. The Sony Beta format was one of the first VCRs on the market, and it furnished the best quality recordings. Beta camcorders can take pictures on a Beta cassette, but they have no playback features. The Beta camcorder has about 280 lines of resolution compared to the 250 lines of VHS machines. The Beta cassette can play and record from 15 minutes up to 5 hours. The L-750 cassette is slightly smaller than the standard VHS cassette (see figure 1-2).

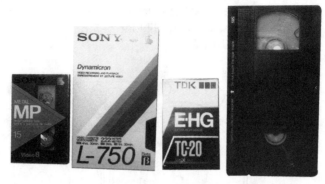

■ **1-2** *The VHS-C, Beta, 8-mm and standard VHS cassette, that is the largest one of all.*

VHS

The video home system (VHS) camcorder employs the same cassettes as the VHS video tape recorder (VCR). They are the most stable and popular units at present. The VHS cassettes are low in price and can be played back in camcorders or VCRs. The VHS tape however, is not interchangeable with the Beta cassette. Many VHS camcorders can be played directly through the TV set or monitor. In standard play (SP), two hours of recording will fit on the standard T-120 cassette. Or, up to six hours of recording will fit on a VHS tape in the extended play (EP) mode.

Since the early VHS format, both the cassettes and VCRs have been improved. The HQ recording system improved the picture with sharper definition, truer colors, and less snow. Today, the super (S-VHS) camcorders provide more lines of resolution, which means more detailed pictures. The standard VHS camcorder usually has 240 to 250 lines, while the super VHS can have over 400 lines of resolution. The S-VHS camcorder can be played through the TV set or monitor but not the regular VCR unit. The VHS cassette can be viewed on an electronic viewfinder. Regular VHS cassettes can be played back through the super VCR machines.

VHS-C

The compact VHS-C camcorder is small in size, light to carry, and uses the small VHS-C cassette. The VHS-C camcorder is much easier to take on vacations because of the physical size, compared to the VHS model. The VHS-C camcorder, however, must be supported for steady pictures. The VHS-C cassette can be played di-

3

rectly into the TV set or color monitor, but it must be placed in the regular VHS-size plastic holder before inserting it into the VHS VCR (see figure 1-3).

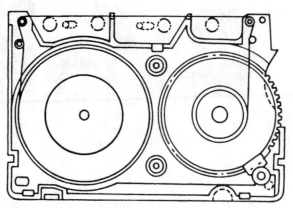

■ **1-3** *Inside view of the supply reel and gears of the VHS-C video cassette.*

Although the tape itself and the recorded magnetic patterns are the same as a VHS cassette, the VHS-C cassette is only one-third the size. The tape movement is actuated by a plastic, geared reel inside the regular VHS cassette. The take-up function is driven by a gear. The VHS-C cassette contains a supply reel disk, but there is no take-up reel disk.

When the VHS-C cassette is inserted into the VHS cassette, the adapter extracts the tape and positions it in the same manner as the full-size VHS cassette. Now the tape can be inserted into the VHS-format deck (see figure 1-4). When inserted, the supply reel disk of the VHS deck drives the supply reel of the VHS-C cassette. Remember, the take-up reel disk of the VHS recorder drives the take-up operation via the pulley and gear of the adapter (see figure 1-5). A small amount of noise is sometimes created by the VHS-C and VHS adapter.

Naturally, with smaller camcorders, all parts are reduced in size. Here, the regular size and weight of the 41-mm-diameter rotating head drum is about one-third the size of the full VHS format. To retain compatibility with the VHS format, the rotation speed is increased to 45 revolutions per second, while the tape-wrapping angle is increased to 270 degrees (see figure 1-6). The conventional cylinder drum diameter is 62 mm and has a 180-degree tape wrap-around angle.

4

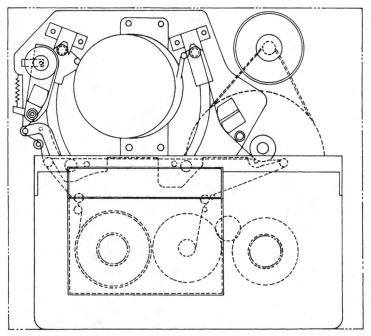

■ **1-4** *Detailed drawing of the VHS-C cassette mounted inside the VHS adapter for playback mode.*

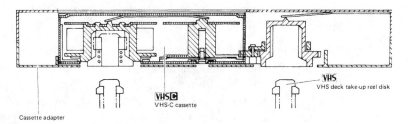

■ **1-5** *The end view of VHS-C cassette inside the VHS cassette adapter.*

8 millimeter

The 8-mm design is the newest type of camcorder. It is made by both electronics and camera manufacturers. The 8-mm camcorder operates with a small lightweight format and thinner tape. The 8-mm video cassette has from 15 minutes to 4 hours of playing time. The 8-mm cassette can be played back through the camcorder's electronic viewfinder, a TV set or color monitor, or an 8-mm VCR. The 8-mm cassette cannot be played through the VHS-C or VHS camcorder.

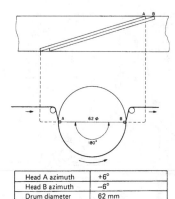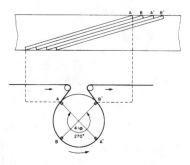

Head A azimuth	+6°
Head B azimuth	−6°
Drum diameter	62 mm
Tape wrap angle	180° + α
Rotation rate	30 rps 30 rps

Head A azimuth	+6°
Head A′ azimuth	+6°
Head B azimuth	−6°
Head B′ azimuth	−6°
Drum diameter	41 mm
Tape wrap angle	270° + α
Rotation rate	45 rps

■ **1-6** *The normal VHS head to the left and the reduced head drum of VHS-C recorder to the right side.*

The latest 8-mm camcorders have optical image stabilization and electronic stabilization. The optical stabilization is considered better with no reduction in picture detail when the stabilizer is on. Some of the latest 8-mm camcorders have a 12-×-1 zoom lens with built-in video lights. A color viewfinder might cost $100 more, but you can see what you take better with it.

The 8-mm camcorder has a smaller drum head diameter and digital audio frequency modulation. The audio portion is recorded right along with the video signal rather than on the edge of the tape like in VHS models. The horizontal resolution is between 300 and 330 lines. Most 8-mm camcorders contain a charge-coupled device (CCD) for image pickup. The flying erase (FE) head prevents the color "rainbow" effect when recording, and is mounted in the same drum or cylinder as the video heads (see figure 1-7).

Video cassette problems

The video cassette itself, like the audio cassette, can cause a lot of audio and video problems. Tape spilling out can be caused by improper alignment, or by a tape that is wound too loose or tight. To prevent jamming of the tape or cassette, inspect the cassette before inserting it into the camcorder for a broken or bulging case. Poor tape recordings in both video and audio sections can be caused by a defective tape head. Try the cassette in both the VCR and the camcorder to determine whether the cassette or cam-

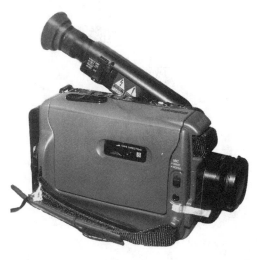

The 8-mm RCA camcorder with adjustable EVF.

corder is defective. If in doubt, try a different recorded cassette that is known to be good in the camcorder.

Camcorder features

Knowing how the camcorder operates is important when servicing the unit. In fact, many reported "problems" are operational. Since the camcorder has become popular, several new features have been added that some users do not fully understand.

Auto focus

The focus is always automatically and precisely adjusted when the camcorder is set in auto focus. Manual focus adjustment is also possible in most cameras. You will probably find optical focusing in small and low-priced camcorders. Most camcorders use the infrared beam for auto focus, except for the NEC V50U (VHS) camcorder, which has a piezo auto focus circuit.

Auto focus works via infrared rays that are emitted from the camcorder to the object, then reflected back to a receiving lens (see figure 1-8). Here the reflected rays strike two photodiodes. The focus lens moves until the two photodiodes receive an equal amount of light, correcting the camera focus.

Auto white balance

The white balance is fully automatically adjusted, and it continuously changes with fluctuations in illumination during shooting. The automatic white balance circuit controls the gain of the red

7

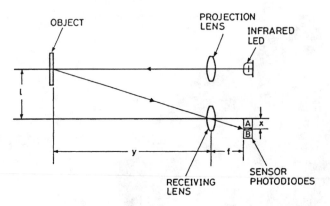

1-8 *The measurement principle of infrared autofocus system.*

and blue chrominance signals to maintain white balance (color temperature) under various lighting conditions in the RCA CPR300 VHS camcorder. *White balance* refers to the adjustment of the recording system to the color temperature of the light illuminating the subject. The auto white balance feature has white balance sensors at the front of the lens assembly.

CCD and MOS sensor

The early TV cameras and camcorders have pickup tubes called the vidicon, saticon, and newvicon tubes. Today, most camera sections use either the CCD or the MOS sensor. A *charge-coupled device* (CCD) is a semiconductor that consists of orderly arranged MOS-cell capacitors. It consists of photoelectric conversion, charge accumulation, and charge transfer and operating time.

In the older camcorders, the CCD device could have up to 250,000 pixels, while in the new camcorder, the average is around 270,000, with several going from 410,000 to 570,000. Charged-coupled devices (CCD) are used almost exclusively today. Most CCD camcorders have ⅓-inch CCDs. Minolta has come out with camcorders that have two CCD units, and Sony has developed three-chip devices. The super VHS and VHS-C camcorders have over 400 lines of resolution compared to the old 250 for VHS camcorders. Of course, picture quality is excellent, but these units require a special tape, camcorder, and a television TV rated at high resolution for best results.

Camcorder models that use MOS image devices include Minolta, Pentax, Radio Shack, RCA, and Hitachi. (The others use CCDs.) The MOS image sensor operates in the same manner with picture

elements (photodiodes with npn three-layer construction). The advantage of the CCD and MOS devices over the tube pickups are the former have longer life, no image lag or burn, no figure distortion, strong chip, instant on, lower power consumption, and are small and lightweight (see figure 1-9).

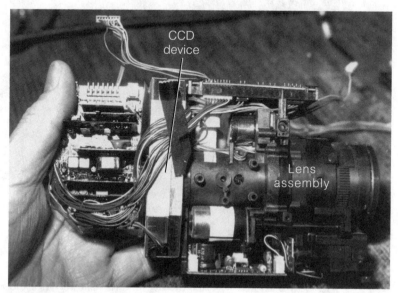

CCD
device

Lens
assembly

■ **1-9** *The CCD image sensor is found in the shielded box behind the lens assembly in a camcorder.*

Automatic iris

The automatic iris mechanism is called a *meter system*, which mechanically connects drive and brake coils. The optical signal is optoelectrically converted by the CCD images and transformed into electrical components. In other cameras, the light is controlled by electronic shutter-speed control circuits.

High-speed shutter operation

During normal camera operations, photo electrons are stored in the MOS or CCD image sensor. For a one-field time period before being scanned, the photodiodes are reset. Selecting the shutter function has the effect of delaying the reset pulse. The reset pulse is set closer to the next readout. Selecting the shutter speed determines the length of time that the reset pulse is applied before the photo tube is scanned. Shutter speed is controlled by a large microprocessor (see figure 1-10). High-speed shutter function makes it possible to catch super-fast action pictures.

9

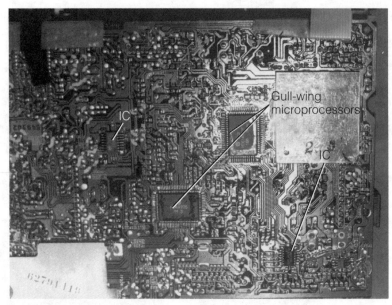

■ 1-10 *Large microprocessors and ICs are found in the camcorder serving many different camcorder circuits.*

Zoom lens

The power zoom switches move the lens assembly for close-ups or distant pictures or for wide angle shots. The zoom buttons are easily controllable while operating the camera. A zoom lever manually zooms the picture in or out. A microbutton can provide for close-up scenes.

Electronic viewfinder (EVF)

Not all camcorders have an electronic viewfinder. With the EVF, you can actually see the picture you are taking on a small screen. What you see is what you get. The electronic viewfinder image is in black and white, while the recording is in color (see figure 1-11). The electronic viewfinder can be used as a monitor in playback operations. Actually, the electronic viewfinder is a tiny TV receiver with video, high voltage, deflection circuits, and a small picture tube.

On about half of the latest camcorders, the electronic viewfinders are now in color. You can quickly play back the tape and see whether the color is adjusted properly (see figure 1-12). The viewfinders are rated in pixels, just like the CCD image device. The color viewfinder in the Canon ES1000 uses a 0.7-inch color LCD with 140,000 pixels for excellent picture quality. This can mean another color chip or circuit for the electronic viewfinder.

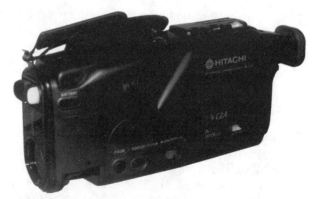

■ **1-11** *The electronic viewfinder is found at the rear of a Hitachi camcorder.*

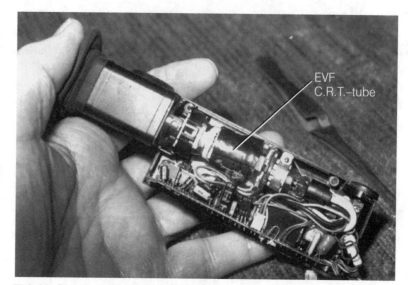

EVF
C.R.T.–tube

■ **1-12** *The B & W viewfinder consists of a small tube packed tightly with video and sweep circuits.*

Audio dubbing

The audio dubbing feature allows you to replace the original recorded sound with background music, narration, or special sound effects. Insert editing capability is handy for editing tapes by inserting new scenes into the already-recorded video cassette.

HQ technology

In some late camcorders, you will find the HQ symbol mark feature of the new VHS high quality picture system. HQ technology im-

proves the picture quality while retaining VHS interchangeability. In some models, this means raising the white clip level and detail enhancer. Remember, the HQ camcorder system will operate in the conventional VHS recording system.

Power requirements

For greater portability, the camcorder operates off of a camcorder battery. These batteries slide in and out of the camcorder for recharging. These batteries start at 6-V, 7.2-V, 9.6-V, 10-V, and 12-V types, with 1 Ah to 3.5 Ah. The JC Penney Model 5115 operates with a 1-V battery, Fisher model FVC73U at 6 V, Minolta 8200 camcorder at 7.2 V, and JVC model GR-S70V at 9.6 V. You can sometimes find a dc/dc converter with several different voltage sources.

A lithium 3-V battery is found in Canon's ES1000 camcorder as a back-up source for the quartz circuit. The lithium 3-V power is supplied when the battery pack is unloaded. While the battery pack is not mounted, the lithium battery outputs 3 V for backing up the quartz circuit. When the main battery is mounted, the lithium 3-V battery is charged with the regulated power from IC230.

Hookups

Most camcorders can be connected directly to the TV set or color monitor with a VHF connecting cable and an audio/video cable (see figure 1-13). An RF adapter might be required between camcorder and the TV antenna input terminals (see figures 1-14 and 1-15). If the TV set or color monitor has video and sound input jacks, the audio/video cord is connected between camcorder and TV set or monitor (see figure 1-16).

When recording from other equipment, the video cassette recorder is connected between the TV set and the camcorder. In some models, the ac video adapter is used when operating the camcorder from the power line (see figure 1-17). Editing the recording hookup can be accomplished with the VCR connected between camcorder and TV set or monitor. Dubbing introduces some degree of picture quality deterioration. It is recommended that the video camcorder recorder be placed in SP mode.

New weights

The older VHS camcorder can weigh 5 lbs. or more, while the VHS-C and 8-mm camcorders weight less than three lbs. with battery.

When using a TV without audio/video input terminals

Connect the Video AC Adapter VF-BA81 (provided) as shown below.

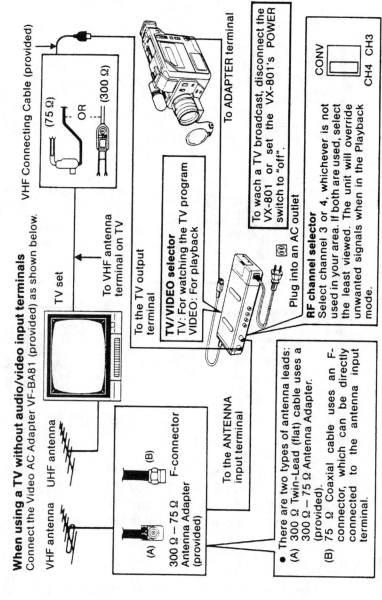

VHF Connecting Cable (provided)

VHF antenna UHF antenna

TV set

(75 Ω) OR (300 Ω)

To VHF antenna terminal on TV

To ADAPTER terminal

To the TV output terminal

TV/VIDEO selector
TV: For watching the TV program
VIDEO: For playback

To wach a TV broadcast, disconnect the VX-801 or set the VX-801's POWER switch to "off".

Plug into an AC outlet

RF channel selector
Select channel 3 or 4, whichever is not used in your area. If both are used, select the least viewed. The unit will override unwanted signals when in the Playback mode.

CONV

CH4 CH3

(A)

(B) F-connector

300 Ω – 75 Ω
Antenna Adapter
(provided)

To the ANTENNA input terminal

● There are two types of antenna leads:
(A) 300 Ω Twin-Lead (flat) cable uses a 300 Ω – 75 Ω Antenna Adapter. (provided).
(B) 75 Ω Coaxial cable uses an F-connector, which can be directly connected to the antenna input terminal.

■ 1-13 *How to connect the 8-mm camcorder to the television set.*

13

Connection to a TV set's antenna terminal

If your television is not equipped with video/audio input jacks, connect the Model 3300 and TV set using RF Output Adapter RF-M3000S.

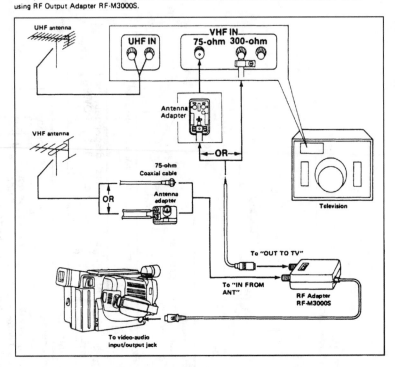

1. Disconnect the VHF antenna cable from the antenna terminal(s) of the television.

Note:
- Leave the UHF antenna leads connected to the TV.

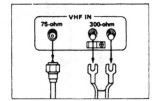

■ **1-14** *Use an RF adapter to connect the camcorder to the back of the VHF terminals of TV set.*

The Canon ES1000 weighs 2 lbs. without battery, Hitachi VM-ES8A is 1.7 lbs., the Panasonic VHS PV-900 weighs 4.2 lbs., and the RCA CC710 VHS-C is 2 lbs. without battery. Today's camcorders are very compact, easy to operate, and light to carry around.

Block diagram

Looking at the camcorder block diagram can help to determine where the trouble is. The manufacturer's service literature is a must item in troubleshooting the camcorder. Not only does it contain the block diagrams, but it breaks down each stage and shows

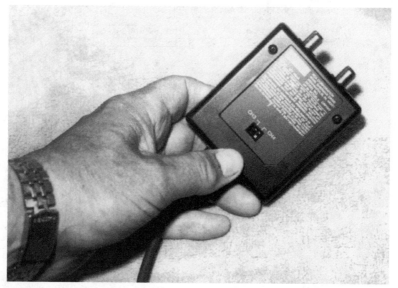

■ **1-15** *RF adapters usually come with the camcorder to connect to the TV antenna terminal.*

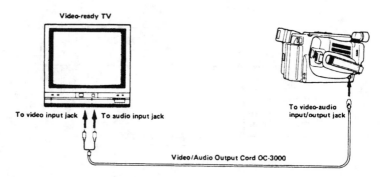

Video-ready TV

To video input jack To audio input jack

To video-audio input/output jack

Video/Audio Output Cord OC-3000

■ **1-16** *Connect the camcorder directly to the video and audio jacks, if provided on the TV receiver.*

how the components are tied together in each separate schematic. The schematic contains not only the circuits, but also voltages and critical waveforms.

VHS

The early VHS camcorder camera block diagram has a pickup tube or CCD stage, processor, AWB, auto focus, and EVF stages (see figure 1-18). The CCD stages consist of CCD image sensor, CCD sync generator, CCD driver, and sampling hold circuits. The iris motor, AIC operation, chroma, and sync pulse generator can be

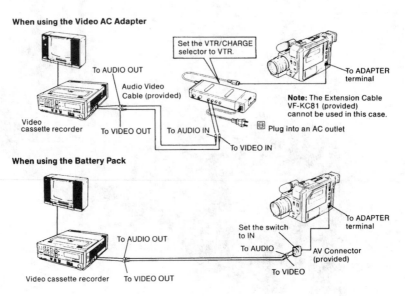

1-17 *An ac adapter connects the video cassette recorder between TV monitor and camcorder.* Olympus Corp

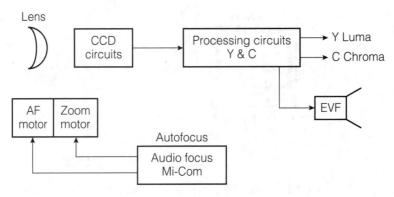

1-18 *A typical camera section with various components and circuits.*

found in the process circuits. The AWB circuit contains AVT sensor, AWB gain, switching, and decoder. The focus lens, zener and iris motors, motor control circuits, demodulator, AGC, and clamping and digital converters are found in the auto focus circuits.

The RCA CC547 VHS camcorder has a digital zoom, built-in video light, and color viewfinder. This camcorder uses a ⅓-inch CCD device with 270,000 pixels as image sensor, with minimum light required is a low 1 lux. It has a 12× optical zoom lens that can be boosted to 24 times with zoom plus. The RCA CC547 has a color

viewfinder of 120,000 pixels. Other features can include a built-in titles, flying erase head, A/V dubbing, and auto date/time.

The electronic viewfinder consists of horizontal and vertical sync, horizontal and vertical oscillator, deflection coils, flyback transformer, and CRT. The input of the EVF stages connects to the video output of camera circuits. The EVF circuits are often contained in one unit.

VHS-C

The VHS-C camera section consists of the AIC circuits, autofocus, automatic white balance, chroma processing, encoder/NTSC signal processing, luminance, MOS or CCD image sensor and circuits, matrix and filter, pulse generator, preamplifier, signal processing, sync generator, power supply distribution, and electronic viewfinder circuits.

The VHS-C camcorder requires an adapter in order to play back through a regular VCR. The small C-type tape cartridge can be placed in a VHS adapter. The VHS adapter can then be inserted into the VCR for playback. These VHS-C camcorders can also be played back through the TV antenna connection of the TV set.

8-millimeter

The 8-mm Samsung SCX854 camcorder camera section consists of the lens, zoom lens, CCD image sensor, V drive, D & A converter, Y signal process block, C signal process block, CDS/AGC/R, digital signal process, and an 8-bit A/D converter on the process board (see figure 1-19). The auto board holds the auto focus Micom/EVR, EEPROM, iris block, Hall detect block, auto focus motor drive, and zoom motor drive circuits.

The camera section of a Canon ES1000 camcorder contains VAP unit, zoom reset, zoom lens, zoom motor, IG meter, focus lens, focus reset, focus motor, and CCD unit upon the lens board. The CCD PCB contains a V driver (IC1052) and connecting circuits.

The VAP PCB contains a gyro sensor, gyro amp, D/A, gain cont, buffer amp, VAP Mi-Com, PSD sensor, PSD amp, D/A, gain cont, buffer amp, driver, pre-driver, PWM, and E2 PROM circuits. A camera key unit consists of several switches of date on, title, AFM/off, shutter, sensor on/off, C reset, fade, and BLC switch circuits.

The camera PCB contains the timing generator, S & H and AGC IC, camera/AF Mi-Con, focus motor drive IC, zoom motor drive IC,

18

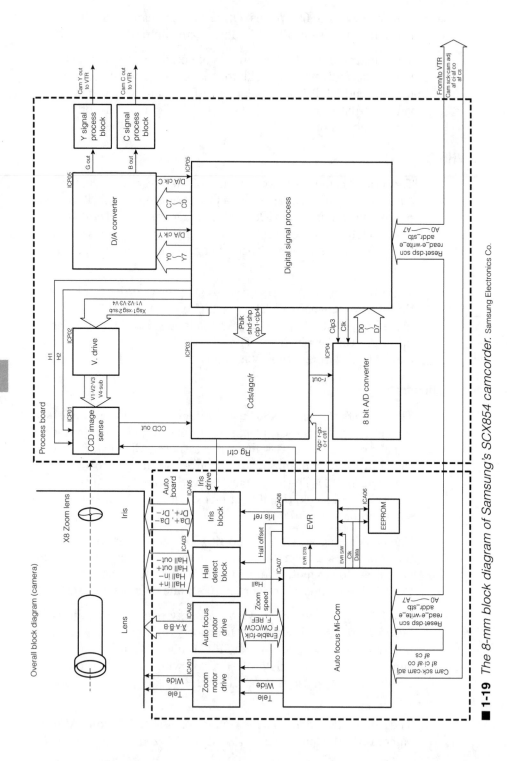

1-19 *The 8-mm block diagram of Samsung's SCX854 camcorder.* Samsung Electronics Co.

flip-flop IC, digital processing, D & A converter, and several camera, iris, and analog regulators.

The camera section

The camcorder features are broken down into the camera and the VCR sections for easy operation. A brief description of each stage in the camera section follows. Although some of these circuits are sometimes called by another name, the circuit functions are the same, as explained in Chapter 3 (see figure 1-20).

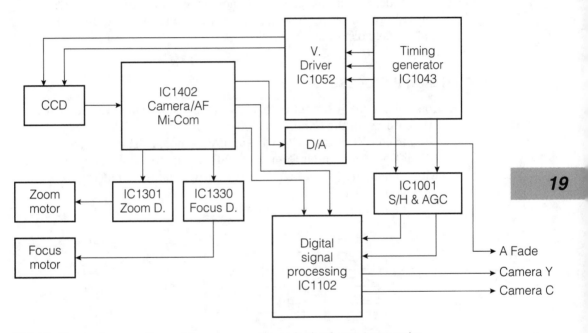

■ **1-20** *The various sections of the camera stages in the 8-mm camcorder.*

CCD and MOS image sensor

The CCD and MOS image sensors take the place of the older pickup tube. A CCD charge-coupled device is a semiconductor that consists of orderly arranged arrays of MOS cells (capacitors). The MOS color image sensor uses picture elements with a structure of npn three-layer photodiodes. The color resolution filter arranges white, yellow, cyan and green color filters in a mosaic pattern. The four-color output improves resolution with reduced image retention. Both devices are integrated circuits.

CCD or MOS drive pulse

The drive pulse generator circuit generates the pulses that drive the image sensor and signal-processing circuits. The drive pulse generator IC is often broken down into four sections: the 5.37-MHz high-speed circuit, the shutter function, and the horizontal and vertical frequency circuits. The 5.37-MHz high-speed section generates the horizontal shift register clock pulse. The shutter speed control determines the shutter speed. The horizontal frequency section generates the horizontal shift register start, vertical shift register clock, vertical buffer, reset, and sweep pulses. The vertical frequency section generates the vertical shift register start, vertical optical block, field discrimination, vertical start, and FA and FB field discrimination pulses.

Digital signal process

You will find many new circuits in the latest camcorders with modern features. In the Canon ES1000 camcorder, the VC 2HI/VCS3A circuits consist of the CCD, CDS and AGC, A/D, DSP, AF process, AF Mi-Com, camera Mi-Com, sub DSP, C. sup and D/A converter with a luminous (y) and chroma (c) output connections (see figure 1-21).

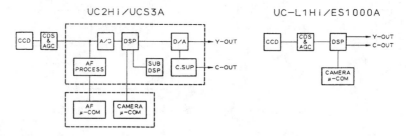

■ **1-21** *The digital signal processing circuits of the older and new Canon ES1000 camcorder.* Canon, Inc.

Within the new camera section of the Canon ES1000 camcorder, the Sub DSP IC and AF IC are incorporated in the digital processing IC that has been employed for UC2HI. The new circuits consist of a CCD, CDS and AGC, DSP, camera Mi-Com, with y and c output terminals. This new circuit arrangement reduces the physical size of the camera section.

Sync generator

The sync generator provides signals that synchronize the operations in the color camera. It is usually one large IC component. It supplies signals to the iris driver, auto white balance, date generator, process, luminance enhancer, chroma amp filter, and MOS image sensor drive pulse.

Signal processing

In the signal-processing circuits, the cyan, white, green, and yellow are driven simultaneously by the 5.43-MHz sampling frequency. The matrix circuit produces luminous (y) and chrominance (R, B, and G) signals.

Preamplifier

The yellow, cyan, green, and white signals from the MOS or CCD image sensor are amplified by the preamplifier circuits. The input impedance is very low and controlled by a single IC.

Matrix color circuits

The amplified cyan, green, yellow, and white signals are fed into the matrix IC to produce the luminance, red, blue, and green signals.

Resampling process

The white, cyan, green, and yellow signals are fed from the preamp circuits to the sampling IC. Improved high-frequency response and signal-to-noise ratio are obtained by averaging the value of every picture element (pixel). The luminance (YL and YH) signals are fed to the process board.

Canon Y/C signal processing

In the conventional Canon models, two ICs were used for the luminous (Y) and chroma (C) process within the signal processing circuits. In the ES1000 camcorder signal processing circuit the luminous and chroma signals are processed in one single IC chip. Likewise, the EVR (electronic volume) arrangement is found within recorder (REC/PB amp) and EVR IC, taking up less space (see figure 1-22).

Luminous signal processing

The luminous signal is clamped, gamma corrected, and blanked to eliminate noise during the blanking period. Also, the signal is

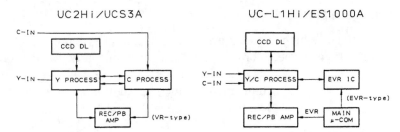

1-22 *In the older Canon camcorders the luma (Y) and chroma (C) were separate ICs. Now both are included in a single Y/C process chip.* Canon, Inc.

white- and dark-clipped before it is fed to the automatic iris control circuits and to the AGC amplifier.

Chroma processing

The red, green, and blue signals are applied to the input of the color processing IC. Here, the red and blue signals are applied to the white balance circuits. These signals are mixed to produce the -R -YL and -B -YL color difference signals that are applied to the encoder processing circuits.

Encoder

The luminance signal is applied to the NTSC signal-processing circuits. The luminance signal is clamped and white clipped to reduce the color output in the bright areas of the picture. The white-clipped luminance signal is blanked, applied to the YC mixing circuit, and added to the chrominance signal. The -R -YL and -B -YL signals are applied, clamped, and balance-modulated by the 3.58-MHz signal. These two modulated signals are added and applied through a 3.58-MHz bandpass filter. The reduced noise signal is applied to the Y/C mixing circuits and then added to the luminance signal.

AIC or iris control

The AIC (automatic iris control) circuit controls the level of the video signal. This circuit controls the iris opening as detected from the processing circuit. The AIC circuit consists of the low light detection, AGC killer, and iris motor drive circuits.

Automatic white balance

The automatic white balance circuit maintains correct white balance under various lighting conditions. These circuits correct the white area of a picture so it does not have a red or blue cast or tint.

Automatic focus

The automatic focus circuit transmits an infrared signal that strikes the subject and bounces back to the infrared receiver located on the camera. This signal is detected by two photodiodes that produce electrical current according to the infrared light received. The auto focus circuit uses these two signals to move the lens in the proper direction. When the two signals become equal, the lens is focused and the auto focus motor stops.

Power distribution

The power distribution circuits regulate and distribute the operating voltage to the various camera circuits. For instance, within the Canon ES1000, the different power sources are an EVER 5 V, SS 5 V, AV 5 V, PB 5 V, EVF 5 V, camera 5 V, +15 V and –8.5 V, +9 V, MiCom 4 V, digital 4 V and lithium battery 3 V.

The EVER 5-V source primarily supplies power to the main MiCom IC231. From the 6-V battery pack, the 6 V is applied to the power supply PCB, to pin 8 of IC230 on the Recorder Main PCB. The EVER 5-V power is output from pin 1 of IC230 on the Recorder Main PCB (see figure 1-23).

An SS (Syscon-Servo) 5-V source powers the Syscon-Servo circuits. This SS 5-V power is always on while the power switch is turned on. The SS on "H" is output from pin 68 of the Main IC231 and triggers on Q902. This activates the circuits of IC901 and Q901 to deliver the SS 5-V power.

The AV (audio/video) 5-V supplies voltage to the video and audio circuits. This 5-V source is always on when power switch is turned on. AV on "H" is output from pin 66 of Main IC231. This voltage is applied to pin 2 of IC921. IC921 is driver to supply output AV 5 V at pin 3 of 5-V regulator IC921.

A PB (play/back) 5-V source provides voltage to the playback video circuits. When the play mode is selected, the PB "H"/EB "L" is output from pin 41 of Main IC231. In the play mode, Q2106 is triggered on at Q2107, with a PB 5-V output at IC231.

The EVF (electronic viewfinder) 5-V source powers the EVF circuits. This EVF 5 V is always on when power switch is turned on. The EVF on "H" at pin 65 of IC231 is fed to 5-V regulator IC941, with output at pins 4 and 8.

A camera 5-V source provides power to the camera and AF circuits. This camera voltage is selected when camera mode is turned

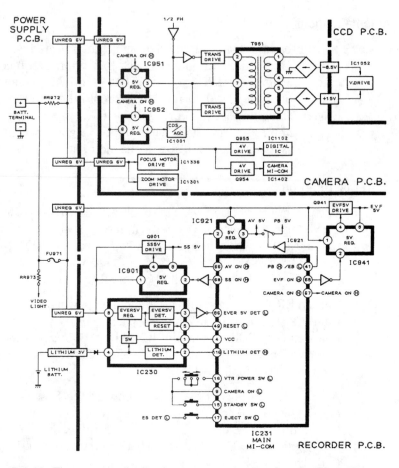

1-23 *The power distribution sources in the Canon ES1000 camcorder.* Canon, Inc.

on. On A the output in pin 66 of Main IC231 feeds to the 5-V regulator pin 2 of regulator IC921. The power output voltage is selected from pin 3.

Both the +15-V and –8.5-V sources power the CCD drive circuits. These voltages are activated when camera mode is selected. The ½-FH waveform signal is applied to IC956 to IC1002 and IC1003. The output signals of IC1002 and IC1003 are fed to the power transformer circuit T951 through driving by Q951 and Q953. The output voltages of T951 are rectified and detected by D951 and D952 to deliver +15 V and –8.5 V to CCD circuits.

The +9-V source feeds the CDS/AGC IC1001. The +15-V source is divided by Q952 and provides a +9-V output source.

A Mi-Com 4-V source provides power to the camera Mi-Com circuits. The camera 5-V source is divided by the resistor circuit to trigger on Q954. The Mi-Com 4 V is output at Q954.

The Digital 4-V source provides voltage to the Digital IC1102. The camera 5-V source is divided by the resistor circuit to trigger on Q954. The Mi-Com 4-V power source is output from Q954 regulator.

The lithium battery serves as a back-up source for the quartz circuits. This 3-V source is supplied when the battery pack is unloaded. When the battery pack is inserted or mounted, the lithium battery is charged with regulator power from IC230. In many of the new camcorders, a dc-to-dc converter supplies the various voltage sources to the camcorder circuits.

VTR or VCR section

The VTR or VCR section consists of the video head, head switching, system control, trouble detection circuits, on-screen display, servo system, luminance record, chroma record process, luminance playback, chroma playback, and audio circuits. Although there are many other smaller circuits within the VTR, the most important ones are given here. In addition to these circuits, many mechanical movements are described in detail in Chapter 9.

Video heads

The upper cylinder or drum in the VHS and VHS-C video recorders have a 41-mm diameter with four heads (see figure 1-24). The tape wrap for this system is 270 degrees, and it rotates at a speed of 2700 rpm. This system produces a more compact camcorder, providing compatibility with previous VHS recorders (see figure 1-25). The 8-mm drum is smaller in diameter and contains two channels and a flying erase (FE) circuit. The FM audio signal is recorded along with the video rather than at the edge of the VHS tape (see figure 1-26).

Audio tracks on tape

The VHS camcorders have a single (mono) linear audio track upon the bottom edge of tape. The linear track runs in a straight line along the edge of VHS tape. The sound quality of a single mono track is only fair, with a frequency response from 50 to 10 kHz (see figure 1-27). The stereo camcorder and VCR split the audio track into two different sound tracks in the stereo machines. A control track is found at the top edge of tape, while the middle area combines the video signal track. The 8-mm FM audio signal is recorded right in with the video signal.

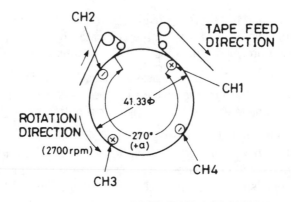

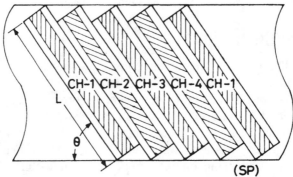

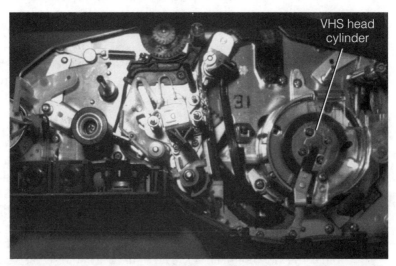

■ **1-24** *The VHS/VHS-C video head configuration.*
RCA-Thomson Consumer Electronics

■ **1-25** *The VHS head assembly in the RCA CPR300 camcorder.*

Camcorder and video cassette formats

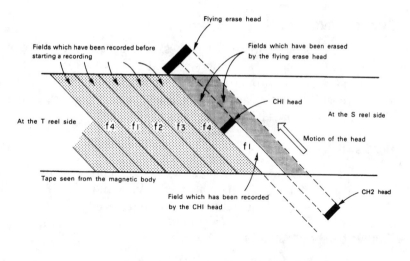

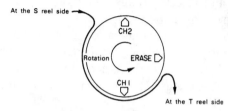

■ **1-26** *The magnetic tape field with flying erase head in the 8-mm camcorder.* Zenith Corp.

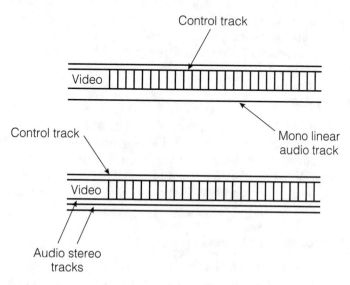

■ **1-27** *The mono and stereo audio sound tracks on a VHS or VHS-C cassette tape.*

System control

The system control microprocessor controls the reset, clock, power, battery detection, function switch, capstan, on-screen display, servo, luma/chroma, trouble detection, tape run, loading motor, mechanical control, and character generator in most camcorders. Usually, one large IC operates all of these functions.

Head switching

The head-switching circuits consists of a preamp and the switches of the four head channels in the VHS and VHS-C models. Head switching is done in the record and playback modes.

Trouble detection circuits

The VHS and VHS-C trouble detection circuits consist of the end circuit, dew sensor, mechanism switch, take-up reel sensor, supply reel sensor, and supply end circuit. The battery detection circuit is usually controlled by the system control IC. The clog head detection circuit warns that there is accumulation of magnetized tape dust in the head gap of the 8-mm head assembly.

On-screen display

When the display switch is on, the system control IC produces a low signal that is applied to the character generator in the VHS-C camcorder. This signal from the character generator displays the battery level, tape counter, shutter speed, and operation mode. This character signal is amplified and mixed with the video in a video amp IC. From here, the video signal is fed to the EVF and AV output.

Servo system

In the VHS-C, the upper cylinder must rotate at 2700 rpm in playback and record in the VHS-C circuits. This means the phase and speed of the capstan and cylinder motors must be controlled. The ½-V sync, REF 30 Hz, 30-Hz PG pulse, cylinder FG (CYL FG) pulse, capstan FG (CFF) pulse, and CTL pulse signals are in the servo system.

Luminance record process

The luminance IC, in the VHS and VHS-C units, contains the record AGC, luminance signal extractor, detail enhancer, preemphasis, clipping, frequency modulation, and the E-E amplifier cir-

cuits (see figure 1-28). The signal is sent through a high-pass filter (HPF) to the record mixer and amp circuits. The luminance and chroma signals are mixed before going to the record amp. The record amp signal is applied to the video heads.

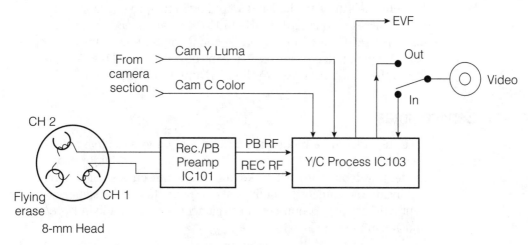

■ **1-28** *The luminous and color recording process in the 8-mm camcorder.*

Luminance playback process

In the 8-mm luminance playback circuits, two different ICs might be used. The pick-up signal of the tape heads is fed to a preamp, channel switch, and AGC circuits in the preamp IC. This signal is fed to the 5.8-MHz peak, trap, and the phase comparator between the preamp and luminance processing IC. The luminance processing IC contains the HP limit, demodulator, DO detector, dynamic deemphasis, noise cancel, line noise expand, Y/C mixer, and video amp. This video playback signal is fed to the EVF and AV connector.

The luminance playback signal is picked up by the four heads, amplified, and switched to the luminance playback IC in the VHS and VHS-C camcorders. This signal is demodulated and mixed with the chroma playback IC to produce a video signal. The video signal is fed to a character mixer IC, then out to the EVF and AV out connector.

Chroma playback process

In the Pentax PV-C850A (8 mm) chroma playback circuits, the signal from CH 1 and CH 2 is amplified by IC201. The signal goes through a 1.3-MHz LPF, AGC, burst deemphasis, PB balance modulator, chroma comb filter, chroma deemphasis, and a PB color

killer and is mixed with the luminance signal in the Y/C mixer. The video signal is amplified to the EVF and AV connector circuits.

The chroma playback signal in the VHS and VHS-C chroma playback circuits are quite similar to the 8 mm. The signal from the four channels are switched and amplified in the preamp stage. The signal passes through a 1.3-MHz LPF, PB balance modulator 3.58-MHz BPF, AGC, burst deemphasis, and a comb filter and is mixed with the luminance playback signal in the Y/C mixer. This signal is fed to the character mixer to the EVF and AV out connector.

Service notes

Like the video tape recorder, there are only a few original manufacturers who make camcorders. You might be working on one model that looks somewhat like another brand on the sales floor, but inside the camcorder body, the components are the same, except a different part number. Most camcorders are made in Korea and Japan (see Table 1-1).

There are a few precautions the electronic technician should take before attempting to repair the camcorder. The camcorder is small, with parts jammed together. To get at one defective component you might have to remove ten others. You need steady fingers and small thumbs. Sometimes it's the little things that save valuable service time and money.

Warm-up time

The camcorder should warm up at least 3 minutes for operation and at least 5 minutes before attempting to make camcorder adjustments. This provides sufficient time for all parts to function properly and remove any moisture inside the camcorder. If moisture condensation is detected in the camcorder, the dew sensor prevents operation of camcorder, so not to produce jamming of tape due to possible sticking.

Tab lock

Make sure the tab at the back of the cassette is in or "turned on" for recording. If the tab is out, the cassette cannot be used for recording. Often when customers bring in the camcorder for repair because it will not record, it's because the tab is broken out of the cassette. Place a piece of tape across the opening where the tab was to record. Then remove it to prevent recording over a recording that you want to keep intact.

■ Table 1-1 Camcorder manufacturers.

Manufacturer	Makes	
Canon	Canon	
Goldstar	Goldstar	
Hitachi	Hitachi	
	Kyocera	
	Minolta	
	Mitsubishi	
	Pentax	
	RCA	
	Realistic	
	Sears	
JVC	JVC	
	Samsung	
	Toshiba	
	Zenith	
Matsushita	Chinon	Olympus
	Curtis-Mathes	Nikon
	Elmo	Panasonic
	General Electric	Philco
	Instant Replay	Quasar
	JC Penney	Sylvania
	Kodak	Technika
	Magnovox	
	NEC	
NEC	NEC	
Sanyo	Fisher	
	Sanyo	
	Vivitar	
Sharp	Sharp	
Sony	Aiwa	Ricoh
	Fuji	Sony
	Kyocera	
	Pioneer	

Write it down

Place the components in a regular order or write down where the parts go as you remove them. If you have to leave the bench or order a part, you might not remember where it belongs after you return or when you receive the part, which could be months.

Service cloth

It's best to place a servicing cloth down on the bench, even if the bench is carpeted, to prevent damage to the camcorder's plastic body. Even small scratches might not polish out. Also, you don't want to lose a small screw or nut underneath the camcorder.

Service literature

This is a "must" item. You cannot troubleshoot the various stages, provide adequate electronic adjustments, replace components, take critical voltage measurements, or find the correct part numbers without the service literature. Camcorder service literature is not cheap, but it will pay for itself in the first repair.

Wrist strap

Always wear a wrist strap when servicing and replacing delicate components such as image sensors, microprocessors, and ICs.

Know when not to touch

Do not attempt electrical adjustments when you don't have the correct test equipment to make these tests. Don't haphazardly tear into the camcorder when you do not have the correct service literature. If you cannot locate the defective component, check with the field service representative, wholesaler, service depot, or your fellow electronic technician. Ask for help—it's out there.

Tips and techniques

2

THERE ARE SEVERAL SERVICE PRECAUTIONS TO TAKE while servicing the camcorder. Always unplug the power source when removing or installing a component, circuit board, or module. Remove the battery or ac power source when disconnecting or reconnecting plugs and electrical connections. Shut off the power and discharge electrolytic capacitors before shunting them with another. Always remove one end of any fixed diode for accurate leakage testing.

Service precautions

Keep chemical or lubrication sprays away from the camcorder. Do not spray chemicals on or inside the unit. Clean off switch contacts with cleaning sticks and alcohol.

33

Do not defeat the purpose of plugs, sockets, or interlocks. Always replace the component to its original position and order. Do not forget to replace heatsinks and shields after replacing components. Keep loose screws and nuts out of the unit.

Keep the camcorder and test equipment grounded. Connect the ground lead first and always remove it last.

When replacing a chassis in the plastic case, all the protective devices must be put back in place, such as barriers, nonmetallic knobs, adjustment and compartment shields, isolation resistors, etc.

When service is required, observe the original lead dress. Take extra precaution to assure correct lead dress in the high-voltage circuits.

Always use the manufacturer's replacement components, especially crucial components. These parts were designed for that particular camcorder and should be replaced by the same part number (figure 2-1).

■ **2-1** *Always use original part numbers of defective components to replace in camcorders.*

Before returning the camcorder to the customer, the service technician must thoroughly test the camcorder for safe operation. Clean the case and outside components, too.

Take a hot and cold leakage test on the camcorder for safety.

Cold current leakage test

With the power cord pulled from the socket, place a wire jumper across the two plug prongs. Turn the ac switch on. Using an ohmmeter, connect one lead to the jumpered ac plug and touch the other lead to metal screws, metal envelopes, and control shafts that are exposed to the operator. You should measure no less than 300 k. Any resistance value below this figure can indicate a shorted component or wire.

Hot current leakage test

Plug the ac line cord of the power pack into the 120-Vac outlet. Turn on the ac power switch. Select a metal, exposed component or shaft and take a current measurement between the camcorder and a good water ground. Recheck the camcorder if the current measured is above 0.5 mA (figure 2-2). Any measurement not within these limits indicates potential shock hazard and must be corrected before returning the camcorder to the owner.

Electrostatic-sensitive devices

Electrostatic-sensitive devices can be damaged by static electricity. These sensitive devices include ICs, field-effect transistors and

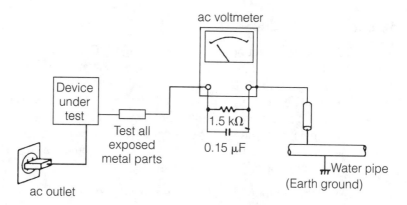

■ **2-2** *Check the camcorder for hot leakage test after repairs.*

semiconductor components (figure 2-3). Carefully handle all sensitive devices in their original electrostatic packet, do not unwrap until they are ready to be mounted.

Keep your body drained of electrostatic charges by keeping all clothing at ground potential. Wear a conductive ground wrist strap. Make sure the camcorder and test equipment are grounded. Use a grounded-tip soldering iron and solder removal tool to prevent antistatic build-up. Keep freon-propelled chemical spray cans away from the camcorder. Prevent extra body motion that might create static electricity from a carpeted floor. Store the MOS IC in the black foam pocket it came in.

■ **2-3** *Small microprocessors and gullwing-type ICs can be found mounted on the PC wiring side.*

Soldering techniques

Always use a grounded-tip, low-wattage (35 watts) or less iron so not to overheat ICs or transistors. A battery-operated solder iron is ideal for IC and transistor terminals. Thoroughly clean all surfaces, especially pc wiring, to be soldered. A small wire brush is ideal. Do not use freon spray cleaners for cleanup, heat the small terminals until the solder melts and then suck up the melted solder with an antistatic suction-type solder remover. Mesh solder braid might be sufficient to do the job.

After the component has been removed and surface-cleaned of excess solder, mount the component. Recheck all terminal leads. Hold the iron tip against the terminal lead and apply solder. Keep a heatsink on transistor and IC component leads to protect the mounted component. Do not overheat the pc wiring, because it will lift up. Now inspect the soldered joint for a good bond and brush out rosin and excess solder with a small wire brush.

Types of chip ICs

There are many different types of chip ICs found in today's camcorder. Here are just a few: Small outline package IC (SOP), shrink small outline package IC (SSOP), very small outline package IC (VSOP), quad flat pack IC, (QFP), very quad flat package IC (VQFP), plastic leaded chip carrier IC (PLCC), and thin small outline package IC (TSOP) (figure 2-4).

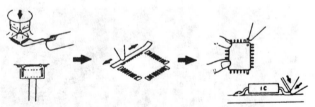

■ **2-4** *IC gullwing terminals can be removed one at a time with iron and flat tool, or all at once with body soldering tool.*

Removing the IC chip

For special applications of the desoldering iron, select the tip according to the size and shape of the IC. Tin the tip with a small amount of the IC leads. Set the tip squarely over the IC leads. When the solder melts, carefully twist the iron. Raise up and re-

move the IC. Some technicians use a sharp knife or tool and cut the gullwing tip terminals close to the body of IC (figure 2-5). Then remove gullwing tips from the PC wiring. Another method used by the electronic technicians is to unsolder one terminal and lift it up with pry tool and bend upward to remove gullwing terminal from the PC board.

Select the correct nozzle when using the shaped airblower unit. Set the temperature at 7 and airblower at 4. Engage the IC removing tool. Use the airblower to preheat the IC for 5 seconds, then heat with the nozzle until the IC remover lifts the part from the PC wiring. Throw away the removed IC chip, do not try to use it again.

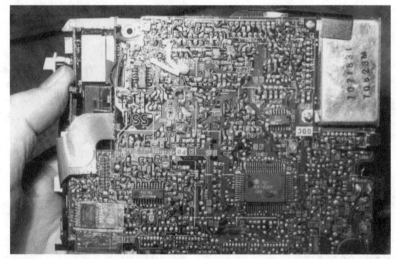

■ **2-5** *Be very careful when removing IC chip terminals, so not to damage pads or PC wiring.*

Tools for IC replacement

The following tools should be used for IC chip replacement:

1. Thin tip type soldering iron

2. Small flat-blade tip type soldering iron

3. Special desoldering tip iron or solder wick

4. Airblower unit, if possible (might be too expensive for the small shop).

5. Flat package pick-up

6. Flux can be cleaned by water

7. 0.3-mm thin solder can be cleaned by water

8. Desoldering wire

9. Tweezers

Installing IC chips

Be sure and use desoldering wire or solder wick to remove the previous solder. Clean up location and PC wire terminals. Apply flux on PC wiring. Check for correct terminal 1 and make sure the IC is in the right place. Position the IC and solder two pins at opposite sides. Use a sharp tipped iron and carefully solder each pin. Remove any solder bridges with desoldering wire or solder wick. Inspect each pin terminal with a magnifier or light magnifier.

Circuit foil repair

It is very easy to damage the PC foil when removing chip or IC components. Sometimes the foil or pieces of it pull up with the terminals being removed. Excessive heat applied to the PC wiring can cause the foil wiring to pop off. Simply remove the defective foil pattern with a sharp knife. Locate the components tied together, and connect a piece of hookup wire from one lead of the nearest component to the other one. Make a hook in the bare hookup wire and place it over the IC pin that has pulled up the foil. Route the hookup wire to the nearest common junction of components.

Service data

Before digging into a camcorder that has any difficult symptoms, obtain the correct service diagram. Many of the present-day camcorders are made by only a few manufacturers, and sometimes the same circuits are in other camcorders. However, it is very difficult to service servo, video, system control, and camera circuits without a schematic. This service literature can be obtained through the camcorder manufacturer or servicing depots. It's extremely difficult to make electrical and mechanical alignment procedures without the manufacturer's service literature. Mechanical adjustments are explained in Chapter 11, and electrical adjustments are covered in Chapter 12.

Voltage measurements

Most voltage measurements in camcorders are taken from the negative side of the power supply. If in doubt, locate the main filter capacitor's negative source. In the Pentax PV-C850A camcorder, the voltage measurements shown on the schematic in the camera section are measured when the VTR is in the record mode. Voltages in the VTR section are measured in both the record and play modes. The voltages in parentheses are those measured in the record mode. Voltages are often listed in black or bright red on the schematic diagram. Usually, voltages should be taken with the lens cap on.

Some camcorder manufacturers place the voltages right on the schematic, while others do not. Often, the camcorder schematic is so large, (fold out type) that it's impossible to list the various voltages. You might be able to find voltage measurements on small section schematics of the camcorder. Check the service literature for different voltage charts, listing the various voltages upon IC and transistor pin terminals (figure 2-6).

Signal paths

When servicing the camera, VTR, and servo sections, use the signal path arrows or colors. In the NEC-VM50U VHS camcorder, the servo block diagram uses gray and red colors to identify the different servo signals. The cylinder servo speed loop is marked with a solid gray line and capstan servo speed loop with dotted gray lines. The cylinder servo phase loop is marked in a solid red line, with the capstan servo phase loop in dotted red lines.

Within the servo system control schematic of a Samsung SCX854 camcorder, the drum servo speed and phase signal lines are a solid red color, while the capstan phase servo is a blue line. A dotted blue line represents the signal of the capstan servo speed and phase control. The drum speed servo is a solid green line, and drum phase servo a dotted green line signal.

Samsung's video/audio schematic consists of a solid red line indicating recording Y process and a dotted red line at playback (PB) Y process. The video/sender FM recording process has a solid blue line and the video/audio FM playback process has a dotted blue line. A solid green line represents the recording color (C) process, with a dotted green line as playback C process.

IC101 (CXA1202R)			
PIN NO	PLAYBACK	RECORD	STOP
1	4.5 V	4.5 V	1.3 V
2	0.0 V	3.1 V	1.0 V
3	4.1 V	4.1 V	1.0 V
4	0.0 V	4.1 V	1.0 V
5	2.5 V	2.5 V	0.4 V
6	0.0 V	3.1 V	1.0 V
7	4.6 V	4.6 V	1.2 V
8	1.7 V	2.1 V	0.8 V
9	3.9 V	4.5 V	1.2 V
10	2.4 V	2.4 V	0.6 V
11	0.0 V	0.0 V	0.0 V
12	2.4 V	2.4 V	0.4 V
13	0.0 V	0.0 V	0.0 V
14	2.4 V	2.4 V	0.4 V
15	2.5 V	1.3 V	0.4 V
16	2.4 V	2.4 V	0.4 V
17	4.6 V	4.6 V	0.0 V
18	2.4 V	4.5 V	0.7 V
19	0.0 V	0.0 V	0.0 V
20	1.7 V	3.8 V	1.0 V
21	0.0 V	0.0 V	0.0 V
22	0.0V	0.0 V	0.0 V
23	3.4 V	3.4 V	0.8 V
24	2.5 V	2.5 V	0.7 V
25	1.7 V	1.7 V	0.7 V
26	2.4 V	0.0 V	0.0 V
27	4.8 V	4.8 V	1.2 V
28	4.8 V	4.8 V	1.2 V
29	2.1 V	2.1 V	0.0 V
30	2.1 V	3.1 V	0.7 V
31	2.1 V	2.1 V	0.7 V
32	2.1 V	2.1 V	0.0 V
33	4.8 V	4.8 V	1.2 V
34	4.8 V	4.8 V	1.2 V
35	2.4 V	0.0 V	0.0 V
36	1.7 V	1.7 V	0.7 V
37	2.5 V	2.5 V	0.7 V
38	3.4 V	3.4 V	0.7 V
39	1.2 V	1.2 V	0.0 V
40	0.0 V	0.0 V	0.0 V
41	0.0 V	0.0 V	0.0 V
42	1.1 V	1.1 V	0.8 V
43	0.0 V	0.0 V	0.0 V
44	0.0 V	0.0 V	0.0 V
45	4.6 V	0.0 V	2.1 V
46	2.5 V	2.5 V	0.4 V
47	4.8 V	4.8 V	2.1 V
48	0.5 V	3.1 V	1.0 V

■ **2-6** *The voltage measurements on IC101, record/playback preamplifier circuits.*

Component connections

To be able to tie different components or sections together, a total wiring diagram is very handy for locating the various parts. The total picture of the camcorder is tied together in a connection schematic. The schematic should point out the numbered terminals of certain boards to other modules or PCB. In the electronic viewfinder connections, the sweep and yoke wires are numbered to connect to the EVF tube. Another connector terminal lists the G1, K, heater, and G2 connections to the tube socket and EVF PC board (figure 2-7).

Connections

Wiring connections with plugs are often marked in various sizes of boxes. The dual box is where a connector ties on. The board connections show boxes at each end, while direct wiring connections have circles with numbered connections. Double-check all connectors for poor contact if there is intermittent operation.

IC chip precautions

Handling and replacing small SMD chips require extra precautions than ordinary components. Do not touch the part of body directly with the soldering iron. IC chips, especially thin small outline package (TSOP), are easily damaged by heat. Use care regarding soldering iron. To prevent damage, do not leave the iron on the connection too long or touch the component with a hot soldering tip. Some parts can be damaged by sudden heating. Preheat the part at about 100 degrees Centigrade for several minutes before installation.

The soldering tip temperature should be about 240 degrees Centigrade. On larger parts, use a slightly higher temperature of about 280 degrees Centigrade. Thin 0.3-mm solder does not contain adequate flux for miniature components. Added flux is needed in most cases.

Be very careful when removing or replacing SMD parts so that the circuit pattern or wiring foil is not damaged. If part of a component is still connected and the part is pried loose, some of the PC wiring can be damaged. Double-check all pin terminals and soldered connections with magnifying glass.

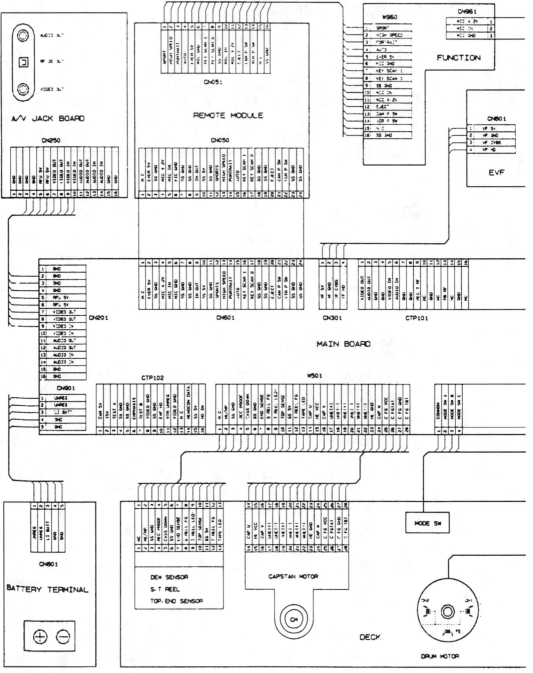

42

■ **2-7** *The total wiring diagram connections of the various circuits and boards.*
Samsung Electronics Co.

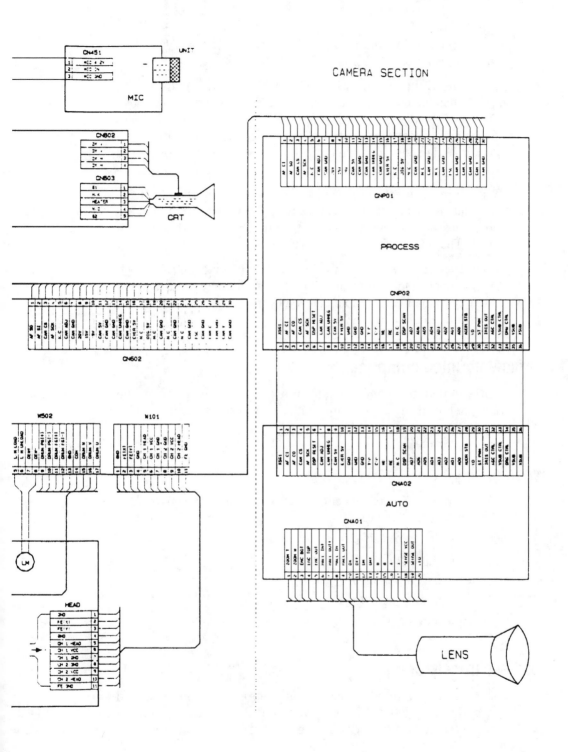

CAMERA SECTION

43

IC chip precautions

Clean up the PC mounting area of soldered blobs or peaks with a solder wick and iron.

Clean up all pin connections after removing the gullwing IC, which has many terminals. Avoid soldered bridges. Remove them with solder wick and iron, if the solder runs together between connections. Sometimes two connections are soldered together, and excess must be removed to see the actual connected wiring.

Make sure the part is in the right place or position. Double-check the white or clear dot, which indicates pin terminal 1 in IC and microprocessors. Solder the opposite pins first to hold the IC in place. That makes soldering the other pins easier.

Do not use an old part that was removed and found good. Throw it away at once. If left lay around, it might accidentally be installed as the new component. Double-check all wiring and connections before firing up the chassis.

Surface-mounted components

Surface-mounted components often consist of more than one component in the signal chip, such as transistors, base and bias resistors.

Types of chips

The following types of capacitor and resistor chips can be found in the camcorder (figure 2-8):

☐ Thick film chip resistors

☐ Carbon film chip resistors

☐ Metal film chip resistors

☐ Chip ceramic capacitors

☐ Chip trimming resistors

Leadless transistor chips

The surface-mounted transistors are represented on the board as a three-legged triangle. Always check the manufacturer's transistor drawings to determine what transistor has the base

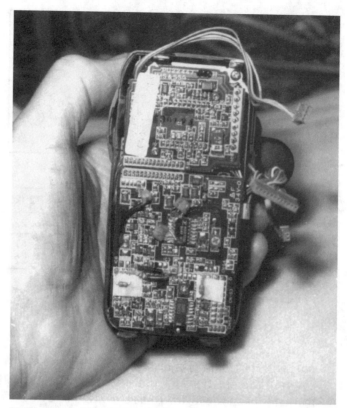

■ **2-8** *Small CD resistors and capacitors are found on the PC board of the small VHS-C camcorder.*

and collector, base and emitter terminals on one side. In the Canon ES1000 camcorder, most of the leadless transistors have the base and emitter terminals on one side and the collector on the other side (middle). The transistors can have letters and numbers representing the value of the transistor, on top of the part. Remember, these components are very tiny and can easily be mistaken for a three-legged diode. Double-check the PC board and service literature for information on mounted components (figure 2-9).

Digital transistor chips

You will find digital transistors in some camcorders surface-mounted components. The digital transistors are either npn or

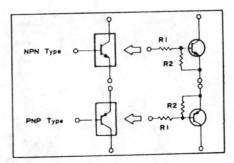

RESISTOR VALUES

JUNCTION	Part No.	R1 (kΩ)	R2 (kΩ)
PNP	DTA124EK	22	22
NPN	DTC144EK	47	47
	DTC124EK	22	22

■ **2-9** *The npn and pnp transistors can appear as standard or digital chips.* Mitsubishi

pnp, with base and bias resistors. In Canon's ES1000 camcorder, several different types of transistors are found. Notice the top markings upon the digital transistors (figure 2-10). The dual digital transistors inside one chip can appear as an IC chip. Notice that each transistor within the dual package is separate from one another and has no internal tie-connections.

Chip diodes

In Pentax 8-mm camcorders, the leadless diode is identified by a code on the surface, using two alphabet letters or numbers. You might find one or two fixed diodes in one chip. Also, the zener diode is used in some models. Chip diodes often have three terminal leads, except only two are used when one diode is contained within (figure 2-11). Correct polarity must be observed.

Leadless resistor chips

Before troubleshooting for intermittent or dead conditions, check the SMD components for cracked or chipped component bodies, cracked or separated solder joints, peeling end terminations or fractured leads, rejection of solder from copper pads or components, foreign matter in copper pads, and soldered bridges.

Equivalent circuits of digital transistors

RN2422 R1, R2 : 2.2KΩ
RN2427 R1 : 2.2KΩ
 R2 : 10KΩ

UMD3 R1, R2 : 10KΩ

UN9215 R1 : 10KΩ

XD1MH6 R1, R2 : 47KΩ

XDC114EU R1, R2 : 10KΩ

XDC114TE R1 : 10KΩ
DTC143TE R1 : 4.7KΩ

XDUMD2 R1, R2 : 22KΩ

XDUMH6 R1, R2 : 47KΩ

XP6215 R1 : 10KΩ

■ 2-10 The equivalent circuits of digital transistors found in the Canon ES1000 camcorder. Canon, Inc.

47

■ **2-10** *Continued.*

The identification value of the SMD chip resistor is found on top, and is indicated with three numbers. The first number is the single digit, number two is the second digit, and the third number, the multiplier (figure 2-12). The leadless resistor chip can have more than one resistor in a single component. Notice a tie-through or solid SMD has "000" marked on top of part. Do not mistake this for a shorted component.

LEADLESS COMPONENT IDENTIFICATION

Leadless Diodes

The identification numbers for leadless diodes are indicated by a code on the surface, using one letter and one numeral, one letter, two letters, two letters and one numeral or three numerals.

Code	Diode Number	Code	Diode Number
B	SB05-05-CP-TB	MN	MA141WA-TX
N	DAN202U-T106	MT	MA141WK-TX
A2	DSH015-TL	NP	MA143A-TX
A4	DCF015-TL	M1M	MA721-TX
A6	DCG015-TL	M3H	MA721WA-TX
C3	1SS302-TE85L	822	RD8.2M-T1BB2
W6	DCG010-TL	8.2A	MA3082WA-TX
MH	MA141K-TX	8.2M	MA3082-M-TW

M1M, M3H: Schottky Barrier Diode

The above diodes have the following internal block structures.

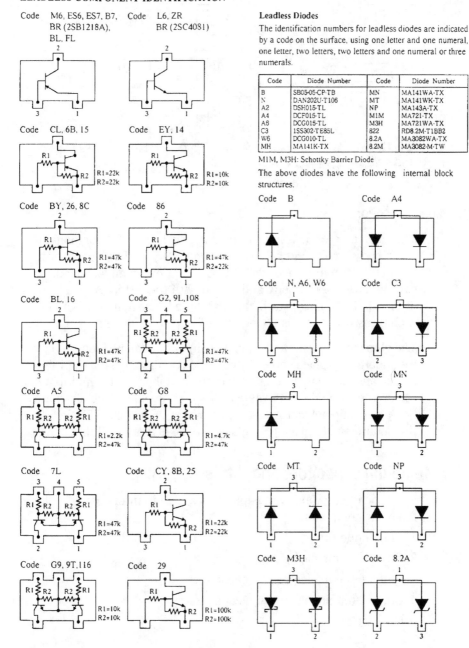

49

■ **2-11** *Chip diodes SMD parts can be one or two diodes inside one body.* Thomson Consumer Electronics

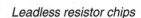
Leadless resistor chips

1) Standard chip resistor code

XXX

Multiplier (0-9)

2nd SIG. digit (0-9)

1st SIG. digit (1-9)

Examples

123 $= 12 \times 103 \,(1000) = 12000 \,\Omega$
$= 12 \,k\Omega$

470 $= 47 \times 100 \,(1) = 47 \,\Omega$

000 $=$ Chip jumper $= 0 \,\Omega$

■ **2-12** *The standard chip code with numbers on top of SMD resistor and examples.* Samsung Electronics Co.

Leadless capacitors

The capacitive value is indicated on the surface of the component, using body color and one letter, or one letter and one number in the Pentax 8-mm camcorder (Table 2-1). For example, a leadless capacitor with a red body and coded with the letter "A" is a 1-pF capacitor. If the body was black with code letter A, it equals 10 pF. A chip resistor listed as L3, equals $2.7 \times 10^3 = 2700$ ohms.

The chip capacitor in the Samsung camcorder can be identified by a standard two-place code (Table 2-2). The first letter is the value of 1st and 2nd single digits, and the number is the multiplier. Check the examples and values listed in the chart. The alternate two-place chip capacitor code is shown in PF values in Table 2-3. A standard single-place pF capacitor code is found in Table 2-4.

Chip tantalum capacitors and filters

The type of chip tantalum capacitors and chip filters come in the following components:

1. Chip inductors
2. Chip tantalum capacitors
3. Chip tantalum electrolytic capacitors
4. Chip aluminum electrolytic capacitors
5. Chip filters

■ Table 2-1
Leadless capacitor values.

Body color	Alphabet	Value
Red	A	1 (pF)
	C	2
	E	3
	G	4
	J	5
	L	6
	N	7
	Q	8
	S	9
Black	A	10 (pF)
	C	12
	E	15
	G	18
	J	22
	L	27
	N	33
	Q	39
	S	47
	U	56
	W	68
	Y	82

Example:

Color	Code	Value
Red	A	1 pF
Black	A	10 pF

Pentax Corp.

■ Table 2-2 Chip capacitors identification code and examples.

1) Standard two place code

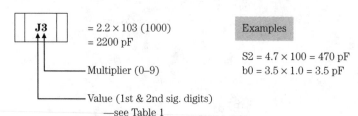

$$\boxed{J3} = 2.2 \times 103\ (1000)$$
$$= 2200\ \text{pF}$$

Multiplier (0–9)

Value (1st & 2nd sig. digits)
—see Table 1

Examples

S2 = 4.7 × 100 = 470 pF
b0 = 3.5 × 1.0 = 3.5 pF

Note: Ceramic chip capacitor is no marking.

Value (33 value symbols)—upper-and lowercase letters					Multiplier
A — 1.0	H — 2.0	b — 3.5	f — 5.0	X — 7.5	0 = × 1.0
B — 1.1	J — 2.2	p — 3.6	T — 5.1	t — 8.0	1 = × 10
C — 1.2	K — 2.4	Q — 3.9	U — 5.6	Y — 8.2	2 = × 100
D — 1.3	a — 2.5	d — 4.0	m — 6.0	y — 9.0	3 = × 1000
E — 1.5	L — 2.7	R — 4.3	V — 6.2	Z — 9.1	4 = × 10000
F — 1.6	M — 3.0	e — 4.5	W — 6.8		5 = × 100000 etc.
G — 1.8	N — 3.3	S — 4.7	n — 7.0		

Samsung Electronics Co.

52

■ Table 2-3 Alternate two code numbers on top of pF capacitor in Samsung SCX854 camcorder.

• Values below 100 pF—Value Read Directly

$$\boxed{05} = 5\ \text{pF}$$

$$\boxed{82} = 82\ \text{pF}$$

• Values 100 pF and above—Letter/number code

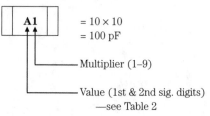

$$\boxed{A1} = 10 \times 10$$
$$= 100\ \text{pF}$$

Multiplier (1–9)

Value (1st & 2nd sig. digits)
—see Table 2

$$\boxed{N3}$$
$$= 33 \times 1000$$
$$= 33000\ \text{pF}$$
$$= 0.33\ \text{mF}$$

Value (24 value symbols)—uppercase letters only					Multiplier
A — 10	F — 16	L — 27	R — 43	W — 68	1 = × 10
B — 11	G — 18	M — 30	S — 47	X — 75	2 = × 100
C — 12	H — 20	N — 33	T — 51	Y — 82	3 = × 1000
D — 13	J — 22	P — 36	U — 56	Z — 91	4 = × 10000
E — 15	K — 24	Q — 39	V — 62		5 = × 100000 etc.

Samsung Electronics Co.

■ Table 2-4 Standard single place code of chip capacitors.

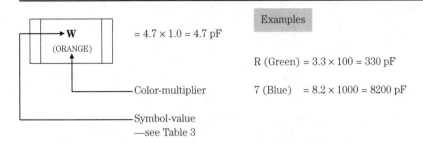

= 4.7 × 1.0 = 4.7 pF

Examples

R (Green) = 3.3 × 100 = 330 pF

7 (Blue) = 8.2 × 1000 = 8200 pF

Color-multiplier

Symbol-value
—see Table 3

Value (33 value symbols)—upper-and lowercase letters					Multiplier
A — 1.0	H — 1.6	N — 2.7	V — 4.3	3 — 6.8	ORANGE = × 1.0
B — 1.1	I — 1.8	O — 3.0	W — 4.7	4 — 7.5	BLACK = × 10
C — 1.2	J — 2.0	R — 3.3	X — 5.1	7 — 8.2	GREEN = × 100
D — 1.3	K — 2.2	S — 3.6	Y — 5.6	9 — 9.1	BLUE = × 1000
E — 1.5	L — 2.4	T — 3.9	Z — 6.2		VIOLET = × 10000
					RED = × 100000

Samsung Electronics Co.

Removing the part

When using a special desoldering iron, select soldering tip according to size of part. When the solder melts, remove the component. Bring the tip into contact with the soldering points. Remove the excess solder with a desoldering wire or solder wick.

When using two soldering irons, use small flat-blade tips. Heat both ends of the part simultaneously. When the solder melts, grasp the part with tweezers. Remove the excess solder with desoldering wire or solder wick (figure 2-13).

Removing chip trimmer capacitors and transistors

Remove the chip part with two soldering irons with small flat-blade tips. Heat the leads of the SMD component simultaneously. When the solder melts, grasp and remove part with tweezers. Remove old and excess solder with solder wick (figure 2-14). Re-check each PC wiring pad.

Installing small SMD components

Clean the area where the new part is to be mounted. Apply flux. Check part for correct polarity terminals, transistor BCE, and where it mounts on PC wiring. Use a sharp soldering iron tip. Bring

■ **2-13** *How to remove leadless transistor, capacitors, and resistors from PC board.*
Samsung Electronics Co.

■ **2-14** *How to remove trimmer capacitors and transistors with fine pointed soldering iron.*
Samsung Electronics Co.

the tip close to the part contact without actually touching it. Melt thin solder between the tip and part so that it flows into the part's contact. Recheck work quality with a magnifier.

Test points

Various test points are shown throughout most circuits in the camcorder from which to take voltage or waveform samples. For example, measure the regulated 5 V out from the power circuits at TP1 (figure 2-15). TP401 provides the waveform signal applied to the end sensor IC407 at pin 10.

Voltage and signal waveforms can be taken at the input and output terminals of IC or microprocessor components to determine if the correct signal is passed on to the next component. The oscilloscope is a very valuable tool when troubleshooting the mechanism, servo, video, luminance, and color circuits, and in making electrical adjustments.

Cleaning

The camcorder is a complicated piece of equipment. It contains belts, rollers, heads, etc., which become worn and deteriorated under extensive usage. Dust and dirt also cause the camcorder to

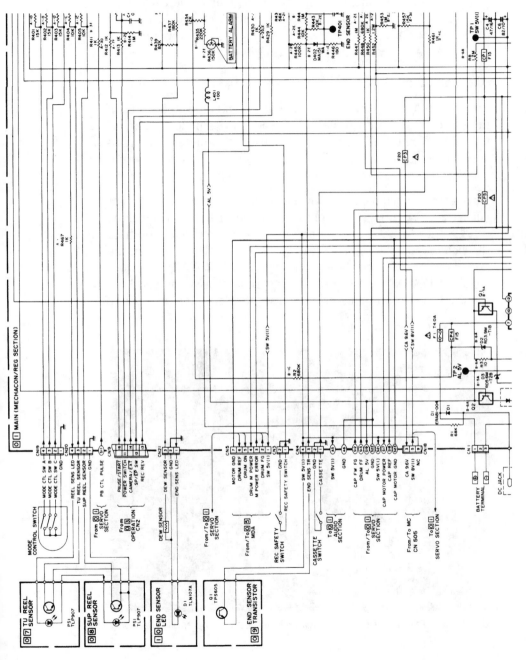

■ 2-15 Test points and various voltage measurements found in Minolta C3300 camcorder. Minolta Camera Co.

malfunction. Regular and periodic maintenance should be performed on the camcorder to keep it in tip-top shape.

Keep the lens assembly clean with a regular camera cleaning brush kit. Clean the video, full erase, and audio/control heads with a cleaning kit and solvent. Periodic cleaning of the tape mechanism's moving parts can help to prevent damage.

Cleaning the video head

First use a cleaning tape to keep the heads and tape guides free of tape oxide. If the dirt on the video head is too stubborn to be removed by the tape cleaning cartridge, use a cleaning stick and solvent to clean the audio head. Some manufacturers recommend using a chamois leather cleaning stick with solvent.

Do not try to clean the head down through the cassette cover vent (figure 2-16). Remove the front cassette cover to get at the video head to clean it. Some manufacturers recommend that you hold the cleaning stick at right angles. While holding the top part of the head only, gently turn the rotating cylinder to the right and left (figure 2-17). Do not move the stick vertically or you might damage the head. Thoroughly dry the head after cleaning. If cleaning

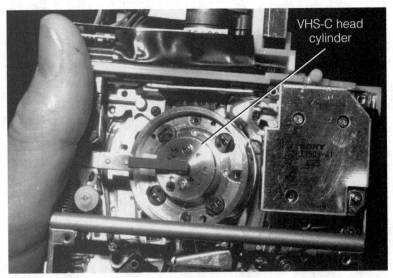

VHS-C head cylinder

■ 2-16 *Remove the top cover to get at the head cylinder or drum for a good cleanup of heads.*

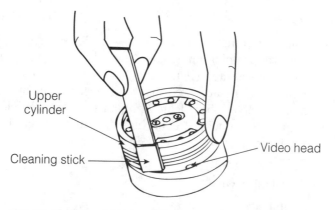

Upper cylinder

Cleaning stick

Video head

■ **2-17** *Rub the video head horizontally with cleaning stick and solvent.*

fluid remains on the video head, the tape could be damaged when it comes in contact with the head surface. The cleaning cassette will clean up some of the rollers and guide pins, but they should also be cleaned with alcohol and cleaning stick (figure 2-18).

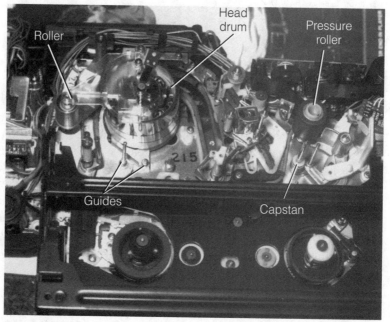

Roller

Head drum

Pressure roller

Guides

Capstan

■ **2-18** *Clean up rollers, guides, and capstans with a cleaning stick and alcohol.*

Tape transport

The tape transport system consists of parts that come in contact with the running tape. The drive system consists of those parts that run the tape (figure 2-19). Periodic cleaning of the components is necessary to ensure good performance of the tape mechanism (Table 2-5). Clean with gauze or lint-free cloth dipped in isopropyl alcohol or freon. Kim wipes and solvent does the job on the following parts:

- ☐ Capstan shaft
- ☐ All idler wheels
- ☐ Impedance roller
- ☐ Pressure roller
- ☐ All tape guide posts
- ☐ Supply reel
- ☐ Capstan belt
- ☐ Pulley belt
- ☐ Capstan motor pulley
- ☐ Center pulley
- ☐ All gear assemblies

Lubrication

The tape transport mechanism is properly lubricated at the factory, and additional lubrication should not be needed during the first year of operation. Periodic inspection for lubrication can be followed as shown in Table 2-5. Remove the old lubricant first. Do not over-oil; only a drop will do. A squeaky bearing should be lubricated. It's better to not lubricate at all than to over-oil, where it could drip down on other moving parts. Wipe off excess oil with cleaning stick and alcohol. Place a drop or two of light oil on the moving parts. Many camcorder manufacturers have their own grease and lubricants. Before replacing a moving part, apply oil or grease.

Apply a light grease, for example Hitazal or Froil, with a small stick or brush on sliding areas. Do not use excess grease. Keep it away from the tape transport or drive system components. Wipe up any

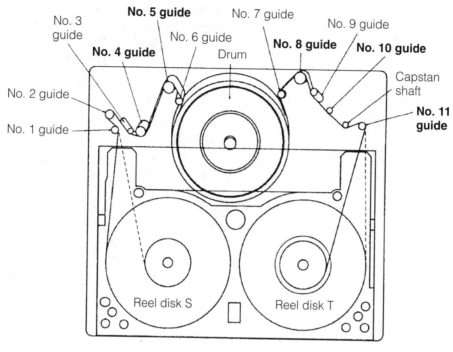

No. 3 guide
No. 5 guide
No. 7 guide
No. 9 guide
No. 4 guide
No. 6 guide
No. 8 guide
No. 10 guide
Drum
No. 2 guide
Capstan shaft
No. 1 guide
No. 11 guide

Reel disk S
Reel disk T

Layout of tape transport adjustment

Guide No.	Component name	Adjustment purpose
No. 1	Tension pole	—
No. 2	Roller lever/G	—
No. 3	Slant pole SUB	—
No. 4	Impedance roller	Tape height
No. 5	Guide roller "S"	Envelope
No. 6	Pole slant "S"	—
No. 7	Pole slant "T"	—
No. 8	Guide roller "T"	Envelope
No. 9	Pole slant CAP	—
No. 10	Shaft pole guide	Tape guide
No. 11	Post review arm	Tape wrinkle

■ **2-19** *Check the drive system, which contains the parts that runs or touches the tape.* Samsung Electronics Co.

■ Table 2-5 Mechanical part maintenance chart.

Use following table as a guide to maintain the mechanical parts in good operating condition.

Parts	Maintained every 1000 hrs R C	2000 hrs R C	3000 hrs R C	4000 hrs R C	5000 hrs R C
Video head	R C	R C	R C	R C	R C
Audio/Control (A/C) Head	C	C	C	C	R C
Full Erase (FE) head	C	C	C	C	R C
Capstan flywheel	C	C	C	C	C
Center pulley	C	C	C	C	C
Supply guide pole	C	C	C	C	C
Take-up guide pole	C	C	C	C	C
Tension band	C	R C	C	R C	C
Supply reel disk	C	C	C	C	C
Supply gear	C	C	C	C	C
Take-up gear	C	C	C	C	C
Impedance roller	C	C	C	C	C
Pressure roller	C	R C	C	R C	C
Pulley belt	C	R C	C	R C	C
Capstan belt	C	R C	C	R C	C
Capstan motor		R		R	
Loading motor		R		R	
Cylinder motor		R		R	
Between both guide roller bases and gutters on chassis		H		H	
Pressure roller arm		H		H	
Loading gear		H		H	
Catcher block		H		H	
Shaft of cassette holder switch		H		H	
Gear of supply loading ring		H		H	
Gear of take-up loading ring		H		H	
Shaft of FE head	S	S	S	S	S
Shaft of supply reel disk	S	S	S	S	S
Shaft of supply sub gear	S	S	S	S	S
Shaft of supply gear	S	S	S	S	S
Shaft of take-up gear	S	S	S	S	
Shaft of take-up reel gear	S	S	S	S	S
Shaft of pressure roller	S	S	S	S	S
Shaft of pressure roller arm	S	S	S	S	S

Parts	Maintained every				
	1000 hrs	2000 hrs	3000 hrs	4000 hrs	5000 hrs
Shaft of cam gear	S	S	S	S	S
Shaft of a/c head base	S	S	S	S	S
Shaft of loading gear (1)	S	S	S	S	S
Shaft of loading gear (2)	S	S	S	S	S
Shaft of center pulley	S	S	S	S	S
Shaft of ring idler gear (1)	S	S	S	S	S
Shaft of ring idler gear (2)	S	S	S	S	S
Shaft of loading ring spacers	S	S	S	S	S

Note 1: R: Part replacement

C: Cleaning (For cleaning, lint-free cloth dampened with pure isopropyl alcohol).

H: Grease refilling (The indicated point should be lubricated with Hitazol or Froil grease every 5000 hrs).

S: Oil refilling (The indicated point should be lubricated with pan motor or Sonic Slidas oil every 1000 hrs).

excess with cloth and alcohol. Periodic greasing can be applied every 1000 or 5000 hours in these places:

☐ Between pressure roller bar and shaft

☐ Between pressure roller and gear assembly

☐ Between the base of guide rollers and gutters

☐ Gutter of cam gears

☐ Gutter of chassis

☐ Loading gear shaft

☐ Loading gears

☐ Ring idler gear

☐ Shaft of loading rings

☐ Shaft of idler gears

Test equipment

Most electronic service establishments already have many of the needed test equipment for camcorder repair (figure 2-20). If you are already servicing VCRs, you have most of the test equipment

■ **2-20** *Most electronic service establishments already have the needed test equipment for camcorder repair.*

and hand tools needed. You might only need a few additional test instruments and cable adapters. Here is a list of basic test equipment needed for camcorder repair:

☐ Oscilloscope

☐ Digital voltmeter and/or multimeter

☐ Frequency counter

☐ Vectorscope

☐ Color video monitor

☐ Tripods

☐ Light box (3200 degrees)

☐ Waveform monitor

☐ Light meter

☐ 0-to 12-V power supply

Besides the schematic diagram and required service literature, there are many small tools, adapters, jigs, and color scale charts. Some manufacturers provide a back focus chart, a gray and white chart, and a hunting chart in the service literature (figure 2-21). Each manufacturer has a complete list of servicing jigs and tools listed in the service literature for each camcorder.

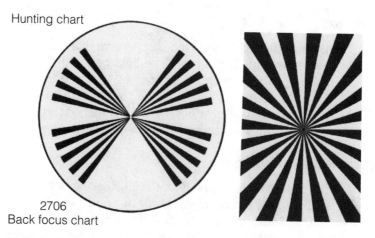

Hunting chart

2706
Back focus chart

■ **2-21** *Several different adjustment charts are included in the service literature.*

The oscilloscope

The dual-trace scope should have a minimum bandwidth of 25 MHz. Delayed sweep is necessary for camera alignment procedures. Most service establishments have a dual-trace scope of higher bandwidth for TV and VCR servicing.

Meters

Accurate voltage and resistance measurements are needed in checking microprocessor, IC, and transistor voltages. Choose a meter with at least 1200 to 1500 volts dc to read the high voltage on the anode of the pickup electronic viewfinder tube. If you are using a VOM, make sure it is at least a 20-kilohms/volt type.

Frequency counter

If you are going to purchase a frequency counter, make sure it will read above 20 MHz.

Vectorscope

Some manufacturers use the vectorscope in making black-and-white balance adjustments, auto white balance, chroma level adjustments, shading adjustments, red/blue/green setup, and red and blue signal gain (some of these adjustments can be made with the oscilloscope). The vectorscope was used many years ago in servicing the TV chassis.

Light box

Although the light box is more expensive than wall charts for camera servicing, it is the best. The light box with 3200-degree light source provides even lumination of test patterns over a white opaque screen. The light box can contain a fixed or variable light output. These light test boxes can be obtained through the various camera manufacturers or wholesale part dealers.

Special test jig and tools

The special tools for the RCA CPR100 camcorder consist of a head adjust driver, special driver bit (3 mm), hex key, hex nut driver (3 mm) and hex nut driver (5 mm). The torque gauge, reel table height jig, and height reference plate are used in the VTR mechanical adjustments. The VHS-C color bar (1 kHz mono) and monoscope (7 kHz mono) alignment tapes round out the electrical adjustment equipment. For camera adjustments, the gray scale chart with 10 or 11 steps, NTSC color chart, autofocus, and back focus charts are mounted in front of the camcorder. You will find different special jigs, tools and harnesses are required by various manufacturers, these special jigs and harnesses should be purchased from the manufacturer. You might be able to put together some of these harnesses after working with the various camcorders.

Test cassettes

Each manufacturer can have its own alignment tapes. Use a regular blank tape for recording and playback tests. Most use at least one alignment tape and others use an additional color cassette (Table 2-6). These tapes are used in mechanical, electrical, and camera setup adjustments.

■ Table 2-6 Camcorder alignment test cassettes.

MFG	Test cassette	Part numbers
Cannon	Color	DY9-1044-001
Minolta	Alignment tape M+C1	7982-8012-01
Mitsubishi	Alignment MH-C1	859C35909
NEC	VHS alignment tape	79040302
Pentax	NTSC alignment	20HSC-2
RCA	Color Bar 1 kHz	180434
	Monoscope 7 kHz	180435
Samsung	Alignment tape 8-mm video	P6-60/EXP

The camera section

THE BASIC CAMCORDER CIRCUIT CAN BE BROKEN DOWN into the camera and VCR sections. The camera section often consists of the lens, CCD or MOS, image sensor, V drive, CDS/AGC/ r, B Bit A/D converter, D & A converter, Y signal processing, C signal processing, auto focus, and electronic viewfinder (figure 3-1). The auto board in the 8-mm camcorder often consists of auto focus Mi-Com, zoom motor drive, auto focus motor drive, Hall detect block, and iris block.

VHS/VHS-C camera circuits

The VHS and VHS-C camera section can contain the lens assembly, automatic focus, iris or AIC control, and zoom motor assembly. The image sensor might have a pickup tube, as in the early VHS camcorders, and the later VHS and VHS-C models use a CCD or MOS pickup device. The drive pulse generator and preamplifier circuits are contained in the MOS or CCD circuits. Other VHS and VHS-C camera circuits are the sync generator, sample and hold, signal processing, matrix and filtering, luminance processing, chroma processing, automatic white balance, encoder, and power distribution systems (figure 3-2).

Canon ES1000 camera signal circuits

The charge coupled device (CCD) picks up the various images from the lens assembly, with the V output applied to terminal 36 of S/H IC1001. The timing generator IC1003 provides S/H pulses one and two and the playback timing signal to IC1001. The picked up signal passes through the S/H, AGC, and BLK stages with output at pin 10 of IC1001. The camera signal passes through transistor clamp circuit (Q1003) to pin 26 of digital signal processor IC1102 (figure 3-3).

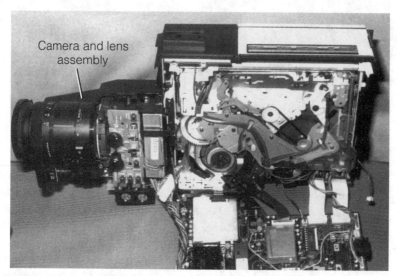

Camera and lens assembly

■ **3-1** *The camera section includes the lens assembly, CCD unit, and camera PC board circuits in the camcorder.*

The A/D input signal is processed within the digital IC1102, with camera Y and C outputs at pins 44 and 46, respectively. The luminous (Y) output signal passes through a buffer (Q1102), low pass filter (FL1101), and buffer transistor Q1104. Camera color signal (C) goes through buffer transistor (Q1101), band pass filter (C1125 and L1106), to buffer Q1103. Both the chroma and luminous camera signals are fed to terminal connection CN1401, to recorder PCB.

Pickups

In the early VHS, VHS-C, and Beta camcorder, a pickup tube was used to detect the image and convert it to an electrical signal. However, the tube's disadvantages have been overcome by CCD or MOS pickup devices.

CCD pickups

The charge-coupled device (CCD) is a semiconductor that consists of orderly arranged arrays of cells (capacitors). When light shines on the CCD element, an electric charge is developed that varies with the intensity of light. The CCD device can store the charge in a well or a hole when certain voltages are applied. The depth of the well or hole varies with the voltage applied to the electrode. The charge collected in the adjacent cell or hole is moved to the cell where voltage is applied. With the many different cells or holes, the self-scanning process keeps repeating.

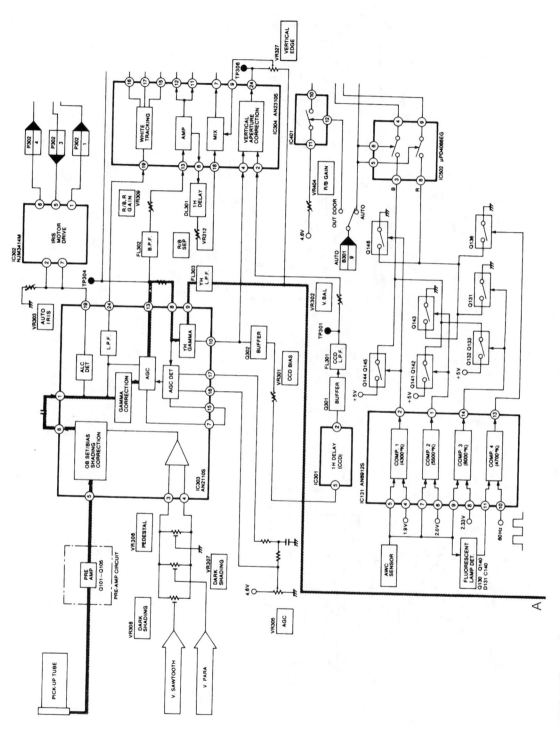

■ 3-2 *Camera process block diagram in the General Electric VHS 9-9605 camcorder.* Thomson Consumer Electronics

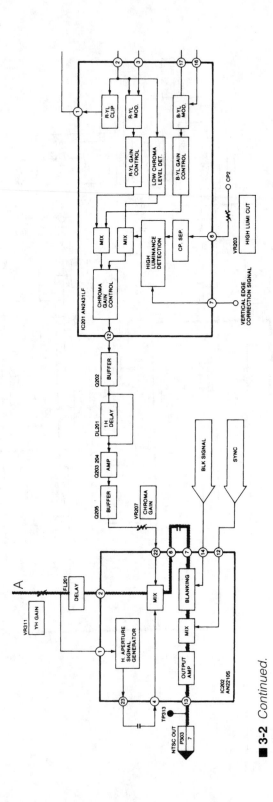

■ 3-2 Continued.

The camera section

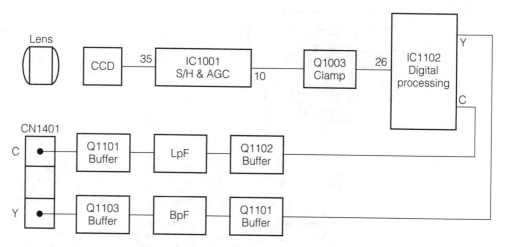

■ 3-3 *The 8-mm Canon ES1000 camera signal circuits to video and color output.*

The surface area of the chip is divided into thousands of light-sensitive spots called *pixels* (picture elements). For example, the Hitachi VME56A camcorder has a ⅙-inch CCD with 270,000 pixels as image sensor. A Fuji FUJIX-H18 H128SW camcorder has a ⅙-inch CCD with 410,000 pixels as image sensors and close to 400 lines in the camera. The Minolta Master C-570 camera section has a ⅙-inch CCD image sensor with 270,000 pixels with Digital Electronic Image Stabilization (EIS). The average camcorder uses a CCD image sensor with around 270,000 pixels.

Pentax PV-C850A (8 mm) CCD

The CCD image sensor consists of 250,920 picture elements (510 horizontal and 492 vertical), giving the camera a horizontal revolution of 330 lines or more. The device also has the function of a $\frac{1}{1200}$ sec shutter. The CCD is a semiconductor device in which MOS capacitors are in arrays. The photoelectric function converts light into a charge. When light comes in, an electric charge occurs that depends upon the intensity of the light. (figure 3-4).

The storage function occurs when a voltage is applied to the CCD under certain conditions. A region where positive holes do not exist appears and charges gather there. This region is called a *depletion region* or *potential well*. The greater the potential difference, the deeper the potential well (figure 3-5).

The charge transfer function occurs with an appropriate voltage. The charge moves from one device element (register) with a lower potential to the adjacent element (register) with a higher potential

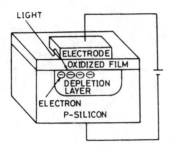

LIGHT

ELECTRODE
OXIDIZED FILM
DEPLETION
LAYER
ELECTRON
P-SILICON

■ **3-4** *Pentax 8-mm charged-coupled device (CCD) construction.* Pentax Corp.

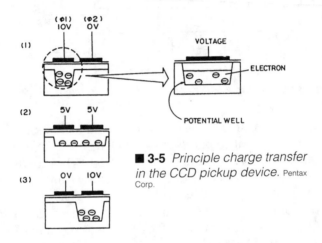

(φ1) (φ2)
10V 0V

(1)

VOLTAGE

ELECTRON

(2) 5V 5V

POTENTIAL WELL

■ **3-5** *Principle charge transfer in the CCD pickup device.* Pentax Corp.

(3) 0V 10V

as the charge tends to fall into a potential well. Now the charge moves from element to element if an appropriate voltage is applied to it. The CCD operation is in all camcorders that use the charged-coupled device pickup element.

MOS pickups

The MOS image sensor is a semiconductor chip device. When light falls on the picture element, the electron/hole pair is generated inside the NT layer and PT layer, which forms the photodiode. As the electrons flow out, the NT layer in the PT layer, the hole remains. With positive and negative voltages applied to the metal electrodes, the electrons are moved through the silicon base, providing vertical and horizontal picture scanning. Low infrared and well-balanced sensitivity is obtained by using photodiodes as the picture element (figure 3-6). The MOS (metal-oxide silicon) image pickup device is in the Hitachi, RCA, and Realistic camcorders. You can find the MOS device in some Kyocera, Pentax, and Sears models.

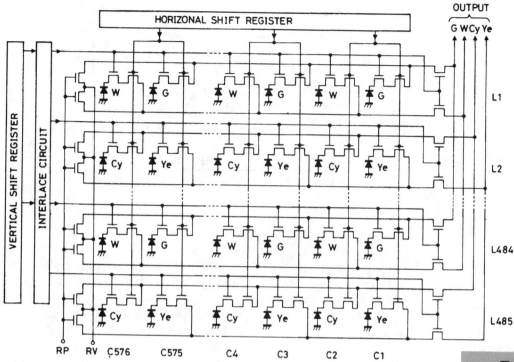

■ 3-6 *RCA's CPR100 MOS (metal-oxide silicon) circuit.* Thomson Consumer Electronics

Realistic 150 (VHS-C) MOS image sensor

The HE98245 MOS color image sensor has an image size of 8.8 (H) × 6.5 (V) mm, matching a ⅔-inch optical system. The chip size is 9.9 (H) × 8.0 (V) mm. The number of picture elements are 570 (H) × 485 (V) with a total of 276,450 pixels. With this type of MOS color image sensor, sensitivity in the infrared region is low, and well balanced special sensitivity characteristics are obtained by use of picture elements (photodiodes) with an npn three-layer structure. Blooming is also suppressed with this structure.

The color resolution filter is made by arranging complementary white (W), yellow (YE), cyan (CY) and green (G) color filters in a mosaic. The four color signals, W, YE, CY, and G, are read out via four output lines, so interlaced scanning with high resolution and without residual image can be performed.

When light falls on a picture element, an electronic hole pair is generated inside the n^+ and p^+ layer. In the n^+ layer, the electron remains and the hole flows to the p^+ layer. The photoelectrons are stored in the n^+ layer as the photoelectronic conversion signal (figure 3-7).

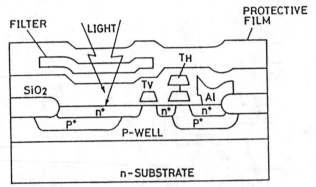

FILTER LIGHT PROTECTIVE FILM

TH

SiO2 Tv

Al

n⁺ n⁺ n⁺

P⁺ P⁺

P-WELL

n – SUBSTRATE

■ **3-7** *MOS picture element of Realistic image sensor.*

A positive pulse is applied to the gate of the vertical switching transistor (TV). When reading the signal, the barrier of the gate lowers, the photoelectron stored in the n layer is drawn into the n layer as drain. When a positive pulse is applied to the gate of the horizontal switching transistor (TH), the barrier of the gate lowers, the photoelectron in the n layer as source is drained into the n layer or a drain connected to the signal line and is derived as the output.

When the positive scanning pulse generated from the vertical scanning circuit opens the gates of the vertical switching transistors (TVs) and the horizontal scanning circuit opens the gates of the horizontal switching transistors (THs) beneath them from left to right in sequence, the photoelectrons of the photodiodes of two horizontal lines are output in sequence to perform horizontal scanning. When the gate opened by the vertical scanning circuit is changed in sequence and the same is repeated, the photoelectrons of all the photodiodes are output in sequence, and all the picture elements are scanned.

Canon ES1000 process board

The Canon camera PCB consists of a timing generator (IC1003), that provides S/H pulses, playback, and clamp reference pulse to the S & H IC1001. The timing generator IC provides timing signals to the V driver IC1052 and Flip Flop IC956. The V driver IC1052 voltage provides drive to the CCD image sensor. The +5 V input voltage to IC1052 provides a +15 V and –8.5 V to the image sensor circuit (figure 3-8).

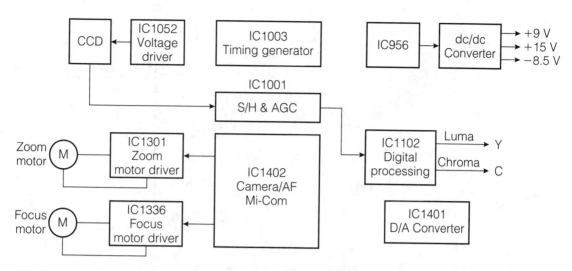

3-8 *Canon ES1000 PCB processing.* Canon, Inc.

The camera AF and Mi-Com processor (IC1402) controls the zoom motor drive IC1301, which in turn drives the zoom motor. IC1402 controls the focus motor drive (IC1336) and focus motor. The same IC provides control of focus reset, LED switch, VAP on, A, B, and C control signals to the digital processing IC1102. Clock and S-data is supplied to the various circuits.

The Flip-Flop IC956 has an HD signal from timing generator and in turn IC956 provides drive to transistors Q953 and Q951. These transistors with transformer T951 consist of a dc/dc voltage circuit with outputs of +9 V, +15 V, and –8.5 V.

The digital processing IC1102 receives camera signal from IC1001, with camera luminance (Y) and chroma (C) signal output. IC1102 receives a clamp pulse from Q1003 (clamp), clock input from timing generator IC1003, control data from IC1402, and Y-C level from D/A converter IC1401. The D/A converter controls the IRIS circuits, Y-C level, A-fade, RG and V-sub control.

RCA CPR100 (VHS-C) sync generator circuit

There are many operations within the color camera section that are synchronized to provide correct operation. IC1107 provides the generated signals to synchronize the different operations in the color camera circuits (figure 3-9).

The reference frequency signal inside IC1107 is controlled with a crystal oscillator (14.31818 MHz). All start and synchronization

73

3-9 *RCA VHS-C sync pulse generator circuit.* Thomson Consumer Electronics

output signals are counted down from the reference frequency. IC1107 generates the following signals:

- ☐ Composite sync (C.SYNC), pin number 16
- ☐ Blanking pulse (BBLK), pin number 9
- ☐ Clamp pulse (CP1), pin number 11
- ☐ Composite Sync (C.SYNC), pin number 12
- ☐ Wide horizontal drive pulse (CP2), pin number 1
- ☐ Horizontal burst flag pulse (H.BF), pin number 3
- ☐ Vertical pulse (VP), pin number 10
- ☐ Camera horizontal drive pulse (CHD), pin number 4
- ☐ 7.16-MHz clock pulse (CLK GEN), pin number 6

Pentax PV-C850A 8-mm CCD image drive circuit

The charged-coupled device (CCD) image sensor is driven by the horizontal drive signals (H1 and H2) with two phases, vertical drive signals (V1 through V4), with four phases, output reset signal (PG), and three fixed dc-bias voltages (VOFD 9–15 V, VPD 14 V, VSG –12 V).

H1 and H2, applied to the H register, time the transfer of charge from the H register to the output circuit during the horizontal scan period. The high (Hi) output level is 1.6 V and the low (Lo) level is –6.5 V (figure 3-10).

■ **3-10** *Pentax 8-mm CCD image sensor drive circuit.*

The precharge gate (PG), applied to the output circuit, times the resetting charge, which remains in the output circuit after the previous scanning before charge is transferred from the H register to the output circuit during the horizontal scanning period. The high (Hi) output level is 9 V, and the low (Lo) level 1 V.

V1 through V4 time the transfer of charge from the V register to the H register during the horizontal blanking period. Also, they time the transfer of charges from the sensor to the V register and their mixing during the vertical blanking period. The output levels of V1 and V3 take three values: Hi, Mid and Lo. V2 and V4 take two values: Mid and Lo. The high (Hi) level is 15 V, Mid level 0 V, and low (Lo) level –10 V.

The voltage of overflow drain (VODF) determines the overflow drain voltage. There is a well of electrons (overflow drain) between adjacent sensor elements. If excess charge occurs at an image highlighted, it will be injected into the well to prevent V register, reducing blooming. The varying voltage of the image sensor is set between 9 V and 15 V.

The voltage of precharge drain (VFD) determines the reset level of the precharge drain in the output circuit. Charge remaining from the previous scanning period will be reset by applying this voltage (14 V) to the output circuit before charge is transferred from the H register to the output circuit.

The voltage of sensor gate (VSG) determines the depth of the potential well in the storage section of the sensor. This voltage is –12 V.

IC1102 produces the drive signals and VSG. The sensor drive signal generator (IC1102) receives the FSC clock pulse generated by the clock generator X1101. The horizontal and vertical drive signals (CHD and VD) generated by the sync generator/encoder (IC1206) through pins 22, 23, and 25 produce the synchronized drive signals. These signals drive the CCD image sensor.

Signal processing circuits

The VHS and VHS-C signal-processing circuits often consist of the CCD or MOS image sensor, preamplifier, resampling, chroma, and luminance circuits. The 8-mm signal processing circuits can consist of CCD image sensor, signal separation S/H, AGC, AGC detector, color separation S/H and white balance (figure 3-11). In the 8-mm signal processing circuits, a CCD image sensor picks up the images and feeds them to the signal separation S/H and AGC circuits. The output of the camera processing circuit consists of luminance (Y) and chroma (C) signals. The camera has two video output signals that are applied to the EE video signal processing circuits in the VCR or VTR. The other is the chroma signal, which is supplied to the chroma signal-processing circuit in the VFR.

Pentax PV-C850A 8-mm CDS and AGC circuits

The signal-processing circuits consist of the output from the image sensor (IC-1101) through buffer (Q1102) to pin 1 of IC1103 and the Y/C separation of IC1201 (figure 3-12). These circuits do two things: one is to make the signal output from the image sensor continuous and the other is to keep the level input to the processing circuits appropriate while the intensity of incoming light varies. IC1103 (CDS)

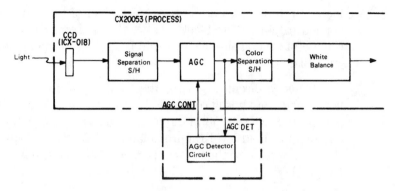

■ 3-11 *Sony's 8-mm signal processing circuits.* Sony Corp.

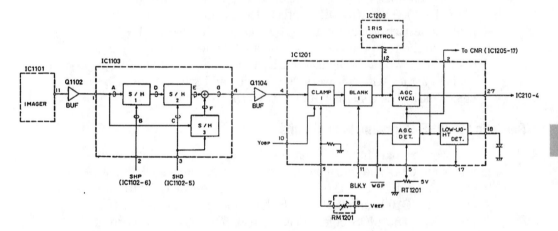

■ 3-12 *Pentax 8-mm CDS and AGC circuits.* Pentax Corp.

performs the first function. IC1201 (AGC) performs the second. In addition to these circuits, there is a clamping circuit that regenerates the dc component for the sensor output signal and a blanking circuit that regulates the blanking period and removes noise.

The CDS circuit (IC1103) samples reset noise. The signal including reset noise separates from the sensor output and subtracts the reset noise from the signal to remove it and makes the signal continuous by replacing the reset noise signal, This removes low-frequency noise and leakage of the sample-hold pulse.

The clamp 1 circuit (IC1201) samples the black level (optical black level) of the sensor output and clamps each line equally to regenerate dc components lost in C coupling before the sensor output is applied to the AGC circuit. Clamp 1 is a keyed clamp with

feedback. It samples the optical black level of the sensor output applied to pin 4. The black level of the sensor output is always clamped to the reference level and is applied to the blanking circuit (Blank-1).

The blanking circuit regulates the blanking period and removes noise occurring during this period before the sensor output is applied to the AGC circuit in the next stage. This clamps the sensor output to a fixed level (approximately 1.8 V). The blank sensor output is applied to the AIC control (IC1209) and the AGC circuit (IC1201).

The AGC circuit keeps the input level to the signal-processing circuits constant by controlling gain, depending on the light intensity. It consists of a voltage-controlled amplifier and AGC detector (AGC DET). The AGC DET detects the mean value (normal) or peak value (with high input) of the signal. The detected level is added to the reference level at pin 5 and applies to the gain combat of VCA. When the light intensity to the object is high (bright sunlight), the AGC will work "too much" and whole picture becomes dark. The sensitivity of the GAC DET prevents this action.

Realistic 150 (VHS-C) preamplifier circuits

The weak signals from the image sensor are amplified by preamplifier circuits. The four complementary-color signals (W, YE, G, and CY) produced by the MOS color image sensor (IC1001) are applied to IC1002 and IC1003, which compose a preamplifier (figure 3-13). The MOS color image sensor (IC1001) is a current source with a low output at about 200 mA. Therefore, the camera's overall signal-to-noise ratio (S/N) depends on the preamplifier.

The preamplifier has the low input impedance of about 500 Ω, as it must read signals with the short clock interlude of 186 ns (5.37 MHz). To reduce the input impedance, the dc output of the second-stage preamplifier (IC1006) is negatively fed back to the FET amplifier in the first stage (IC1002). The amplified color signals come out of pins 4, 5, 12, and 13 and enter the resampling circuit (IC1007) and matrix circuit (IC1100).

Luminance signal processing

The purpose of the luminance circuits is to separate the luminance signals and form the composite video signal. The VHS and VHS-C luma circuits consists of a shading connection, setup, feedback clamp, gamma correction, blanking and linear chip, AGC, AGC de-

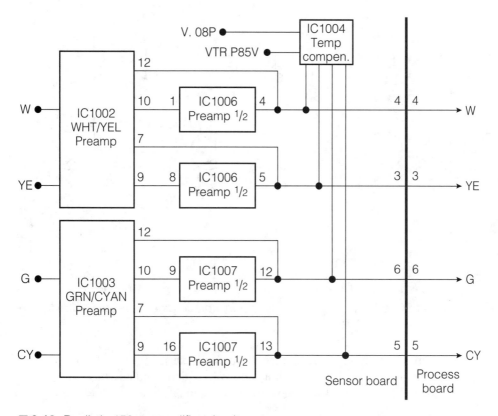

■ **3-13** *Realistic 150 preamplifier circuits.* Radio Shack

tector, and gamma control circuits. While in the Samsung SCX854 camcorder, the luma (Y) signal is fed from D/A converter to Y signal process block.

The luminance output signal from D/A converter (pin 7) couples directly to buffer transistor GP09. This Y signal is taken from the emitter terminal of GP09, fed through a low pass filter (LPF) to the base of buffer transistor GP10 (figure 3-14). The output Y signal from emitter of GP10 is mixed with the sync output at transistor amp GP07. The collector terminal of GP07 connects directly to the base terminal of buffer amp GP08. The camera Y signal at pin 29 of GP08 is fed to the video VTR circuits. A test point (10) can be taken with the scope to determine if the luminance (Y) signal is present.

Realistic 150 (VHS-C) luma process circuit

The luma signal enters the process circuit (IC1103) at pin 18. The luma shading correction circuit corrects the horizontal shading

■ 3-14 *Samsung SCX854 camera luminous (Y) signal processing.* Samsung Electronics Co.

signal from IC1105. The correction signal passes pin 11 (IC1105) and enters the luma shading control, which adjusts the signal level. This output is added to the luma signal to correct shading.

To fix the black level of the luma signal, the control RM 1101-5 determines the set-up voltage, which is added to the luma signal. The black level of signal, which serves as the reference level, must be fixed to perform gamma correction and white clipping. The feedback clamp feeds back a sampled voltage to the input signal to fix the black level. The black level of the output of the gamma correction circuit is sampled and held at the timing of the vertical optical block pulse from pin 15 (figure 3-15). The sampled voltage is compared to the set-up voltage generator. This difference voltage is fed back to the input signal when the V.OBP pulse is applied. Now the black level of the luma signal is fixed.

The gamma correction circuit amplifies the luma signal nonlinearly according to the gamma (1) and gamma (2) (dc voltages) supplied by the gamma control circuit in order to set the overall gamma characteristic value.

The blanking (blank) and linear clip (white/dark clip) circuits remove the high-level noise produced by the MOS color image sensor and perform linear clipping to limit the white level within the rated range. The output is applied to a dark clip circuit (dark clip) that performs linear clipping during the blanking period, in which

The camera section

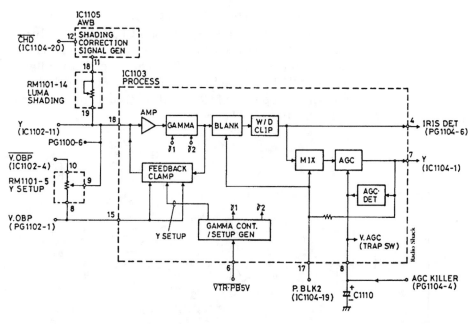

■ **3-15** *Realistic 150 VHS-C luma (C) processing circuits.* Radio Shack

synchronous noises remain so that noise is removed and black level limited. The luma signal is applied to the mixer (MIX). The iris detect signal (iris det) is found at pin 4 and enters the iris control circuits (IC1404).

When the object brightness varies, the automatic iris control circuit controls the lens iris to vary the amount of light striking the MOS image sensor. If the object brightness fails, the automatic iris control circuit opens the lens iris and the video signal output level remains unchanged. The AGC circuit (AGC) raises the gain to keep the video signal level constant at all times.

Chroma processing circuits

The VHS-C red, blue, and green signals are fed to the luminance (luma) and chrominance (chroma) signal-processing circuits from the LPF or chroma amp circuit. The red and blue circuits are applied to the white balance circuits in the RCA CPR100 chroma circuits. These three color signals are corrected like the luminance signal through the various blanking and clipping circuits.

The chroma (C) signal outputs at terminal 5 of D/A converter (ICP05) in the Samsung chroma processing circuits. This C signal

is connected directly to buffer transistor GP11 and the emitter signal is capacity coupled to buffer transistor GP12 (figure 3-16). The C signal is taken from the emitter terminal of GP12, fed to emitter terminal of chroma amp GP13, and coupled directly to buffer output transistor GP14. Scope the chroma signal (11) at the emitter output of GP14 to pin 27 of CNP01. This chroma output signal is then fed to the main VTR circuits.

Chroma signal

■ **3-16** *Samsung 8-mm camera chroma (C) processing circuits.* Samsung Electronics Co.

Pentax PV-C850A 8-mm chroma signal processing circuits

The chroma signal processing circuits separate the YL, 2RG, and 2B-G signals and generate a composite video output signal. The 0.7-MHz LPF (IC1210) separates the narrow band luminance signals to create the R, G, and B signals from the image sensor output. This signal applies to pin 5 of IC1204 (figure 3-17). The 4.77-MHz BPF (IC1210) separates the high-frequency variations and modulates this signal from the sensor output. The output (pin 8) is applied to pin 4 of the sync det (IC1202).

The RGB matrix (IC1204) demodulates the R, G, and B signals and adjusts the gain and balance on the modulation axis. The gain of each signal is adjusted so that the R-Y and B-Y become zero when a white object is viewed. The modulation axis is similarly adjusted when shooting a black object. When the gain of the G channel is fixed, those of the R and B channels are equalized to the G channel. The output pins 6, 8, and 10 are applied to 8, 9, and 10 of the clamping circuits (IC1207).

■ 3-17 *Pentax PV-C850A (8-mm) chroma signal-processing circuits.* Pentax Corp.

Before the R, G, and B signals are sent to the auto white balance control circuit (AWB) and gamma correction circuit (gamma correct), this circuit regenerates the dc components last due to C coupling by keyed clamping and equalizes them for every line. The clamp pulse is applied to pin 13. The G signal is fed to the gamma correction circuit and the R and B signals to the auto white balance control circuit (AWB).

The RGB gamma correct (IC1207) circuits function the same as the luminance signal processing circuits. Gamma correction occurs separating the R, G, and B signals. The outputs are applied to the blank/clipping circuits.

R-Y/B-Y matrix (IC1207) converts the R, G, and B signals, with white balance adjustments resulting in (R-Y) and (B-Y) difference signals. These signals are applied to the color noise remover (CNR) with (B-Y) at pin 17 and (R-Y) through pin 18.

The color noise remover (CNR) circuits improve the signal-to-noise ratio (S/N) by making use of vertical correlation of the chroma signal and color resolution. The –(R-Y) signal is applied at pin 13 and –(B-Y) at pin 14 of IC1205. The S/N signal is improved 1.4 times.

The –(R-Y) signal is applied at pin 7 and –(B-Y) through pin 16 of the clamp/clip IC1206. The dc component, last due to C coupling, are equalized for every line, and then the –(R-Y) and –(B-Y) are clipped to a fixed level. The outputs are applied to the encoder circuit.

In the encoder (BAL MOD IC1206), the subcarrier (SC1) is in phase with the burst signal and amplitude-modulated by –(B-Y). The subcarrier (SC2) is 90 degrees delayed in phase by –(R-Y). These signals are added together, providing a two-phase balance-modulated chroma signal. When the burst flag pulse (BF) is high (Hi), during burst period, blanking stops and SC1 is amplitude-modulated by –(B-Y), which is present during the burst period to obtain the burst signal.

The output from the encoder is fed to the VCA (IC1206). VCA limits the maximum amplitude of the balance-modulated chroma signal to a fixed value controlling the gain. The gain is determined by the dc bias applied to pin 15. The output is applied to the 3.58-MHz bandpass filter (BPF) network.

The 3.58-MHz BPF limits the bandwidth of the balance-modulated chroma signal to a fixed value. The output is divided into two. This signal is applied to the Y/C mixer for the YH signal-processing circuits and to the VTR through the buffer (pin 9).

Canon ES1000 chroma processing circuits

The chroma (C) output camera signal is taken from pin 46 of the digital processing IC1102. This C signal is directly coupled to buffer transistor Q1101 (figure 3-18). The emitter terminal of pnp transistor is coupled through 1-k resistor, 20-p capacitor, and coil L1105 to the base of buffer transistor Q1103. The chroma signal is taken from the emitter of Q1103 and directly fed to the connector terminal 9 of CN1881. A color (C) camera output signal waveform can be taken from TP1102 or pin 9 to determine if camera chroma circuits are functioning.

Automatic iris control (AIC)

The AIC circuit controls the opening of the lens iris according to the object brightness. The AIC circuit can consist of controlling IC, iris motor, and manual iris control. The iris detect signal is applied at pin 2 of the AIC control (IC1404). The gate cuts off the signal during low (Lo) periods and permits the signal to pass during high (Hi) periods (figure 3-19). The level detector provides an average

3-18 *Canon ES1000 camera chroma (C) processing circuits.*

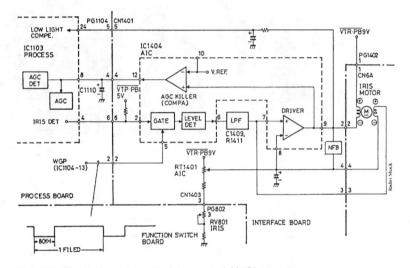

3-19 *Realistic automatic iris control (AIC) circuit.* Radio Shack

iris detected signal. If the luma signal level falls, the iris motor operates to close the iris. The AIC (IC1404) controls the iris motor at pin 9 (figure 3-20).

Pentax PV-C850A 8-mm AIC circuit

The auto iris control circuit (AIC) keeps the input level to the signal processing circuits constant by controlling gain, depending on light intensity (8-lux minimum, 200-lux saturation). When the light intensity is higher than 201 lux, this circuit operates to fix the input level of the signal-processing circuits by controlling the iris so that the light intensity to the image sensor is lower than saturation at 200 lux. The circuit consists of AIC detector/driver (IC1209, RM 1201, and

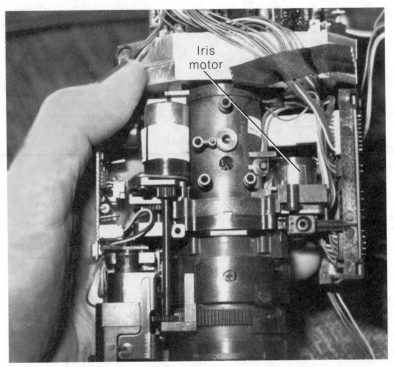

■ 3-20 *Some camcorders have an automatic iris motor located on the lens assembly.*

RT1301) to adjust the iris motor and exposure (figure 3-21). IC1209 contains the gate, iris detector, and iris driver circuits. Outputs of pins 8 and 9 (IC1209) are fed directly to the drive and clamping coils of the iris motor.

Automatic white balance

White balance refers to the adjustment of the recording system to the color temperature of the light illuminating the subject to be recorded. When properly adjusted, white balance produces accurate recording of the colors in the scene. Keep the camcorder set at automatic white balance at all times.

Automatic white balance generates gain control signal of the R and B signals from the two color difference signals and feeds them back to the gain-control circuit. Now a white object is white, regardless of the light source (color temperature). –(R-YL) and –(B-YL) signals from the process circuits are fed to the automatic white balance control circuit (IC1103) through pins 2 and 3 (figure 3-22).

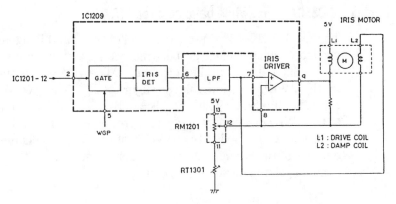

■ 3-21 *Pentax PV-C850A 8-mm AIC circuit.* Pentax Corp.

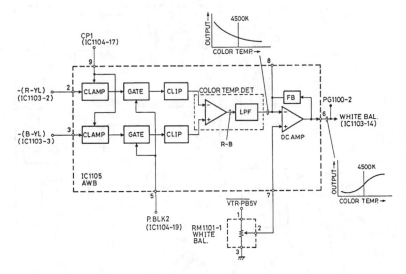

■ 3-22 *Realistic VHS-C automatic white balance control circuit.* Radio Shack

The dc level of the color temperature signal is fixed with a clamp pulse at pin 9. The gate permits the input signal to go to the following stage only when the preblanking pulse is at pin 5. The clip circuit clips the color difference signals at the high and low levels. The color temperature detector consists of a differential amplifier that subtracts the –(R-YL) from –(B-YL) to generate the color temperature R-B. The dc amp controls the white balance control voltage to control gain of the R and B signals.

Pentax PV-C850A 8-mm white balance circuit (AWB)

The AWB (IC1207) corrects the level of the R and B signals to reproduce a white object properly according to the color temperature (2800–7000 K) of the light source. The VCA gain is controlled by the AWB detection voltage (figure 3-23). The AWB DET detects the difference where $R - B = -(B-Y) - [-(R-Y)]$, compares it to the AWB correction voltage, and produces an error voltage. The error voltage is applied to the VCAs of the R and B channels. The outputs of the R and B channel VCAs are applied to the R and B channel gamma correction circuits.

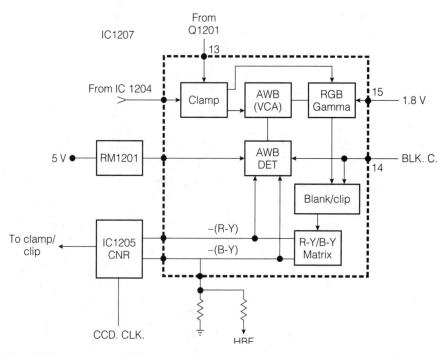

■ **3-23** *Pentax 8-mm white balance circuits.* Pentax Corp.

Automatic focus control

The auto focus system measures the distance from an object by emitting infrared rays towards the object and detecting the reflection, using the principle of triangulation. Infrared rays from an infrared LED pass through a protecting lens to the object (figure 3-24). The infrared rays hit the object and reflect back through a receiving lens and enter the sensor. The sensor consists of two photodiodes. Now the autofocus system moves the receiving lens

88

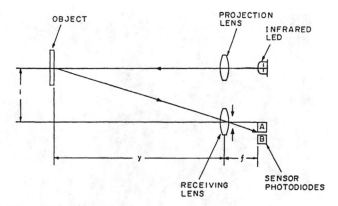

■ 3-24 *Principles of automatic focus.*

to equalize the light intensity of the photodiodes. The object lens is moved by the same amount as the receiving lens (figure 3-25).

Canon ES1000 auto focus circuits

The auto focus drive signals start at the camera/auto focus (AF)/ Mi-Com processor IC1402 (figure 3-26). IC1402 provides a focus stop, focus power saver, focus CW and H/CCW, focus pulse, and focus reset signals to the focus motor drive IC1336. Inside IC1336 consists of a decoder and drive circuits. IC1336 drives the focus motor with an A and B signal from pins 13 and 17 from focus motor drive IC. Pins 15 and 19 of IC1336 provide –A and –B focus drive signals (figure 3-27). A focus reset signal is fed from focus reset circuit in the lens assembly to pin 20 of IC1402.

RCA CPR100 autofocus block diagram

With the focus switch in the auto position and with the power switch in, +5 V is applied to auto focus circuits. The infrared circuit generates an 8-kHz infrared signal and is applied to LED drive (Q3). Now the infrared signal travels to the object and reflects back to the photodiodes and sensor preamp circuit (IC1). The reflected signal is detected by the two photodiodes producing electrical current. Both signals are amplified by the preamp circuits and applied to IC2 (figure 3-28). The signals are synchronized by the 8-kHz clock signal and applied to the comparator circuits. The resultant connection signal is applied to microprocessor IC3. The output signal from IC3 is applied to the motor drive circuits (Q4 through Q12), operating the auto focus motor (figure 3-29).

Manual
macro lever

Lens
assembly

■ **3-25** *The macro lever on a VHS camcorder lens assembly.*

Focus control
motor

■ **3-26** *The focus control motor is found on the lens assembly of a VHS camcorder.*

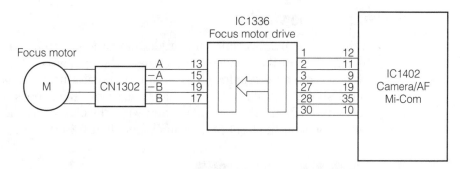

■ **3-27** *Canon ES1000 autofocus circuits.* Canon, Inc.

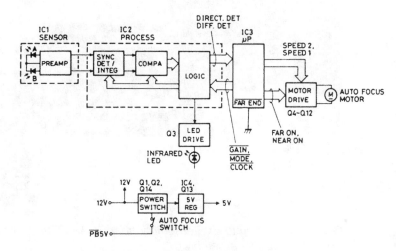

■ **3-28** *RCA CPR100 autofocus block diagram.* Thomson Consumer Electronics

■ **3-29** *The focus and zoom motors are found on lens assembly of camcorder.*

The electronic viewfinder

Although the most recent camcorders have the electronic view-finder, some of the smaller cameras have the optical viewfinder. The electronic viewfinder (EVF) permits monitoring the image being shot or played back. The electronic viewfinder looks and acts somewhat like the small black-and-white TV chassis. The EVF unit is found at the front of the camcorder (figure 3-30).

■ **3-30** *The separate EVF assembly from RCA CPR300 with various adjustments under assembly.*

The EVF circuits consist of a miniature picture tube with horizontal and vertical deflection circuits. The flyback transformer provides high voltage to the CRT. Vertical and horizontal sync circuits are generated and fed to the EVF deflection and VCR system control circuits. A small amplifier and sync separation circuit round up the EVF circuits (figure 3-31).

Samsung SCX854 electronic viewfinder circuits

The EVF video signal is found at pin 3 of CNB01 and is fed to pin 11 of sync separator inside IC801. The video/horizontal and vertical sweep IC provides video output at pin 13, capacity coupled to base of video amp Q801. The video output from video amp is fed to terminal 61 of the EVF CRT tube (figure 3-32).

A +5 voltage at pin 1 of CN801 provides voltage to the video/deflection IC801, at pin 12, positive voltage to pnp emitter of video

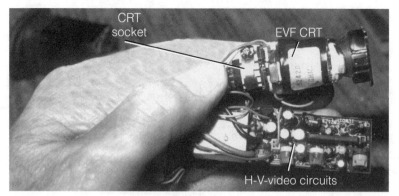

■ **3-31** *The small B & W amplifier and sweep circuits with small CRT removed from EVF assembly.*

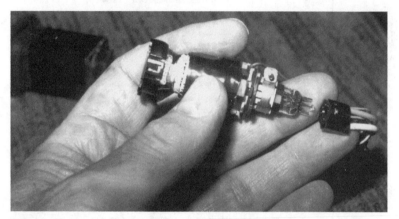

■ **3-32** *The small B & W CRT has only four pin socket connections.*

amp, to vertical drive inside sweep IC, horizontal drive transistor Q802, flyback transformer, and to the brightness circuit K of CRT.

IC801 combines the vertical and horizontal sweep signals to their respective circuits (figure 3-33). The horizontal drive waveform is found on pin 16 of IC801 and feeds to transistor Q803. The horizontal drive pulse is fed to base of horizontal drive transistor Q802, with collector connected directly to the primary winding of flyback (FT801). The B+ voltage to flyback and Q802 is fed through a filter network at C813, C814, and L801.

The secondary winding of flyback provides HV to the anode button of small CRT. A negative voltage is found at terminal to the brightness control. C818 (3.3 µF) provides filter action with this negative voltage. A higher B+ voltage at pin 4 is fed to G2 of the CRT socket.

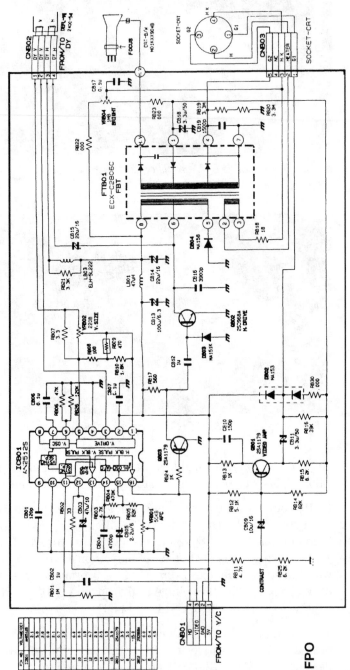

■ 3-33 *Samsung SCX854 electronic viewfinder circuits*. Samsung Electronics Co.

FPO

A vertical drive pulse is fed from pin 3 of deflection IC801 directly to the vertical winding of the deflection yoke. The positive +5-V source is fed to one side of horizontal deflection yoke through L803 and the return yoke lead capacity coupled (22 μF) to pin 6 of flyback and collector of horizontal drive transistor Q802.

There are three adjustments found in the EVF circuits, AFC VR801, VR802 vertical size and VR804, the brightness adjustment to CRT. All of these adjustments are prefixed pots and can be located on the bottom side of viewfinder.

Canon ES1000 EVF circuits

The electronic viewfinder shows a color picture upon an LCD screen assembly. The LCD assembly connects to the EVF PC board. The black light assembly also connects to the EVF PCB. All of these assemblies are controlled from the recorder PCB (figure 3-34). A regulated 5-V source is fed to the EVF board at pin 1 of CN2302.

The EVF luma (Y) and chroma (C) signal is fed into pins 3 and 6 of CN2302 socket connections. The EVF HD and VD are fed at pins 7 and 8. EVF flame and EVF character are found on pins 9 and 10. The EVF PCB drives the LCD unit and black light unit (figure 3-35).

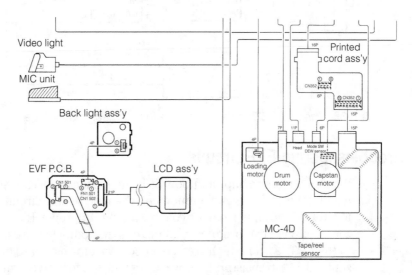

■ **3-34** *Canon ES1000 color video finder (EVF) assembly.* Canon, Inc.

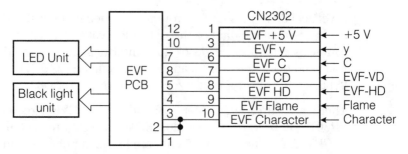

■ **3-35** *Canon EVF PCB, LCD, and black light unit circuits.* Canon, Inc.

Canon image stabilization

The camera image stabilization circuits of Canon's ES1000 camcorder provide a stable picture under most types of movements of the camera section. The VAP section that controls the image stabilizer in the lens assembly receives signal at pin 27 of Camera/AF Mi-Com IC1402 (figure 3-36). Check pin 27 for around 5.1 V in the recording mode. The voltage on pins 50 and 57 are around 0.1 V. See Table 3-1 image stabilization chart when lens and unstable pictures are noted.

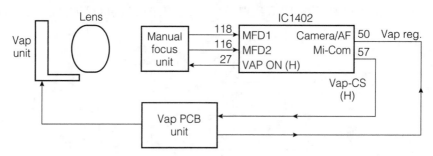

■ **3-36** *Canon ES1000 image stabilization connections.* Canon, Inc.

Troubleshooting EVF circuits

With a no raster symptom upon EVF tube, check the +5 V source feeding the EVF circuits. Remember, the EVF heater circuit is fed like the TV circuits from a flyback winding. Improper HV or horizontal circuits can produce a no raster symptom. Measure the HV to the CRT. With no high voltage, check waveform at base of horizontal driver transistor. If no waveform, check for waveform upon horizontal output terminal of horizontal and vertical sweep IC.

■ Table 3-1 Canon image stabilization troubleshooting chart.

Lens trouble
Image stabilizer trouble

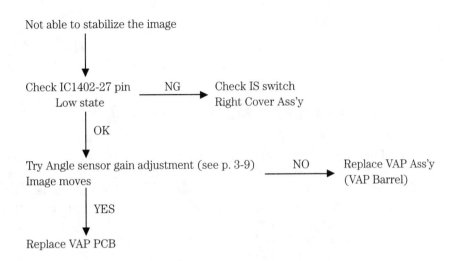

Not able to stabilize the image

Check IC1402-27 pin NG Check IS switch
 Low state → Right Cover Ass'y

 OK

Try Angle sensor gain adjustment (see p. 3-9) NO Replace VAP Ass'y
Image moves → (VAP Barrel)

 YES

Replace VAP PCB

AF trouble

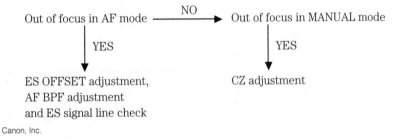

Out of focus in AF mode ──NO──→ Out of focus in MANUAL mode

 YES YES

ES OFFSET adjustment, CZ adjustment
AF BPF adjustment
and ES signal line check

Canon, Inc.

If high voltage is normal and no light of CRT heaters (this can be difficult to see), check continuity of heater terminals. Remove the small CRT socket for this test. Then check the continuity of heater winding of flyback and tube. Note that a small series heater resistor is included in the heater lead (figure 3-37).

Check the vertical section for only a horizontal white line or insufficient vertical height. Readjust the vertical height control for insufficient vertical sweep. Check the vertical waveform at vertical drive output pin on sweep IC. Check for open yoke winding or a bad socket connection when a normal vertical drive waveform is found. Suspect open low ohm yoke return resistor (around 3.3 Ω).

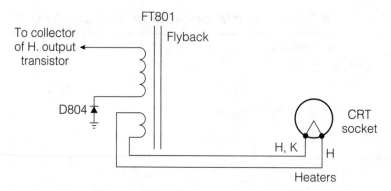

■ **3-37** *The heater circuit of the EVF CRT socket.*

For only a white raster and no picture, check the video input and output waveforms. Take a waveform fed to the sweep IC and output that feeds to video amplifier. Signal trace the video signal right up to grid G1 of CRT. On color EVF circuits, check the color (C) input waveform and follow through the various color circuits. Usually, if a flyback transformer or small CRT is found defective, it is cheaper to replace the whole EVF unit.

Video circuits

THE VIDEO CIRCUITS CONSIST OF THE VIDEO IN AND OUT circuits, head switching, operations in the record and play modes, luminance signal recording and playback circuits, and color signal recording and playback circuits. All of these circuits appear in the early camcorders, while the flying erase head was seen in the 8-mm camcorders. Today, many of the latest VHS, VHS-C, and 8-mm camcorders have a flying erase head for better video pictures (figure 4-1).

■ **4-1** *The camera video section is located towards the front of the camcorder.*

Video signal input/output circuits

The video signal input circuits are switched into the input either from the camera or external devices connected to the AV connector. Within the Samsung SCX854 8-mm camcorder, the camera luminance (Y) and chroma (C) signal is fed to the Y/C processor board video section. The video jack serves as the input and output

jack with switching the video in or out from Y/C process board (figure 4-2).

In the older VHS and VHS-C camcorders, the video signal had a separate input and output jack. In the Canon ES1000 8-mm camcorder, the video is switched in and out of the same jack on a jack unit. The video in from the jack unit, appears at pin 30 of IC2101. The Y/C process IC switches the video out at terminal pin 32. The video in and out waveform can be checked right at the jack or checked on pins 30 and 32 to determine if video is present (figure 4-3).

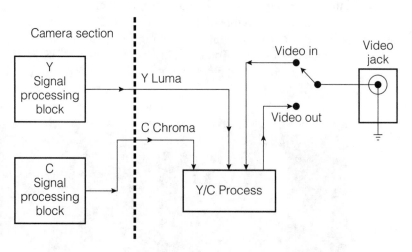

■ **4-2** *Samsung SCX854 8-mm camera Y and C input/output circuits.*
Samsung Electronics Co.

■ **4-3** *Canon ES1000 video in and out from Y/C process IC2101 circuits.* Canon, Inc.

Pentax PV-C850A 8-mm video signal input/output circuits

Either the camera video signal (pin 1) or the external device video signal (pin 5) will be selected according to the camera signal and external device (figure 4-4).

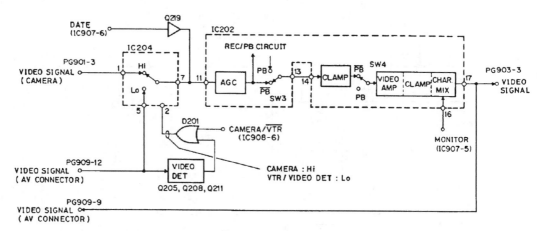

■ **4-4** *Pentax PV-C850A video signal input/output circuits.* Pentax Corp.

The camera/VTR signal supplied from IC908 is high (Hi) during camera mode. The high voltage from the camera sets the switch to Hi through the OR circuit (D201), so the camera video signal applied to pin 1 is selected.

When the video signal detector (Video DET) detects the video signal coming from the external device, its output is low (Lo) and sets a switch (SW) at Lo (external device to select the external device video signal applied to pin 5).

The video signal selected by the signal-selecting circuit (IC204) comes out through pin 7 and, after the date signal (Date) has been added, enters the luminance signal-processing circuit (IC202). Character signals (OSD) are added to the video signal processed in the video circuits. The output is supplied to the electronic viewfinder (EVF) and the external device (RF converter) connected to the AV connector.

RCA CPR100 input/output video circuits

Pin 14 of the encoder IC (IC1107) is low (Lo) when the electronic viewfinder (EVF) is connected to the EVF connector during camera recording (figure 4-5). SW 1 is on and SW 2 is off, allowing video to pass through to the luminance (luma) process section

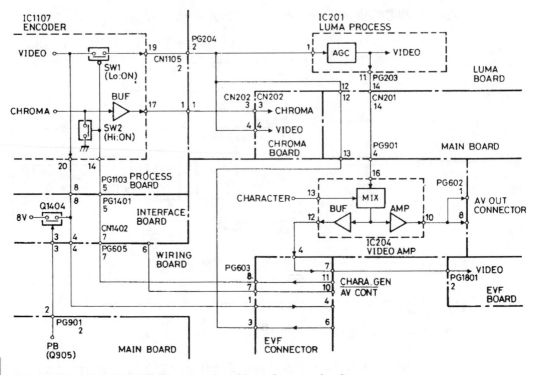

■ **4-5** *RCA CPR100 (VHS-C) video signal input/output circuits.* Thomson Consumer Electronics

(pin 1 of IC201). When SW 2 is off, the chroma signal passes through the buffer to the chroma processing circuits.

Pin 10 of the electronic viewfinder (EVF) is grounded and the PB 9 V and PB 5 V are turned off when the AV input adapter is connected to the EVF connector. Likewise, the video signal from the adapter goes through pin 6 of the EVF connector to the luminance/color (luma/chroma) circuits.

Pin 14 of IC1107 becomes high (Hi), SW 1 turns off, and SW 2 turns on during character generation operations. The camera video signal goes through the interface and wiring board with pin 4 of the EVF connector to the character generator where the two video signals are added.

Head-switching circuits

The head-switching circuits in the camcorder are often controlled by an IC component. The head-switching circuits set the video heads in the record or play mode with several control signals.

Pentax PV-C850A 8-mm head-switching circuits

The head-switching control signals in this model are: REC inhibit, SW 30 Hz, ASBL/PB, REC signal, squelch, and head SW signals (figure 4-6).

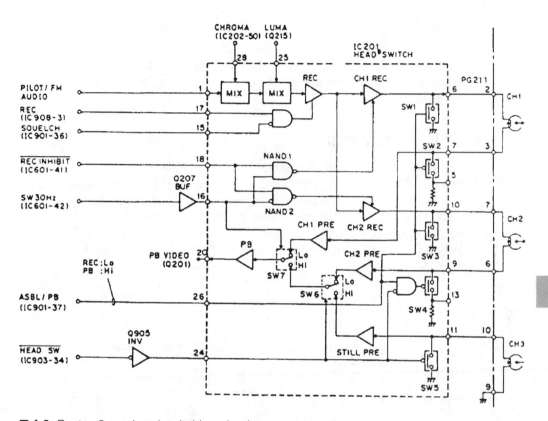

■ **4-6** *Pentax 8-mm head-switching circuits.* Pentax Corp.

The REC inhibit signal in pin 18 of the head-switching IC201 is generated by the servo circuit during the record mode. This signal, with the SW 30 Hz, controls the recording amplifier.

The SW 30-Hz signal with input at pin 16 of IC201 is supplied from the servo circuit. This signal, with the REC inhibit signal, controls the recording amp. During the play mode, the head output will be selected to make the signal continuous.

The ASBL/PB signal with input at pin 26 of the head-switching IC201 is supplied from the system control microprocessor, selecting the mode (either record or play) of the video heads.

The record (REC) signal input at pin 17 of IC201 is supplied from the system control microprocessor. This signal controls the recording amplifier.

The squelch signal input at pin 15 of IC201 is supplied from the system-control microprocessor (IC901). It controls the recording amp and holds recording in check during record pause.

The head SW signal at pin 24 of IC201 is supplied from the system control microprocessor. This switches the CH 2 head to the still head with the same azimuth as the CH 1 head during the slow and still modes.

Operation in the record mode

During record mode in the General Electric 9-9605 VHS luminance and chrominance circuits, the video signal is fed in at the line-in video jack or from the camera video signal to the switching IC3002 (figure 4-7). The output signal is fed to the character mix signal to pin 5 of the luminance REC/PB process or IC3001 to the AGC amp. The REC switch turns the signal to the sub amp inside the luma IC. The video signal can be switched by the EE amp to

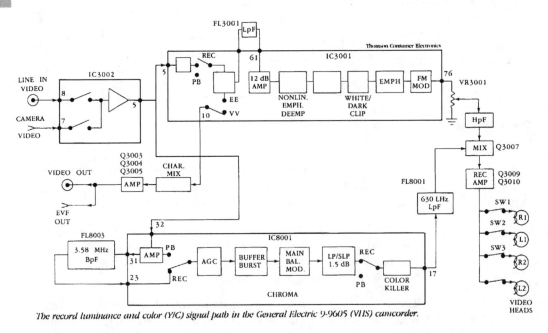

The record luminance and color (Y/C) signal path in the General Electric 9-9605 (VHS) camcorder.

■ **4-7** *The record luminance and color (Y/C) signal path in the General Electric 9-9605 (VHS) camcorder.* Thomson Consumer Electronics

the character mix (Q3006) and Q3003, Q3004, and Q3005 amps to the video out jack and to the electronic viewfinder (EVF).

From pin 28, the signal goes externally to the low-power filter network FL3001 and back into IC3001 at pin 61. Here is a 12-dB amp, and the signal proceeds through the nonlinear emphasis deemphasis stage to the clamp amp. The luma video signal goes through the main emphasis section to the white-dark clip stage through the FM modulator.

The recording current level control VR3001 adjusts the FM recording signal and is fed through a high-power filter (HPF) network to a MIX transistor (Q3007) to the recording amps Q3009 and Q3010. The REC FM signal is fed to the head-switching transistors Q3506, Q3511, Q3516, and Q3521 and applied directly to the four heads (R1, L1, R2, and L2).

The video signal is also fed to the chroma section after splitting at pin 5 of the switching IC8001. The video signal enters pin 32 of the chrominance REC/PB processing IC and is amplified and fed out of pin 31 to the 3.58-MHz BPF circuits and fed back into IC8001 at pin 23. Internally, the video signal is switched to record, passes through AGC, PB buffer, REC burst, 6-dB boost, LP/SLP and switched by REC switch through the color killer and out pin 17. The video/chroma signal passes through a low power filter (630- kHz LPF) and is mixed with the luminance/video signal at mixer Q3007.

Samsung video record circuits

The camera luma (Y) signal inputs at the syscon servo block of IC605 and IC604. The signal is fed from pin 7 of IC605 to pin 30 of the Y/C process IC201. Likewise the chroma (C) is fed in at terminal 53 of Y/C process IC201. The video record signal appears at output pin 39 (Y) and 8 (C) of IC201. The luma signal is fed through a delay line and buffer stage to the preamp IC101 (figure 4-8). The chroma output of pin 8 of IC201 is fed through an audio trap and buffer transistor to pin 2 of preamp IC101.

The chroma and luma signal is mixed inside IC101 and switched to the recording heads. Both CH 1 and CH 2 have a record amp circuit inside IC101 of the video signal. The recorded video signal is coupled to CH 1 and CH 2 of the head cylinder. The head cylinder also includes an 8-mm FE (flying erase) head which ties to an FE amp and flying erase oscillator circuit.

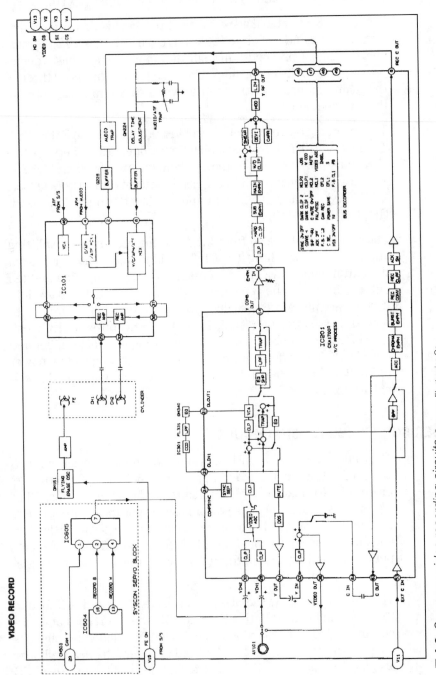

■ **4-8** *Samsung video recording circuits.* Samsung Electronics Co.

Sony CCD-M8E/M8U 8-mm video signal recording system

The Y signal (luminance) and C signal (chroma) are fed from the camera block to the various circuits (figure 4-9). The Y signal from the camera is delayed 650 ns by DL501, 502 and time matching of Y and C is performed. This delayed signal is fed to the YM-2 board. Here the preemphasis circuit is composed of a subemphasis and main emphasis circuit. In the subemphasis circuit, the nonlinear emphasis and deviation settings are performed. In the main emphasis circuit, the linear emphasis circuit and A/C clip are in operation.

The Y signal is fed from the YM-2 board to the recording amp circuits. Likewise, the C signal is fed directly to the recording amp circuits. The AV-16 board contains the FM modulator circuit, which feeds to the recording amp. Also, the pilot signal camera block feeds to the same recording amp.

The Y and C (luminance and chroma) signals enter Q101 mixed and feed to pin 3 (figure 4-10). The Y FM signal is fed into pin 1 of recording amp CX 20034. The Y signal is controlled by the dc voltage at pin 21 and the mixed signals are controlled by the dc voltage at pin 44. ME tape/MP tape switching is also operated at pin 44.

The four mixed signals are converted from voltage to current, pass the recording amp and rotary transformer, and are then supplied to the video heads.

107

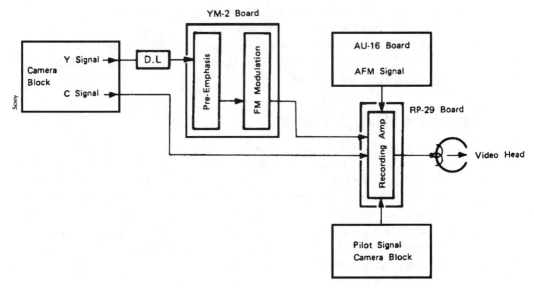

■ **4-9** *Sony CCD-M8E/M8U video signal recording system.* Sony Corp.

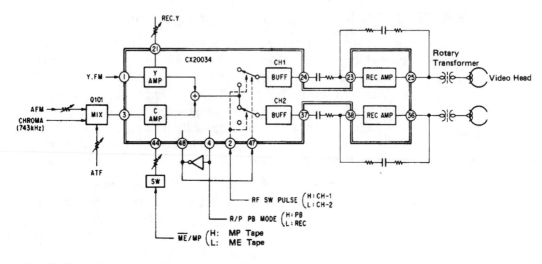

■ **4-10** *Sony 8-mm recording amp circuit.* Sony Corp.

Canon ES1000 8-mm Y & C record mode

In record mode, the Y/C process IC2101 provides recording output at pin 8 and feeds this signal to pin 4 of the head amplifier IC2001. The recording waveform can be taken at pin 4 or 8, whichever is easiest to get to. The head signal is amplified, switched, re-entered on pins 37 and 40, and output at terminals 27 and 34 of head amplifier (figure 4-11).

Channel one (CH 1) output at pin 34 of IC2001 is applied to pin 10 connection CN2001 and applied to CH 1 of drum head. Channel CH 2 output at pin 27 and appears at pin 8, to CH 2 of drum head. The flying erase head signal ties to terminal pin 1 and onto the flying erase of drum head.

Operation in the play mode

In the General Electric 9-9605 VHS luminance and chrominance circuits in play mode, the signal is picked up by heads R1, L1, R2, and L2. The play heads feed the signal to the head amp IC3501. The luminance signal is fed from pin 20 and 21 to the phase compensator circuits of Q3501, L3501, and C3526, while the chroma signal path comes out of pin 15 of IC3501 and feeds to Q3502 amp through a 630-kHz low-power filter (LPF) going to pin 34 of IC8001, the chrominance processing IC.

■ **4-11** *Canon ES1000 Y/C record mode circuit.* Canon, Inc.

The chroma signal at pin 34 feeds to the internal buffer stage out of pin 30 through the 3.58-MHz BPF circuit and back to pin 23 of IC8001, to the burst 6-dB ATT and onto the playback switch. With the switch in playback mode, the chroma signal is switched to the color killer stage, out pin 17 to pin 20 of the luminance IC3001, where the chroma signal is mixed with the luminance video signal.

The playback luminance FM signal from the phase compensator circuits is fed to pin 56 of IC3001 through the DOC SW, DOC AMP, drop-out detector to the 1-H delay and limiter circuits inside IC3001. It passes through the FM demodulator, out pin 42 through the low-pass filter (FL3002) into pin 36 and is amplified, deemphasized, and goes through picture control to output pin 29 of IC3001.

The luminance signal path in playback mode with output at pin 29, enters pin 7 of IC3001 to the PB switch. The luminance video signal is switched to a sub clamp, out pin 28 through a low-power filter network (FL 3001) into pin 61. Here it is amplified by a 12-dB amp and fed to the nonlinear emphasis/deemphasis to the mixer stage, mixing with the chroma video signal.

The W signal is switched inside IC3001 and the output appears at pin 10. The chroma/luma video signal goes through a character mix and is amplified by Q3003, Q3004, and Q3005. The luma/chroma video signal playback mode path feeds to the video out jack and the electronic viewfinder (EVF) (figure 4-12).

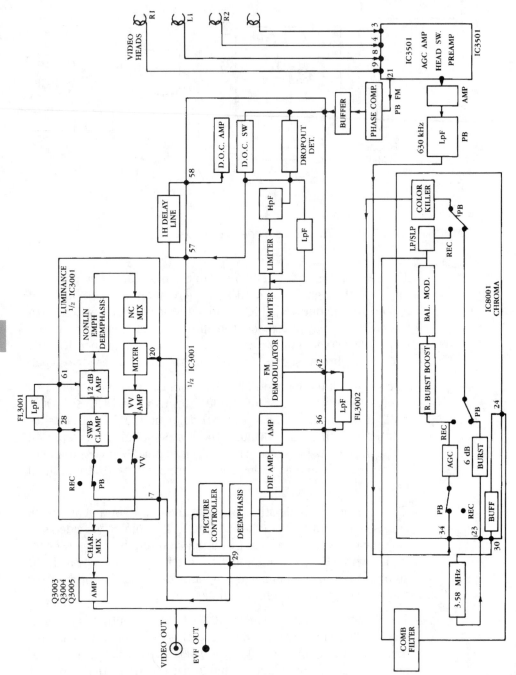

4-12 *The playback luminance and chroma (Y/C) signal path of VHS General Electric camcorder.* Thomson Consumer Electronics

Pentax PV-C850A 8-mm operation during play mode

During play, the ASBL/PB signal (pin 26) is Hi. So, switching circuit (SW 1 and SW 3) turns on to ground the recording terminals of the heads to form the playback circuit. Signals that have passed through preamplifiers (CH 1/CH 2 PRE) come to a switching circuit (SW 7), which forms a continuous signal by selecting the CH 1 signal when SW 30 Hz is low (Lo) and the CH 2 signal when SW 30 Hz is high (Hi). The continuous signal passes through a playback amplifier (BP) before coming out through pin 20.

During the play, the output of the still head is grounded by SW 5 while a switching circuit (SW 6) selects the output of the CH 2 preamplifier. During the slow or still modes, the head SW signal (pin 24) is high (Hi). Now SW 5 does not ground the still head, and the switching circuit (SW 6) selects the output of the still preamplifier. In place of the CH 2 head, the still head picks up the signal. The output of the CH 2 head is grounded by SW 4.

Samsung SCX854 8-mm video playback

IC201 contains the luma (Y) and chroma (C) processing circuit that consists of limiter, demodulator, peaking, clip, deemphasis, BPF, LPF, limiter, chroma, luma, mixer, attenuator, burst, VCA, trap and cancel internal circuits. The video out is found at pin 36 with another connection of video output to the electronic viewfinder.

In video playback, head CH 1 and CH 2 picks up the signal from the tape and applies it to pins 29 and 32 of the head amplifier IC101 (figure 4-13). The weak tape signal is amplified, mixed and after passing through several circuits is found output at pin 10 of IC101. Here the video signal goes through a trap, buffer, soft limiter, LPF, and input at pin 41 of the Y/C processor IC201. After passing through many internal stages video output is found on pin 36.

Pentax PV-C850A

The following section applies to the circuits of the Pentax PV-C850A camcorder.

Luminance signal recording circuits

The luminance signal recording circuits consist of IC204, IC202, and IC201 (figure 4-14). IC202 operates in the record mode when the playback (PB) signal is Lo and in play mode when the playback

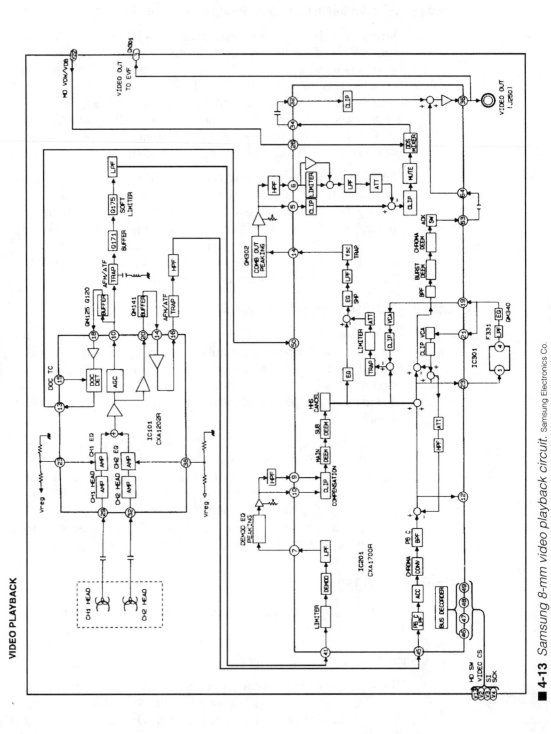

■ **4-13** Samsung 8-mm video playback circuit. Samsung Electronics Co.

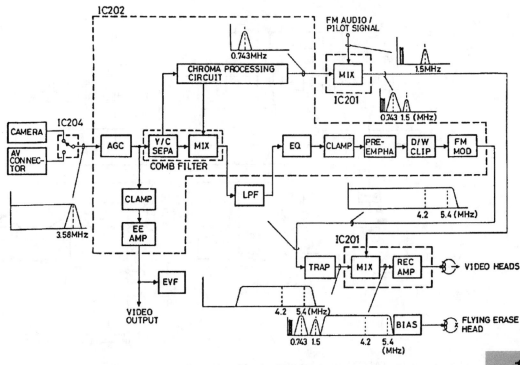

■ **4-14** *Luminance signal recording circuits of a Pentax 8-mm camcorder.* Pentax Corp.

signal is Hi. IC204 is the camera/external device video signal se-
lector. IC202 does the function of luminance signal record/pro-
cessing (recording AGC, luminance signal separator, preemphasis,
clip, FM modulator, and EE amp). IC201 is the recording Y/C
mixer and recording amplifier.

AGC circuit

The AGC circuit detects the input level of the video signal and
controls the gain to keep the output level fixed (figure 4-15). The
input video signal is applied to the AGC circuit luminance signal
separator (luma comb filter), pin 6, the 3.1-MHz low-pass filter
(CP204), pin 25, the equalizer (EQ), through SW 6 to the sync
separator (SYNC SEPA), and through a clamping circuit (clamp)
to the AGC detector (AGC DET).

Sync separator

The sync separator (SYNC SEP) separates the sync signal from
the luminance signal and applies it to pin 7 and the AGC detector
(AGC DET).

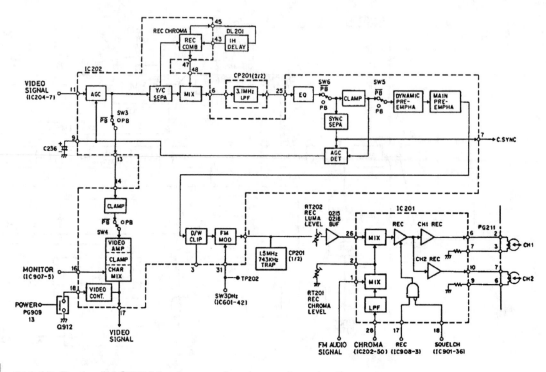

■ **4-15** *Pentax PV-C850A luminance signal recording circuits.* Pentax Corp.

Clamping circuit

In the clamping circuit (clamp), the sync signal level at its top (SYNC TIP) must be fixed at (4.2 MHz) independently of the video signal to frequency modulate the luminance signal. The luminance signal is applied to the AGC detector (AGC DET) and goes through SW 5 to the preemphasis circuit (PRE EMPHA).

Referring again to the AGC detector (AGC DET) generates the key pulse (3), which has a fixed level by delaying the horizontal sync signal (H SYNC) applied from the sync separator (SYNC SEPA) until the back pulse, and adds it to the clamped luminance signal (4). The AGC detector (AGC DET) detects the sum level of the key pulse (fixed level) and the horizontal sync (H SYNC varying level) and generates an AGC voltage that is inversely proportional to the sum level. C236, connected to pin 9, holds the output and supplies it to the AGC circuit (AGC), and it controls the gain to fix the level of the horizontal sync signal.

Luminance signal separator

The luminance signal separator (REC luma comb filter) consists of a comb filter, removes the chroma signal from the input video signal, and extracts the luminance signal (figure 4-16).

The luminance signal separator (Y/C SEPA) consists of a subtractor (subtract) and a 3.58-MHz trap that extracts the 3.58-MHz chroma signal by subtracting the video signal (inverting input—from which the 3.58-MHz chroma signal is removed) from the video signal (noninverting input). The 3.58-MHz chroma signal is applied to the chroma signal-processing circuit through a buffer stage.

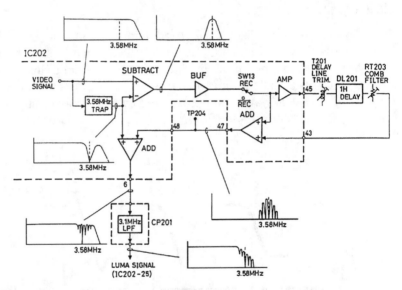

115

■ **4-16** *The luminance separator circuits in the Pentax 8-mm camcorder.* Pentax Corp.

Comb filter

The comb filter circuit consists of a 1-H delay line (DL201-1-H delay) and an adder (ADD). The output of the adder, which adds the original signal with the 1 H = delayed signal is the 3.58-MHz luminance signal from which the 3.58-Hz signal is removed. The output comes out of pin 47 and enters the adder (ADD) in IC202 through pin 48.

Delay line trim

The delay line trim (T201) is connected to the 1-H delay line. It matches the impedance and the level of the 1-H delayed sync. It is adjusted to balance the signals added together so that characteristics of the separator are optimized.

Mixer (ADD)

The mixer adds the video signal from which the 3.58-MHz chroma signal is removed to the 3.58-MHz luminance signal. The output is a luminance signal with a frequency response extending to high frequencies and comes out of pin 6.

Video equalizer

The video equalizer raises the luminance signal level at about 2 MHz (edge) by about 1.5 dB to let the luminance signal preshoot so that the amount of clipping by the subsequent clipping circuit (clip) is actually reduced (figure 4-17). During play, preshooting of the signal waveform is corrected by an overshoot circuit to improve signal-to-noise (S/N).

116

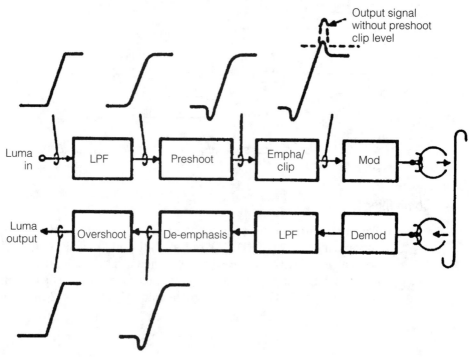

■ **4-17** *The video equalizer circuits in the Pentax 8-mm camcorder.* Pentax Corp.

Preemphasis circuits

The dynamic and main preemphasis circuit emphasizes high-frequency components during recording so that noise is removed when the original frequency response is restored during play. The dynamic preemphasis (dynamic pre-empha) varies the amount of emphasis, depending on the level of the input signal. The amount of emphasis is increased when the level is low and reduced when it is high to prevent excessive clipping in the subsequent clipping circuit (clip) and overmodulation in the FM modulator (FM mod).

The main preemphasis circuit results in a fixed amount of emphasis that is independent of the input level. The preemphasis luminance signal comes to a clipping circuit (D/W clip).

Dark/white clipping circuit

The preemphasis luminance signal overshoots or undershoots at the rising or falling edge because the level of high-frequency components is enhanced. If this were to be frequency modulated, overmodulation would occur, resulting in inversion of black and white. To prevent this, the clipping circuit clips the signal at 100 percent for the dark level and at 120 percent for the white level.

FM modulator

The FM modulator (FM mod) modulates the input signal so that the sync tip corresponds to 4.2 MHz, and the white peak to 5.4 MHz (figure 4-18).

The FM carrier frequency is offset by ½ FH alternatively from field to field according to the SW 30 Hz applied to pin 31. This prevents beat interference caused by adjacent tracks during play.

Mixer

The mixer (MIX) mixes the luminance signal, with its level adjusted with the down-converted chroma signal and FM audio/pilot signals.

The mixer (MIX) mixes the 743-kHz down-converted chroma signal with the 1.5-MHz FM audio/pilot signals. The output, after having its level adjusted by RT201 (red chroma level), is connected to pin 2 and again mixed with the luminance signal. The output passes through a recording amp (AMP) and comes to the CH 1 and CH 2 recording amplifier.

■ 4-18 *Pentax's 8-mm dark-white clip layout.*
Pentax Corp.

The recording amplifier (REC) is controlled by the (squelch) signal applied to pin 15. It is high (Hi) during record pause and the leading time for restarting record. A switching circuit turns on and the recording amp stops.

EE video signal output circuit

The EE video signal is supplied from the AGC circuit (AGC) and is applied to a clamp (clamp) through pins 13 and 14. After being clamped, it is applied to the video signal (figure 4-19).

The video signal amplifier (video amp) is a feedback amp consisting of an operational amp (video amp) and a transistor. The output is a 2-V_{p-p} video signal.

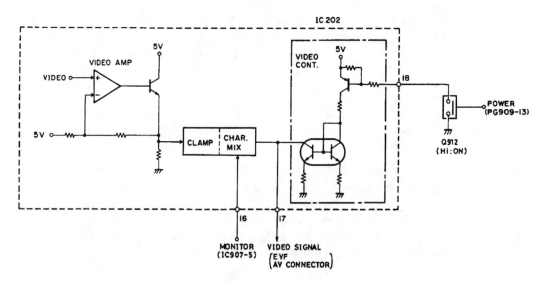

■ 4-19 *The EE video signal output circuit of Pentax 8-mm camcorder.* Pentax Corp.

The clamping circuit clamps the dc level of the 2-V_{p-p} video signal and applies it to the character signal adder. The character signal adder (char mix) adds the character signals (data of tape counter, counter memory, available remaining time, and battery level) to the video signal. The output is applied to the electronic viewfinder (EVF) through pin 17 and to the RF converter unit connected to the AV connector.

The video output control circuit (video cont) consists of a constant-current circuit and a switching circuit that controls output video signal. If the RF converter unit is not connected to the AV connector, the switching circuit (Q912) on the main circuit board is held off, together with constant-current circuit, so that current consumption is reduced.

Canon ES1000 flying erase head

The FE on signal starts at pin 38 of the main Mi-Com (IC231) and feeds into Q231 (switch), and to the flying erase head oscillator Q2083 (figure 4-20). An FE oscillator circuit operates somewhat like the bias oscillator on a record cassette erase head. This FE signal is amplified by Q2082 and connects to pin 1 of CN2001. Connector pin 1 ties directly to the flying erase head winding of the drum 8-mm head. Check the erase head oscillator waveform at output of Q2083. The flying erase head erases the previous recording upon the 8-mm tape.

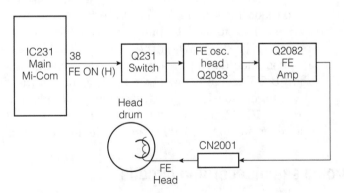

■ **4-20** *Canon ES1000 flying erase head circuits.* Canon, Inc.

Sony CCD/M8E/M8U rotary transformer and video head

The rotary transformer has a three-channel structure. The inner side contains the erase head, the middle side is CH 2, and the outer side CH 1 (figure 4-21).

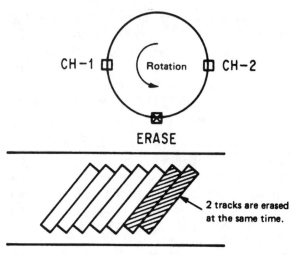

■ **4-21** *Erase head channels in the Sony 8-mm camcorder.* Sony Corp.

The video head contains two pieces, while the erase head one piece. Here two tracks are erased at the same time. Erasing is performed along the track by a rotary, rather than a stationary, erase head.

120

RCA CPR100 luminance record process circuit

The luminance record process is the same as the conventional VHS system except for the head-switching circuits of the four-head recording system. To select the record or playback mode, 5 V (PB 5 V) is applied to pin 12 of the luminance signal record processor (IC201). When the PB 5-V signal is present, the play mode is selected (figure 4-22). The record mode is selected when the PB 5-V signal is low (Lo). IC201 contains the Y/C separator, AGC, preemphasis, clipping, frequency modulation, and EE amp circuits. IC203 contains the luminance/chroma (Y/C) mixer and the recording amp. IC206 is the detail enhancer circuit.

Chroma signal recording circuits

During the camera mode, the 743-kHz down-converted chroma signal is generated from the 3.58-MHz chroma signal coming from the camera. In the VTR mode, the 3.5-MHz chroma signal is extracted from the input video signal, and the 743-kHz down-converted chroma signal is generated. IC202 operates in the record mode when the REC signal is high (Hi), and in play mode, when it is low (Lo) (figure 4-23).

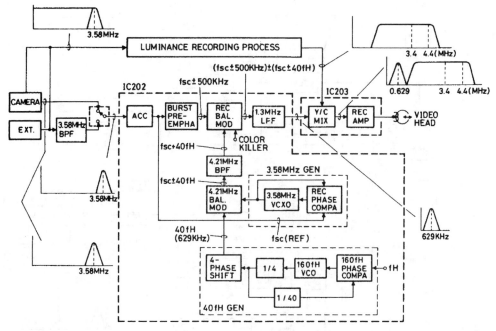

■ **4-22** *RCA VHS-C luminance record process circuit.* Thomson Consumer Electronics

IC204 and IC205 contain the camera/external device video signal selector. IC202 contains the luminance signal record/processing (AGC and chroma signal separator), chroma signal record/processing (AGC, burst preemphasis, chroma preemphasis, frequency converter, 3.58-MHz generator and 47¼-FH generator). IC201 contains the recording Y/C mixer and recording amplifier.

Pentax PV-C850A chroma recording circuits

If you select the recording signal in the camera mode, the 3.58-MHz chroma signal from the camera is received. In the VTR mode, the 3.58-MHz chroma signal is extracted from the composite video signal coming through the AV connector. This selection is performed in IC205 (figure 4-24). In the camera mode, the camera/VTR signal is high (Hi) and IC205 selects the 3.58-MHz chroma signal coming from the camera through pin 4. The chroma signal for the camera passes through a 400-ns delay circuit, which adjusts the timing of the luminance signal before entering IC205. In the VTR mode, the camera/VTR signal is low (Lo), and IC205 selects the 3.58-MHz chroma signal applied to pin 6 after being extracted from the composite video signal. The output of IC205 is sent to the AGC circuit in IC202.

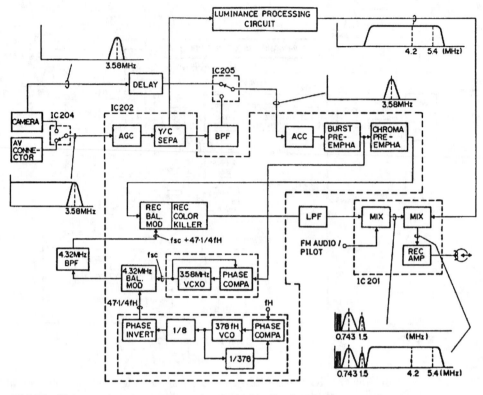

■ 4-23 *Chroma signal recording circuits in the Pentax 8-mm recorder.* Pentax Corp.

The AGC circuit consists of the AGC amp and AGC detector and fixes the output burst signal level regardless of variations in the input level.

The burst gate pulse (BGP) is generated by the burst gate generator (BGP GEN) with the burst signal extracted from the input chroma signal, and the gain of the AGC amp is controlled so that the level of the burst signal remains constant.

The burst preemphasis circuit is used to reduce color irregularities and noise appearing as horizontal lines this raises the burst level by 6 dB when the burst gate (BGP) is input.

The chroma preemphasis circuit consists of a 3.58-MHz trap connected across pins 32 and 33, an amplifier (AMP), and a subtractor (subtract). It emphasizes low-level sideband components during recording so that the signal-to-noise (S/N) can be improved when emphasized components are deemphasized during play. The subtractor (subtract) subtracts the original signal (inverting input) from the inverted-and-amplified signal (noninverting input),

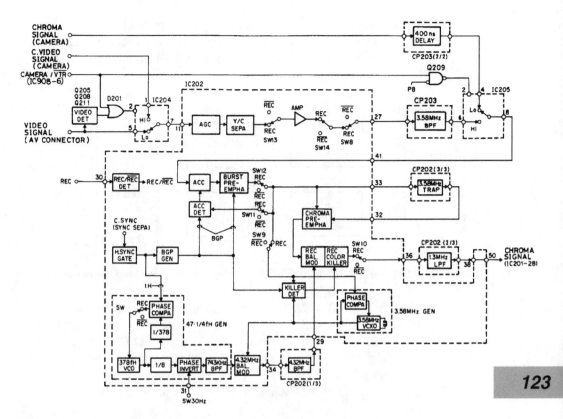

■ **4-24** *The chroma signal recording circuits in a Pentax camcorder.* Pentax Corp.

and the output is the sum of the input signals added together in phase.

In the main converter, the frequency of the 3.58-MHz chroma signal is converted by the 4.32-MHz signal from a 4.32-MHz bandpass filter (CP202). From the output, the 1.3-MHz low-pass filter (CP202) in the later stage removes the sum signal (4.32 MHz + 3.58 MHz) and outputs the difference signal, that is, the 743-kHz down-converted chroma signal (4.32 MHz–3.58 MHz).

The color killer (killer DET) detects the burst signal in the input signal, and the output is the 743-kHz down-converted chroma signal. When a burst signal is not detected, the chroma signal will not be output.

Samsung Y & C record circuit

The Y and C recording circuits in the Samsung SCX854 camcorder starts at the luma and chroma processing IC201. The Y signal is fed

out of pin 39 and the C or chroma signal from pin 8 of IC201 (figure 4-25). The luma signal passes through a delay time adjustment circuit and to buffer amp. You can check the record Y signal at TP204 before entering preamp IC101.

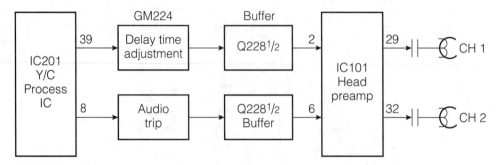

■ **4-25** *Samsung 8-mm block Y & C recording circuit.* Samsung Electronics Corp.

The chroma (C) signal is found on output terminal 8 of Y & C IC201, feeds through an audio trap and buffer transistor Q228 to input pin 6 of IC101. At the emitter terminal of Q228 (pnp), you can check the color waveforms (C) at TP228 before it enters pin 6 of preamp IC101. The head preamp (IC101) amplifies the Y and C signals with CH 1 output at pin 29 and CH 2 at pin 32 (figure 4-26).

Luminance playback processing circuits

The luminance playback circuit consists of the video heads, preamplifiers, demodulated and playback, signal synthesizer, AGC, deemphasis, dropout compensation, luminance mixer, and 1-H delay for drop-out compensation. In the RCA CPR100 VHS-C luminance playback process circuits, the RF signal picked up by the heads is amplified by IC203 (figure 4-27). Also, the PB 5-V signal is switched between playback and record in IC203. When the PB 5-V signal is high (Hi), playback is in operation, and when the PB 5-V signal is low (Lo), recording operation is switched in. IC203 contains the luminance chroma (Y/C) mixer and preamplifier. The FM demodulator, deemphasis and Y/C circuits are contained in IC201. IC204 amplified the luminance playback signal and is fed to the electronic viewfinder (EVF) and AV out connector.

Realistic 150

The following circuit descriptions pertain to the Realistic 150 camcorder.

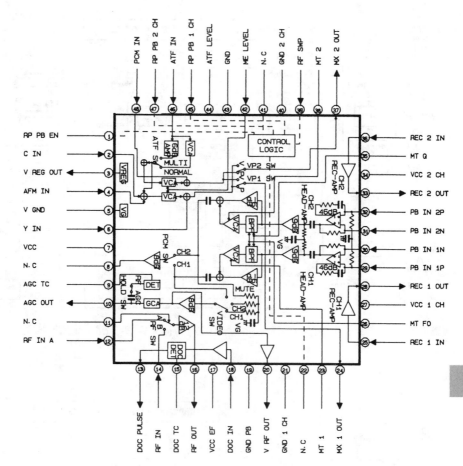

■ 4-26 *The internal operation circuit of head amplifier IC101 in a Samsung camcorder.* Samsung Electronics Co.

Luminance playback process circuits

The signal picked up by the tape heads is preamplified and switched by IC203 (figure 4-28). It is then fed to a 4.6-MHz peak playback equalizer (CP201). As the preamplifier has a flat frequency response, this performs correction of the head frequency response playback output. It raises the response around the upper limit (4.6 MHz) of the FM carrier to flatten the overall frequency response.

AGC circuit

The AGC circuit corrects the deviation, including interchannel deviation, of the outputs of the video heads. The AGC detector

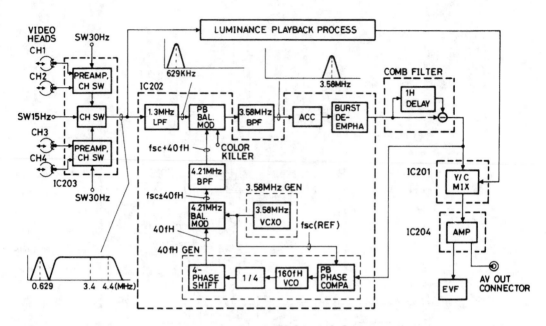

■ 4-27 *Luminance playback process circuits in RCA VHS-C camcorder.* Thomson Consumer Electronics

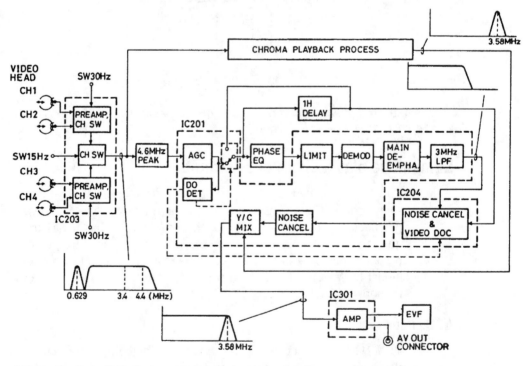

■ 4-28 *Realistic VHS-C chroma signal playback circuits.* Radio Shack

Video circuits

(AGC DET) detects the input level and feeds the output back to the AGC circuit to control gain. The signal passes through the dropout (SW 8), SW 4, and pin 4 before coming to the phase equalizer Q201, DL201, and dropout detector (DO DET) included in the IC.

Phase equalizer

Q201 is the phase equalizer stage. This circuit corrects phase distortion occurring when the playback equalizer (CP201) equalizes the amplitude so that distortion of the playback waveform is reduced. The output passes through a buffer (Q214) and input at pin 2 before entering IC201 once again.

High-pass limiter

The high-pass limiter suppresses lower side-band components to prevent black/white inversion. If the recording is done with preemphasis applied to that part of luma signal where the black level changes to white level, the carrier would be subject to dropout at the edge during playback, and inversion between black and white would occur together with deterioration of S/N.

Main deemphasis circuit

The effect of this circuit is reversed compared to that of the main preemphasis circuit during recording. It restores the original signal level by alternating the high-frequency components that were boosted during recording. The output goes through SW 1, pin 14 and the 4.1-MHz bandpass filter (L213 and C252). The output is at pin 13 of IC201 and goes through a low-pass filter (3 MHz).

Playback equalizer

The playback equalizer contains Q207, Q208, and Q213. This circuit operates when the PB 5 V is applied to the base of Q207. The output enters the H-correlation noise canceller/dropout compensator IC204. The luma signal goes out of pin 6 to pin 23 of IC201.

Noise canceler

The noise canceler circuit removes high-frequency noise (random noise) in the played-back luma signal to improve the S/N. The greatest effect occurs with the low-level luma signals. The output luma signal passes through SW 5, pins 24 and 28, before coming to the sync expander (SYNC expand) and passes through SW 2 before coming to the sync separator (SYNC SEPA).

Sync separator

In the sync separator (SYNC SEPA), the output video signal passes through SW 2 and comes to the sync separator (SYNC SEPA), which separates the sync signal as in recording. The output appears at pin 20 and feeds to chroma sync (IC202).

Chroma signal playback circuits

After being processed in IC202, the chroma signal mixes with the luma signal and becomes the video signal in the Radio Shack 150 chroma playback circuits (figure 4-29). IC203 contains the preamp and continuous signal generator. The chroma playback processing, which contains chroma signal separator, AGC, burst deemphasis, playback balanced modulator, and crosstalk cancel, is contained in IC202. The luminance and color (luma/chroma) mixer is found in IC201 with the output video amplifier (IC301).

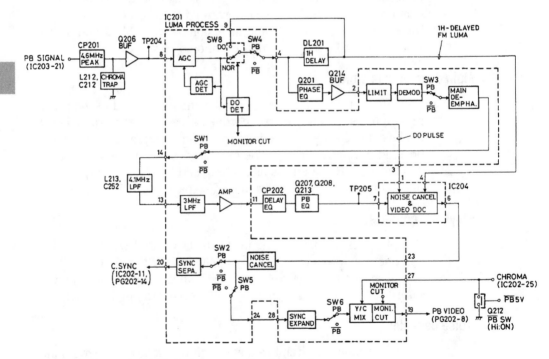

■ **4-29** *Realistic 150 VHS-C chroma playback circuits.* Radio Shack

Pentax PV-C850A chroma playback circuits

The playback signal enters pin 35 of IC202. A 100-kHz trap removes pilot signal (FL-F4). After pilot signal removal, the play-

back signal enters a 1.3-MHz low-pass filter (CP202) through SW
10 (pin 36). The 1.3-MHz low-pass filter removes the FM audio
and FM luminance signals from the playback signal to extract a
down-inverted chroma signal (743 kHz + 500 kHz). The AGC and
AGC DET controls the gain of the chroma signal to keep the burst
level fixed (figure 4-30).

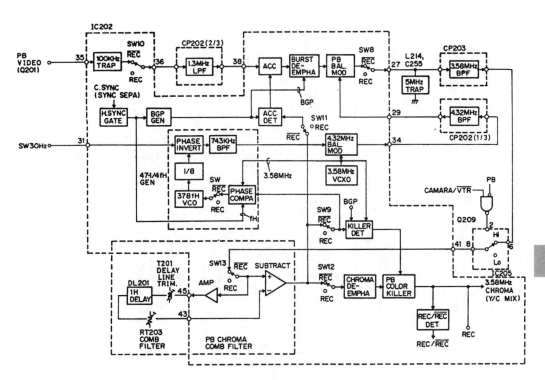

■ **4-30** *Chroma playback circuits of Pentax 8-mm camcorder.* Pentax Corp.

The burst deemphasis circuit alternates the burst signal. The main
converter mixes the down-converted chroma signal (743 kHz +
500 kHz) with 4.32 MHz to convert the frequency. A 3.58-MHz and
bandpass filter extracts the chroma signal by removing spurious
components. The playback chroma comb filter adds the 1-H de-
layed signal to remove crosstalk. The chroma deemphasis circuit
alternates the sideband components. A color killer detects the
burst signals synchronized with the burst gate pulse (BGP) and
uses a 3.5-MHz continuous signal to detect whether it is present or
not.

During playback, the burst frequency fluctuates due to jitter, etc.
and is removed by the 47¼-FH generator. After the playback color

C-chroma record

y-record luma

■ **4-31** *Samsung's Y & C color and luminance recording circuits to CH 1 and CH 2 heads.*

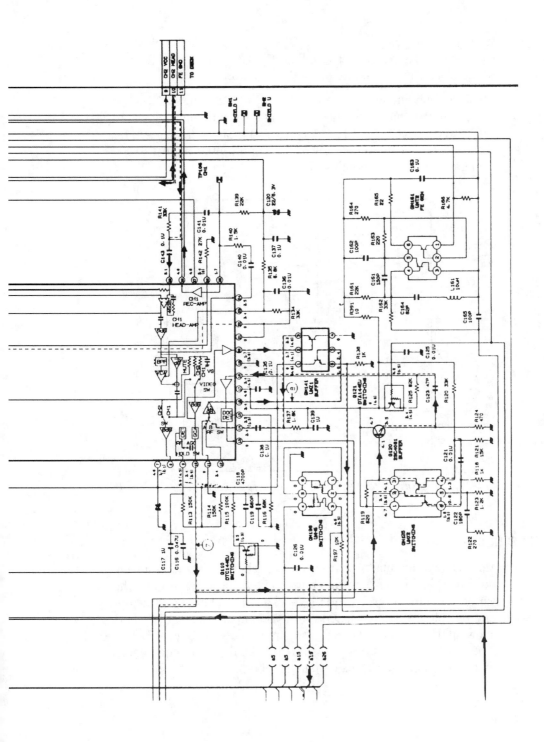

131

Chroma signal playback circuits

killer, the luminance and color (Y/C) is mixed and the result is the video signal. The video amp amplifies the video signal and feeds it to the electronic viewfinder and AV connector.

The color and luminance circuits (Y & C) of Samsung's IC201 and preamp IC101 that feeds the recording color and luma signals to the head drum (CH 1 & CH 2) (figure 4-31). Check figure 4-32 for Samsung A/V jack circuits. Table 4-1 represents Canon ES1000 camera video troubleshooting chart.

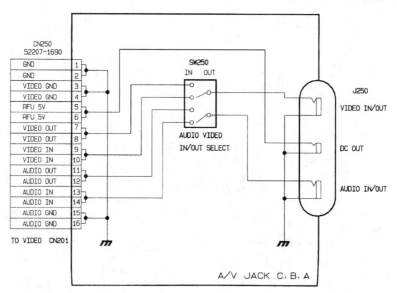

■ **4-32** *Samsung's 8-mm A/V jack circuits.* Samsung Electronic Co.

Conclusion

Most camcorder manufacturers give a circuit diagram showing how the video, luminance, and chroma paths proceed through the various circuits in record and playback modes. Sometimes the operating voltages are not listed on the schematic; a separate chart showing the correct voltage is given. In this case, it's a good idea to write on the schematic. Always replace the defective component with the manufacturer's exact part number.

■ Table 4-1 Canon ES1000 video troubleshooting chart.

No EE picture

EVF picture appears? $\xrightarrow{\text{YES}}$ Check VCR part. (see part A).

↓ NO

Video signal at VIDEO OUT terminal? $\xrightarrow{\text{YES}}$ Check EVF (see part B).

↓ NO

Composite sync. at VIDEO OUT terminal? $\xrightarrow{\text{YES}}$ AF, PZ motors initialized correctly? $\xrightarrow{\text{YES}}$ Check CAMERA process (see part C).

↓ NO (AF, PZ motors)

Check lens part (see part D).

↓ NO (Composite sync.)

Check RR972 (POWER SUPPLY PCB) $\xrightarrow{\text{NG}}$ Replace RR972

↓ OK

Check IC951-3 pin: Camera 5 V (CAM.MAIN PCB) $\xrightarrow{\text{NG}}$ Check IC951-2 pin: Camera ON High (CAM.MAIN PCB) $\xrightarrow{\text{NG}}$ Check main Mi-com. IC231 (REC.MAIN PCB)

↓ OK (IC951-2 pin)

Check IC951

↓ OK (IC951-3 pin)

Check IC952-4 pin: Camera 5 V (CAM.MAIN PCB) $\xrightarrow{\text{NG}}$ Check IC952-1 pin: camera ON High (CAM.MAIN PCB) $\xrightarrow{\text{NG}}$ Check main Mi-com. IC231 (REC.MAIN PCB)

↓ OK (IC952-1 pin)

Check IC952

↓ OK (IC952-4 pin)

Check dc/dc part
CN1001-1 pin: 15 V
CN1001-2 pin: –8.5 V
(CAM.MAIN PCB) $\xrightarrow{\text{NG}}$ Check T951, D951, 2 (CAM.MAIN PCB)

↓ OK

Check SSG: IC1003 (CAM.MAIN PCB)

133

Part A.

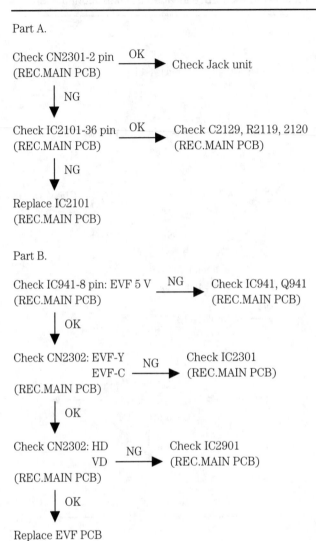

Check CN2301-2 pin ── OK ──▶ Check Jack unit
(REC.MAIN PCB)

│ NG
▼

Check IC2101-36 pin ── OK ──▶ Check C2129, R2119, 2120
(REC.MAIN PCB) (REC.MAIN PCB)

│ NG
▼

Replace IC2101
(REC.MAIN PCB)

Part B.

Check IC941-8 pin: EVF 5 V ── NG ──▶ Check IC941, Q941
(REC.MAIN PCB) (REC.MAIN PCB)

│ OK
▼

Check CN2302: EVF-Y
 EVF-C ── NG ──▶ Check IC2301
(REC.MAIN PCB) (REC.MAIN PCB)

│ OK
▼

Check CN2302: HD
 VD ── NG ──▶ Check IC2901
(REC.MAIN PCB) (REC.MAIN PCB)

│ OK
▼

Replace EVF PCB

134

Part C.

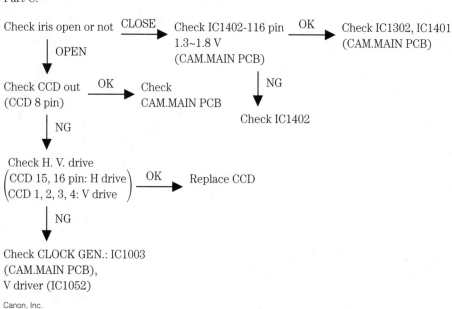

Check CLOCK GEN.: IC1003
(CAM.MAIN PCB),
V driver (IC1052)

Canon, Inc.

135

System control

THE MOST IMPORTANT COMPONENT IN THE SYSTEM CON-
trol circuits is a microprocessor, also called a microcomputer or in-
tegrated IC. This system control IC can have from 48 to 82 con-
necting terminal leads (figure 5-1). Usually, the microprocessor
controls all functions of the camcorder, including the camera and
VCR functions. In the VHS models, the system control micro-
processor can control the loading motor, trouble detector, camera
control, power control, battery overdischarge detector, servo con-
trol, function control, luma/chroma control, character generator,
and audio circuits (figure 5-2).

System
control IC

■ **5-1** *The system control IC has many gullwing terminals.*

All of the above functions are controlled in the VHS-C camcorders
with added tape run control, mechanism control, tape speed de-
tect, and screen display.

■ **5-2** *Block diagram of Samsung's 8-mm system control circuit.* Samsung Electronics Co.

System control circuits

The system microcomputer in the 8-mm camcorders provides signals to the warning detection, loading motor, sync generator, D-D converter, continuous recording, video, digital servo, capstan signals, LED indication, and key and mode switch circuits. The CPU or microprocessor IC is a very delicate component and must be handled with care. Make sure all possible tests are made before replacing this system control component. Besides, it is very expensive to replace.

In the Samsung 8-mm system control circuit, the system control IC601 (micom) controls the sensor reel, end sense, top sense, dew in, record proof, cassette in, T/E LED, mode switch A, B, and C, loading motor load, and unload loading motor. A lithium 3-V battery operates the system control while the battery pack (5 V) has been removed for charging. A 5-V regulator and reset IC602 provides 5-V regulation and charging of the lithium battery. The SP/LP clog detector IC501 provides correct SP/LP operation and clog detection circuit.

Notice that the loading motor operates from a loading drive IC504 and is controlled by IC601. IC601 provides loading motor forward and reverse drive voltage. The Mi-Com IC601 controls the various sensor circuits.

Pentax PV-C85OU (8 mm)

Although IC901 (main system control NP) controls the system control circuits, there are three different microprocessors in these circuits (IC901, IC902, and IC903). IC901 controls the following functions (figure 5-3):

☐ Controls the power latch relay to turn the power on and off according to power switch input.

☐ Calculates the length of tape wound and controls the character generator to display the data in the electronic viewfinder.

☐ Transfers counter data to calendar generator (IC906) and maintains data just after the power is off.

The sub-system control IC (IC902) controls the following:

☐ Receives key commands through a matrix switch circuit and supplies it to IC901.

☐ Detects battery terminal voltages and sends the signal to IC901. IC901 controls power source and character generator IC907 to display battery status in the electronic viewfinder.

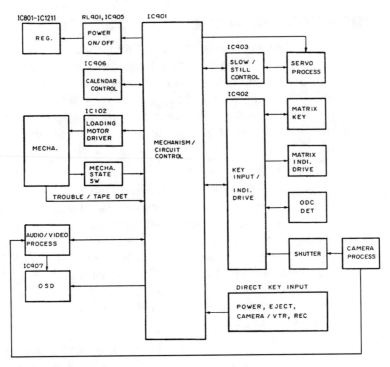

■ **5-3** *Pentax PV-C850V (8-mm) configuration of system control circuit.* Pentax Corp.

☐ Detects $\frac{1}{1200}$ shutter speed mode and sends signal to IC901. IC901 controls the character generator IC901 to display the shutter speed in the electronic viewfinder.

☐ Receives mode data from IC901 and controls the matrix driver to the drive mode indicator.

The functions of the slow/still(SS) UP (IC903) are the following:

☐ Receives still, slow, frame advance and play data and controls the servo circuit in place of IC901.

☐ Communicates with the calendar generator (IC906) to correct and read the date, adds the date to the video signal in the character generator (IC8907), and records it as required.

☐ Controls the loading motor and mechanism mode.

☐ Detects trouble in the mechanism to protect the tape and mechanism.

☐ Controls the signal-processing system.

☐ Transfers display data to the character generator (IC907).

☐ Controls the mode of the servo circuit.

- Communicates with the slow/still microprocessor (IC903) to match commands and operation.
- Communicates with the sub microprocessor (IC902) to match commands and operation.
- Directly inputs operation of the POWER, EJECT, CAMERA VTR, and REC switches.
- Calculates the remaining tape time and controls the character generator to display data in the EVF.

RCA CPR100 (VHS-C)

Microprocessor IC901 controls the system control operation. IC901 controls the power operation, function switch control, over-discharge detect power control, tape speed detect, servo luma/chroma control, trouble detection, tape run, loading motor, clock generator, mechanism control, and on-screen display control circuits (figure 5-4). The system control microprocessor is usually found on the main chassis board (figure 5-5). In most RCA cam-

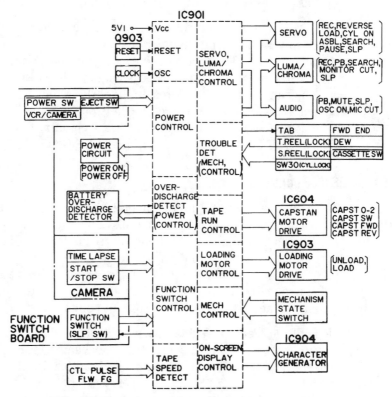

■ **5-4** *RCA CPR100 (VHS-C) system control circuit.* Thomson Consumer Electronics

corders, the system control circuits control the camera assembly, VCR assembly, power control, and distribution.

The loading motor control drives the loading motor circuitry, which in turn mechanically operates levers and gears to control the mechanisms. The tape run control section provides signals to the capstan motor drive IC with capstan switch, capstan forward and capstan reverse procedures. In the VCR system, various trouble and monitor devices are fed to the trouble detection mechanism control of IC901. The system control circuitry found here is similar to all camcorders in the VHS and VHS-C units.

Canon ES1000 control circuits

The main Mi-Com IC231 in the Canon ES1000 camcorder controls the loading motor circuits and circuits that are found upon the mechanism unit. Pin 1 of IC231 controls the unloading of load motor through loading motor drive IC101. Cassette in load is found on pin 7 of main Mi-Com IC. A load voltage is applied from 2 and 3 of IC101 and unload voltage at pins 18 and 19 (figure 5-6). Check the loading voltage at FP101 and FP102 test points.

Mode SW 1, 2, and 3 are fed from pins 22, 23, and 24 respectively, to connecter CN102 that connects to mechanism PCB. The dew sensor is H at pin 121 and fed to pin 14 of CN102. Recording proof is controlled at pin 21. Supply reel sensor + and – connects at pin 7 and 8 of CN102. Take-up reel + and – sensors are found at pins 5

and 6 of CN102. All four reel sensors are controlled by reel sensor amp IC110. The supply and take-up reel sensor signal is found at pins 120 and 115 of Mi-Com IC231.

Function switch key input circuits

Some of the function switch input circuits are tied into the system control microprocessor. Usually, the function input switch circuits consist of the key matrix, the input to the camera section, and the system control microprocessor. The VCR section of the switch key input is connected to the PAUSE, STOP, REWIND, PLAY, F.FWD, RESET, DISPLAY, and receiver buttons (figure 5-7). The clock output pulses place diodes in series with the key input switches in some camcorders, supplied by two phase signals from system control IC.

IC901 supplies two phase signals to the key matrixing circuits. When the function switch is pressed, IC901 detects the switch by monitoring the data input. IC901 now sends out the required signals to carry out the function of the key pushed. Often, the key input buttons are mounted on a separate PC board that slides into position with one of the side panels removed (figure 5-8).

In the more expensive camcorders, a shutter and shutter speed circuits are tied into the function switch input circuits. Shutter switches S607 and S608 are only accepted in the record or record pause modes in the RCA CPR300 VHS camcorder (figure 5-9). With S607 set in normal position, the shutter speed is $\frac{1}{60}$ second. When S607 is in the high-speed position, switch S608 can be used. Each time S608 is pressed, the shutter speed advances to the next sequence $\frac{1}{120}$ to $\frac{1}{250}$ to $\frac{1}{1000}$, etc. Now this shutter high speed is registered in the electronic viewfinder. The shutter speed switches (S608 and S607) key inputs are applied to the shutter IC701, and these signals are applied to IC901 at pins 19, 20, and 21.

Pentax PV-C85OA 8-mm control key input circuits

Four out of 20 control keys on the case are directly connected to IC901: CAMERA/VTR, EJECT, POWER, and REC (figure 5-10). The remaining key buttons are connected to IC902 through the matrix key through the key input circuits. The matrix key input circuit generates a five-phase key scan signal, timed by the four-phase signal (phases 0 through 3), developed at pins 9 through 12 of IC902 and feeds it back to pins 15 and 16 and 19 through 21 of IC902.

143

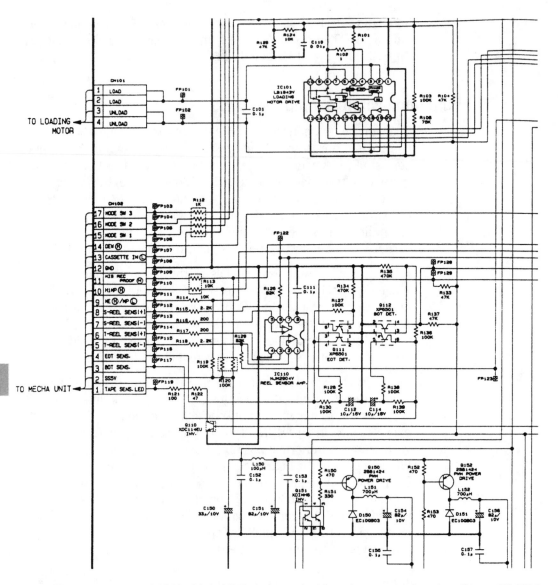

5-6 *The system control IC231 Main Mi-Com controls the various operations in a Canon ES1000 camcorder.* Canon, Inc.

144

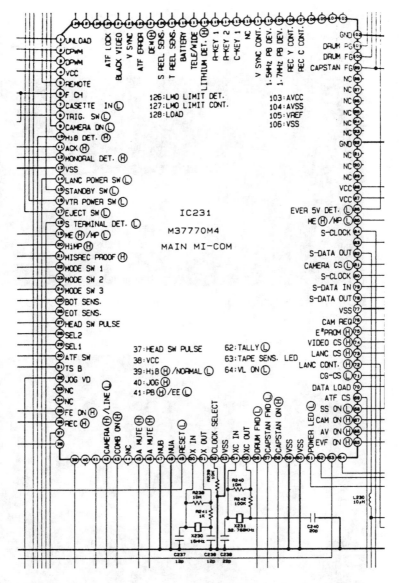

■ 5-6 *Continued.*

■ **5-7** *The top function switch assembly on the RCA CPR300 VHS camcorder.*

■ **5-8** *Top keyboard buttons on RCA VHS camcorder.*

Out of the eight mode indicators on the case, the REC/BAT is directly driven by pin 1 of IC901. The rest are driven through the matrix drive circuit. In the matrix drive circuit, phases 0 and 1 of the four-phase signal (phases 0 through 3) pass through D901 while phases 2 and 3 pass through D902 so that a two-phase indicator drive signal is gen-

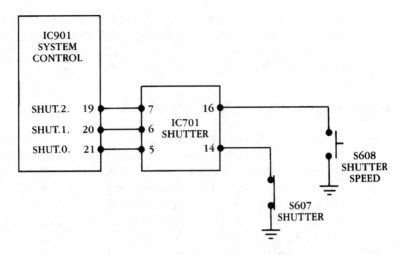

5-9 *The function shutter control circuits in the RCA VHS camcorder.*

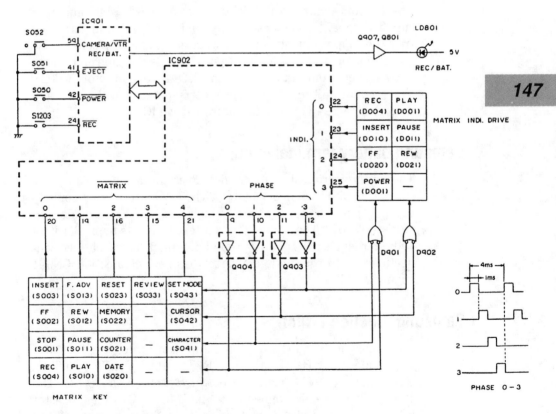

5-10 *Pentax 8-mm control key input circuit.* Pentax Corp.

erated. This signal is applied to each indicator. The cathodes of the indicators are connected to pins 22 through 25 of IC902. IC901 controls the output levels at pins 22 through 25 to drive the LEDs, synchronized with the four-phase signal (phases 0 through 3).

Power control circuits

The power supplies for the camcorder are also controlled by the system control microprocessor. The correct voltage source is furnished by batteries or the ac power line via the ac adapter/charger. Often, these voltages are regulated with IC or transistor components. A relay can be found in some models to apply the regulated voltage to the function control microprocessor. In turn, these output voltages are fed to the various camcorder circuitry. The power control operation consists of turning the power off and on, VTR power, camera power, and eject operations.

The Mi-Com control IC601 in the Samsung SCX854 camcorder supplies signal to the sensor detector IC501, which in turn controls the supply and take-up reel sensors, end and top sensor. The cassette in operation is found at pin 17, while the tape end sensor is controlled from pin 31, through LED drive transistor (Q602). The forward and reverse voltages correspond with the load and unload voltages to loading motor from drive IC504.

Samsung battery terminal circuits

The battery terminal connections consist of an unregulated 6-V camcorder and lithium 3-V battery. The 6-V battery input connection is at pins 1 and 2 of CNB01, which connects to the dc/dc converter (CN901). The lithium (L1) battery connects to pin 3, with 4 and 5 terminals of CN801 at ground potential. These battery connections go to the dc/dc converter terminal connection CN901 (figure 5-11).

Samsung function switches

The Samsung SCX854 camcorder function switch consists of a stop (fade), play (BLC), memory, FWD (edit +), REW (editT-1), C/reset, still (date), eject, and power switch (figure 5-12). The stop (S960) switch is connected to the EVER 5 V through resistor R960 (18 K) and to key scan 1 on pin 7 of CN962 connection. Play switch S961 connects to the same 5 V source and to resistor dividing networks R961 (100 K), R962 (33 K), R965 (47 K), and R966

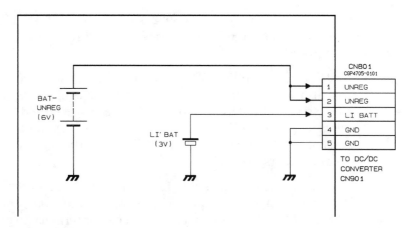

■ **5-11** *Samsung battery terminal connections.* Samsung Electronics Co.

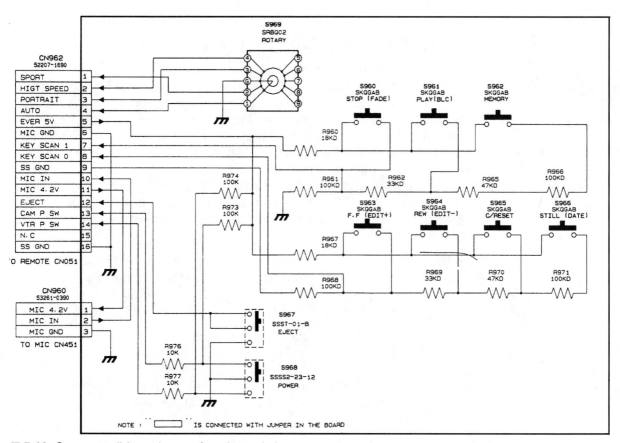

■ **5-12** *Samsung slide and rotary function switches.* Samsung Electronics Co.

(47 K). The memory switch S962 is connected to the EVER 5 V and fed to R966 (100 K) in series with R965 (47 K) to one side of play switch.

Switch S963, the FWD (EDIT +) connects to resistor R967 (18 K) that also connects to EVER 5 V. The other side of S963 connects to key scan 0 at pin 8 of CN952. Switches S964, S965 and S966 are paralleled to the 5-V source through R967 (18 K) and to several resistor network R969, R970 and R971. R968 (100-K) ties all of the above resistors to SS ground.

The eject switch (S967) ties to terminal 12 of CN962 and the other terminal to chassis ground. The power switch S968 connects through R976 (10 K) to Cam p SW and center terminal to ground. The other end of power switch is connected to R977 (10 K) and terminal 14. All of these connections go to remote connections CN051. A rotary switch (S969) switches in sport, high speed, portrait and auto at CN962.

Canon ES1000 power supply PCB

The Canon ES1000 supply board consists of a zoom unit, 6-V battery, lithium battery, ac battery pack (DC100), Lanc terminal jack (JC001), and video light. A zoom unit consists of a wide and tele resistor control with SS 5-V connection and ground. The tele-wide control is found at terminal 2 and connects directly to contacts 3 of CN002 (figure 5-13). The regular 6-V battery pack and DC100 power source plug into the + and – battery connections with minus terminal to ground and the hot + 6 V through fuse (FU971) to pins 17, 21, and 22 of CN002. This unregulated 6 V goes to VTR and EVF circuits. Resistor RR972 ties to Cam and AF unregulated 6 V in terminals 11, 15, and 16.

The lithium battery has + and – terminals that connect directly to battery holder, with negative terminal grounded and positive terminal to lithium 3 V pin 10 of CN002. This 3-V source goes directly to pin 4 of EVER 5 V regulator IC230.

The Lanc terminal jack connections tie into terminals 5 and 7. The positive terminal of video light connects through resistor RR973 to positive 6-V battery. Pin 2 of the video light (–) connects to a light drive transistor Q1902 with transistor switch (Q1901) that turns the light on at terminal 8 of CN002. A trigger and standby switches connect to pins 1, 2, and 4.

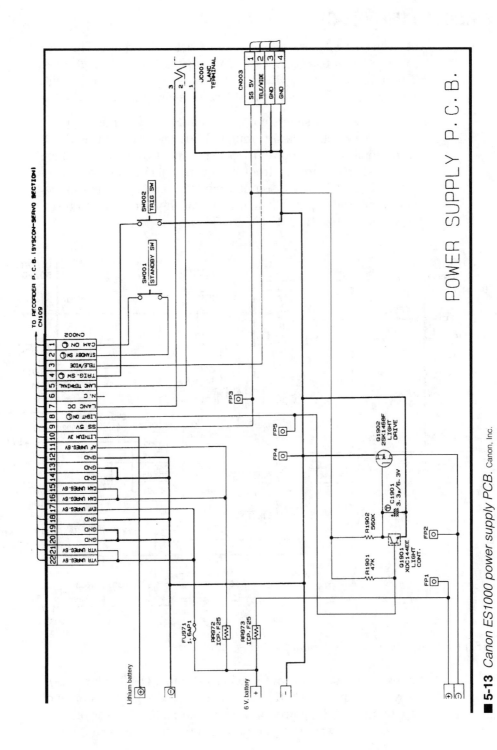

POWER SUPPLY P.C.B.

151

■ **5-13** *Canon ES1000 power supply PCB.* Canon, Inc.

Realistic 150 (VHS-C)

The main board generates power supplies for all circuits. The battery or external battery pack (12 V) applies power through fuse F970 to the latch relay (RI901). The system control (IC901) controls RL901 to supply power to the various circuits.

For VTR power, the sliding power switch (S809) grounds the base of the 12 V switch (Q904) through ZD901 and D803, turns Q904 on, and applies 12 V of power to the 5.6-V regulator (IC905). When the 5-V 2 source is applied from D914 to pin 26 (V_{CC}) of the system control IC (IC901), 5-V 3 source from D914 is also applied to the reset circuit (Q903, ZD902, and reset) at the same time to reset the system control (IC901) (figure 5-14).

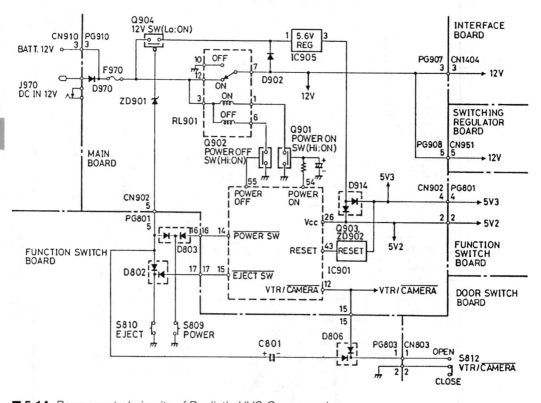

■ 5-14 *Power control circuits of Realistic VHS-C camcorder.* Radio Shack

Because input pin 14 (power switch) through D903 is low (Lo), the system control (IC901) determines that the power is on and outputs a high (Hi) power-on signal from pin 54 (power on) for 100 ms. The power-on signal output turns relay driver (Q901—

power on SW) on and switches relay (RL901) on to supply 12 V to the voltage regulators and generate power as shown in Table 5-1.

■ Table 5-1 Realistic 150 power supply sources.

Supply power	Generator	Supply destination	Application
12 V	RL901-7	Camera	*
		AV OUT connector	For RF converter
		System control circuit	IC903
		Servo circuit	IC604, IC551
8 V	SWR	Camera	*
		Luma/chroma circuit	IC301
		EVF (Camera)	
5 V1	SWR	Audio circuit	IC401, IC402, Trouble sensors
		Servo circuit	Main power (IC601–IC603, IC605)
		Luma/chroma circuit	Main power (IC201–IC204)
		System control circuit	IC904
PB5 V	Q908-C	Camera	*
		Luma/chroma circuit	IC201–IC203
REC5 V	Q909-C	Luma/chroma circuit	IC202
		Servo circuit	IC601
5 V2	IC905-3	System control circuit	µP (IC901)
		Function switch circuit	Backup detector
5 V3	IC905-3	System control circuit	IC902
		Function switch circuit	POWER LED B+/ Backup detector
B+ CYL.	SWR	Servo circuit	IC551
B+ CAPST.	SWR	Servo circuit	IC604

Radio Shack

153

The 5.6-V regulator (IC905) inputs power via D902 and maintains the system control V_{CC} power (5 V 2). When the power is on and the power switch (S809) is in position, the system control (IC901) determines that power has been switched off and outputs a high (Hi) power-off signal with a duration of 100 ms from pin 55. The power-off signal turns relay driver Q902 on and switches relay RL901 off to cut the 12-V power supply (enters stop mode).

During the eject operation of the VTR, when eject switch S810 is pressed in the power-off state, the system control IC901 operates because 12-V switch (Q904) is on as it was with the power on. At the same time, the system control (IC901) outputs a high (Hi) power-on signal with a duration of 100 ms through pin 54, because pin 15 (eject SW) input is low (Lo) and eject is detected. The high (Hi) power on signal raises each power source during power on and operates the eject function (figure 5-15).

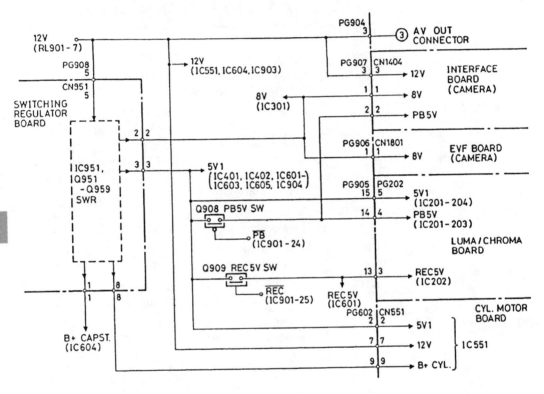

■ 5-15 *Realistic 150 (VHS-C) power distribution circuits.* Radio Shack

When the eject operation is completed, the power off signal sets the power off (stop) mode. With the power on, eject operates in all modes except record. The power-on state is held after eject is completed.

In camera power operation, the lens door is opened during camera recording, the VTR/camera switch (S812) interlocked with the door is set to open. This grounds the base of the 12-V switch (Q904) through ZD901, D806, and S812 until C801 is charged in the same way when the VTR power is turned on. Because pin 12 (VTR/CAM-

ERA) receives a low (Lo) input via S812, the system control (IC901) detects power on in the camera mode. The power-off mode is detected when the lens door is closed, S812 is switched to close, and pin 12 is set to high (Hi) (figure 5-16).

■ **5-16** *Power control circuits are mounted on the main circuit board of the RCA CPR300 camcorder.*

Samsung power supply sources

The unregulated 6-V and 3-V lithium batteries are fed into the dc/dc converter circuit with various voltage supply sources. An EVF 5 V, VTR 5 V, and SS 5 V is fed to the Syscon/Servo circuits out of D19, D20, and D2, respectively (figure 5-17). Also a 20 V at D13, 15 V at D14 and –9 V at D15 to the Syscon/Servo circuits. A switching voltage for the drum V 5 is at D10, capstan V 5 at D11, and camera 5 V at D16. These various voltages are developed inside the dc/dc converter from a 6-V battery.

Canon ES1000 power supply sources

This camcorder power supply has various different voltage sources from a 6-V battery. The EVER 5-V source supplies power to the main Mi-Com IC231. A SG 5-V source serves the Syscon/

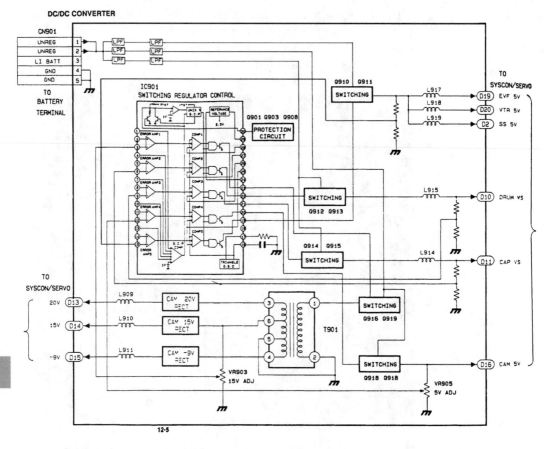

DC/DC CONVERTER

■ **5-17** *Samsung power sources from the dc/dc converter circuit.* Samsung Electronics Co.

Servo circuits. The AV 5-V source feeds the audio and video circuits. PB 5-V power is output when in the play mode. EVF 5-V source supplies power to the electronic viewfinder (figure 5-18). The camera 5-V source supplies voltage to the camera and A+ circuits. A +15 V and –8.5 V is fed to operate the charge-coupled-device (CCD). The +9-V source serves voltage to IC1001 (CAS/AGC). A Mi-Com 4-V power source supplies voltage to the camera Mi-Com circuits. The digital 4 V serves power to the digital IC. Last but not least, the lithium 3-V battery serves as backup power source for the quartz circuit.

Canon power off/on sequence

The following operation sequences occur when the camcorder is started (turned on) and shut down (off) after completion of usage:

EVER 5 V	Power to Main Mi-Com IC231
SB 5 V	To Syscon-Servo circuit
AV 5 V	To video and audio circuits
PB 5 V	Power source for playback video circuits
EVF 5 V	Voltage to electronic viewfinder circuits
Camera 5 V	Power to camera and AF circuits
+15 and −8.5 V	Voltages to CCD drive circuits
+9 V	Power source for IC1000 (CDS/AGC)
Mi-Com 4 V	Voltage source to camera Mi-Com
Digital 4 V	Power source for digital IC
Lithium 3 V	Backup power source for Quartz circuit

■ **5-18** *The power supply sources and what they operate in the Canon ES1000 camcorder.*

When the battery pack is loaded the unregulated 6-V power is supplied from the battery terminal. EVER 5-V power is output from pin 1 of IC230 (figure 5-19). The Reset signal is output from pin 5 of IC230. Then, the Main Mi-Com IC231 is reset to begin initialization. The Main Mi-Com IC231 outputs SS on "H" to turn on SS 5-V power. The Main Mi-Com IC231 checks communication with the EEPROM IC232. At this step, it also checks the mechanism position. On completion of initialization, the Main Mi-Com IC231 turns off power to each section to enter the stop mode. In the stop mode, the Main Mi-Com IC231 does not perform communication with other sections. Only the power key, eject key and cassette switch are acceptable in this mode.

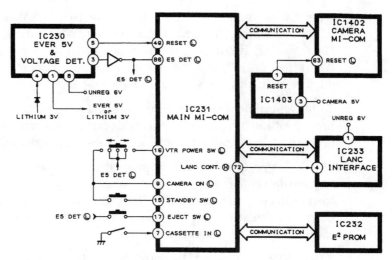

■ **5-19** *The power off and on operation sequences of Canon ES1000 camcorder.* Canon, Inc.

When the power key is turned on, the "low" signal at pins 9 and 15 or pin 16 of the Main Mi-Com IC231, knows that the power key is turned on. This turn on activates the Main Mi-Com from the stop mode. When ON "H" signal is output from the Main Mi-Com IC231, this turns on each power source and microcomputer circuit.

When the eject key is pressed with the battery pack mounted, power is turned on even in the power-off state. Then, after the videotape cassette is ejected, power is turned off. For cassette ejection, the following circuit sequence is carried out:

1. When pin 17 of the Main Mi-Com IC231 goes "low," it knows that the eject key has been pressed.
2. The Main Mi-Com IC231 is activated from the stop mode.
3. The SS on "H" signal is output from the Main Mi-Com IC231, thereby turning on SS 5-V power.
4. The Main Mi-Com IC231 controls the mechanism for ejecting the video tape cassette.
5. The Main Mi-Com IC231 turns off SS 5-V power and enters the stop mode.

When the videotape cassette is inserted with the battery pack mounted, power is turned on even in the power-off state. After the cassette loading sequence is performed, power is turned off. For cassette insertion pin 7 of the Main Mi-Com IC231 goes low, it knows that the video cassette has been inserted. The sequence steps are the same as cassette injection.

When the power is turned off, pin 9, 15, or 16 of the Main Mi-Com IC231 goes "high," it knows the power has been turned off. The Main Mi-Com IC231 sets the mechanism to its home position. When the ON "H" signal disappears, each power source is turned off. The Main Mi-Com IC231 enters the stop mode.

To prevent a physical damage or jamming of the tape due to improper setting, this camcorder carries out the warning indicating processing, key-input rejection, or operational restriction.

The detection of a decrease in the main battery and lithium battery are detected during operation. When the voltage level of main battery decreases below 5.65 V for more than two seconds, the power LED indicator blinks and the "battery mark" warning indication flashes on the viewfinder screen.

If the UNREG 6-V power decreases below the predetermined voltage level, the low-voltage-level detecting signal at pin 118 of Main Mi-Com IC231 goes "low" and the under cut 1 state is recognized

in the microcomputer. Upon knowing the condition, the Main Mi-Com IC231 charges the CHARA GENE data to indicate the "battery mark" warning upon the viewfinder screen. At the same time, the power LED is flashed by the LED signal output from pin 61 of Main Mi-Com IC231.

If the UNREG 6-V power further decreases below 5.45 V for more than two seconds, the power-off state is taken automatically through the stop state. In the circuit, the low-voltage-level detecting signal at pin 118 of Main Mi-Com IC231 goes "Low" and the under cut 2 state is recognized in the microcomputer.

In the circuit sequence, if the UNREG 6-V power drops rapidly to cause EVER 5 V to become less than 4.5 V, the E5 DET "L" signal is output from pin 3 of IC230 (figure 5-20). This puts the Main Mi-Com IC231 in the sleep mode to shut power off immediately.

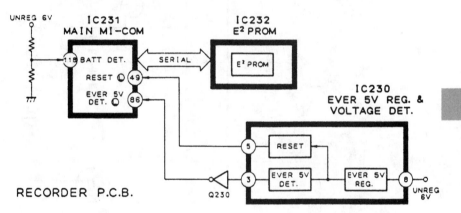

159

■ **5-20** *When voltage is less than 4.5 V, IC230 shuts down operations in the Canon ES1000 8-mm camcorder.* Canon, Inc.

Sony CCD-M8E/M8U 8-mm standby sleep mode

The purpose of the CPU standby sleep mode is to conserve battery consumption. The system control microcomputer IC consumes most of the power. The battery power should be conserved at all times, especially when the camcorder is not in use. With the standby sleep mode circuits, the system control CPU cuts off the power when not required.

The system control CPU controls the signal (power) for the dc-dc converter and turns the 5-V switch off when in the high (Hi) state. The system control is now in the standby mode. When the input pulse is applied at the start port (pin 16) of IC101, the standby

mode is released (figure 5-21). The system control enters the standby mode with the cassette door up or the LS (linear skating) becomes a ready state. The system control goes into the standby mode when the LS chassis stops during error detection.

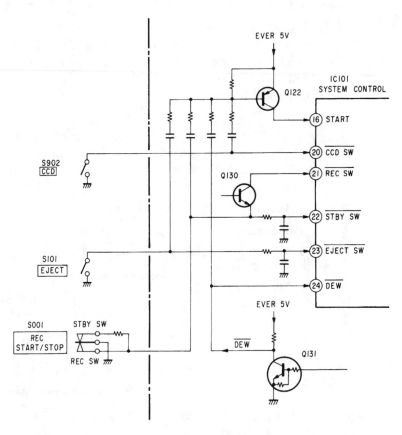

■ **5-21** *Sony CCD-M8E/M8U 8-mm standby sleep mode.* Sony Corp.

On-screen display circuits

When the display button is pressed, the system control IC generates a signal to a character generator that the system control microprocessor applies the data to display battery level and tape counter in the electronic viewfinder (EVF) of many camcorders. In the RCA CPR300 camcorder, the system control microprocessor provides the display of battery level, tape counter, shutter speed, and operation mode. The signal from the character generator IC is fed to the video amp IC for on-screen display in the electronic viewfinder.

RCA CPR100

The system control microprocessor generates a low (Lo) signal at pin 25 with the display switch pressed (figure 5-22). This signal is fed to the character generator (IC904). The system control (IC901) applies data to the character generator (IC904) in displaying battery level and tape counter indications. The character signal at pin 10 is fed to pin 13 of the video amp (IC204) and synchronizes with the horizontal and vertical sync fed into pins 14 and 15 of IC904. The character signal at pin 13 is mixed with the video signal at pin 16 and applied to the EVF.

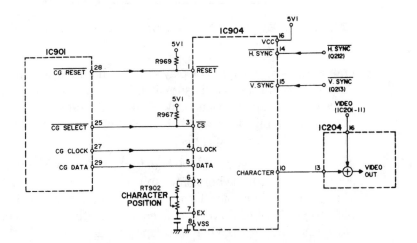

■ **5-22** *The on-screen displays on RCA VHS-C camcorder.* Thomson Consumer Electronics

Realistic 150

When the display switch is pressed, the battery voltage, tape speed, operation mode and four-digit tape counter are displayed in the electronic viewfinder (EVF) screen (figure 5-23). The tape speed is displayed only in the SP mode and the operation mode is displayed only in the record, fast forward, and rewind modes. When the display switch is pressed one more time, the display in the EVF screen disappears. However, the REC indicator is displayed in the record mode.

When the power is first supplied, the system control (IC901) and character generator (IC904) are reset. When the character generator (IC904) is activated after being reset, the system control (IC901) provides a high (Hi) signal at pin 28 of the character gen-

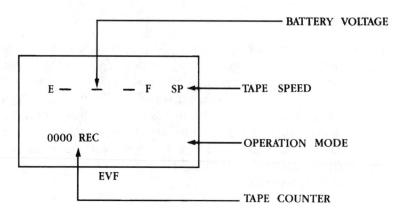

BATTERY VOLTAGE

E — — — F SP ← ── **TAPE SPEED**

0000 REC ← ── **OPERATION MODE**

EVF

── **TAPE COUNTER**

■ **5-23** *Realistic 150 electronic viewfinder (EVF) screen display.* Radio Shack

erator (IC904). When the display switch is not pressed, no display data and no output data is supplied. When the display switch is pressed, the character signal data showing the tape counter, operation mode, tape speed, and battery voltage are output, synchronized with the C.G. clock pulse.

The character generator (IC904) outputs a character data signal, synchronized with the horizontal and vertical sync signals (H. and V. sync) input from pins 14 and 15. The character signal is supplied to pin 13 of IC301 and is mixed inside with the luminance or video signal at pin 16. When the display mode is changed, the system control (IC901) outputs low (Lo) at pin 28 to reset the character signal generated by the character signal generator (IC904). The character generator (IC904) makes pin 1 (reset) low (Lo) when there is no V.SYNC signal input at pin 15 to inhibit the display data output of the system control (IC901).

Canon ES1000 video light

The video light is used when there is insufficient light in a given area for proper lux readings of the camcorder. The light turn ON switch is found in the C-key unit with the camera and VTR switches. The light on (L) connects from C-key unit to pin 8 of CN109 and pin 8 of CN002. The ON return is applied to switch transistor Q1901 and light drive transistor Q1902 (figure 5-24). The output of light drive transistor goes to one side of video bulb while the other lead ties into the battery +6 V terminal. RR973 provides correct voltage to the video light bulb.

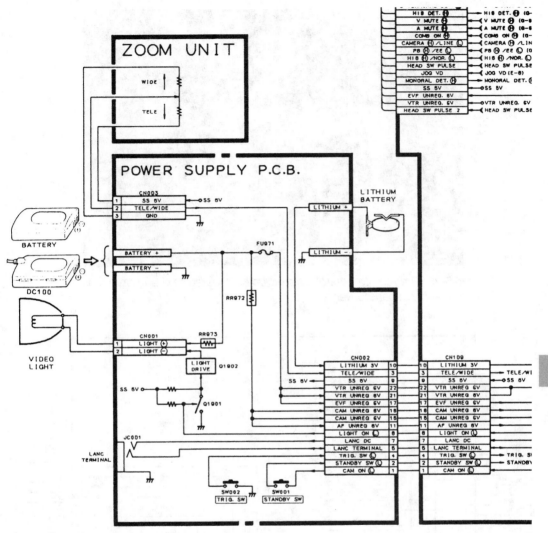

■ **5-24** *Canon ES1000 video light circuits.* Canon, Inc.

Samsung remote control module

The remote module connects many different circuits together and also contains the infrared remote receiver module. The remote module RM050 terminals consist of a ground, IR signal out and a positive supply voltage (V_{CC}) (figure 5-25). The IR out signal ties into pin 9 of CN050, while the SS 5-V supply is found at pin 10, through resistor R050 (47 Ω) to pin 3 of RM050 (figure 5-26). The IR out connects to pin 9 of CN601 of system control and connects to pin 85 of IC601 Mi-Com. The Canon power supply troubleshooting chart is found in Table 5-2.

5-25 *The remote control infrared unit is located to the front of lens assembly in camcorder.*

5-26 *Canon ES1000 remote control module.* Canon, Inc.

■ Table 5-2 Canon ES1000 power troubleshooting chart.

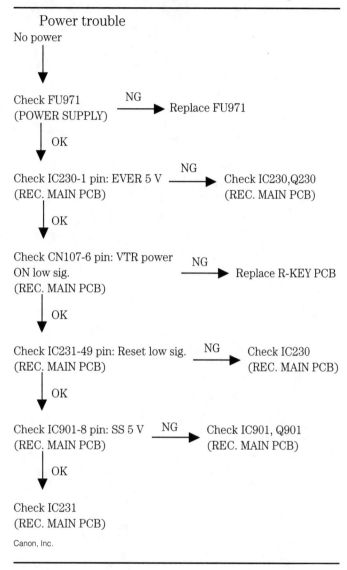

Power trouble
No power

Check FU971 ——NG——▶ Replace FU971
(POWER SUPPLY)

↓ OK

Check IC230-1 pin: EVER 5 V ——NG——▶ Check IC230,Q230
(REC. MAIN PCB) (REC. MAIN PCB)

↓ OK

Check CN107-6 pin: VTR power
ON low sig. ——NG——▶ Replace R-KEY PCB
(REC. MAIN PCB)

↓ OK

Check IC231-49 pin: Reset low sig. ——NG——▶ Check IC230
(REC. MAIN PCB) (REC. MAIN PCB)

↓ OK

Check IC901-8 pin: SS 5 V ——NG——▶ Check IC901, Q901
(REC. MAIN PCB) (REC. MAIN PCB)

↓ OK

Check IC231
(REC. MAIN PCB)

Canon, Inc.

Trouble detection and servo circuits

THE TROUBLE DETECTION CIRCUITS TROUBLESHOOT THE tape transport system, mechanism, tape type, and recording condition for tape protection, mechanisms, and the actual recording process. Usually, the various sensor indicators are controlled by one large microprocessor. The system control microprocessor monitors the supply-end sensor, take-up reel sensor, dew sensor, supply reel sensor, safety tab switch, cassette switch, and mechanism state mode switch (figure 6-1). If the correct signals are not applied to the system control microprocessor, the VTR will stop functioning.

Tape-end sensor

When the tape reaches its end, the clear leader of the tape allows the end sensor light shine through the tape to fall on the end photo sensor. The end photo sensor then applies a voltage to the system control IC and the control microprocessor stops the tape movement. The operator then knows it is time to change the cassette.

In a Canon ES1000 8-mm camcorder, if the videotape is run beyond its end, the tape guide might be damaged or the head drum might be squeezed with the tape. To prevent such action, the end-of-tape check is conducted to detect the end of tape during operation. Upon detection of the end of tape, the tape is stopped immediately.

The end-of-tape detecting LED indicator is turned on/off with the tape sense LED signal appearing at pin 63 of Main Mi-Com IC231. If the signal input across pins 22 and 26 of Main Mi-Com IC231 goes low twice in succession, it recognizes the end of tape. A check of this signal is performed with timing 1A/2A/1B/2B (figure 6-2).

■ **6-1** *Top view of the VTR RCA CPR300 (VHS) showing the different detection circuits.*

■ **6-2** *The tape end sensor signal of tape sensor LED waveform in Canon ES1000 camcorder.*

The beginning/end of tape is checked under condition that 1A is low, 2A is high, 1B is low, and 2B is high. The BOT and EOT are detected at the same time. Also, if the low state is found in timing 2A/2B in reading of 1A/1B, the Main Mi-Com IC231 judges that the cassette is loaded. In this case, the "no-tape mark" blinks in the viewfinder screen.

Pentax PV-C850A 8-mm tape-end sensor

Sensors that detect failures in the tape transport system are the tape-end sensors (Q104 and Q105) on the take-up and supply sides, reel sensors (Q102 and Q103), and cylinder lock sensor. The condensation sensor and cassette holder sensor (S103) detect the mechanism condition. Added to these are the tape thickness sensor (S101) and the tab sensor (S102) (the latter detects whether there is a tab on the cassette).

For tape-end sensors (Q104 and Q105) on the take-up side, phototransistor Q104 detects light from an LED (D101) through a transparent part at the end of the tape (figure 6-3). Likewise, phototransistor Q105 checks for the end of the tape at the supply side. D101 is driven by the pulse signal developed at pin 64 of IC901 to save power.

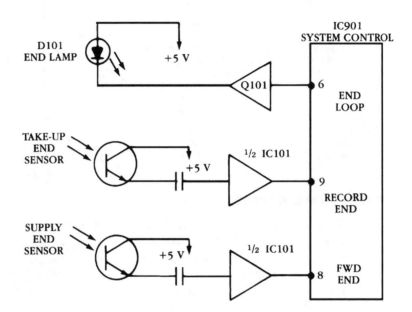

■ 6-3 *Pentax 8-mm end sensor circuits.*

After being shaped by comparator IC101 to protect against optical noise, the outputs of Q104 and Q105 are applied to pins 9 and 8 of IC901. The IC901 checks the inputs at pins 9 and 8 synchronously with the LED drive pulse and sets the input to the stop mode as soon as pin 9 or 8 turns high (Hi). Also, it detects how the tape is installed from both inputs.

RCA CPR100 (VHS-C) end-sensor circuits

When the tape reaches the end while moving in the forward direction, the light shows through the clear leader of the tape and allows light to shine on the surface of the supply-end photo sensor. The end-sensor lamp is turned on by control microprocessor IC901 (figure 6-4). Now the supply-end photo sensor applies 5 V to pin 5 of the comparator IC902. A high signal from IC902 is applied to pin 18 of IC901. Then IC901 detects this high signal and shuts off the tape movement.

169

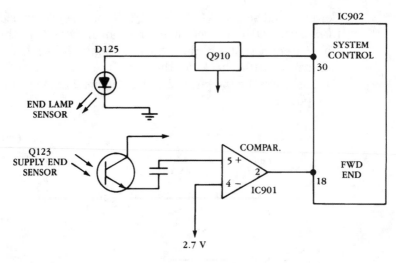

■ **6-4** *RCA CPR100 (VHS-C) end sensor circuits.*

Samsung 8-mm tape end-sensor

When the tape end reaches its final destination, a transistor signal is sent to pin 7 of W501 board and is found entering pin 41 of the sensor detector IC501. This signal is detected inside IC501 and output at pin 39 to end sense at pin 56 of Mi-Com IC601. IC601 stops the tape at once (figure 6-5).

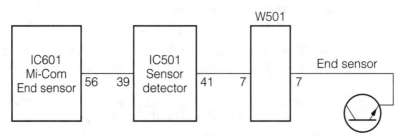

■ **6-5** *Samsung 8-mm tape end sensor circuits.*

Pentax PV-C850A 8-mm reel sensors

On the take-up side, phototransistor Q102 detects a beam of light reflected by eight reflector plates fitted at equal intervals on the underside of the reel disk. Phototransistor Q103 works similarly on the supply side. The speed of the reel disk rotation is obtained from the rate of the reflected pulses. The light source (LED) is integrated in the same reel sensor chip. After being shaped by comparator IC101 to protect against optical noise, the outputs of Q102 and Q103 are

applied to pins 10 and 11 of IC901 (figure 6-6). Here IC901 computes the length of tape by counting sensor pulses from the take-up reel sensor and detects failure (reel lock) of the reel disk from the pulse frequency. Detecting the inputs from both the sensors and at pin 61 (tape reel thickness), it calculates the tape remaining time.

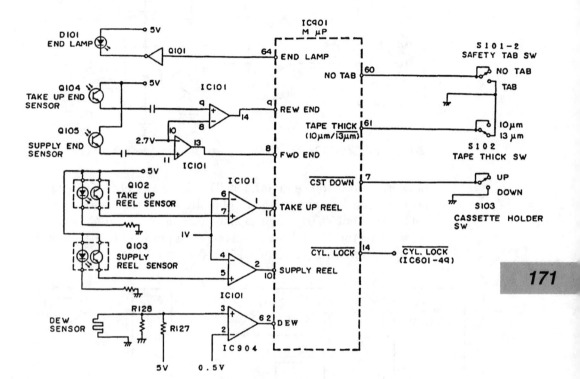

■ **6-6** *Pentax 8-mm reel sensor main trouble detection circuits.* Pentax Corp.

RCA CPR100 supply reel and take-up reel sensors

With no take-up end sensor in the reverse direction, the tape is stopped at the end by sensing reel pulses from the supply reel sensor and take-up reel sensor. Input pins 20 and 21 of system control microprocessor (IC901) receive the applied pulses. The speed is reduced at a point near the end where the tape can be stopped without damaging it. The rewind operation is stopped when the tape reaches the end of tape travel. Q126 and Q119 are the supply reel and take-up reel sensors, respectively (figure 6-7).

Samsung 8-mm tape LED top sensor

The tape end sensor LED shows through the clear end of tape with a SS 5-V source at one end. The tape end LED is driven by (Q602)

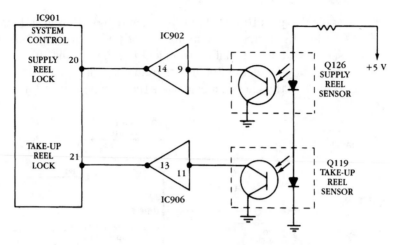

■ 6-7 *RCA CPR100 (VHS-C) supply and take-up reel sensors.*

LED driver from tape end terminal 31 of Main Mi-Com IC601 (figure 6-8). This light shines upon a phototransistor that sends a signal to pin 10 of W501. The signal appears at input pin 44 of top sensor detector IC501. This signal output at pin 42 of IC501 and is fed to the top sense pin terminal 57 of Mi-Com IC601.

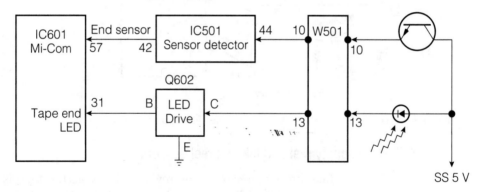

■ 6-8 *Block diagram of Samsung 8-mm tape end tape sensor circuits.*

Take-up reel detection circuits

The tape can pull out, unwind, or clog up the mechanism when the take-up reel does not rotate. With the take-up reel detection circuit running, the tape is stopped to protect it. The tape might get jammed if the reel stops during the unloading period and cannot eject the cassette. Then the loose tape must be removed from the VTR.

Sony CCD-M8E/M8U 8-mm take-up reel rotation check

Take-up reel detection is done with a phototransistor and LED mounted underneath the take-up reel (figure 6-9). The LED shines light against the reflected surface of the underside of the take-up reel. This light is reflected back into the phototransistor. The LED and phototransistor are located in one component. When the reel rotates, the phototransistor contains a pulse. Detection is done during the REC, PB, or GG mode (figure 6-10).

LED Photo transistor

■ **6-9** *The take-up reel rotation check with LED and photo-transistor in the Sony 8-mm camcorder.* Sony Corp.

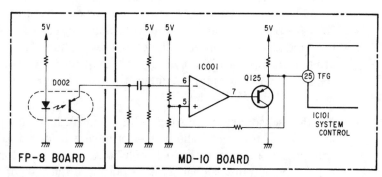

■ **6-10** *Sony 8-mm VTR take-up reel rotation check circuits.* Sony Corp.

Dew sensor

The dew sensor detects moisture in the VCR or VTR section of the camcorder. With moisture increasing, the dew sensor resistance increases, sending a voltage to a comparator that shapes and applies pulses to the control microprocessor, not allowing tape operation. If tape operation began with moisture on the tape heads, the tape and mechanism can be damaged. The dew sensor is often located in the center of the VTR section (figure 6-11).

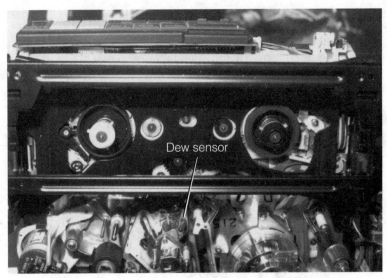

■ **6-11** *The dew sensor component in RCA CPR300 camcorder.*

Samsung 8-mm dew sensor circuits

Dew moisture in the camcorder can cause tape sticking and can possibly result in jamming the machine. When moisture occurs in the camcorder, as when the unit is brought into a hot room from the cold, the camcorder will not operate if moisture is found around the tape heads or cylinder. The moisture detecting device resembles a resistor and it changes the resistance when moisture is found in the camcorder.

The dew sensor in the Samsung SCX854 camcorder contains dew + and a dew – terminals. The dew – terminal is soldered to ground and the dew + connects to pin 47 of IC501 a sensor detector (figure 6-12). The output terminal of dew + output terminal 46 of IC501 is fed to terminal 58 of Mi-Com (IC601) with dew In signal. IC601 prevents camcorder operation with moisture in the camcorder.

When dew indicator keeps indicating moisture is in the camcorder and the camcorder will not play, rewind or fast forward, make sure no moisture is in the head area. This can be an intermittent problem which can be caused by poor pin connector and socket, in which dew sensor connects. Even though the soldered contacts look normal, a high resistance connection can cause the same problem as the dew sensor.

Solder up all pin socket connections to the PCB. If trouble still exists, remove wire from dew sensor to the socket and solder both

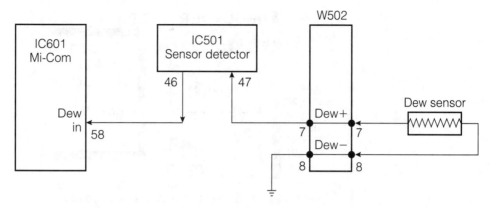

■ **6-12** *Samsung 8-mm dew sensor circuits.*

wire terminals together. This same condition can exist when one pin connector corrodes and places a high resistance connection in the dew socket, resulting in camcorder shutdown. Sometimes this condition can occur when the covers are removed from camcorder or when unit is roughly handled.

Canon ES1000 dew condensation circuit

If moisture condensation is detected during operation, the power LED indicator blinks for warning. Also, the "DEW" mark blinks in the viewfinder screen to let the user know detection of moisture condensation. With this condition, the mechanism is put into the stop state and the tape loading sequence is not carried out even if the tape cassette is inserted. Upon detection of moisture condensation, the internal one-hour timer of the Main Mi-Com IC231 is made active to hold dew mark indication unless the battery pack is removed.

The dew sensor is connected to ground terminal and pin 121 of the "Dew H" terminal of IC231 (figure 6-13). A positive voltage is also applied through a voltage dropping resistor of pin 121 from the SS 5-V source.

Sony CCD-M8E/M8U 8-mm dew detection circuit

Sometimes when the camcorder is brought into a warm house from a cold place, condensation will appear on the drum surface. The tape can stick to the drum surface, causing the drum to stop or jam the take-up reel and capstan assemblies. Tape can pull out or wrap around the capstan and pressure rollers. The purpose of

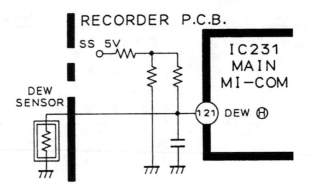

6-13 *Canon ES1000 8-mm dew sensor conden-sation circuit.* Canon, Inc.

the dew detection circuit is to detect condensation and place VTR in stop mode.

During the excess condensation period, the dew sensor has a higher resistance value (from a few kilohms to tens of kilohms). The higher voltage is applied to IC102 (figure 6-14). Although the dew signal is low when condensation is detected, the dew state is accepted when the signal is low for 100 ms due to the chattering cancel period.

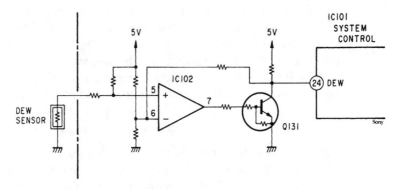

6-14 *Sony's 8-mm VTR dew sensor detector circuit.* Sony Corp.

Cylinder lock circuits

Pentax PV-C850A 8-mm cylinder lock circuit

The speed/phase control IC601 compares the cylinder speed cir-cuits voltage with the cylinder lock voltage. It sets the unit to stop mode when pin 14 turns low on the system control microprocessor IC901.

Realistic 150 (VHS-C) cylinder lock circuit

The cylinder lock (IC601) detects pulse width of SW 30-Hz signal obtained by the servo circuit for detecting drop in cylinder motor speed. If the pulse width is less than the rated value, the microprocessor IC901 judges the cylinder lock (SW 30-Hz Cyl. lock).

Detection is made in the VTR mode and enters the stop mode. In camera mode, it enters the stop mode and will not go to any other mode except eject or off.

Pentax PV-C850A 8-mm cassette holder sensor

The cassette holder sensor (S103) detects the cassette holder status. The output is applied to pin 7 of IC901. IC901 drives the loading motor to change the mechanism from the eject mode to stop mode with a high signal at pin 7 (figure 6-15).

■ **6-15** *Pentax 8-mm cassette holder sensor.*

Pentax PV-C850A 8-mm tape thickness sensor

The tape thickness sensor switch (S102) detects a tab indicating the correct tape thickness. The output is applied to pin 61 of IC901 (figure 6-16). It judges the tape thickness to be 13 μm when pin 61 is high and 10 μm when it is low and calculates the length of tape remaining time using this data.

Pentax PV-C850A 8-mm safety tab sensor circuit

The safety tab switch (S101) detects the write-protect tab (safety tab) on the back of the cassette. This output is applied to pin 60 of IC901. It prohibits recording when the input is Hi, (figure 6-17).

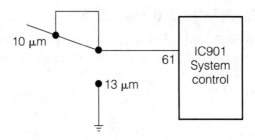

■ **6-16** *Pentax 8-mm tape thickness sensor.*

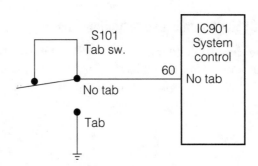

■ **6-17** *Pentax safety tab sensor circuit.*

Samsung 8-mm reel sensor circuits

The supply and take-up reel sensor circuits consists of two op-toisolators in the Samsung camcorder. An optoisolator is a coupling device in which the coupling device is a light beam. The optoisolator component consists of an LED and phototransistor located in one part. The supply reel optiosolator pins 1 and 3 connect to SS 5-volt source. Pin 4 of opto part goes to another optoisolator that operates the take-up reel (T. reel), while pin 2 goes to pin 28 of sensor detector IC501 (figure 6-18).

Pin 3 of take-up reel of opto part has a SS 5-V source to collector of phototransistor with the corresponding LED connected to pin 9 of W501 through a resistor to ground. The phototransistor emitter terminal of optoisolator pin 2 connects to pin 29 of the sensor detector. The supply and take-up reel signals are amplified in the sensor detector IC501 and IC601 applied to terminal 64 (S. reel) and 63 (T. reel) terminals. IC601 controls the operation of the two reel sensors.

Mode switch

The mode or mechanism state switch applies signal to the system control IC microprocessor. At the end of the unloading operation,

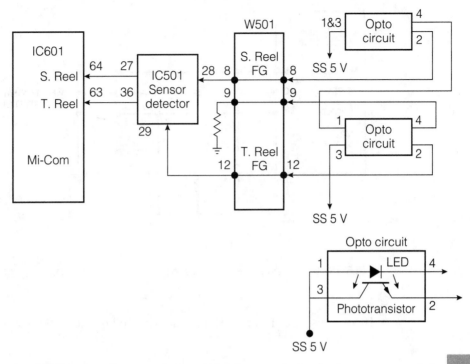

■ 6-18 *Samsung 8-mm reel sensor circuits.*

the loading is stopped with a signal applied to the microprocessor. Also, the mechanism state switch provides signals to the microprocessor to indicate state of the mechanism. These signals are used to determine if the mechanism and mechanical state function switches agree. The VTR is placed in stop mode if they do not agree. The mechanism state switch is used in loading and unloading of the cassette.

RCA CPR100 (VHS-C) mechanism state (mode sense) switch

Signals from the mechanism mode switch control the system microprocessor (IC901). The instrument is placed in stop mode at the end of the unloading operation. The mechanism switch (S124) also applies input signals to IC901 to indicate the mechanical state of the VTR mechanism. These signals determine if both agree. If not, the VTR is placed in stop mode (figure 6-19).

Realistic 150 (VHS-C) mechanism state switchcircuit

The system control (IC901) inputs mechanism mode data from the mechanism state switch to decide whether to select mode and mechanism mode are the same. If they do not become the same in

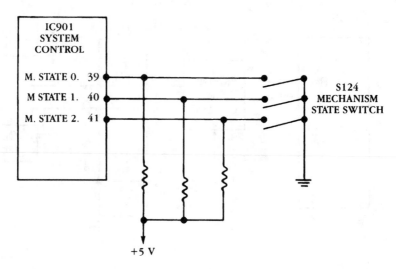

10 seconds, IC901 judges the mechanism to be locked (M. state 0 to M. state 3).

Radio Shack 150 (VHS-C) tape detection circuit

The system control (IC901) inputs the FLW.FG pulse at pin 49 and the CTL pulse at pin 50 from the servo circuit and counts the FLW.FG pulses within one period of the CTL pulse to detect the playback tape speed (SP or EP) according to the formula. The tape speed detection circuit is shown in (figure 6-20).

When the play/pause mode continues for more than 5 minutes, the stop mode is entered to protect the tape with the 5-minute timer control. When the record pause mode continues for more than 5 minutes, the REC lock mode is entered to protect the tape.

Canon trouble stop error circuits

If any trouble occurs in the rotation drive mechanism (drum, capstan, loader, reel), the tape can be jammed or the mechanism can be damaged. To prevent this, the fault control sequence specified for each mode is carried out upon detection of an error. In the event of trouble, the power LED indicator flashes and "Eject" blinks in this viewfinder screen for warning (Table 6-1).

Table 6-2 shows the processing steps to be taken after error detection. If only the loading direction (1) is NG, dew eject is indicated. When both the loading and unloading directions are NG, an

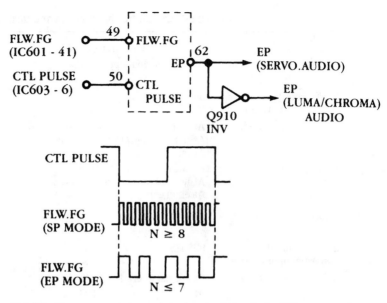

■ 6-20 *Tape speed detection circuit of Realistic 150 camcorder.*
Radio Shack

error stop takes place immediately. If only the loading direction is NG (2) dew eject is indicated. If only the unloading direction is NG, loading is performed. If both the loading and unloading directions are NG, an error stop takes place immediately. In this camcorder, any error indication is cleared when the battery pack is unloaded and then loaded.

Loading motor drive circuits

The loading and capstan motors are not considered to be in the servo circuits but are controlled by the system control microprocessor. In some camcorders, the capstan motor is driven with the cylinder motor circuits. The output terminals of the system control IC control the loading motor drive circuits, which drives the loading motor that ejects and loads the cassette and loads and unloads the tape.

Canon ES1000 loading motor circuits

The Main Mi-Com IC231 controls the loading motor to set mechanism in operating mode. IC231 drives the "to load" out of pin 120 to pin 13 of the loading motor drive IC (figure 6-21). Unloading terminal 1 of IC231 is connected to pin 14 of the loading motor drive IC. IC101 provides a loading voltage out of pin 2 to the loading motor

Event		Condition	Detection/signal
Drum error	1. Error detection state	At start/normal operation	Pin 100 of MAIN MI-COM IC231 (D-FG)
	2. FG frequency at normal operation	360 Hz	
	3. Error detection level	At start : Less than 356 Hz At normal operation: Less than 50 Hz At emergency : –	
	4. Error detection period	At start : 5 sec At normal operation: 0.5 sec At emergency : –	
Capstan error	1. Error detection state	At start/normal operation	Pin 99 of MAIN MI-COM IC231 (C-FG)
	2. FG frequency at normal operation	993 Hz	
	3. Error detection level	At normal operation : 100 Hz At start : 196 Hz	
	4. Error detection period	2 sec	
Reel error	1. Error detection state	At normal operation	Pin 120 of MAIN MI-COM IC231 (S-REEL FG)
	2. Error detection level	More than 2048 C-FG pulses in half cycle of take-up/supply reel FG sequence. (Only on the side of take-up reel)	Pin 119 of MAIN MI-COM IC231 (T-REEL FG) PIN 99 of MAIN MI-COM IC231 (C-FG)
Loading error	1. Error detection state	At mode transition	Pins 22, 23, and 24 of MAIN MI-COM IC231 (MODE SW)
	2. Error detection level	Proper positioning is not accomplished within a predetermined period of time. EJECT ↔ UNLOAD 2 sec UNLOAD ↔ STOP 5 sec STOP ↔ PINCH ON 2 sec	

Canon, Inc.

and the unloading voltage of pin 18 to loading motor. These dc loading motors can be reversed by changing the polarity of the voltage applied to the motor terminals. IC231 can prevent loading motor action of dew condensation is found in the camcorder.

Samsung loading motor circuits

IC601 (Mi-Com) in the Samsung 8-mm camcorder controls loading motor circuits. The loading motor signal (LM FWD) is found at pin

■ Table 6-2 Canon processing steps to be taken after error detection.

	Cassette-in	Loading in progress	Unloading in progress	Loading completed	Tape running	Mode transition in progress
Drum error	Dew eject	Dew eject	Dew eject	Error stop	Error stop	Error stop
Capstan error	—	—	Loading	Error stop	Error stop	Error stop
Reel error	—	—	Loading	Error stop	Error stop	Error stop
Loading error	—	——	—	Error stop	—	Error stop

Canon, Inc.

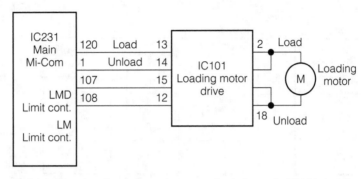

■ 6-21 *The loading motor is controlled through IC101 by the Main Mi-Com IC231 in the Canon ES1000.*

73 of IC601 and connects to pin 6 of loading motor drive IC504 (figure 6-22). The loading motor voltage is found at pin 3 and applied to the loading motor through pin 5 of W502. In reverse procedure or unloading, the LM REV signal at pin 74 of Mi-Com IC601 applies to pin 11 of IC504. Here the unloading voltage out of pin 14 is applied with a different voltage polarity to the loading motor terminals.

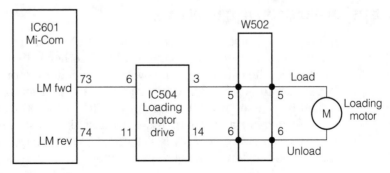

■ 6-22 *The loading motor in a Samsung 8-mm camcorder is controlled by loading motor drive IC504.*

Loading motor drive circuits

183

RCA CPR100 (VHS-C) loading motor drive circuits

The system control microprocessor (IC901) controls the loading and unloading of the cassette. Loading signal from pin 22 of IC901 controls the loading motor driver IC903 to load the cassette (figure 6-23). During loading, pin 22 is high and pin 23 is low. The unloading signal is sent from pin 23 to the driver IC903 to unload the cassette. During unloading, pin 23 is high and pin 22 is low.

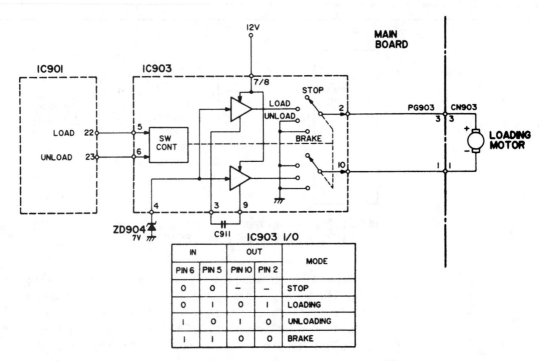

IN		OUT		MODE
PIN 6	PIN 5	PIN 10	PIN 2	
O	O	–	–	STOP
O	I	O	I	LOADING
I	O	I	O	UNLOADING
I	I	O	O	BRAKE

■ **6-23** *The loading motor drive circuit of RCA CPR100 VHS-C camcorder.* Thomson Consumer Electronics

Capstan motor drive circuits

In many of the small VHS-C camcorders, the capstan motor is driven by the control microprocessor, while in other VHS and 8-mm camcorders the capstan motor is with the cylinder motor circuits. Within the RCA CPR 300 camcorder, the capstan motor is controlled by the servo IC601 while in the RCA CPR100 camcorder the system control microprocessor controls the capstan motor in record, fast forward, and rewind (figure 6-24). The capstan motor rotates the capstan flywheel to pull the tape from the cassette.

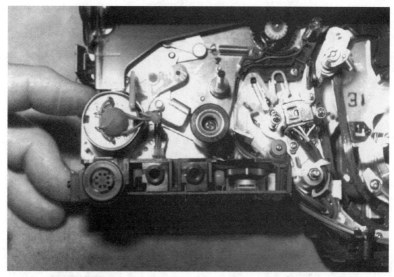

■ **6-24** *The finger points toward the location of the loading motor in a VHS camcorder.*

Samsung capstan motor circuit

The capstan motor circuits are controlled by the capstan servo Mi-Com IC601. A capstan on signal is sent from pin 100 of IC601 to pin 7 of capstan motor drive IC and the capstan forward and reverse (CAP F/R) signal out of pin 99 of IC601 connects to terminal 18 of IC503 (figure 6-25). The capstan PWM signal is amplified by IC501 with capstan error (CAP error) signal sent to the capstan PWM circuits IC901. The output of PWM circuits connects to terminal 4 of IC503. A capstan FG (CAP FG) signal is inserted at pins 70 and 77 of IC601 from IC503.

The capstan motor drive IC consists of a matrix, level shaft and amp circuit for capstan rotation. A wave shaper circuit provides the FGA and FGB signals from the FG generator of capstan motor circuits. The three capstan motor windings U, V, and W connect to terminals 27, 28, and 3 respectively, to the capstan motor drive IC503.

Servo circuits

During recording, the servo circuits control the tape speed. The tape speed can be 1800 rpm with 8 mm and 2700 rpm in VHS-C

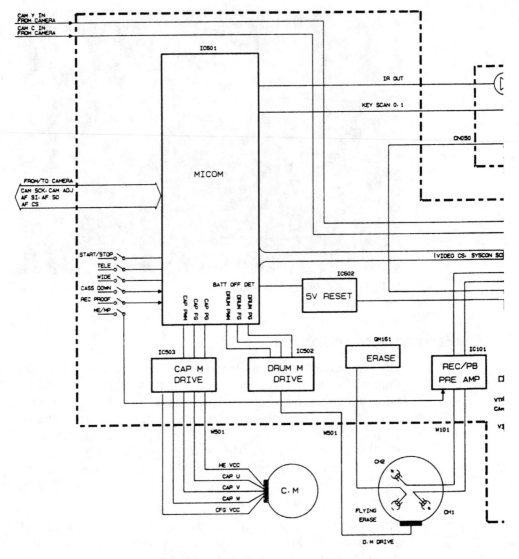

■ 6-25 *A block diagram of the 8-mm Samsung capstan motor circuits.* Samsung Electronic Co.

camcorder servo circuits. During playback, it ensures the same accurate tape speed, aligning the video track with the scanning of the video heads. Speed and phase control of the capstan and cylinder or drum motor are found in the servo circuits. This tape speed control is to keep the speed of the video head track constant, while phase control is performed by the tracking control system.

Canon capstan motor circuits

Like most camcorder capstan motor circuits, the capstan motor is controlled by the Main Mi-Com IC, to a capstan motor drive IC and to the motor windings. In Canon's ES1000 capstan motor circuits, the capstan forward control comes from pin 57 of IC231 to pin 26 of capstan motor drive IC (figure 6-26). The capstan on signal from pin 58 appears at input pin 27 of capstan motor drive IC. The motor drive IC consists of a U-V-W driver internal circuit which applies voltage to motor out of pin 1 (U), pin 4 (V), and pin 33 (W), to capstan motor windings.

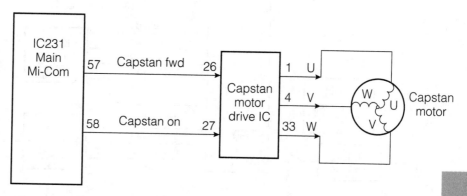

187

■ **6-26** *Canon ES1000 capstan motor circuit controlled by Main Mi-Com IC231.*

Canon ES1000 servo circuits

The main circuits of the Canon ES1000 camcorder servo circuits consists of SS 9-V and EVER 5-V regulators, AFT, reel sensor amp, capstan motor circuits, loading motor circuits, and drum motor circuits. Main Mi-Com IC231 receives signals from the AFT, regulator, reel sensor amp, D - FG, and DPG from drum motor IC and C.FG from capstan motor drive IC (figure 6-27). IC231 provides controlling signals and voltages to the capstan motor circuits, loading motor circuits, and drum motor circuits.

The Main Mi-Com IC231 provides a capstan forward (C.FWD), (C.ON) and (C PWM) signal to the capstan motor drive IC to the capstan motor. IC231 provides a load, unload, LMO L.CN, and LMO limit detect signal to the loading motor drive IC101 which loads and unloads the motor loading mechanism. The Main Mi-Com IC231 provides signal of DPWM and drum drive to the drum motor IC180, providing voltage to the W, V, and U motor terminals.

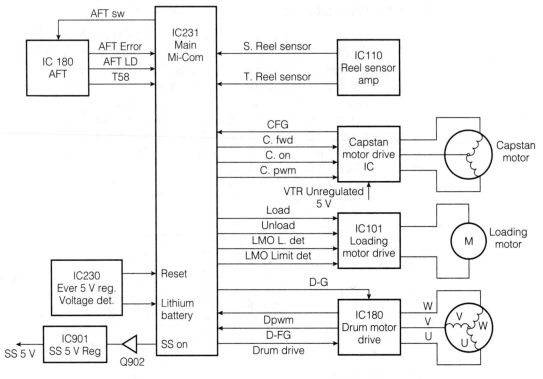

■ 6-27 *Block diagram of servo circuits in the Canon camcorder VTR circuits.*

An EVER 5-V regulated voltage from IC231 applies voltage to re-set and lithium battery detection. SS ON provides a drive voltage through Q902 to IC901. The SS 5-V regulator source appears from the Main Mi-Com IC231.

Samsung 8-mm VTR block diagram

The main circuit in the VTR block diagram centers around Mi-Com IC6011 (figure 6-28). The servo circuits of IC601 control the cap-stan drive motor and drum motor circuits. IC601 controls the Y/C process through video and syscon control. The VTR voltage cir-cuits from the dc to dc convertor applies VTR unregulated, cam unregulated, SS 5-V, video 5-V, and EVF 5-V voltage sources. The capstan PG, FG, and PWM signals are applied to the capstan mo-tor drive circuits. The drum PG, FG, and PWM signals from and to drum motor drive IC control the drum motor that rotates the head drum assembly. The loading motor of Samsung SCX854 camcorder is controlled by IC601 out of terminals 73 and 74.

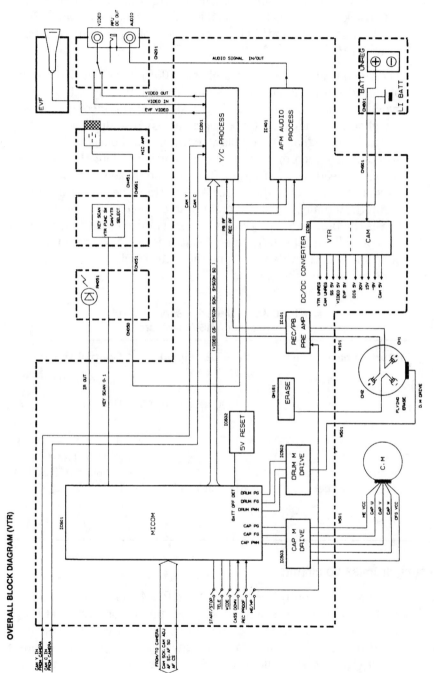

OVERALL BLOCK DIAGRAM (VTR)

■ **6-28** *Block diagram of the VTR servo circuits in Samsung's SCX854 8-mm camcorder.* Samsung Electronics Co.

Realistic 150 (VHS-C) servo circuits

During recording, the servo system controls the VTR to obtain the VHS track format. The tape speed is controlled at 33.35 mm/s (SP) or 11.1 mm/s (EP) so that the video track pitch is 58 μm (SP) or 19 μm (EP).

The video heads rotate accurately at 2700 rpm so that the length of the video track is fixed at 97.4 mm. The rotating video heads are synchronized with the vertical sync signal of the incoming video signal so that the video track begins at 6.5 H + alpha before the vertical sync signal. During play, continuity and exactly the same speed used in recording are maintained by controlling the speed of the video heads accurately at 2700 rpm and by keeping the phase fixed, thereby causing the video heads to trace the video tracks accurately. Actually, the speed and phase of the capstan motor that drives the tape and the cylinder motor that drives the video head are controlled (Table 6-3). Speed control is exercised over the relative speed of the video head and the video track. Phase control is done for correct tracking.

■ **Table 6-3 Signal used in servo control of the Realistic VHS-C camcorder.**

Motor	Phase/Speed	Mode	Ref. signal	Control signal
Cylinder	Phase	Record	½ V SYNC	Tach pulse (45 Hz)
		Play	REF 30 Hz	
	Speed	Record /play	Cylinder FG (CYL.FG: 720 Hz)	
Capstan	Phase	Record		Flywheel FG (FLW.FG: 360 Hz)
		Play	REF 30 Hz	Control pulse (CTL30 Hz)
	Speed	Record /Play	Capstan FG (CAPST.FG: 1704 Hz)	

Radio Shack

Samsung drum servo circuits

IC601 Mi-Com controls the servo drum PWM and drum on signals with drum FG and PG signal from the drum motor circuits at terminals 68 and 69. Drum PWM output at pin 76 or IC601 is applied to a drum error IC502 and to the drum PWM circuits of dc/dc converter (figure 6-29). The drum VS is applied to pins 13 and 19 of the drum motor drive/control IC502. Inside of IC502 are the star-

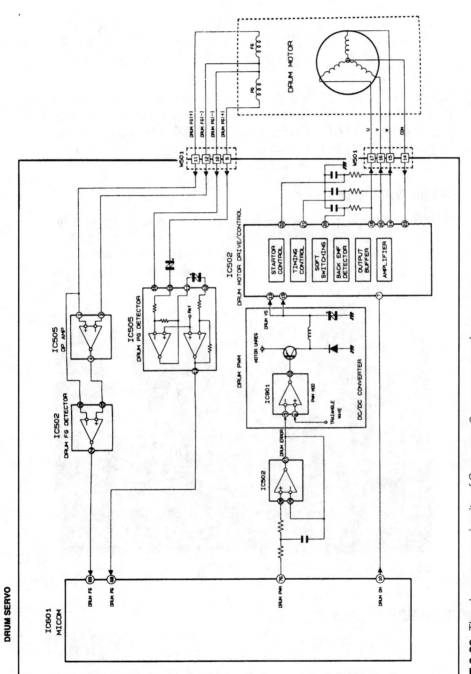

6-29 The drum servo circuits of Samsung 8-mm camcorder. Samsung Electronics Co.

191

tor control, timing control, soft switching, back EMF detector, output buffer and amplifier.

The three motor drum motor windings are fed out of pin 18 (U), pin 16 (V), and pin 14 (W) of the drum motor drive IC502. A common connection to the motor delta windings is fed back to pin 23 of IC502.

Motor windings PG+ and PG– are fed to the input terminals of 10 and 16 of the drum PG detector IC505. The drum PG signal is amplified and applied to pin 68 of Mi-Com IC601. The drum FG+ and FG-signal is applied to op amp IC505 and fed to the drum FG detector IC502 and to terminal 69 of IC601.

RCA CPR300 (VHS) servo system

During recording, the tape runs at a fixed speed of 3.34 cm/s. The upper cylinder rotates at 2700-rpm speed. The same speed (2700) is maintained in both playback and recording. The capstan and cylinder motors are controlled with phase and speed servo circuits (figure 6-30).

Capstan motor

■ **6-30** *Location of the cylinder motor in the RCA CPR300 camcorder.*

Servo control signals

The servo control signals are quite common to all VCR or VTR systems. The ½-V sync reference signal is found in most camcorders. It is the reference signal for the cylinder phase control during recording. This is obtained by dividing the V SYNC extracted from the video signal.

The play reference signal (REF 30 Hz) is common to all VCR or VTR systems. It is the reference signal for cylinder phase control during play and for the capstan phase during recording. This is obtained by dividing the 3.58-MHz color subcarrier extracted in the chroma processing circuit down to 30 Hz.

The TACH (PG) pulse is the signal used for cylinder phase control. A magnetic sensor fitted to the lower cylinder generates the signal when it detects the passage of a magnet fitted ahead of the CH1 rotary video head in the upper cylinder Table 6-4.

■ Table 6-4 Servo control signals in a Pentax PV-C850A camcorder.

Motor	Control	Mode	Reference signal	Feedback signal
Cylinder	Phase	Record	½-V SYNC	Tach Pulse
	Speed	Play	REF 30 Hz	
	Speed	Both	Cylinder FG (CYL FG 600 Hz)	
Capstan	Phase	Record	REF 30 Hz	Capstan FG (CFG-720 Hz)
	Speed	Both	Capstan FG (CFG-720 Hz)	

Pentax Corp.

The TACH (PG) pulse is used also for cylinder phase control in the VHS and VHS-C servo circuits. The magnetic sensor that generates this signal detects the passing of the N-pole of a magnet fitted approximately 6.3 degrees before the CH 3 video head on the upper cylinder. When the video head is rotating at 2700 rpm, the frequency of the TACH (PG) pulse is 45 Hz with its phase advanced by approximately 186.3 degrees from the CH 1 video head position in the VHS-C camcorder. The cylinder phase control loop times the division of the cylinder FG pulse using this TACH (PG) pulse to convert it to tach (PG) pulses with three frequencies (15 Hz, 30 Hz, and 60 Hz).

Samsung 8-mm drum FG pulse signal

The Frequency Generator pulse signal is to detect the speed of the drum motor. Usually, the FG pulse controls the speed of the drum motor during record and playback operations. The FG+ and FG– winding from motor circuits is applied to op amp IC505, amplified and passed on to the FG detector IC502 (figure 6-31). The drum FG signal is applied to the Mi-Com IC601 at pin 69.

Samsung 8-mm drum FG pulse from motor assembly, amplified and detected by IC505 and IC502.

RCA CPR300 (VHS) cylinder FG (CYL FG) pulse

The signal is used to detect the speed of the cylinder motor. Here the FG pulse is a 360-Hz pulse generated by a stator coil and a 16-pole magnet attached to the rotor on the cylinder motor. This FG pulse controls the speed of the cylinder motor during playback and record operations.

Realistic 150 (VHS-C) cylinder FG pulse (CYL FG)

This signal is used to detect the speed of the DD cylinder motor. It is generated from a printed pattern magnetic sensor included on the motor body that detects the passing of a rotary magnet with 32 poles fitted to the rotor of the DD cylinder motor. When the video head speed of 2700 rpm is maintained, the frequency of the cylinder FG pulse is 720 Hz.

Samsung 8-mm capstan FG pulse

The capstan FG pulse is generated in the capstan motor assembly and fed to a wave shaper IC503. The waveshaper is a section inside the capstan motor drive IC (figure 6-32). The FG pulse is used to detect the speed of the capstan motor. FG output of IC503 is fed to terminal pins of Mi-Com IC601.

Canon ES1000 capstan FG pulse

The FG head in the capstan motor assembly of the Canon ES1000 camcorder provides an F+ and F− pulse to the capstan motor drive IC (figure 6-33). Here the FG pulse is amplified and shaped and fed to terminal 88 of the Main Mi-Com IC231. The capstan FG

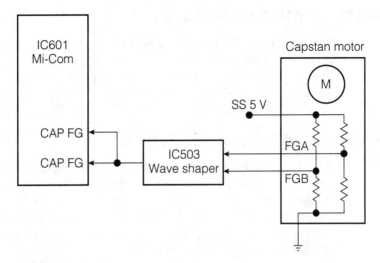

■ 6-32 *Samsung 8-mm capstan FG pulse from capstan motor network, through wave shaper IC503 and to IC601.*

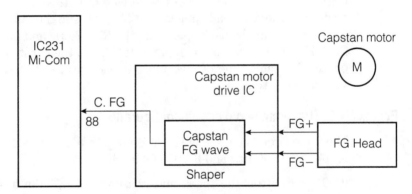

■ 6-33 *Canon ES1000 8-mm capstan FG pulse from FG head, through capstan shaper IC to pin 88 of IC231 Mi-Com.*

pulse is a squarewave and can be checked at the capstan motor drive output terminals or at pin 88 of IC231, in record mode.

Realistic 150 (VHS-C) flywheel FG pulse (FLW.FG)

During record mode, the FG pulse is used for capstan phase control. This is generated with a printed pattern magnetic sensor installed on the chassis that detects the passing of a rotary magnet having 204 poles fitted to the capstan flywheel. When the video head speed is maintained, the frequency of the generated pulse signal is 360 Hz in the SP mode and 120 Hz in the EP mode. The frequency is divided to 30 Hz to obtain the flywheel FG pulse.

RCA CPR100 (VHS-C) flywheel FG pulse

During playback, the flywheel FG pulse is used for capstan phase control. A printed magnetic sensor pattern on the chassis is generated with the rotary magnet having 204 poles. The frequency signal in the SP mode is 360 Hz and 120 Hz in the SLP mode. To produce the flywheel FG pulse, the signal is divided down to 30 Hz.

Radio Shack 150 (VHS-C) control (CTL) pulse

The signal is used for capstan phase control during play mode. The cylinder phase control reference signal (½-V SYNC) is shaped into a square wave and recorded on the control track of the tape during recording. The control (CTL) pulse is this signal reproduced during playback. When the rated video head speed is maintained, the frequency of the signal is 30 Hz.

RCA CPR100 (VHS-C) control (CTL) pulse

During record, the CTL pulses are derived from the incoming vertical sync. The A/C head applies the CTL pulses to the tape during record mode. In playback operation, the REF 20 Hz and phases of the CTL pulse signals are compared to control the capstan motor phase. The same type of CTL pulse is used in the RCA CPR300 VHS servo system.

Pentax PV-C850A 8-mm servo circuit configuration

The servo circuits consist of six different IC circuits: IC601, IC602, IC603, IC701, IC702, and IC705 (figure 6-34).

IC601	Controls the speed and phase of the cylinder and capstan motors and generates three control signals: head-switching signal (SW 30), record inhibit signal (REC inhibit), and artificial V sync signal (V DRV).
IC602	Generates speed correction voltage for the cylinder and capstan motors.
IC603	Generates pilot signals during recording. Controls phase (ATF) during playback, Limits bandwidth of playback pilot signals. Controls phase during search. Switches phase control outputs. Smooths PWM cylinder speed error signal. Smooths PWM cylinder phase error signal. Adds smoothed error voltages. Opens and closes cylinder servo loop.
IC701	Drives the DD cylinder motor. Controls power for the cylinder motor.

IC702 Drives the DD capstan motor. Controls power for the capstan driver.

IC705 Amplifies cylinder FG pulse.

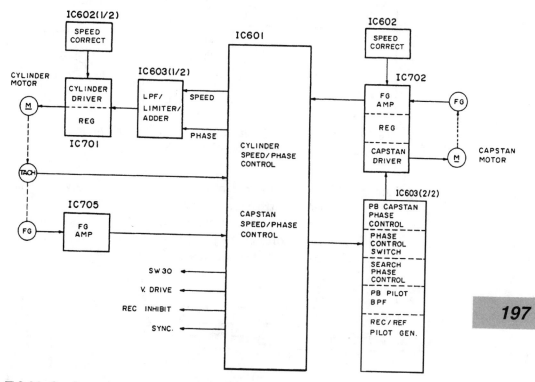

■ **6-34** *Configuration of servo circuits in the Pentax 8-mm camcorder.*

Canon 8-mm drum FG pulse

The Main Mi-Com IC231 controls the speed and phase of the drum motor by comparing the speed and phase of the drum in the canon ES1000 camcorder. An FG and PG of the FG/PG head in the drum motor assembly is fed to the drum motor drive IC180 which provides a wave shaper circuit (figure 6-35). The shaped wave is fed to drum FG pin terminal 100 of IC231. Likewise the PG pulse is fed in the same manner. Both of these pulse waveforms can be checked with the scope at terminals 100 and 101 of the Main Mi-Com IC231.

Pentax PV-C850A 8-mm capstan servo

IC601 performs speed control of the capstan servo. Phase control is done in two different ICs (IC601 during record and IC603 during playback).

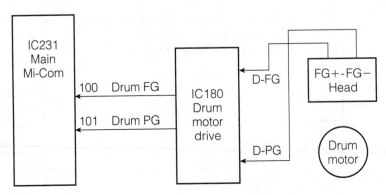

■ 6-35 *Canon ES1000 8-mm drum FG pulse from drum motor, amplified by IC180 and to Main Mi-Com IC231.*

Signals fed back in the control loops are a 720-Hz capstan FG pulse in the speed control loop, capstan FG pulses divided by 24 in the phase control loop during recording. Also, the pilot signals recorded during recording are played back from the tape in the phase control loop during play and search (figure 6-36).

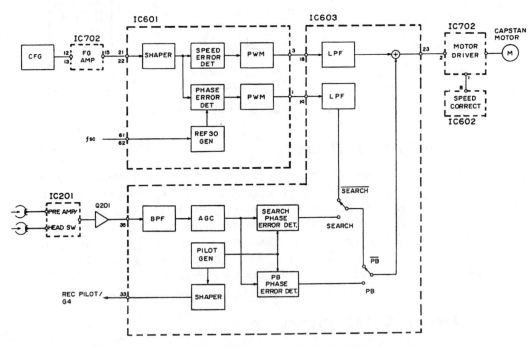

■ 6-36 *Pentax PV-C850A 8-mm capstan servo circuits.* Pentax Corp.

Speed and phase error signals are smoothed and added and the sum signal is supplied to the capstan driver IC702. It controls the drive current and power voltages of the three-phase motor drive coil to keep the motor speed at the rated value.

Failure of the capstan servo system is detected by the system control IC as it monitors the rotation of the reel disk. The capstan servo loop is opened and closed by the system control IC as it controls the power voltage of the motor driver. During fast forward/rewind, the tape is released from the capstan, and with the speed set at nine times the normal speed, the capstan driver is driven by the speed error voltage.

Canon ES1000 lithium battery circuit

When the terminal voltage of lithium battery decreases below 2.7 V, the "lithium battery mark" warning indication flashes upon the viewfinder screen. Upon knowing the low voltage-level detecting signal at pin 116 of Main Mi-Com IC231, it charges the "chara gene" data to provide the "lithium battery" mark flashing on the viewfinder screen (figure 6-37).

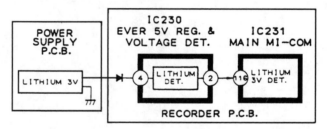

■ **6-37** *Canon ES1000 lithium battery voltage detection circuits.*

Conclusion

There are many trouble detection circuits in the camcorder. The larger and expensive camcorders have more trouble detection circuits. These detection circuits are placed in the camcorder to protect components in the unit and to warn the operator of what is happening and why the camcorder might not operate. Often, the control system microprocessor controls the detection circuits.

In the servo circuits, the capstan motor drives the tape operation and the cylinder motor drives the video heads. The capstan motor can be belt driven and the cylinder motor directly driven (DD) with the motor shaft. Speed controls the relative speed of the video heads and trade system phase control is done for correct tracking. Check Chapter 7 for speed, phase, and drive motor circuits.

Motor circuits

THE LARGE CAMCORDER CAN CONTAIN SEVERAL SMALL motors, including the drum or cylinder, capstan, loading, autofocus, iris, and zoom motors. The small or inexpensive camcorder can operate with only a loading, capstan, and drum motor. These small motors operate from a dc source. Most motors are controlled from the main, system control, servo, and motor drive IC (figure 7-1).

These small motors can be checked with voltage or resistance measurements. A continuity check with the low range of the ohmmeter can determine if the motor winding is open. Measuring the voltage at the motor terminals determines if the motor or drive IC is defective. Applying a small external dc voltage to the motor terminals can determine if the motor is intermittent or slow in rotation.

In this chapter, a brief description is given on how the motors are controlled and operated. Several brief descriptions are given of different motors' operation in the different camcorders. Removing and replacing the defective motor is given in each motor section. Servicing and troubleshooting the various motors is given in Chapter 13.

Loading motors

The loading motor can eject, load, and unload the video cassette. Its functions include releasing brakes and engaging the fast forward/rewind idler gear and playback gear. If you press the eject button on most camcorders, the loading door opens to receive the cassette. After loading the cassette, the door can be manually or electrically closed. The motor is often located off to the side of the main chassis. Usually, the loading motor is controlled from the system control IC and a motor drive IC (figure 7-2). The load or mode motor can be one and the same.

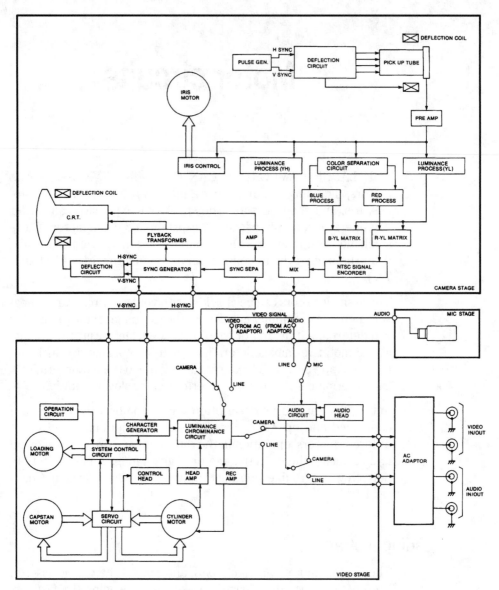

■ 7-1 *Block diagram of the different motors and circuits within the system control and servo circuits.*

RCA CPR 100 loading motor drive

The loading and capstan motors are controlled by microprocessor IC901 (figure 7-3). Here the load signal is applied at pin 22 and the unloading signal at pin 23 of IC901. During loading, pin 22 is high and pin 23 is low, while in the unloading process, pin 23 is high and pin 22 is low.

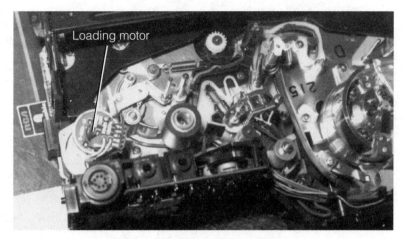

■ **7-2** *The loading motor in an RCA VHS camcorder.*

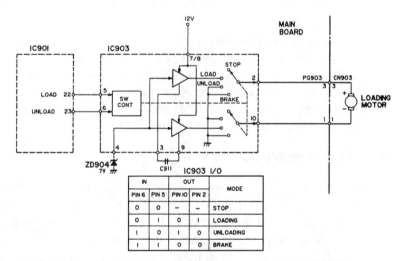

IN		OUT		
PIN 6	PIN 5	PIN 10	PIN 2	MODE
0	0	–	–	STOP
0	I	0	I	LOADING
I	0	I	0	UNLOADING
I	I	0	0	BRAKE

■ **7-3** *Block diagram of loading motor circuit in RCA CPR100.*

The controlled signal is applied to the motor drive IC903. In stop mode, zero voltage is at pins 5 and 6. In loading, a signal is at pin 5 and voltage is applied at pin 2 of IC903. When unloading, a signal is at pin 6 and applied voltage is at pin 10 to the loading motor. Zero voltage is at both pins 2 and 10 in the brake mode.

Samsung 8-mm loading motor circuits

The loading motor in the Samsung SCX854 camcorder is controlled by the loading motor IC504 at pin terminal 14 (figure 7-4). A loading motor voltage to unload the cassette is applied to the

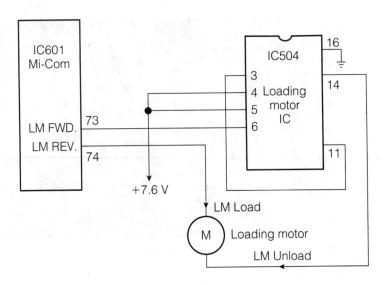

loading motor from IC504. The LM load voltage for the loading motor is fed from LM REV of pin 74 of IC601 Mi-Com. An LM FWD load is fed to pin 6 of the loading motor IC. Check for dc voltage applied to the motor terminals when loading mode is entered. Measure the continuity of dc motor when voltage is found upon motor terminals and no rotation of motor.

Canon ES1000 loading motor circuits

The loading motor signal from the Main Mi-Com IC231 in the Canon ES1000 camcorder is found at pin 126 and fed to pin 13 of the loading motor drive IC101 (figure 7-5). Terminal 1 of IC231 unloads or reverses the motor rotation and is fed to terminal 14. The LMO limit control signal is sent from pin 127 to pin 15 of drive IC. An LMO limit detector signal is from 128 to pin 12 of IC101. The connector block CN101 contains load, unload, load and unload voltage that is applied to the motor terminals of loading motor. Check the dc voltage at the motor terminals if it does not rotate. Also, take a continuity measurement of motor windings to determine if motor is open.

Loading motor removal

Often the loading motor can be removed very easily with only one or two screws and without removing a lot of other nearby compo-

204

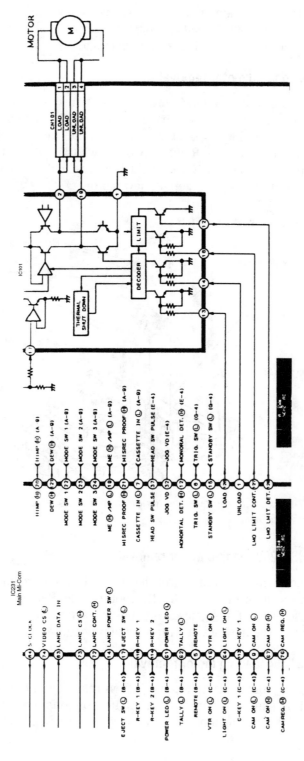

7-5 *Loading motor circuits in the Canon ES1000 camcorder.* Canon, Inc.

nents. The loading motor hookup cable can be unplugged in some models or terminal leads unsoldered for removal. Always replace the loading motor with the exact manufacturer's part number.

RCA PRO845 loading motor removal

Make sure that the mechanism (deck) is in the standby position. Remove the cassette mechanism. Remove the flexible PC board (4) after desoldering the terminals from the loading motor assembly (1) (figure 7-6). Remove two screws (3). Lift up the loading motor assembly (1) to remove it from the main chassis. Reverse procedure for replacement of new motor.

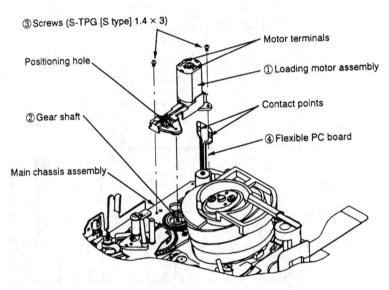

③ Screws (S-TPG [S type] 1.4 × 3)

Motor terminals

Positioning hole

① Loading motor assembly

② Gear shaft

Contact points

④ Flexible PC board

Main chassis assembly

■ **7-6** *How to remove the loading motor assembly in the RCA PRO845.* Thomson Consumer Electronics

Mitsubishi HS-C20U loading motor removal

After the main chassis is free, locate the load-control motor on the chassis (figure 7-7). Unplug the motor cable. Remove two mounting screws. Lift the gear-driven motor assembly out of the chassis. Replace the new motor with reverse procedures.

Samsung SCX854 loading motor removal

Remove four screws 1, 2 and 3 then remove the bracket deck A and B (4 and 5) (figure 7-8). Then take out one screw (6), and remove the loading motor (7). Remove two screws 2 and 3, then re-

2.3 MAIN PARTS LOCATIONS

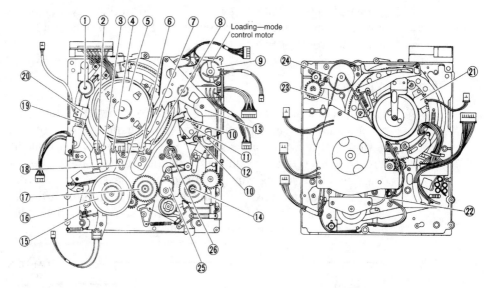

Loading—mode control motor

■ 7-7 *Location of loading motor in a Mitsubishi VHS-C camcorder.* Mitsubishi Electric of America

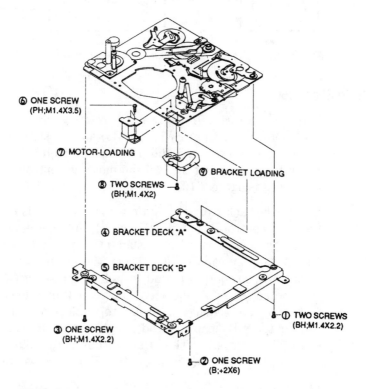

⑥ ONE SCREW
(PH;M1.4X3.5)

⑦ MOTOR-LOADING

⑨ BRACKET LOADING

⑧ TWO SCREWS
(BH;M1.4X2)

④ BRACKET DECK "A"

⑤ BRACKET DECK "B"

③ ONE SCREW
(BH;M1.4X2.2)

② ONE SCREW
(B;+2X6)

① TWO SCREWS
(BH;M1.4X2.2)

■ 7-8 *Samsung SCX854 loading motor removal.* Samsung Electronics Co.

207

move the bracket loading (9). Place all small screws and bolts in a container so they will not get lost. Mark down the varying lengths of screws and where they were removed from. To reassemble, install in the reverse order.

Capstan motors

The capstan motor can be belt or gear driven to various mechanical assemblies. They provide tape movement in play, record, rewind, fast forward, and search modes. Due to the fact that different modes operate at different speeds, the dc voltage must be controlled by a servo, capstan speed, and phase control system. The system or servo IC can control the capstan motor through a capstan motor drive IC (figure 7-9). Often, the capstan and cylinder motors are fed from the same signal source.

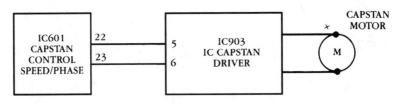

■ **7-9** *Block diagram of the capstan motor with control IC601.*

Radio Shack 150

The system UP (IC901) controls the rotating direction of the capstan motor by capstan FWD (pin 36) and capstan REV (pin 37) signals supplied to pin 5 and 6 of capstan motor driver (IC604). The rotation speed of the capstan motor is controlled in two different ways (figure 7-10).

During playback (forward and reverse) mode, it is controlled by the servo control output (IC601, pin 54). In other modes, it is controlled by the system UP's capstan 0 to capstan 2 (pins 32 to 34) output. The capstan SW (IC901, pin 35) selects one of these two. In the low (Lo) output period, switching transistor (Q608, a capstan switch) is off, so the servo control output is fed to the SWR (capstan servo signal). According to the level of this signal, the SWR outputs B+ capstan and supplies it to the capstan motor driver (IC604), pin 8. Then the capstan motor rotating speed is controlled by IC604 according to this B+ capstan voltage level.

In the high (Hi) output periods of capstan SW, Q608 turns on and obstructs the servo control output. Instead of this signal, a three-

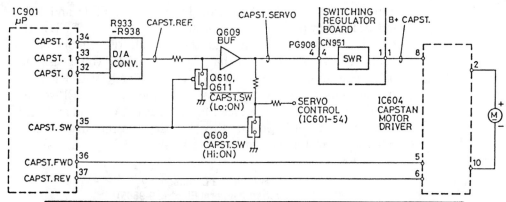

	IC901 OUTPUT					CAPST.	CAPSTAN MOTOR	MODE
PIN36	PIN37	PIN35	PIN34	PIN33	PIN32	REF(V)		
0	0	–	–	–	–		STOP	STOP/STILL
1	0	0	0	0	0	2.0	PLAY(FORWARD)	PLAY/FORWARD SEARCH/REC
0	1	0	0	0	0	2.0	PLAY(REVERSE)	REVERSE SEARCH/REC PAUSE
1	1	–	–	–	–		BRAKE	
1	0	1	0	0	1	2.4		REEL DRIVE IDLER MOVING
0	1	1	0	1	0	2.8		SLACK REMOVAL DURING UNLOADING
1	0	1	1	1	1	4.6	F.FWD	F.FWD AT TAPE START
0	1	1	1	1	1	4.6	REWIND	REWIND AT TAPE END
1	0	1	⚡	⚡	⚡	⚡	F.FWD	F.FWD
0	1	1	⚡	⚡	⚡	⚡	REWIND	REWIND

⚡ VARIES ACCORDING TO THE TAPE REMAINING VALUE.

■ **7-10** *Realistic 150 camcorder capstan motor drive circuits.* Radio Shack

digit control signal from the system UP (IC901) determines the capstan servo signal. The truth table of capstan 0 to capstan 2 and digital-to-analog-converted capstan REF signal is shown in Table 7-1. Simply measuring the capstan reference voltage at pin 8 of IC602 in the different modes indicates the correct signal voltage from the system control IC901.

■ **Table 7-1 Realistic 150 capstan reference chart.**

Pin 34	Pin 33	Pin 32	CAPST.REF (V)
0	0	0	2.0
0	0	1	2.4
0	1	0	2.8
0	1	1	3.1
1	0	0	3.5
1	0	1	3.8
1	1	0	4.3
1	1	1	4.6

Radio Shack

Especially, a fine speed control during the F. FWD and REW modes is newly provided. Looking at Table 7-2, with F. FWD at the tape start and REW at tape end, the capstan REF voltage is at a maximum (4.6 V). But after that, the capstan REF voltage is gradually reduced in 7 steps from 4.3 V to 2 V. Finally, with F.FWD at the tape end and REW at the tape start, the capstan REF voltage is a minimum of 2 V to reduce the shock at F. FWD end and REW end. This control is provided by counting the reel disc rotating rate that indicates the remaining tape.

■ Table 7-2 Disassembly flowchart (General Electric 9-9605).

Thomson Consumer Electronics

Canon ES1000 capstan motor circuits

IC231 the Main Mi-Com controls the direction of the capstan motor with a capstan on H at pin 58, capstan forward at pin 57, with a C-PG waveform and C-PWM waveform at pin terminals 88 and 2, respectively (figure 7-11). The C-PG pulse is received at pin 98 and pin 2 sends out the C-PWM waveform signal to Q151, PWM power drive transistor Q152, and the lower pass filter (LPF) to capstan VS connector 6.

The capstan FWD signal at pin 2 of CN104 is applied to pin 28 of capstan motor drive IC. Capstan on signal is found at pin 3 and connects to pin 27 of motor drive IC. Pin 5 of CN104 contains the capstan VS and is applied to terminal 29 of capstan motor drive IC. A VTR unregulated 6 V is found fed to pin 28 (VCC) of motor drive IC. The internal circuits inside the motor drive IC contains the U-V-W driver, start cont and C-FG wave shaper from the motor FG head.

The capstan motor has a delta winding with applied voltage at terminals 1 (U), terminal 4 (V), and pin 33 (W) to motor terminals. An FG+ and FG– waveform is fed to terminal pins 22 and 23 of

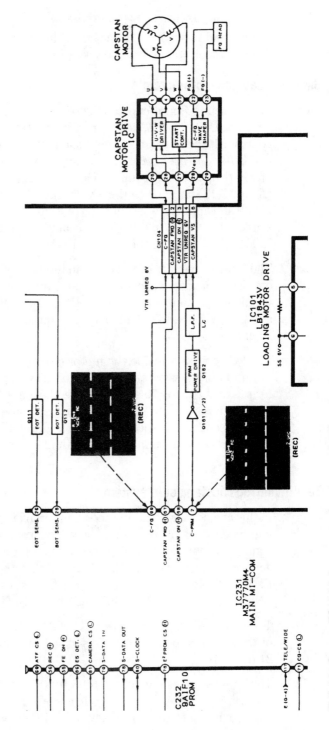

211

7-11 Canon ES1000 8-mm capstan motor circuits. Canon, Inc.

Capstan motors

capstan motor drive IC. Check the motor terminals with applied voltage and waveforms from the FG head. The capstan FG waveform, in record mode, can be taken from pin terminal 88 of IC231.

Samsung capstan motor circuits

The Samsung 8-mm capstan servo circuits consist of controlling Mi-Com IC601, IC501, capstan PWM, IC503 capstan motor drive/control IC, and capstan three-phase motor with Hall ICs and FGA and FGB control signals. The capstan ON is found at terminal 100 of IC601 and fed to terminal 7 of the capstan motor drive IC503 (figure 7-12). A CAP (F) forward and (R) reverse is taken from pin 99 and applied to terminal 18 of IC503. The capstan CAP PWM signal is fed through IC501 with a capstan error applied to pin 8 of IC901. The output of the capstan PWM is fed to pin 4 of IC503.

The internal circuits of the capstan motor drive and control IC503 consist of a matrix, level shift, and amplifier. The delta motor windings are connected to CAP U pin 14 of W501, CAP V at 16, and CAP W at terminal 24. These voltages are fed out of pins 27, 26 and pin 3 of IC503.

The FG generator inside the motor circuits is fed to terminal pins 10 and 11 of the wave shaper in IC503. This capstan CAP FG waveform is sent to pins 70 and 77 of the Mi-Com IC601. Take a square waveform test at pins 70 and 77 to determine if the capstan FG pulse is sent out by the capstan motor circuits. A continuity measurement can determine if any winding is open inside the capstan motor.

Zenith VM6150 capstan servo system

In this camcorder, capstan recording servo circuits are the recording speed control, recording phase control, and capstan motor control. Within the recording speed control, the capstan frequency generator output is 2113 Hz (2.113 kHz) in the SP mode and 704 Hz in the EP mode. The FG signal goes via main control board CN401, pins 3 and 4, to IC407, pins 2 and 13 (figure 7-13).

The amplified signal appears at TP402 and goes to pins 10 and 11 of the comparator (IC407). This shaped waveform applies to pin 21 of IC401.

The capstan FG is divided to 1408 Hz (SP) and is supplied to the capstan speed detector where it is converted into a PWM pulse corresponding to the frequency. The LPF converts the pulse from pin 34 to an error voltage.

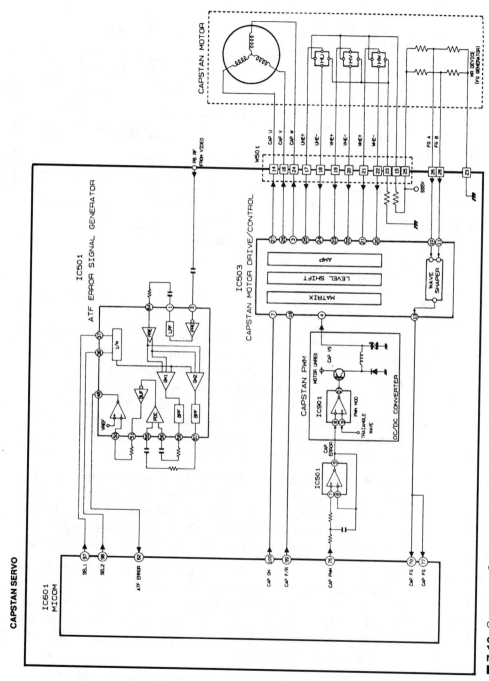

■ **7-12** *Samsung 8-mm capstan motor circuits.* Samsung Electronics Co.

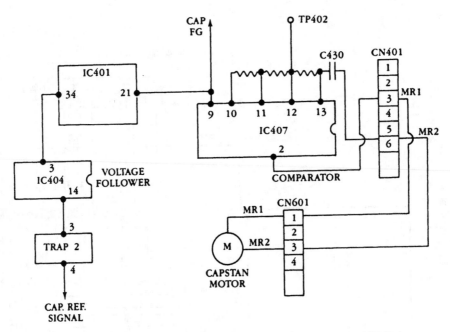

7-13 *Zenith capstan servo path of CN401, IC407, IC401, and IC404.*

This error voltage is sent through the voltage follower (IC404) circuit to the capstan gain control circuit of IC401. This connects the capstan motor rotating speed voltage according to the mode. The IC404 mixing amplifier combines the voltage with the phase system error voltage. Trap-2 removes the 704-Hz component. The resulting voltage is supplied to the capstan motor control circuit. Right here, the mechacon IC301 pin 47 capstan control command circuit selects between servo and mechacon control of the motor.

The reference voltage selected by the mechacon is supplied to the capstan power switching regulator of the servo circuit. The switching regulator output from pin 9 goes via MDA board CN401 (pin 8) to the emitters of Q601, Q602, and Q603 (figure 7-14). The collector of these three transistors are connected to the three motor coils.

Hall elements respond to the magnets embedded in the rotor to produce the coil switching pulse. The Hall amp and three-phase logic circuit of IC601 sequentially selects the capstan motor rotation. The MDA rotates the capstan motor in order to transport the tape at a stable speed. Rotational frequency is regulated by the capstan servo control circuit.

The recording phase control reference signal generator signal is derived from a 3.58-MHz crystal oscillator connected to pins 42

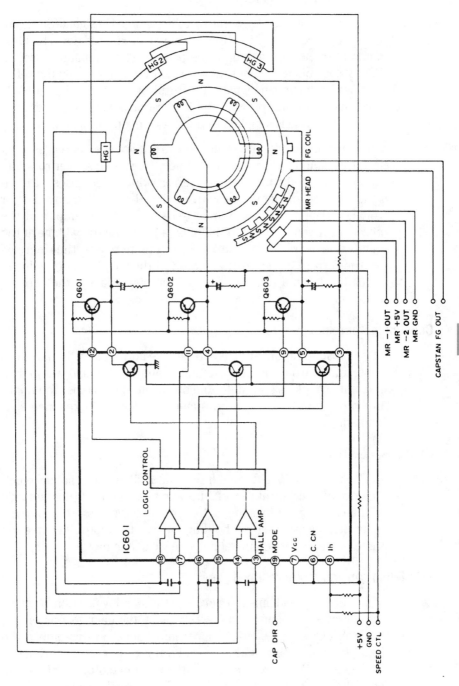

215

7-14 *Zenith capstan motor drive circuits.* Zenith Corp.

and 43 of IC401. This is counted down to 30 Hz and sent to the capstan phase comparator.

The comparison signal generator of the capstan FG signal (SP-2, 113 Hz) is supplied to pin 21 of IC402, where it is counted down to 30 Hz and sent to the capstan phase comparator. The comparator uses an FSC/8 clock pulse to count the phase difference between the reference and comparison signals. The result is converted into a PWM pulse and appears at pin 35. After integration by the low power filter (LPF), the signal is supplied to the IC404 mixing amplifier.

The capstan motor speed control error voltage increases with faster capstan motor rotation and decreases with slower rotation. In the phase control system, the error voltage decreases with advanced phase and increases with a delayed pulse. The speed error voltage is applied to the minus (−) side of an op amp, and the phase error voltage goes to the plus (+) side. As the voltage at the minus side decreases, the inverted output increases, thus increasing the current in the capstan motor. At the plus (+) side, reduced input results in a reduced output, thereby delaying the capstan motor phase.

Capstan motor removal

Most capstan motors are easy to remove and replace. Remove the capstan belt from the motor pulley. Then remove screws holding the motor in place and pull the motor from the chassis. You might find a few motors are more difficult to remove, as explained subsequently.

Olympus VX-801U

Lift point A and hold it, then draw point B slightly for manual eject. Remove two screws at the left side and two screws at the right side of the cassette compartment. Now remove the cassette compartment. Remove two screws holding the capstan motor. Reverse the same procedure when installing a new capstan motor.

RCA 8-mm capstan motor removal

Make sure the mechanism (deck) is in the standby position. Remove the cassette mechanism, the LED bracket, the idler gear assembly, the reel chassis, the tape stopper/impedance arm assembly, the head/drum assembly, and the head/drum base assembly. Remove two screws (3) (figure 7-15). Turn the capstan motor (1) clockwise one full turn (in the direction of arrow) (A) and then lift the capstan motor (1) to remove it from the main chassis assembly (2).

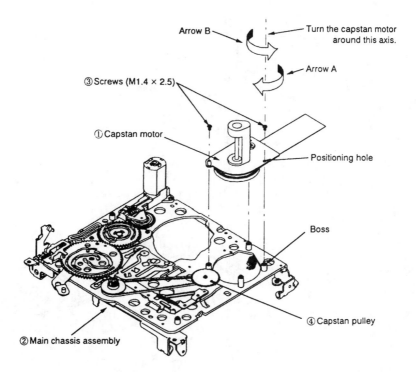

Arrow B

Turn the capstan motor around this axis.

Arrow A

③Screws (M1.4 × 2.5)

①Capstan motor

Positioning hole

Boss

④Capstan pulley

②Main chassis assembly

■ **7-15** *RCA PRO845 capstan motor removal.* Thomson Consumer Electronics

Samsung capstan motor and base removal

Remove two screws (1) and one screw (7) to remove the base capstan assembly. Remove the base capstan assembly (2) from two bushings (4), then remove the holder PPC (8) by releasing the hook (figure 7-16). Remove the motor capstan (3) from the three Bush (4). Reassemble the motor and base capstan assembly in reverse order. When assembling, make sure the gears of motor capstan (3) and the gears of Gear capstan assembly (6) are matched correctly.

Drum motors

Usually, the cylinder or drum motor is controlled by the servo circuits like the capstan motor. The cylinder or drum is located at the top of the motor assembly. The drum or cylinder can consist of an upper and lower drum assembly. Operation of the cylinder or drum motor is quite complex and contains the cylinder or drum speed control, recording phase control, and drum motor (figure 7-17).

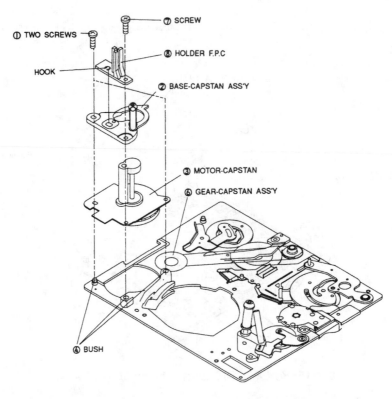

■ **7-16** *Samsung 8-mm capstan and block assembly removal.* Samsung Electronics Co.

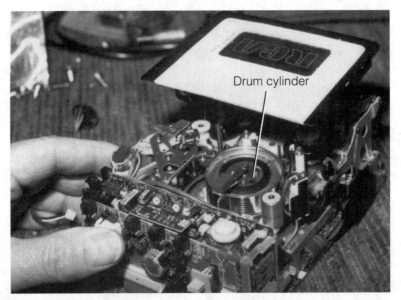

■ **7-17** *RCA CPR100 drum servo components.*

RCA CPR100 cylinder motor servo circuits

Both the cylinder and capstan motors are controlled by the servo circuits. IC601 controls the phase and speed of the cylinder motor (figure 7-18). The two control signals from pins 61 and 64 (IC601) are added in the buffer IC552 and then applied to the motor driver IC551.

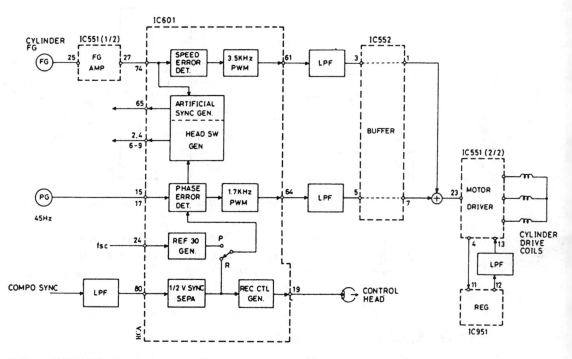

■ **7-18** *RCA VHS-C cylinder speed/phase control circuits.* Thomson Consumer Electronics

By comparing the 720-Hz cylinder FG pulse and the 45-Hz PG pulse to the reference signals (½-V sync) during record and REF (30 Hz) during playback, the speed and phase are easily controlled. In each control loop, the error signal is converted to a pulse-width modulated (PWM) signal, filtered through the low-pass filter circuits (LPF), and applied to the input motor terminal (pin 23) of motor driver IC551. The cylinder motor drive voltage to IC551 controls the current flowing through the three-phase drive coils of the cylinder motor.

Samsung 8-mm drum motor circuits

The Samsung 8-mm drum motor circuits consist of Mi-Com IC601 controller, IC502, drum PWM, drum motor drive/control IC502,

and drum motor. A PWM drum signal is found at pin 6 of IC601 and fed to IC502 which provides a drum error signal fed to drum PWM IC901 (figure 7-19). Drum VS is fed to terminals 13 and 19 of the drive motor IC502. A starter control, timing control, soft switching back EMF detector, output buffer, and amplifier circuits are contained in the drum motor driver IC502.

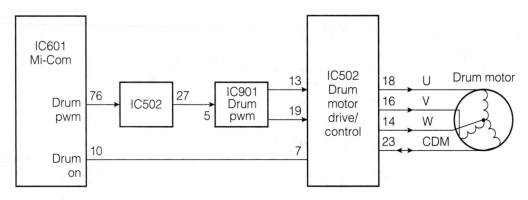

■ **7-19** *The drum servo circuits of Samsung 8-mm camcorder.* Samsung Electronics Co.

The U winding voltage is fed out of pin 18 to the drum motor. Terminal 16 feeds the V voltage to the V motor winding and W winding is tied into terminal 14 of IC502. The center or common terminal of the delta winding motor feeds to pin 23.

Canon ES1000 drum motor circuits

A drum forward (FWD) signal is fed from pin 56 of IC231 Mi-Com to pin 26 of drum motor drive IC180. The drum D-PWM signal is found at pin 3 and fed to Q161, PWM power drive transistor Q150, and to a low pass filter network before entering pin 5 of IC180 (figure 7-20). Inside IC180 the PWM signal is fed to the U-V-W driver, that in turn is fed to the U-V-W windings of the drum motor.

The drum FG/PG pulse is fed from the motor FG/PG head to pins 20 and 18 of IC180. Here both the FG and PG pulses are wave shaped inside IC180 and the D-FG pulse feeds to pin 100 and D-PG pulse to pin 101 of Main Mi-Com IC231. Both of these waveforms can be scoped at terminals 100 and 101 when camcorder is in the record mode. Two separate voltage sources feed IC180 with an unregulated 6-V and SS 5-V source, at pins 6 and 14 of drum motor drive IC.

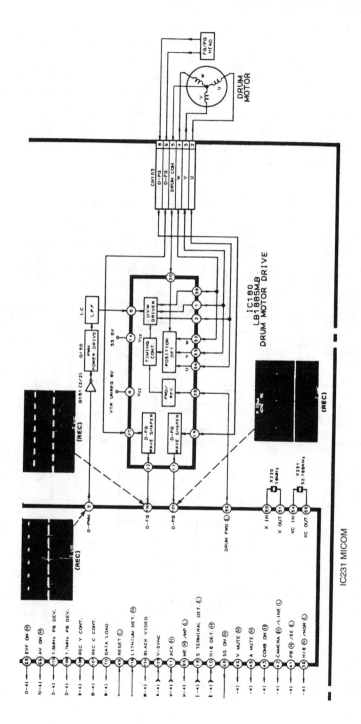

7-20 *Drum motor circuits in the Canon ES1000.* Canon, Inc.

Sony CCD-M8E/M8U drum driving circuit

The drum motor is a sensorless three-phase unidirectional brushless current motor. The drum motor drive IC202 activates CX20114. The drum motor speed error signal and phase error signals detected by IC203 are fed to the drive motor drive IC202 (pin 11) as a drum servo error signal after it has been mixed by MC-4 board resistors, capacitors, and diodes (R205, R245, R246, R251, R214, C214, and D206) (figure 7-21). The error signal is converted into a PWM signal at output pin 5. Q211 is driven by this power PWM signal from pin 5.

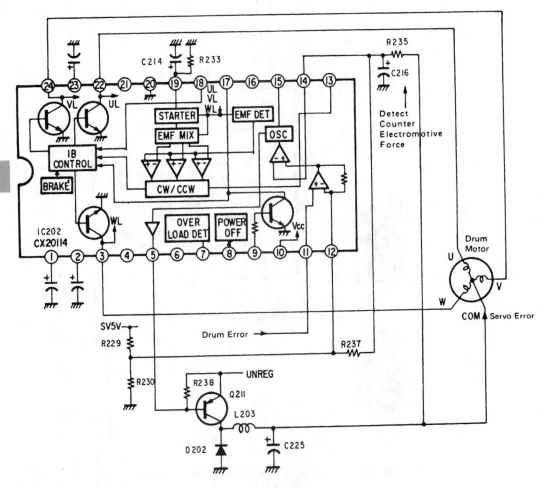

■ **7-21** *Drum motor circuits of a Sony 8-mm camcorder.* Sony Corp.

Direct current voltage results from the PWM signal after removing the carrier component by means of the filter of L203 and C225 and is added to the drum motor COM terminal. From the motor terminals U, V, and W, phase coil switching is accomplished by the drum motor at drive pins 3, 22, and 24. The switching timing is determined by detection of motor reverse voltage (pin 14).

A motor-starting circuit is needed because the drum motor coil phase switching is a carried-out system detection of the reverse voltage. C214 and R233 provide the start timing circuit. Sometimes the motor might rotate slightly in reverse direction. When unadjusted, the drum servo adjustment can only be made by SW position adjustment. The alignment tape is required for this adjustment.

Zenith VM6150 drum motor circuits

The drum servo system consists of the recording speed control, recording phase control, and drum MDA control. The drum motor frequency generator (FG) output signal is converted into a PWM (pulse-width-modulated) pulse and applied to an integrator circuit for detecting the error voltage.

Each rotation of the drum motor yields 40 pulses, which at 45-Hz rotation results in a 1800-Hz drum FG output signal. This signal goes via MDA board CN50l pins 8 and 11 to IC501 pins 18 and 19 (figure 7-22). The signal is amplified and applied to a Schmitt trigger for a waveform shaping and sent down from pin 21 to the main board CN401 pin 12 and IC401 pin 17.

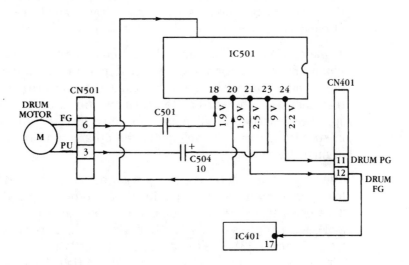

■ **7-22** *Zenith VM6150 drum motor circuits.* Zenith Corp.

IC401 produces a PWM pulse corresponding to the frequencies' difference due to irregularities in drum motor rotation with the output at pin 37. If the drum motor speed is excessive, the FG pulse frequency increases and the PWM pulse widens. Insufficient speed results in a lower frequency and narrower PAM pulse.

A low-pass filter (LPF) integrates the IC401 pin 37 output to produce an error voltage corresponding to the motor rotation frequency. The error voltage goes through a voltage-follower circuit to a mixing amp for mixing with the error voltage from the phase system. Trap-1 removes the 45-Hz component, after which the error voltage is sent from pin 5 of CN401 to MCA board and pin 10 of IC501.

IC501 functions to control the magnetic field for rotating the drum motor. The IC output voltage is added or subtracted from the drum motor power supply voltage produced by the drum power switching regulator circuit.

The recording phase control reference signal generator for the drum servo during recording is derived from the vertical synchronization (V Sync) component of the input video signal applied to pin 5 of IC401. With IC401, the V SYNC is separated and counted down ½ to a 30-Hz pulse, which resets the reference counter. The 30-Hz reference signal is supplied to the drum phase comparator.

The drum MDA control consists of the error voltage from the drum speed control system, which increases with a faster rotation and decreases with slower rotation. From the phase control system, the error voltage decreases with phase advance and increases with phase delay.

These error voltages are applied to IC406 (operational amplifier). When the phase error voltage at pin 10 plus (+) input increases, the op amp output voltage increases. The motor drive amplifier then increases the current to accelerate the drum motor. The speed error voltage at the minus (−) side is inverted. An increase in speed decreases the voltage at the op amp and reduces the drum motor current.

The Zenith drum motor is a three-phase direct-drive (DD) motor, featuring high efficiency for producing the torque required by the 270-degree tape wrap while minimizing power consumption. The 80 FG magnet poles produce an 1800-Hz signal at normal 45-Hz rotation (figure 7-23). The three-phase stator coils are at 90 degrees with 30-degree spacing between coils. Three Hall elements are located at 120-degree positions for detecting the rotor position. The

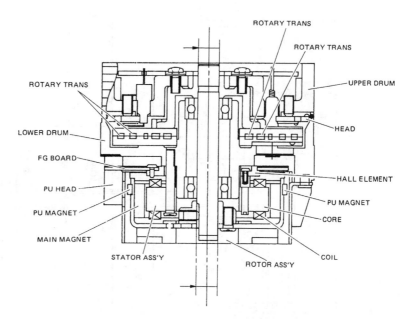

■ **7-23** *Zenith VM6150 upper and lower drum assembly.* Zenith Corp.

motor is driven by eight magnetic poles. The four rotary transformers are distributed with CH 1 innermost and CH 4 outermost.

The Zenith VM6150 motor drive circuits are shown in figure 7-24. The power transistors are switched for supplying current to drive coils 1, 2, and 3. The motor drive start position is detected by IC501 from Hall elements located between stator coils. These supply 120-degree phase signals to the three-phase logic circuit. The logic circuit sends switching signals to the power transistors for supplying coil current at the optimum positions for driving the rotary magnet.

Rotational control is performed by adding to or subtracting from the voltage supplied from the switching regulator. The servo error voltage (drum reference) is supplied via the switching regulator to the power transistors, thereby controlling the voltage applied to the motor.

Drum motor removal

The drum or cylinder can have top and bottom replacement components. Sometimes the top half must be removed before the bottom half. In other camcorders, the whole cylinder or drum unit is replaced. Make sure the cylinder or drum motor is defective be-

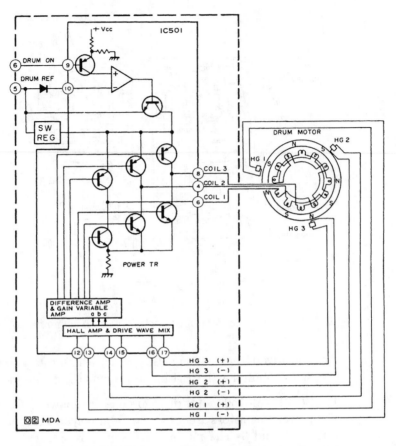

7-24 *Zenith VM6150 camcorder drum motor circuits.* Zenith Corp.

fore trying to remove it, as several parts might have to be removed before getting to the motor unit.

RCA PRO845 head/drum assembly removal

Make sure the mechanism (deck) is in the standby position. Remove the cassette mechanism. Remove the tape stopper. Remove these three screws (3) (figure 7-25). Carefully lift up the head/drum assembly (1) to remove it from the head/drum base (2). Be very careful not to touch the video heads when removing the head/drum assembly. Be careful of surrounding parts to prevent damage to the surface of drum assembly. Reverse procedure to replace head drum component.

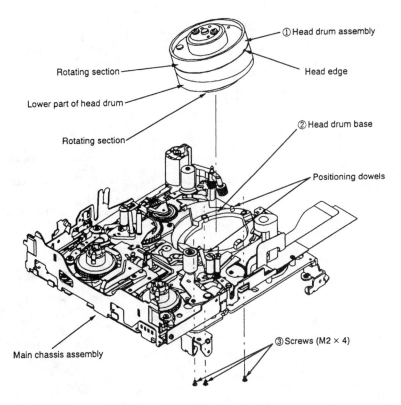

■ **7-25** *Remove RCA 8-mm head drum assembly.* Thomson Consumer Electronics

Samsung 8-mm drum assembly removal

Take extreme care when removing the drum assembly. Do not touch the head tip (11) during servicing. Remove the housing assembly before the drum assembly. Remove four screws and then remove the cover. Now you can get at the drum assembly (figure 7-26).

Remove one screw (1), then remove the guide tape T (2). Remove two screws (4), then remove the base drum (6). Remove one screw (7), to remove the earth brush (8). Remove two screws at (9) to remove the drum assembly.

To reassemble the drum assembly (10) to the boss (12) and secure with the two screws (9) and secure the two screws (9). Mount the earth brush 8, then secure one screw (7). Mount the base drum (6) to the main deck and then secure the two screws (4) and (5). Mount the guide tape T (2) and then secure one screw (1).

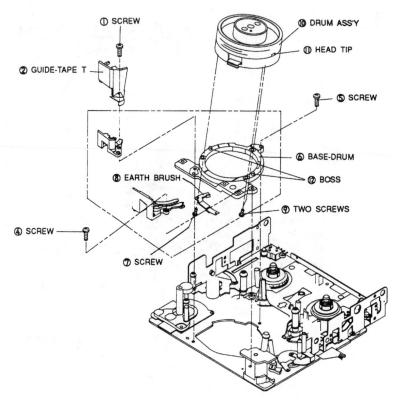

■ **7-26** *Samsung 8-mm drum assembly removal.* Samsung Electronics Co.

Autofocus motors

Many camcorders use infrared rays to provide automatic focus control. The autofocus motor is located on the camera lens assembly. The automatic focus control system is an external focusing system operating on the principle of triangulation, using the reflection of infrared rays (around 870 nm).

Infrared rays emitted by the infrared LED pass through a projection lens and reach the object. The infrared rays are reflected from the object and back to the sensor via the receiving lens (figure 7-27). The receiving lens (sensor) contains two photodiodes. The focus lens is moved until the two photodiodes receive an equal amount of light. The two photodiodes detect the infrared rays reflected back from the object and convert them to current values. The current signals are converted to voltages and are output (figure 7-28).

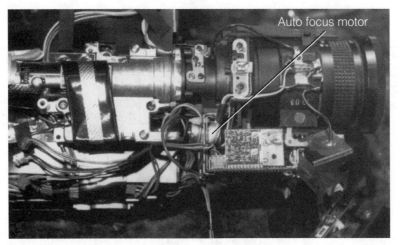

7-27 *The autofocus motor in the VHS camcorder.*

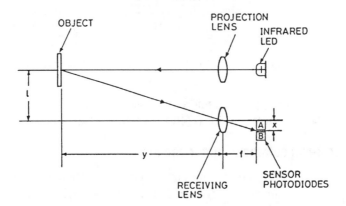

7-28 *Measurement principles of the automatic focusing system.*

RCA CPR100 autofocus block diagram

When the focus is in AUTO position, the 5-V B+ source is applied to the autofocus control circuits (figure 7-29). The autofocus circuit generates an 8-kHz infrared signal applied to the infrared circuit (Q3). This infrared signal is transmitted to the subject, reflected back, and picked up by the two photodiodes (A and B). The reflected signal is rectified by the diodes and produces electrical current in proportion to the amount of infrared light received by each diode. IC2 amplifies the two signals. The signals are synchronized and detected by the 8-kHz clock signal in IC2. The signals are now compared with a reference signal. The correction signal

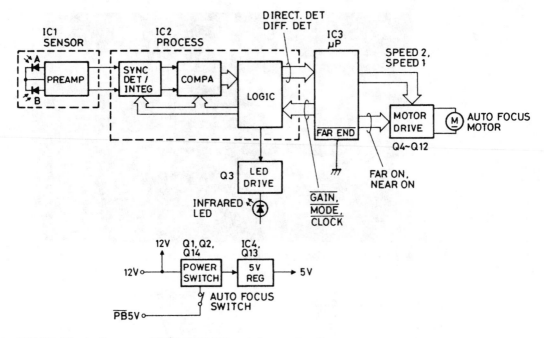

data is applied to microprocessor IC3. This signal is applied to the motor drive circuit (Q4Q12) to control the autofocus motor.

Canon 8-mm autofocus motor circuits

The autofocus circuits in the Canon ES1000 camcorder consist of the camera/AF Mi-Com IC1402, focus drive IC and focus motor (figure 7-30). The focus CW is at H and CCW rotation is L out of terminal 9 from IC1402 to pin 3 of the focus motor drive IC1336. Pin 12 signal provides focus stop and feed to terminal of focus

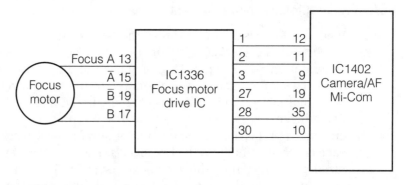

■ **7-30** *Canon 8-mm focus motor circuits.* Canon, Inc.

drive IC. The focus power save is at terminal 11, focus monitor at pin 19, focus pulse at pin 35, and focus reset at terminal 10 of IC1402.

Internal decoder and drive circuits inside the focus motor drive IC1336 is applied to the connector CN1302 at pins 13, 15, 17, and 19. The focus A, focus \overline{A}, focus \overline{B} and focus B are applied to the focus motor terminals. Scoping the waveforms on IC1402 and IC1336 with critical voltage measurement can help locate focus problems.

Samsung 8-mm focus motor circuits

Autofocus Mi-Com ICA07 provides counterclockwise (CCW) and clockwise (CW) signal at pin 55, focus reference at terminal 56, and FULK signal at pin 54. These signals are sent to pins 1, 4, and 23 of the step motor drive ICA02 (figure 7-31). The focus motor is driven by B, \overline{B}, A, and \overline{A} from the stop motor drive ICA02.

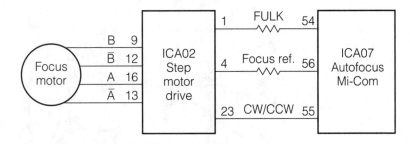

■ **7-31** *Samsung focus motor circuits.* Samsung Electronics Co.

Autofocus motor removal

In some camcorders, the whole lens unit assembly must be removed before getting to the AF motor, while in others, the autofocus motor is held with just two mounting screws. The autofocus motor is located on the lens assembly of all camcorders.

General Electric 9-9605

The lens unit, autofocus CBA and angle must be removed before the autofocus motor can be removed in this camcorder (Table 7-2 on page 210). Remove the processor CBA and then remove the lens unit from chassis by removing three screws (A) (figure 7-32). Remove two screws at the bottom of the assembly. Release the metal fasteners. Remove two screws (D) fixing the angle (PCB)

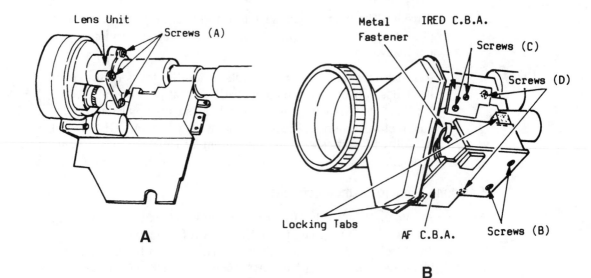

Lens Unit

Screws (A)

A

Metal Fastener

IRED C.B.A.

Screws (C)

Screws (D)

Locking Tabs

AF C.B.A.

Screws (B)

B

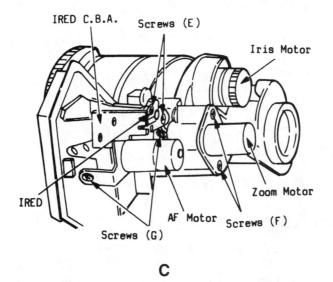

IRED C.B.A. Screws (E)

Iris Motor

Zoom Motor

IRED

AF Motor Screws (F)

Screws (G)

C

■ **7-32** *General Electric model 9-9605 autofocus assembly.* Thomson Consumer Electronics

holder. Remove the autofocus CBA by unlocking the tabs. Now re-move two screws to pull out the motor assembly.

Canon ES1000 AF and PZ motor removal

Unsolder parts A and B to remove the AF and PZ motors (figure 7-33). Loosen two screws (P), and remove the AF motor. Remove two screws (q), and remove the PZ motor. Detach the blind seals

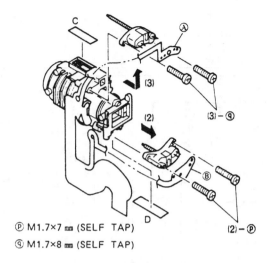

℗ M1.7×7 mm (SELF TAP)
ⓠ M1.7×8 mm (SELF TAP)

■ **7-33** *Removal of Canon ES1000 AF and PZ motors.* Canon, Inc.

C and D, and then monitor the motors while checking their position to reassemble motor assembly. After mounting the motors, be sure to reattach the seals C and D.

Iris motor drives

In the early VHS iris mechanism, a meter system was used to mechanically connect brake and drive coils. This iris mechanism worked somewhat like the camera aperture. Today, besides this iris mechanical system you will encounter an iris motor with an AIC (auto iris circuit).

The auto iris circuit operates the lens iris in order to maintain the optimum average video signal level (figure 7-34). The luminance (YE) and wide blanking (W.BLK) signals control the auto iris circuit. The luminance signal level declines with reduced scene brightness. This increases the Q13 bias and the Q13 emitter voltage declines. The reduced Q14 gate voltage reduces the Q14 drain current, decreasing the voltage at pin 6 of IC7.

The op-amp output from pin 7 of IC7 increases and the current flows in the iris driver coil in the direction from pin 2 to pin 4. Now the iris opens to increase the incoming light. Voltage is produced in the iris damper coil with the speed at which the iris operates. As the iris opens, positive voltage appears at pin 3, which tends to increase the voltage at pin 6 of IC7. This damping action provides smooth iris operation.

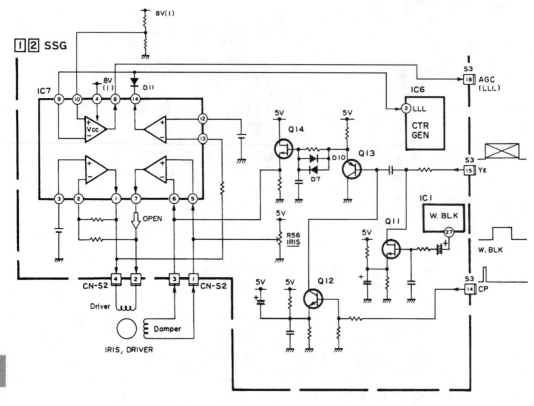

■ 7-34 *Block diagram of the auto iris circuits.*

An increase in scene illumination yields the opposite generation. D7, in the Q14 gate resistance circuit, provides quick iris response to rapid increase in incident light. if the scene brightness declines to where the iris is completely open and pin 13 of IC7 voltage becomes lower than that of pin 12, pin 14 of IC7 comparator output goes high. Then the AGC circuit functions. Spring force is applied to the iris driver in the "close" direction. With the power turned off, the 5-V power supply is low and the iris is closed.

RCA CPR100 AIC (automatic iris circuit)

This circuit controls the lens iris according to the object brightness. It contains the AIC circuit IC1402, iris motor AGC, and the iris control (figure 7-35). The output level from the video signals are controlled by the AIC circuit. This circuit controls the iris opening, depending on the level of the iris detect signal from the processing IC1102.

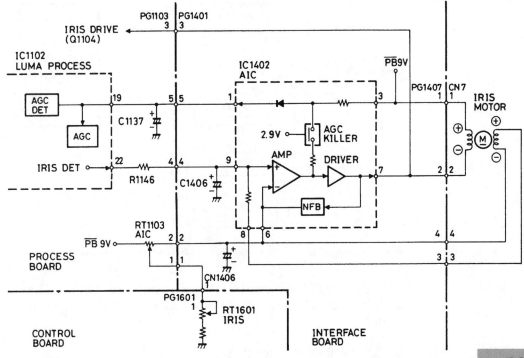

■ 7-35 *Automatic iris circuit of RCA VHS-C camcorder.* Thomson Consumer Electronics

The generated voltage is the difference between the reference voltage at the differential amplifier circuit and the comparison voltage at the noninverting input. The comparison voltage input is the iris detect signal filtered by the capacitor connected to pin 9. RT1103 adjusts the reference voltage and RV1601 the iris control. When the average lighting of the scene viewed by the camera decreases, the comparison voltage input decreases. Likewise, the output of this circuit decreases, and when the average light increases, the output also increases.

The video output level is controlled by a combination of AIC and AGC circuits. RT1401 controls the crossover point for the auto iris control and automatic gain control. RT1401 is adjusted during setup of video output level procedures.

Samsung iris block assembly

The iris drive signal is provided by CDS/AGC/r ICP03 in a Samsung SCX854 camcorder to the iris block, containing ICA05, ICA07, GA08, GA09, GA11, GA12, and GA15 (figure 7-36). The iris reference signal is sent from ICA08 to the IRIS block assembly. A DAT,

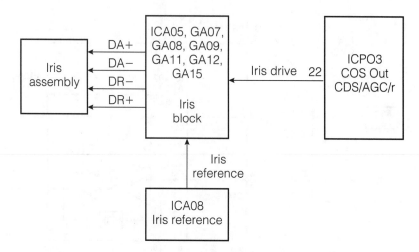

■ 7-36 *Samsung SCX854 iris block assembly.* Samsung Electronics Co.

DA−, DR−, and DR+ signal from the iris block assembly is applied to the iris assembly, controlling the amount of light into the camcorder.

Zenith VM6150 lens shutter removal

Take out two screws (A) to remove the lens shutter, from power switch board (figure 7-37). Reverse the procedure for installation. To install, set the shutter to OPEN position and the front panel power switch to the ON position. When installing the lens to the front panel, set the close-up switch lever to the normal position.

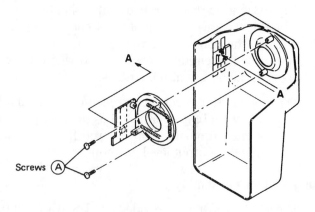

■ 7-37 *Zenith's VM6150 camcorder lens assembly removal.* Zenith Corp.

Zoom motors

The zoom motor brings the image close or far away from the lens. In some camcorders, the zoom motor is called a PZ (power zoom) motor. The zoom motor is on the lens board assembly. in the early camcorders, the zoom motor was controlled by transistors (figure 7-38). The zoom motor drive circuits are controlled by voltage in the zoom motor circuits.

■ **7-38** *Location of the zoom motor in the VHS-C camcorder.*

Samsung 8-mm zoom motor circuits

The zoom motor is controlled from the autofocus Mi-Com ICA07 with a TELE and WIDE signal out of pins 58 and 59. This control signal is sent to zoom motor drive ICA01 at pins 9 and 10 (figure 7-39). The zoom motor drive IC provides voltage to open the zoom wide and tele operations. Some manufacturers refer to the zoom motor as a PZ (power zoom) motor. Check the voltage at the dead zoom motor and take continuity measurements. Check ICA01 for no motor voltage. Do not overlook a bent or binding zoom gear train upon the lens assembly, to prevent moving lens assembly.

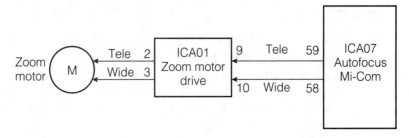

7-39 *Zoom motor circuits of Samsung 8-mm camcorder.* Samsung Electronics Co.

Radio Shack 150 zoom motor drive circuits

The zoom motor driver (IC1403), located on the interface board, drives the zoom motor. The zooming speed is determined by the level applied to pin 9 (figure 7-40). When the input level is 1 V, it will take about 8 seconds to zoom the lens all the way. The zoom direction is determined from the level applied to pin 2 of IC1403. With the TELE switch (S1101) on, the lens assembly is zoomed all the way in with an input voltage (0.3 V). When S1102 (wide) is on, the motor will zoom the lens way out with approximately 6.4 V applied to the input voltage terminal.

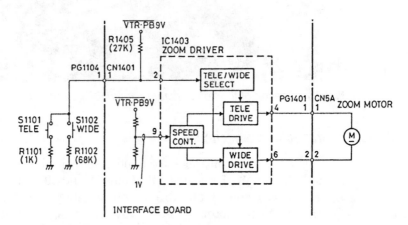

7-40 *Zoom motor drive circuit of Realistic 150.* Radio Shack

Canon zoom motor circuits

The Canon ES1000 zoom motor circuits consist of the camera/AF Mi-Com IC1402, zoom motor driver IC1301, and zoom motor. The zoom motor provides close-up of an object or person far away or

close-up. You can zoom right down upon the action found in the street.

The zoom motor clockwise rotation (CW) and counterclockwise rotation is controlled by pin 13 of IC1402 and fed to pin 3 of IC1301 (figure 7-41). The zoom stop (17), zoom power save (15), zoom monitor (18), zoom pulse (37), and zoom reset (14) signal are fed to the zoom motor drive IC from the Camera Mi-Com. A decoder and driver circuits are found inside zoom motor drive IC1301. The focus A, focus \overline{A}, focus \overline{B} and focus B voltages are sent to the zoom motor assembly, from pins 13, 15, 19 and 17 of IC1301.

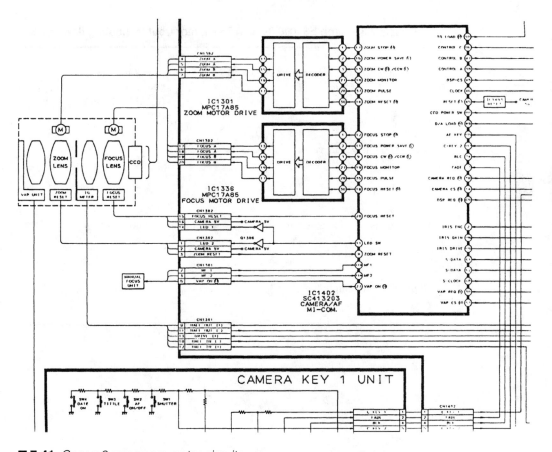

■ **7-41** *Canon 8-mm zoom motor circuits.* Canon, Inc.

Conclusion

The various motors found in the camcorder can be checked with critical voltage and continuity measurements at each motor termi-

nal. Check the motor driver IC when no voltage is found at the motor terminals. Test the motor output terminals from the motor driver IC and also the supply voltage applied to the driver IC. Take waveform signals upon the control Mi-Com when the motor and driver circuits are normal. Make sure the Main Mi-Com IC is defective, by checking the various circuits that the Mi-Com operates. Check the supply voltage furnished to the Main Mi-Com IC. You might find more than one voltage supply source fed to the system control Mi-Com IC. Scope the PG and FG waveform from each motor at the Mi-Com control IC. For AF and PZ motor operation, check the troubleshooting chart in Table 7-3.

■ **Table 7-3 Canon ES1000 8-mm AF-PZ motor troubleshooting flow chart.**

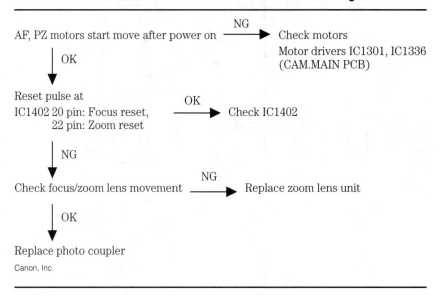

AF, PZ motors start move after power on ──NG──▶ Check motors
 │ OK Motor drivers IC1301, IC1336
 ▼ (CAM.MAIN PCB)

Reset pulse at
IC1402 20 pin: Focus reset, ──OK──▶ Check IC1402
 22 pin: Zoom reset
 │ NG
 ▼
Check focus/zoom lens movement ──NG──▶ Replace zoom lens unit
 │ OK
 ▼
Replace photo coupler
Canon, Inc.

Audio circuits

THE AUDIO CIRCUITS ARE QUITE SIMPLE WHEN COMPARED to the video or color circuits. The VHS and VHS-C audio circuits are quite similar in operation. The audio control head (A/C) is in both circuits, while in the 8-mm camcorders, frequency-modulated audio signals can be recorded by multiplexing them with video signals. PCM recording is also possible, or a conventional fixed head may be used to record audio signals near the edge of the tape. Most 8-mm camcorders employ the multiplexing FM audio signals with the video signals, which is called FM audio signal recording.

Audio circuits in the camcorder

The audio circuits start at the play/record head and amplifies the signal of the REC/PB preamplifier stage in the block diagram of an 8-mm camcorder (figure 8-1). The REC/PB signal from the preamp is fed into the AFM audio process circuits. The audio signal is fed in and out of the audio process circuit to the audio jack.

General Electric 9-9605 VHS audio circuits

The audio circuits consists of three IC components, line-mic-amp, audio REC/PB process, and switching IC. There are six transistors, which include mic amp, switching line-on, bias oscillator, inverter, switching audio delay REC/on, and ripple filter transistor. Provisions are made for earphone operation, external microphone, and external audio line input.

The signal path in record mode starts at the microphone input (3) and feeds to the mic amp (Q4001). Here the amplified audio is capacitor-coupled to the line-mic input IC4001 (pin 2) (figure 8-2). If the audio is to be recorded through the line input terminal of P4002, it is capacitor-coupled to pin 7 of IC4001. The signal of both line or mic input is switched here and amplified with the output on terminal 5.

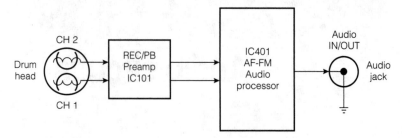

■ **8-1** *Block diagram of CH 1 and CH 2 in playback mode in the 8-mm camcorder.*

■ **8-2** *Record signal path in General Electric 9-9605 (VHS) camcorder.*

The amplified signal is fed to pin 18 of IC4002, which acts as the audio REC/PB processing IC. In REC mode, the signal is again amplified by IC4002, taken out of terminal 7 and capacitor-coupled to the audio head at pin 4. An audio signal is then transferred from the A/C head to the passing tape.

In playback mode, the signal is picked up from the tape by the A/C audio tape head and fed to pin 4 of IC4002 (figure 8-3). The signal is fed to an equalizer amp out of pin 2 through the PB level control and to the PB switch through pin 1. Here IC4002 switches to the PB position and feeds the signal out of pin 11 and capacitor-coupled to the line output terminal 3 of P4002.

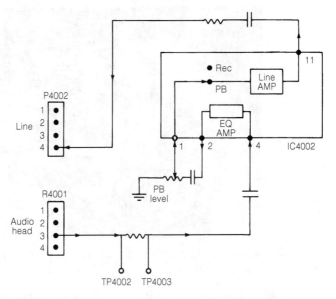

■ 8-3 *General Electric VHS playback (PB) signal path.*

Q4002 provides an oscillator bias signal and is coupled through transformer T4001 to erase the previous recording. The bias signal from pin 5 of T4001 is fed to pin 1 of P4001 to excite the erase head like all cassette audio erase heads (figure 8-4).

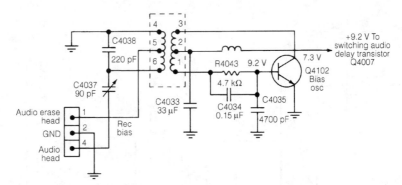

■ 8-4 *The oscillator bias erase head circuit in a General Electric VHS camcorder.*

RCA CPR100 VHS-C audio circuits

The VHS audio circuit in the RCA CPR300 camcorder is quite similar to the CPR100 VHS-C model except for differently numbered components. The audio signal enters the input circuit with the built-in microphone or the external mic (figure 8-5). J452 is the external mike jack. Also, external audio may enter the A/V input

243

■ **8-5** *The condenser microphone is along side of front of camcorder.*

adapter connector. A circuit in the A/V input adapter reduces the incoming audio signal to a level equal to that produced by either microphone. This audio signal is applied to the audio amp at pin 23 of IC401 (figure 8-6). The mic amp (IC401) amplifies the audio signal through the ALC circuit and output at pin 10 of IC401. The picked-up E-E signal may be heard in the earphone to the A/V output connector.

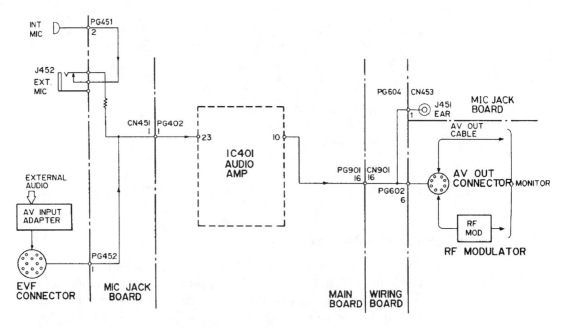

■ **8-6** *Audio input circuit of RCA CPR100 VHS-C camcorder.* Thomson Consumer Electronics

The record/playback audio heads are switched by the playback
(PB) signal by the system control microprocessor (IC901). When
the playback signal is high (Hi), Q401 is turned on and IC402 is low
(Lo) at pin 5 (figure 8-7). SW 1 inside IC402 is turned off. Also,
this high (Hi) playback signal is applied to pin 7 of IC402 which
turns SW 2 on. This switching grounds the record terminal of the
audio head and allows the playback signal to be picked up by the
audio head with outputs through IC401 and R401.

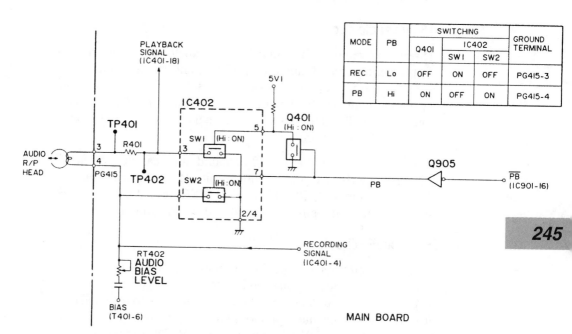

| MODE | PB | SWITCHING | | | GROUND TERMINAL |
| | | Q401 | IC402 | | |
			SW1	SW2	
REC	Lo	OFF	ON	OFF	PG415-3
PB	Hi	ON	OFF	ON	PG415-4

245

■ 8-7 *RCA VHS-C audio band-switching circuits.* Thomson Consumer Electronics

In record position, the playback (PB) signal is low (Lo) and turns
off SW 2 and Q401. Now SW 1 is on, which grounds out the play-
back terminal through R401. Now the record signal is applied to
the audio head to record. The bias oscillator is controlled by sys-
tem control IC902. The oscillator is turned on when the OSC on
signal is high (Hi) and supplied by IC901.

IC401 is placed in the playback mode by a high (Hi) signal applied
to pin 2 and a low (Lo) mute signal at pin 3, during playback oper-
ation. IC901 provides the playback signal. The playback head au-
dio signal is sent to the playback amplifier. This amplified audio
signal passes through a PB equalizer. The audio signal is equalized
to produce a flat response. The signal passes through a 15750-Hz

trap to the line amplifier. This amplified audio signal is picked up by the earphone jack and A/V output jack.

The playback signal is applied to pin 2 of IC401. The mute signal goes low (Lo) and is applied to pin 3 of IC401 in record operation. The input audio signal is applied at pin 23 of IC401 and amplified by the mike amp. This amplified signal goes through a 15750-Hz trap to the record amplifier. This signal is then applied to the audio record head.

Samsung 8-mm audio circuits

The audio circuits in the 8-mm SCX854 camcorder consist of a microphone, mic board, audio amp IC401, and the audio in/output circuits. The microphone picks up the sound of the scene being taken and connects to the amp board and mic input at pin 41 of sound IC401. The audio in and out signal connects to pins 36 and 18, respectively (figure 8-8).

A 5-V source is found at pin 42 of sound amp, cam/line at pin 37, ALC TC pin 40, and audio mute at pin 34. A PLL LPF input is found on terminal 47, PB AFM at pin 1, REC AFM at pin 8, RF SWP signal at pin 10 and pin 7 is ground at the audio amp IC401.

Canon ES1000 audio circuits

The audio circuits in this Canon 8-mm camcorder has stereo sound. The left stereo mic feeds into an HPF (IC701) and ½ of IC701 where the audio is amplified, and connects to terminal 62 of IC801. Right input microphone audio is applied to Q701 (HPF) and amplified by IC701 to pin 2 of audio-FM IC801 in record mode (figure 8-9).

The record signal is found at pin 24 of IC801 and fed to the head amp IC2001 at pin 2. A CH 1 head signal at pin 34 is applied to connector CN2001 and on to channel 1 drum head. CH 2 signal comes out of terminal 27 of IC2001 and feeds to channel 2 of the drum head circuits.

In the sound playback mode the CH 1 channel picks up audio off of tape and connects to pin 33 of IC2001. The CH 2 channel from head drum goes to pin 28 of head amp IC (figure 8-10). The head amp signal out of pin 14 of head amp is fed to amplifier Q801, and 1.5-Hz band pass filter (BPF) FL801 to pin 22 of IC801. The other signal goes to Q802 and FL802 to pin 18 of audio-FM IC.

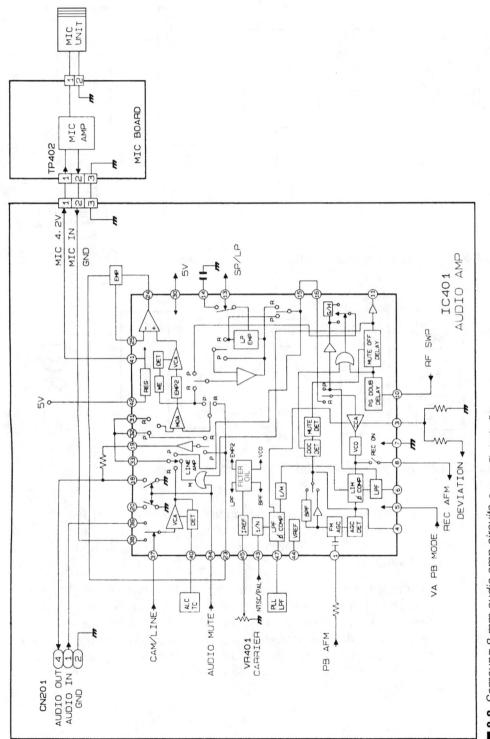

247

■ 8-8 Samsung 8-mm audio amp circuits. Samsung Electronics Co.

Audio circuits

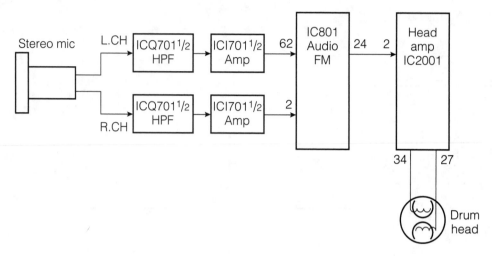

■ **8-9** *Block diagram of Canon ES1000 stereo sound circuits.*

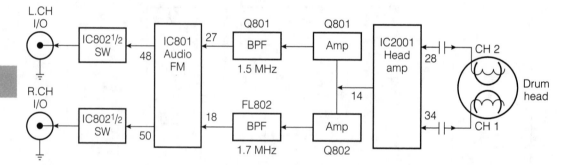

■ **8-10** *The audio playback mode in the Canon 8-mm camcorder.*

The playback audio signal is found at pins 48 and 50 of IC801 fed to IC802 switching, then up to CN301 with L channel at pin 5 and right CH at pin 7. The two stereo in and out jacks are tied to CN301 5 and 7 terminals.

The audio circuits can be signal traced with the scope at head amp, in record mode at pin 34 of head amp IC2001. Likewise in playback audio circuits the signal can be detected with scope upon terminals 28 and 33. The right (RCH) and left (LCH) channels can be scoped at the connector CN2301 or at the in/out audio jacks, with a dual trace scope to determine if both audio playback circuits are operating.

Pentax PV-C850A 8-mm audio circuits

The Pentax 8-mm camcorder employs the multiplexing FM audio signals with the video signals (called FM audio signal recording) the FM audio signal recording provides single-channel monaural sound. The FM carrier frequency is 1.5 MHz and frequency deviation of ±100 kHz. A noise reduction system is employed like that in a hi-fi VTR. It is 2:1 compression-expansion type noise reduction, which is basically the same as in VHS hi-fi (figure 8-11). The audio signal is compressed to one-half (in decibels) during recording and expanded two times in playback. At the same time, fixed emphasis is applied to reduce high-frequency noise (figure 8-12).

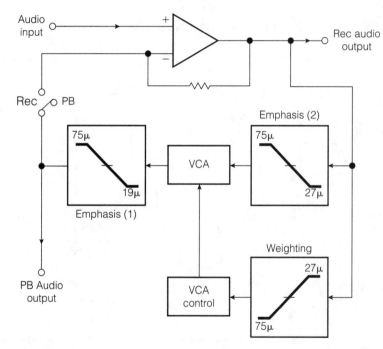

■ 8-11 *Block diagram of FM audio noise reduction circuit in a Pentax 8-mm camcorder.* Pentax Corp.

The configuration audio signal processing is shown in figure 8-13. The audio circuits consist of Q403 and Q404 (amplify the microphone input), IC402 (switches over between the built-in and external microphone), IC401, and AGC (in record/play modes), FM modulator/demodulation, noise reduction, preemphasis/deemphasis and muting circuits, and IC201 (included in the video circuits and performs head switching). Record/play modes and muting are controlled by the PB, mute, and SW 30 signals applied to IC401.

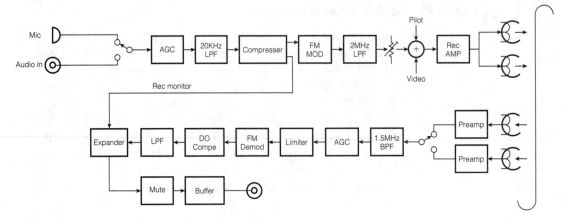

■ **8-12** *Block diagram of audio recording/playback circuits of Pentax PV-C850A.* Pentax Corp.

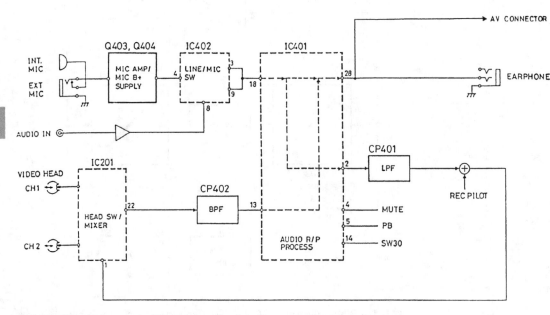

■ **8-13** *Block diagram of Pentax audio signal-processing circuits.* Pentax Corp.

The audio signal-processing circuits during EE/record consists of Q403 and Q404 (amplify the microphone input), IC402 (switches over the microphone and line audio inputs, IC401, the AGC, noise reduction, and FM modulator circuits.

The built-in microphone is a condenser microphone to which power is supplied from R424 through the microphone output line (figure 8-14). When an external microphone is connected, the

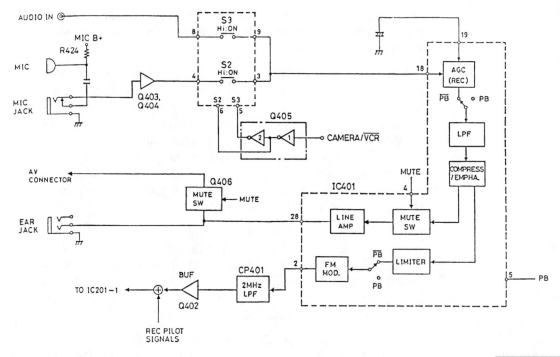

■ 8-14 *Pentax PV-C850A audio EE/record signal-processing circuits.* Pentax Corp.

built-in mike is switched out of the circuit. When no external microphone is connected, the built-in microphone output is supplied to Q403 through the external mike jack. Q403 and Q404 amplify the signal amplitude so it is enough for the audio signal processing IC401 in the next stage.

The output is supplied to pin 4 of IC402. It selects either the built-in or external microphone output applied to pin 4, the line signal applied to pin 4, or the line signal applied to pin 8, controlled by the camera/VTR and camera/VTR signals from Q405. The selected output comes out to pin 9 or 3. Camera/VTR applied to Q405 is high when the camera/VTR switch on the side of the unit is set to camera (VTR). Camera/VTR, inverted by Q405-1, controls S2 through pin 6. After inversion again by Q405-2, it controls S3 through pin 5. Thus, the built-in or external microphone output is selected in the camera mode and the audio signal coming in through the AV connector is selected in the VTR mode.

The selected signal comes to pin 18 of IC401. Its mode depends on the PB signal applied to pin 5. When PB is low, IC401 is in the record mode. The audio signal comes from pin 18 to the AGC cir-

cuit. It detects the mean value of the input and controls the gain to fix the audio output according to the detected voltage averaged by the capacitor connected to pin 19.

After passing through the AGC circuits, the audio signal comes to a low pass filter (LPF). This extracts audio signal components under 20 kHz. Next, the output passes through a compressor/preemphasis circuit (compressor/emphasis), which compresses the signal to one-half over the entire frequency range and then applies emphasis. The output passes a muting circuit (mute) and a limiter (limiter). During the record mode, the muting circuit permits the input signal to simply pass through. The signal comes out pin 28 through the line amplifier (line amp).

The limiter limits the audio signal amplitude to under the maximum frequency deviation before FM modulation to prevent over modulation. It also removes AM noise. The limited audio signal enters the FM modulator (FM MOD), which frequency modulates the input with a frequency deviation of within ±100 kHz and a carrier of 1.5 MHz. The output comes out to pin 2.

From pin 2 of IC401, the FM audio signal is supplied to a low-pass filter (CP401), which limits the signal to 1.5 MHz ±100 kHz. After this, it is supplied to the pilot signal mixer through buffer Q402.

The audio signal-processing circuits during playback are shown in figure 8-15. They consist of IC201, which amplifies the mixed RF playback signals and produces a continuous signal from the mixed RF signals of CH 1 and CH 2 supplied alternately, IC401, performing AGC, FM demodulation, muting, noise reduction, and deemphasis of the playback FM audio signal.

The mixed RF signal from Q201 (described in the video circuits) passes a bandpass filter (CP402), which extracts the FM audio signal of 1.5 MHz ±100 kHz. The output is supplied to pin 13 of IC401 through a buffer Q401.

IC401, set in the play mode by the PB (playback) signal applied to pin 5, supplies the FM audio signal to the AGC circuit. It detects the AGC voltage by synchronous detection, rectifies the voltage, and controls gain in order to fix the output by examining the voltage (stored in a capacitor in the IC). The gain of the AGC circuit is controlled by the output of the playback FM signal level detection.

The playback (PB) FM signal, with its output level fixed, is supplied to the playback FM signal level detector (AM detector) and limiter (limiter). The playback FM signal level detector detects the

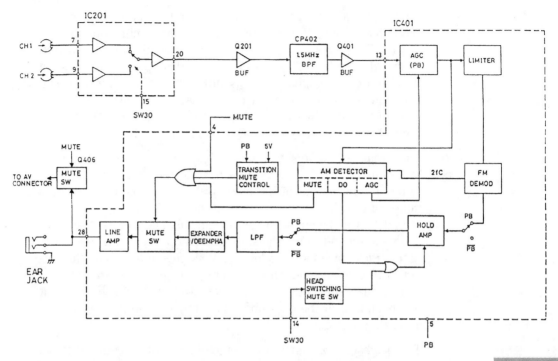

■ 8-15 *Pentax 8-mm camcorder audio signal-processing circuits.* Pentax Corp.

playback FM signal level by multiplying the doubled FM audio signal carrier from the PLL FM demodulator by the FM audio signal.

The output is used to control the AGC circuit gain, compensate for dropout, and control muting. The limiter limits the FM audio signal amplitude before demodulation to remove the AM noise. The limited FM audio signal is supplied to the FM demodulator (FM demod). In this PLL FM demodulator, when the VCO's output frequency is locked at twice the input FM audio signal frequency, the voltage controlling the oscillation frequency is taken as the audio output. The oscillator frequency of the VCO (equal to double the FM audio signal frequency) is also used as a timing signal of the playback FM signal level detector.

The demodulated audio signal then enters a hold amplifier. This holds the signal amplitude before dropout with a width of about 1 ms or less or before head switching to compensate for the dropout or prevent switching noise. The FM signal level detector detects dropout. On head switching, an edge of the head-switching signal applied to pin 14 is detected. A pulse about 10 µs wide is generated according to the detection output and the hold time of the audio signal, which is determined from the pulse.

Having passed through the hold amplifier, the audio signal passes through a low-pass filter (LPF) that cuts off its components over 20 kHz. The output enters the expander/deemphasis circuit (expander/de-empha). This has characteristics opposite to those of the compressor/emphasis circuit during recording. The audio signal compressed to one half (in decibels) during recording is expanded two times in order to expand the dynamic range, improve the S/N, and prevent deterioration of high-frequency components.

The expanded audio signal enters the muting circuit (mute SW). This mutes the audio signal (controlled by the mute signal applied to pin 4), the output of the mode transition detector (transition mute control) in the IC, and the output of the playback FM signal level detector. The mute signal remains high at power-on time for about 0.5 seconds after transition from stop to play mode and until the track play mode is released. While the mute is high, the output of the expander/deemphasis circuit is grounded to mute the audio signal. The mode transition detector remains high, for about 0.5 seconds after the play mode changes to the stop mode, generating a muting signal.

The playback FM signal level detector generates a muting signal when dropout continues for 1.1 ms or more. In these cases, the audio signal is muted as when mute turns to high (Hi). The audio signal having passed through the muting circuit comes out to pin 28 and is supplied to the circuits described for the recording mode.

Sony CCD-M8E/M8U 8-mm audio tape path

The 8-mm audio tape path begins at the mike unit and is fed into pin 10 of the AV-16 board (figure 8-16). In sound record the audio comes from pin 2 of the AV-16 board and is fed to pin 2 of the RP-29 board assembly. The REC audio signal and the video Y/C signal are found at terminals 24 and 19 of the RP-29 board. Here the recording signals are sent to pin 2 of video head CH 1 and pin 5 of video head CH 2. Many of the tape path circuits are shown with arrows in different color showing the record and playback routes.

Microphones

Most of the microphones used within the camcorder are the unidirectional condenser or electret types. These small mikes must have from 2 to 10 dc voltages applied to the terminals to make them work. In a Pentax PV-C850A microphone circuit, dc voltage is applied to pin 2 from R424 of the +5-V source (figure 8-17). The audio signal is capacitor-coupled (C420) through the external mike

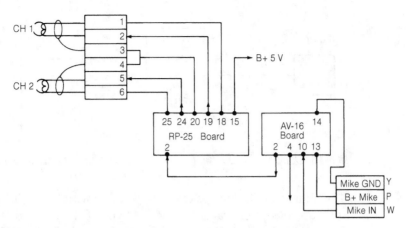

■ **8-16** *Recording tape path of Sony 8-mm audio board.*

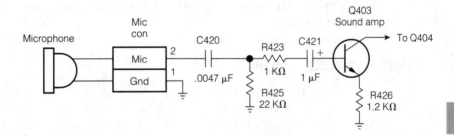

■ **8-17** *Pentax audio microphone and preamp circuits.*

jack shorting terminals to the base of Q403. Q404 and Q403 amplify the audio mike signal and feed it to the line/mic Switch (IC402). Some mike circuits contain a low-pass filter to eliminate wind and low-frequency noises.

In the Canon ES1000 camcorder, the mic unit consists of a left and right stereo microphone. The mic input is fed to the recorder PCB. The stereo input signals go through an HPF (high pass filter) Q701, then to an IC701 amplifier to the audio FM IC801 (figure 8-18).

Samsung mic circuits

The mic unit in Samsung SCX854 camcorder is a monaural type that is fed to the mic board, TP402 connector, and to pin 41 of audio amp IC401 and common ground. When in record mode, the electret microphone has 4.2 V applied to the mic preamplifier and biased microphone. The ungrounded lead of mic has a B+ voltage applied through R451 (2.2 K) ohm resistor.

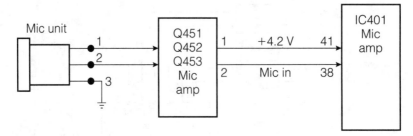

■ 8-18 *Canon ES1000 mic unit and amplifier circuits block diagram.*

The audio from the mic is capacity coupled with C451 (0.1 µF) to the base of buffer transistor Q451 (figure 8-19). Audio is taken from the collector of Q451 and capacity coupled with C453 (0.1 µF) to the base of Q452 amplifier. The last amplifier transistor (Q453) is directly coupled to Q452 and provides mic in from the collector terminal.

External microphone jack

Most camcorders have the external mike jack so another microphone can be plugged in to get closer to the sound of the subject taken. J401 is a self-shorting jack that bypasses the internal mike signal to the amplifier circuit. When the external mike is plugged in, the internal mike is cut out of the circuit. Erratic or intermittent sound may be a result of a dirty external mike jack.

Canon ES1000 mic input

The stereo microphone input connects to connector CN701 (pins 1 and 3) to each respective high pass filter network (HPF) transistor Q701 (figure 8-20). Q701 is a dual RC network. The left audio signal is fed from network to IC701 amplifier. The dual IC701 amp operates in both the left and right input circuits. From here the amplified left channel connects to pin 62 of audio-FM (IC801). The right stereo channel goes through the same Q701 and IC701 to pin 2 of IC801.

Earphone jack

Many of the larger camcorders have earphone circuits so you can listen to the sound recorded and played back. The audio sound is often tapped off at the line amp output of the audio process IC. The audio is taken from pin 28 of IC401 and capacitor-coupled to earphone jack J402 with capacitor C418. Check for a dirty earphone contact with erratic or dead earphone reception.

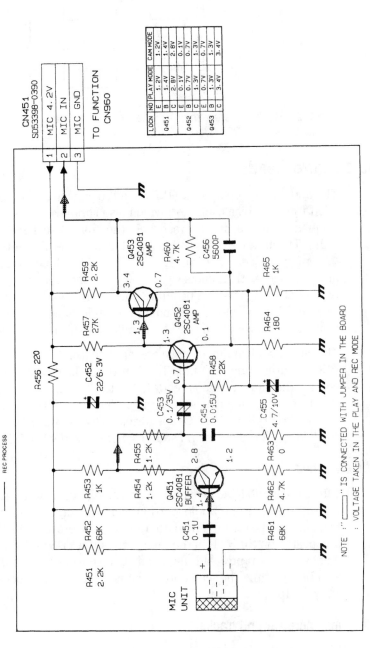

8-19 *Samsung 8-mm microphone amplifier circuits.* Samsung Electronics Co.

MIC

MIC

257

Earphone jack

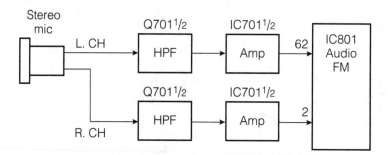

8-20 *Canon stereo microphone HPF (high pass filter), amp, and audio FM IC801.*

Audio control heads

The audio record/playback (R/P) head may have a bias signal applied from the bias oscillator, which also supplies a bias oscillator frequency to the audio erase and the full erase heads (figure 8-21). The audio A/C control head is located after the upper cylinder or drum assembly (figure 8-22). The R/P audio head terminals are switched by the head switch IC when either recording or playback operation is used. The audio A/C control head is found in the VHS and VHS-C models. Usually, the audio signal in the 8-mm camcorder is processed to FM and mixed with the video heads.

The video and audio signals are applied to the tape with the REC/PB drum and A/C tape head in the helical scan format. Of course, the video signal is recorded in the center of the tape with the drum or cylinder head and the audio track at the edge of the tape in the VHS and VHS-C tape formats (figure 8-23). The control track keeps the picture and sound synchronized with a CTL head.

Audio erase head

Often, the audio head is excited from the bias oscillator circuit and is used to erase the audio portion from the tape. The full-erase head erases the entire tape path. Both the full erase and A/C heads are located on the VTR in the tape path of the VHS and VHS-C machines. Audio tape head alignment is discovered in Chapter 11. Troubleshooting the camcorder audio circuits is discussed in Chapter 13.

Audio 8-mm stereo sound tracks

The audio mono stereo sound track is similar to the VHS sound track, except there are two tracks recorded at the bottom side of the tape (figure 8-24). The video information is recorded in the

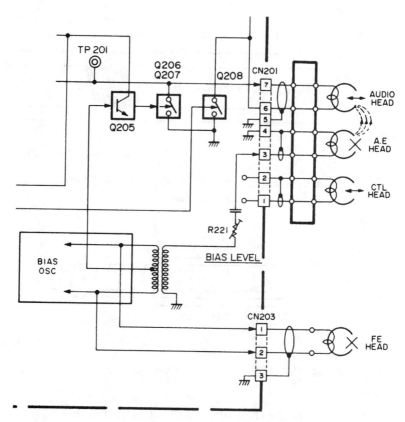

8-21 *Sony 8-mm bias oscillator circuit excites the audio, audio erase (AE), and full erase (FE) heads.* Sony Corp.

Audio tape head

8-22. *The audio tape head in the VHS-C VCR transport.*

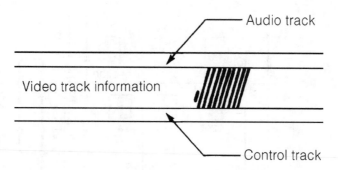

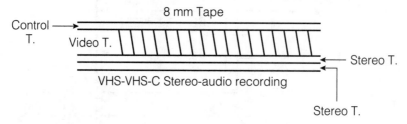

■ **8-23** *The audio track is located at the edge of the tape in the VHS and VHS-C formats.*

■ **8-24** *The VHS- VHS-C stereo recording sound tracks on the tape.*

center of the track and control data at the top of the tape in the stereo camcorder. In the 8-mm camcorder, stereo sound is recorded right in the audio-FM IC. IC801 provides FM stereo modulation in record mode of the Canon ES1000 camcorder audio stereo circuits.

Audio output jacks

The audio input and output jacks in the Canon ES1000 stereo audio channels are located in the jack unit. The right and left audio output jacks can be cabled to a stereo amplifier with speakers or to the TV stereo audio system (figure 8-25). A right stereo output jack is tied to switching IC802 and fed to pin 50 of audio FM IC801. The left stereo channel jack is fed to switching IC802 to pin 48 of IC801. These same stereo jacks are wired for input sound recordings. IC802 is a three section switching IC. Check figure 8-26 for Samsung 8-mm A/V jack circuits.

■ 8-25 *The audio and video output jacks are found at the back side of an Hitachi camcorder.*

■ 8-26 *The Samsung 8-mm A/V jack circuit.*

Mechanical tape operations

<div style="text-align: right; font-size: 3em">9</div>

THE MECHANICAL VTR OR VCR SECTION OF THE CAMCORDER
contains components that provide tape movement. Most of these
mechanical components are located in the main chassis. Each part
may be outlined or located on the chassis (figure 9-1). To service
the mechanical section, the VTR main chassis should be removed.
The main components are described in this chapter with its mode
of operation along the tape run path. The audio heads and capstan
motor operations are described in Chapters 8 and 7 respectively.

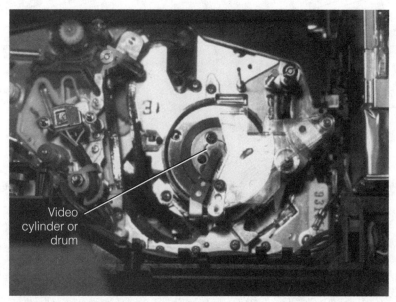

Video
cylinder or
drum

■ **9-1** *The video head can be called a drum or cylinder in the camcorder.*

Mechanical movements in the VTR or VCR section consists of any
part moving, rotating, and sliding. The most important compo-
nents are the drum or cylinder, capstan flywheel assembly, take-

up and supply reels, pressure roller, impedance roller, guide rollers, gear and pulley assemblies, loading mechanism, tension arm, pressure roller, and cam gear assembly. Most of these components are rotated or moved by a motor, tape, belt or gear driven. Any component in the mechanical section can become worn, dry, and frozen, preventing proper tape movement.

General head description

The video tape head, upper cylinder, or drum assembly picks up the recording from the tape in playback and record on the tape in the record mode. The conventional tape head (VHS) has two video heads 180 degrees apart on a 62-mm cylinder. The VHS-C camcorder uses the same size tape as the VHS units, except that a smaller video head is used with a 41.33-mm cylinder or drum assembly (figure 9-2). The 8-mm camcorder has a smaller tape width (8 mm) with a 40-mm diameter drum or cylinder. The video head assembly is rotated with a cylinder or drum motor.

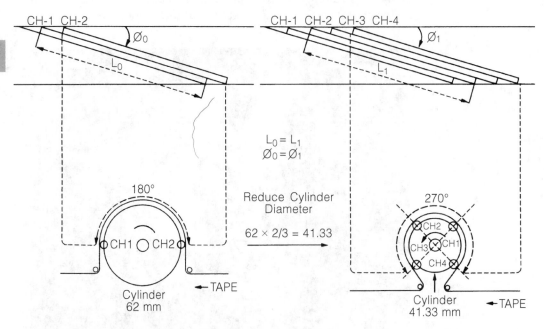

■ **9-2** *The VHS cylinder is 62 mm in diameter with a tape wrap of 180 degrees and the VHS-C cylinder is 41.33 mm with a 270-degree tape wrap.*

To reduce the camcorder overall size, the cylinder or drum assembly was reduced with a smaller size cassette. To maintain compatibility with the standard VHS system, the tape head cylinder diameter was

reduced by two-thirds in the VHS-C camcorder. To get the same length of tape around the head surface, a greater tape wrap must be made around the small cylinder or drum assembly. The same tape track length is recorded on the video tape with the same length of tape wrapped around the cylinder or drum. With a smaller diameter tape head, the speed rotation is increased to maintain relative head-to-tape speed compatibility.

Pentax PV-C850A 8-mm video head cylinder

The cylinder is 180 degrees + wind (without PCM recording). The track width is 20 microns (in SP) on a 40-degree cylinder diameter for a tape speed of 14.345 mm/s, which is slower than VHS. The relative speed of the cylinder and tape is 3.8 m/s (figure 9-3).

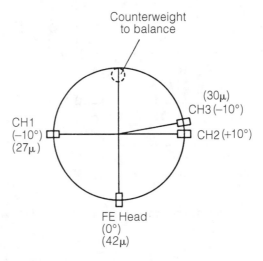

■ 9-3 *CH 1 and CH 2 are 180 degrees apart with the FE head between them in the Pentax camcorder.* Pentax Corp.

Two video heads (CH 1 and CH 2) are separated and attached to the cylinder 180 degrees apart. The angle of azimuth for CH 1 is –10 degrees, for CH 2 +10 degrees (as seen from the front surface of the head. The upper cylinder has another CH 3 head, which is ahead of the CH 2 by 1.7 degrees (2.5 H). This head is used for trick play with the azimuth angle at –10 degrees.

Between the CH 1 and CH 2 video heads, 90 degrees counter-clockwise from CH 1 head, is a rotating erase head. Opposite to the rotating (flying) erase head is a counterweight to maintain balance (figure 9-4). The rotating erase head is 42 microns wide so that it

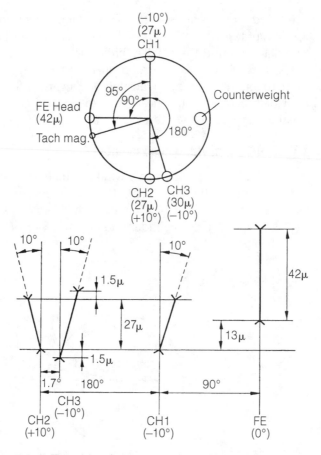

9-4 *The video flying erase head in a Pentax 8-mm camcorder.* Pentax Corp.

can erase two tracks at the same time. The video tape runs in the same direction as the rotating cylinder rotates.

Sony CCD-M8E/M8A 8-mm tape head format

The Sony CCD-M8E/M8A tape head format is 8 mm wide with two rotary heads and helical scanning FM signal. The drum diameter is 40 mm and travels at 37.5 m/s in standard play, 3.12 m/s in SP (short play) and 3.13 m/s in LP (long play). Besides CH 1 and CH 2, there is a flying erase head (FE) (figure 9-5).

Samsung preamp circuits

The video head drum contains CH 1 and CH 2 that are fed into preamp IC101, at pins 29 and 32. CH 1 and CH 2 are mounted 180 de-

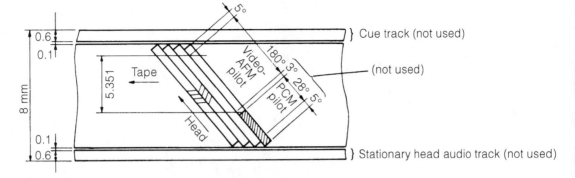

■ **9-5** *The 8-mm tape format in a Sony 8-mm camcorder.* Sony Corp.

grees apart. Also in the drum is a flying erase head (FE) that is controlled by erase oscillator GM161 from the FE "on" circuits. The drum head is rotated by a drum motor (figure 9-6).

Mechanical operations

Most of the mechanical parts found in the VHS, VHS-C, and 8-mm camcorders are the same, except they might be called by another name. Of course, the VHS camcorder's main tape transport assembly is much larger than the VHS-C or the 8-mm (figure 9-7). The bottom side of the VHS-C camcorder is shown.

Canon mechanical chassis

The mechanical chassis of Canon ES1000 camcorder begins with the cassette compartment (1) assembly (figure 9-8). Number 2 and 3 are the damper assembly with a stopper washer. The protect base assembly (5) contains a tension spring (6), washer stopper (7), and roller HC (8). Number 9 is the gooseneck retainer and number 10 is the cover for the capstan assembly. Several parts might have to be removed to get at the defective component or assembly within the mechanical chassis.

Pentax PV-C850A 8-mm supply reel disk

The supply reel disk has a slip mechanism inside, which is used for tape take-up during reverse visual search and unloading. At the bottom of the reel disk is a reflective plate used in indicating the amount of tape remaining. It emits an eight-pulse sinewave every time the disk rotates. The periphery of the reel disk is a gear that

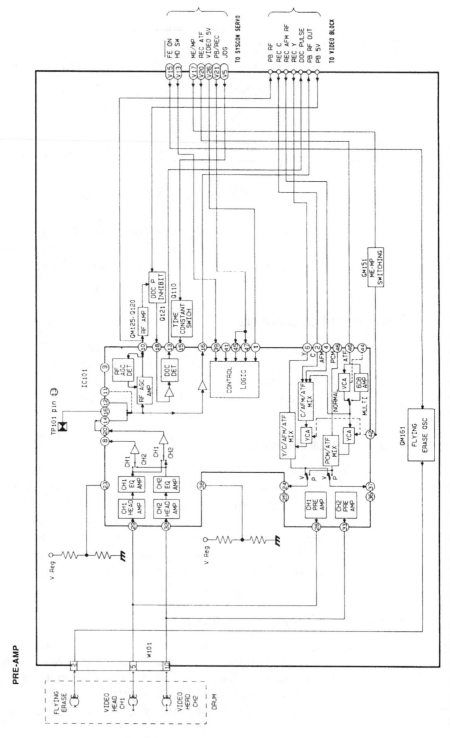

■ **9-6** *CH 1, CH 2 and FE video heads with preamp IC101 circuit in the Samsung 8-mm camcorder.* Samsung Electronics Co.

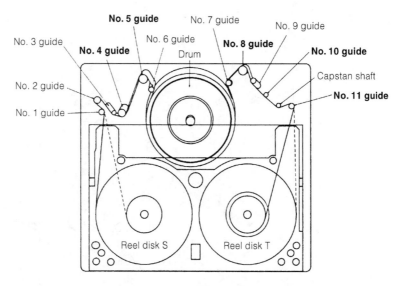

■ **9-7** *Layout of tape transport with tape guides and reels of Samsung 8-mm camcorder.* Samsung Electronics Co.

accurately transmits torque. A tension band wound around the side of the reel disk controls tension on the supplied tape. See Table 9-1.

RCA 8-mm stop-to-play tape path

The tape is pulled out of the S-reel. The tape passes the number 2 guide (impedance roller). The tape passes the number 3 guide (figure 9-9). The angle post (number 4 guide) positions the tape at the correct angle. The tape wraps on the head drum. Angle post (number 5 guide) directs the tape from the head drum to tape guide number 6. The tape passes the capstan shaft and the pinch roller to tape guide number 7. The tape is reeled into the T-reel.

Pentax PV-C850A 8-mm tension arm assembly

The tape winds around the tension pin standing on the tension arm. The force and balance of the spring attached to the opposite edge of the arm controls tape tension. Changing the strength of the spring is the way to adjust tape tension. The other end of the tension band is attached to the tension arm so that it can freely rotate the arm. The other end of the band is rigidly attached to the adjustment plate on the chassis. Adjusting the position of this fixed plate changes the angle of the wind in relation to the tension pole and changes the tension servo's gain.

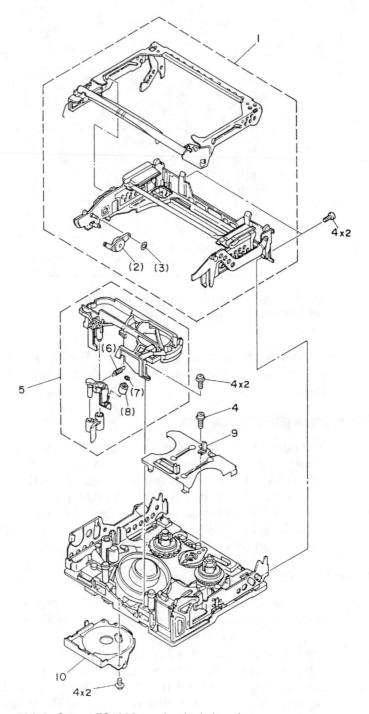

1

4 x 2

(2) (3)

5

(6)

(7)

(8)

4 x 2

4

9

10

4 x 2

■ **9-8** *Canon ES1000 mechanical chassis.* Canon, Inc.

■ Table 9-1 Mechanism modes of Pentax PV-C850A camcorder.

	Mode SW position	Operation mode	Main brake	T. brake	Pressure roller	Tension arm	Guide pole	Capstan motor	Subchassis	Cylinder motor	Remarks
1	Eject	Eject	Off	On	Off	Off	Off	Stop	Unload	Stop	Cassette up / Power off / Mode: UL stop
2	UL stop	Unloading stop	Off	On	Off	Off	Off	Stop	Unload	Stop	Power off
	Unloading	Unloading	Off	On	Off	Off	Off → On	On (Rev)	Unload → Load	Stop → On	
3	Loading	Loading	Off	On	Off	Off	On	On (Fwd)	Load	On	C. motor: M
4	FF / Rew	F. Fwd / Rew	Off	Off	Off	Off	On	On (Fwd) / On (Rev)	Load	On	C. motor: Hi / Clutch torque: Hi
5	L. Stop	Loading stop	On	On	Off	Off	On	Stop	Load	Stop	Power off / Clutch torque: L
6	Rec	Rec/PB	Off	Off	On	On	On	On	Load	On	C. motor: L / Clutch torque: L
	Play	Rec-pause	Off	On	On	Off	On	Stop	Load	On	C. motor: Stop
		PB-pause	Off	Off	On	On	On	Stop	Load	On	Clutch torque: L
		Fwd search	Off	Off	On	On	On	On	Load	On	C. motor: M
7	Reverse	Rev. search	Off	On	On	Off	On	On (Rev)	Load	On	C. motor: M / Clutch torque: L
		Reverse PB	Off	On	On	Off	On	On (Rev)	Load	On	C. motor: L / Clutch torque: L

Pentax Corp.

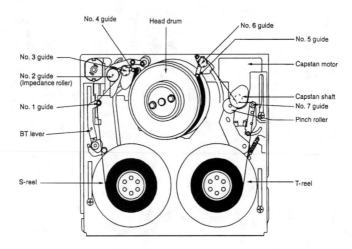

No. 4 guide Head drum No. 6 guide

No. 5 guide

No. 3 guide

Capstan motor

No. 2 guide
(Impedance roller)

No. 1 guide

Capstan shaft
No. 7 guide
Pinch roller

BT lever

S-reel

T-reel

■ **9-9** *RCA 8-mm stop to play tape path.* <small>Thomson Consumer Electronics</small>

Realistic 150 (VHS-C) impedance roller

This consists of a body of polyacetal resin and a brass ring fitted around the body. Jitter is reduced by raising the moment of inertia. This is a precision-made roller. Be careful not to damage the surface. If it is damaged, jitter will occur, synchronized with the roller's rotation. Light oil is applied slightly to the bearing. Felt rings (oil barriers) are attached to the top and bottom of the roller to prevent oil from leaking and adhering to the tape. Be sure and replace the felt washers when replacing the impedance roller.

RCA PR845 pinch roller operation

The loading motor rotates. The reel chassis slides forward and the pinch slide plate slides to the left (figure 9-10). The pinch lever shaft slide slides along the edge of section (A) on the pinch roller plate. The pinch roller rotates.

Samsung mechanical part movements

The special part movement components upon the chassis are an arm pinch roller (440), arm pole base (422), arm pole base assembly (412), arm review assembly (435), arm tension (445), tension band holder (447), arm clutch assembly (451), lever brake assembly (453), take-up reel (456) and supply reel (458), brake lever (462), arm brake (456), and slider (470) (figure 9-11).

The different sensors consist of the reel sensor (486), end sensor (491), start sensor (492), top/end sensor (493) and switch detec-

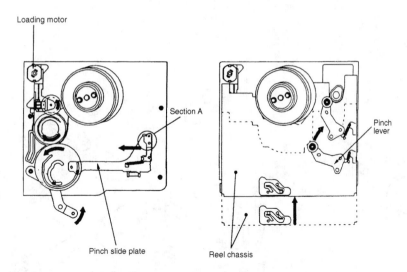

Loading motor

Section A

Pinch lever

Pinch slide plate

Reel chassis

■ **9-10** *RCA PRO845 pinch roller operation.* Thomson Consumer Electronics

tor (490). The IR LED is (488). A defective movement or sliding component can cause improper speeds, poor brake problems, pulling of tape, erratic movement of tape, and no tape movement.

Realistic 150 guide rollers

These have the same construction as conventional guide rollers and are precision-made rollers molded of polyacetal resin. These rollers change the direction of the tape transport and control tape height. One is provided on the supply side and the other is on the take-up side (figure 9-12). The guide rollers are adjusted so that the bottom edge of the tape runs along a reference line called the lead.

Pentax PV-C850A cylinder

The cylinder is attached to the pedestal with two screws. Signals from the video heads go to the upper rotary transformer, which is attached by the converter to the pedestal (figure 9-13). Below this is attached a fixed transformer that transfers the video signals and sends them to the circuit board. The center shaft is supported by two ball bearings at the top and bottom. Mounted in the upper cylinder are the video heads with azimuths of ±10 degrees and the FE head with azimuth of 0 degrees. Channels (1 and 2) heads are 27 microns wide, channel 3's head is 30 microns wide, and the FE head is 42 microns wide. At the opposite edge of the FE head is a counterweight to balance the FE head.

Mechanical operations

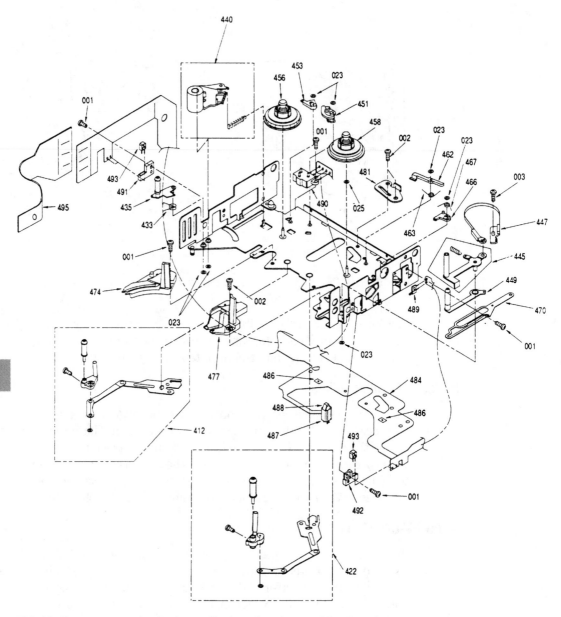

■ 9-11 *Samsung mechanical parts layout of reel assembly chassis.* Samsung Electronics Co.

Since the track pitch of an 8-mm VTR is 20 microns, the overlapped write during recording is 7 microns. Since the width of the FE head is 42 microns and it is placed at a point 90 degrees ahead of the CH 1 video head, after erasure by the FE head the video signals are

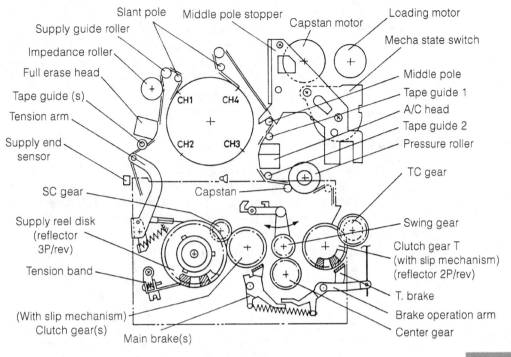

Slant pole
Supply guide roller
Impedance roller
Full erase head
Tape guide (s)
Tension arm
Supply end sensor

Middle pole stopper
Capstan motor

Loading motor
Mecha state switch

Middle pole
Tape guide 1
A/C head
Tape guide 2
Pressure roller

CH1 CH4

CH2 CH3

SC gear
Supply reel disk (reflector 3P/rev)
Tension band
(With slip mechanism) Clutch gear(s)

Capstan

Main brake(s)

TC gear
Swing gear
Clutch gear T (with slip mechanism) (reflector 2P/rev)
T. brake
Brake operation arm
Center gear

■ **9-12** *Realistic VHS-C 150 guide rollers.* Radio Shack

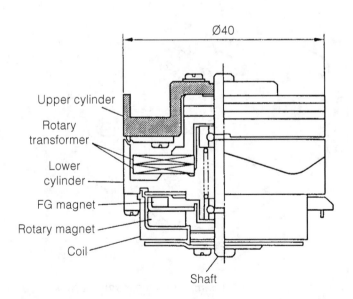

Ø40

Upper cylinder
Rotary transformer
Lower cylinder
FG magnet
Rotary magnet
Coil

Shaft

■ **9-13** *The cylinder structure in the Pentax 8-mm camcorder.* Pentax Corp.

Mechanical operations

first recorded by CH 1 and then CH 2 head. There is a 13-micron gap between the video heads and the FE head in view of the various errors that can occur. The tach magnet is attached at a position 95 degrees ahead of the CH 1 head. This allows the creation of the SW 30-Hz signal for switching. An FG magnet, which is magnetized in about 40 places, is attached to the bottom of the rotary transformer. A signal of 600 Hz is generated for the cylinder FG.

Samsung 8-mm drum assembly

The drum assembly is located upon the main mechanical deck assembly. The drum motor is the bottom part of the drum assembly while the top section contains the two CH 1 and CH 2 heads with the flying erase head. The drum head picks up information from the tape and plays it back in the camcorder (figure 9-14). Also, the drum applies video and sound recording upon the revolving 8-mm tape.

276

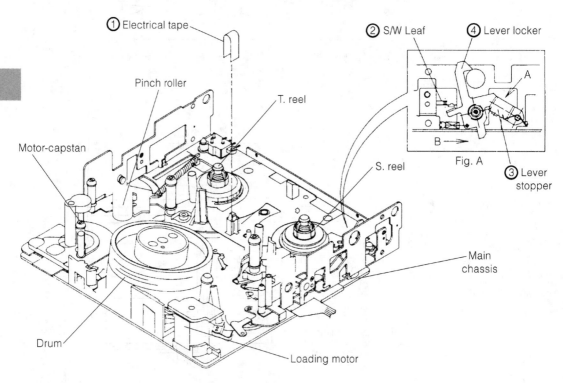

■ **9-14** *The main chassis in the Samsung 8-mm camcorder.* Samsung Electronics Co.

A take-up and supply reel, supplies and takes up the tape after revolving around the drum assembly. In this chassis the loading motor is at one corner and the capstan motor assembly at the other. The pinch roller is located between capstan and spindle, close to the take-up reel. The capstan and pinch roller moves the tape.

Realistic 150 (VHS-C) middle pole and stopper

After leaving the cylinder and the slant pole, the tape runs around another pole before it reaches the A/C head. The middle pole is horizontal inside the take-up side guide rail before the tape is loaded. It becomes erect as the tape loading proceeds, and on completion of loading, the middle pole is positioned by the middle pole stopper over the capstan motor and is locked by the arm on the A/C head plate. Adjust the inclination of the middle pole by loosening three screws and move the stopper correctly. Adjust so that the FM output becomes maximum and flat.

Canon ES1000 drum and capstan assembly

The drum head in the Canon ES1000 camcorder has a top section (2) and bottom section. The drum head contains CH 1 and CH 2 with the flying erase head (FE). The drum takes off and applies picture and sound upon the 8-mm tape. The tape drum is the largest part found upon the main chassis (figure 9-15A).

The capstan motor (9) drives the capstan that rotates the tape through pressure or pinch roller around the drum cylinder. A flat loading motor (15) is found at the opposite end of chassis from the capstan motor assembly. The loading motor loads and unloads the 8-mm cassette. Sixteen different parts are listed by the number in figure 9-15B.

Realistic 150 (VHS-C) capstan assembly

The capstan has a diameter of 3 mm, and its speed is 3.5 revolutions per second. The capstan FG detection coil generates 102 pulses per rotation, and therefore the capstan FG is 360 Hz in the SP mode and 120 Hz in the EP mode. The flywheel is supported by two ball bearings (figure 9-16).

Pentax PV-C850A 8-mm pressure roller

Most pressure rollers operate the same in most camcorders. This pressure roller has the same construction as the conventional table-top VCRs. It has one ball bearing in the center and uses ball

■ 9-15A *The capstan and drum assembly on mechanical chassis section of Canon 8-mm camcorder.* Canon, Inc.

MECHANICAL PARTS

SYMBOL	PART NO.	CLASS	QTY	DESCRIPTION
1	DY4 – 3096 – 000 000	E	1	DRUM ASS'Y
2	DY4 – 3097 – 000 000	E	1	DRUM ASS'Y UPPER
3	DY4 – 3073 – 000 000	C	1	SPRING, LEAF, TG7 ARM
4	DY4 – 3014 – 000 000	C	1	ARM ASS'Y, TG7
5	DY4 – 3075 – 000 000	F	6	SCREW
6	DY4 – 3021 – 000 000	C	1	PLATE(T), SIDE
7	DY4 – 3059 – 000 000	C	1	ARM, HC CONVERTION
8	DY4 – 3065 – 000 000	F	1	SCREW
9	DY4 – 3066 – 000 000	E	1	MOTOR, CAPSTAN
10	DY4 – 2583 – 000 000	F	3	SCREW
11	DY4 – 3051 – 000 000	C	1	ARM, LS
12	DY4 – 3052 – 000 000	C	1	ROLLER, LS
13	DY4 – 3098 – 000 000	C	1	ROLLER, ASS'Y, TG2
14	DY4 – 3067 – 000 000	F	1	SPRING, COMPRESSION
15	DY4 – 3013 – 000 000	E	1	MOTOR, LOADING
16	DY4 – 3046 – 000 000	C	1	PLATE(S), SIDE

■ **9-15B** *Mechanical parts list by the number to correspond with main chassis.*

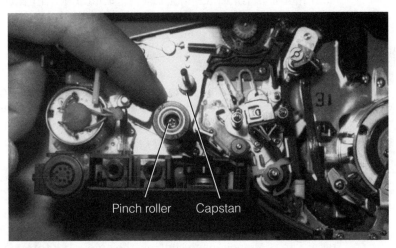

Pinch roller Capstan

■ **9-16** *The capstan and pinch roller in a VHS camcorder tape path.*

bearing chatter to push it parallel to the capstan shaft. This structure moves the tape in an even line without pulling it up or down. The pressure roller pushes the tape against the metal capstan shaft to move the tape, like in all audio cassette players.

Mechanical operations

Slant and guide poles

The slant poles guide the tape so that it winds around the cylinder at an angle. They do not control the tape height. The angle of inclination cannot be varied. Do not try to straighten these slanted poles.

The tape comes from the capstan shaft through the guide pole to be wound by the take-up reel disk. The guide pole allows a neat wind by regulating the tape in the height direction and letting the reel disk wind the tape so that it does not touch the inside walls of the cassette.

Pentax PV-C850A 8-mm center gear and FRP gear

The capstan motor with a square belt drives the center gear. The center gear meshes with the FRP gear and oscillates the FRP gear to left and right in line with the center gear's direction of rotation. If the capstan shaft is rotating counterclockwise (normal winding direction), the center gear rotates clockwise, which oscillates the FRP gear to the take-up side. This allows the take-up reel disk to rotate clockwise, which takes up the tape and enters play (record) or search mode. When the capstan motor is rotating clockwise, all rotation is in reverse, and the supply reel disk rotates counterclockwise to take up the tape in the rewind or unloading modes.

Realistic 150 (VHS-C) center gear

The torque produced by the capstan motor is transmitted to the center gear through the flywheel. The swing gear is engaged with the center gear, which swings to the left and right according to the direction of rotation of the center gear, to drive the take-up or supply clutch gear assembly.

Realistic 150 (VHS-C) clutch gear

The clutch T gear has a slip mechanism where the capstan motor rotates the take-up reel hub and permits slipping, to take up the tape. The slip mechanism controls the amount of torque transmitted. This clutch also operates during the fast-forward mode. A reflector (two pulses per revolution) fitted on the bottom is used to detect rotation of the take-up reel hub. The clutch T-gear stops rotating when rewinding is complete. The T-brake pressed against the bottom of the clutch T-gear applies reverse torque to the tape at the take-up side during loading and reverse search.

The clutch S gear like the T-gear, has a slip mechanism that applies capstan motor torque to the supply reel disk, permitting slippage, to take up the loose tape.

Samsung SCX854 take-up and supply reels

The supply reel supplies the tape to be wound around the drum head with help from the capstan and pinch roller. Usually, the supply reel has a slip mechanism that applies the tension band assembly (A), permitting slippage to loose tape (figure 9-17). The

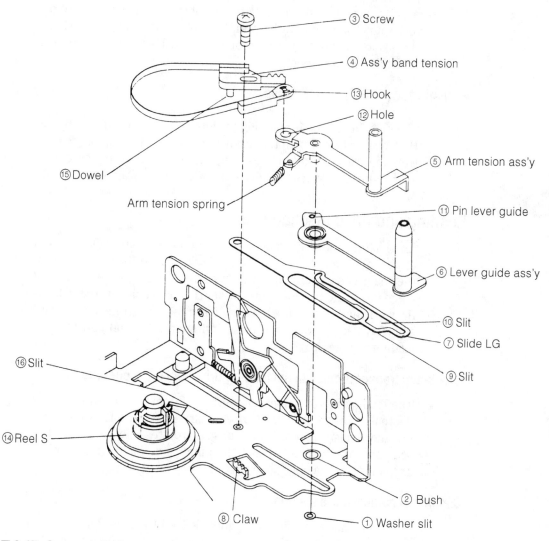

■ **9-17** *Samsung SXC854 8-mm reel assembly with tension band and guide assemblies.* Samsung Electronics Co.

take-up reel picks up the loose tape from drum and pinch roller and prevents pulling or spill-over of excess tape. Often, a brake assembly applies pressure to the outside area of take-up (T)-reel in stop, loading, and reverse modes.

Pentax PV-C850A 8-mm take-up reel disk

The take-up reel disk operates the same way as the supply reel disk slip mechanism slipping during take-up, fast forward and visual search. At the bottom of the take-up reel disk is the reflecting plate for outputting a sinewave at eight pulses per revolution, which is used to indicate the amount of tape remaining and to detect rpm. The gears on the periphery of the take-up reel disk are the same as those on the supply reel disk—they provide sure transmission of torque.

Realistic 150 (VHS-C) main S brake

The main brake applies braking to clutch gear S when driven by the B-cam lever linked with the groove provided at the top of the control cam. The T-brake pressed against the bottom of the clutch gear T applies reverse torque (weak brake) to the take-up reel hub.

Loading and drive mechanisms

The loading and drive mechanism components are usually found on the bottom side of the main chassis (figure 9-18). The top of the main chassis contains the take-up and supply reel, braking mechanism and tension arms. Under the main chassis are the loading worm and cam gears, lower cylinder motor, loading motor, capstan flywheel, main brake arm, and supply loading and take-up loading cam gears.

RCA 8-mm transport mechanism loading drive/reel drive operation

The loading motor begins to operate. The motor speed is farther decreased by the convert gear. A rotary switch rotates to the output mechanism mode. The cam gear rotates (figure 9-19). The slide arm, the link slide plate, the pinch slide plate, and the eject slide plate slide along the grooves in the cam gear.

Canon mechanical parts section

The mechanical section of Canon ES1000 camcorder contains many cams, levers and gear assemblies. The different arm assemblies of HC driving (1), pinch press arm (3), GL arm assembly

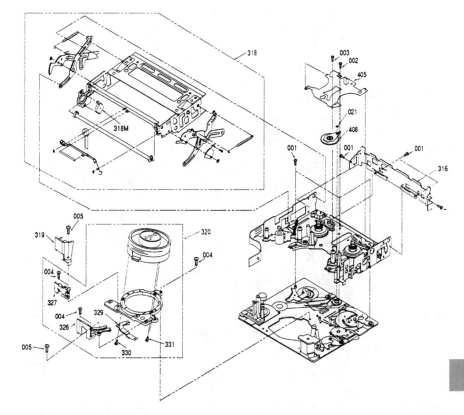

■ **9-18A** *Samsung mechanical parts with drum assembly.* Samsung Electronics Co.

LOCA. NO	PART NO.	DESCRIPTION & SPECIFICATION
001	60504 – 0005 – 00	SCREW – BH;BH + M1.4 L2 WHT
002	60504 – 0015 – 00	SCREW;BH + FP M1.4 L1.2 S45C – HC BLK
003	60504 – 0017 – 00	SCREW;BH + FP M1.4 L2.2 S45C – HC BLK
004	60504 – 0038 – 00	SCREW – MACHINE;BH B M1.7 L5 FE WHT
005	60504 – 0039 – 00	SCREW – MACHINE;BH B M1.7 L8 FE WHT
021	60534 – 0005 – 00	WASHER – SLIT;ID0.75 OD2.0 T0.2 POLYSLIDER
316	63312 – 0011 – 01	COVER – BACK;A5052P 314H
318	62051 – 0012 – 00	HOUSING – ASS'Y;STS304/STS303 T0.5 DE – 4
318M	62663 – 0014 – 00	DAMPER – HOUSING;SUS/POM/NYLON 30G DE – 2A
319	63353 – 0057 – 00	GUIDE – TAPE T;DURACON M90 – 02 NTR
320	69063 – 214 – 356	ASSY DRUM;DE – 4UNN – SS
326	63081 – 0011 – 00	RAIL – STOPPER L;ZDC12
327	63082 – 0012 – 00	RAIL – STOPPER R;ZDC12
329	66534 – 0006 – 00	CONTACT – EARTH BRUSH ASS'Y;SECC/PBS P/CR/C DE – 4
330	60509 – 0065 – 00	SCREW – MACHINE;BH UP M2 L7 SWRCH10A WHT WL
331	67094 – 604 – 410	SCREW – BH;1+M2X5 FE FZY,WL
405	63312 – 0005 – 00	COVER – REEL ASS'Y;SUS304 – CSP T0.2+DURACON M90 – 02 BLK
408	61603 – 0005 – 00	IDLER(ASSY);DE – 4A

■ **9-18B** *Part number location and description of components in Fig. 9-18A.*

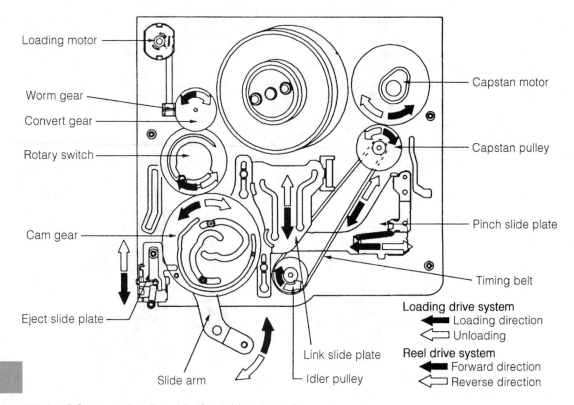

Loading motor

Worm gear

Convert gear

Rotary switch

Cam gear

Eject slide plate

Slide arm

Link slide plate

Idler pulley

Capstan motor

Capstan pulley

Pinch slide plate

Timing belt

Loading drive system
Loading direction
Unloading

Reel drive system
Forward direction
Reverse direction

9-19 *RCA 8-mm loading drive/reel drive operation.* Thomson Consumer Electronics

(13), and FF arm assembly provide pivoted movements (figure 9-20A). The eject lever (6) ejects the cassette and slides M assembly (11), slides over the cam gear assembly (12). There are several gear assemblies including cam gear, change gear (8), L gear A and B (18 and 19). Belt (9) rotates relay pulley (10). Check figure 9-20B for numbered list of mechanical parts.

Pentax PV-C850A 8-mm reel disk drive mechanism

The supply reel disks' slip mechanisms generate the torque necessary to eliminate tape slack and take up the tape during reverse visual search and unloading (figure 9-21). The take-up reel disk's slip mechanism works in the same way to eliminate tape slack and take up the tape during the take-up modes and visual search. This allows the slip torque on the take-up and supply sides to be independently controlled.

Loading motor force that moves the change base assembly plate up and down passes the capstan motor torque through the FRP and to both reel disks. If the center gear assembly is set in the high

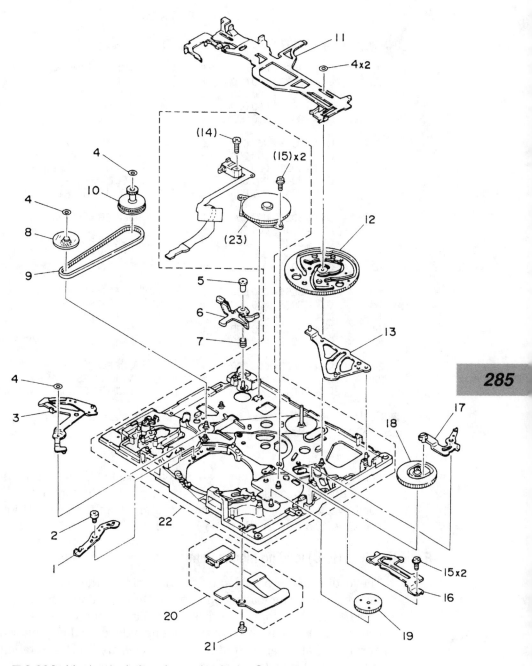

■ **9-20A** *Mechanical chassis section in the Canon 8-mm camcorder.* Canon, Inc.

MECHANICAL PARTS

SYMBOL	PART NO.	CLASS	QTY	DESCRIPTION
1	DY4 – 3058 – 000 000	E	1	ARM, HC DRIVING
2	DY4 – 2822 – 000 000	F	1	SCREW
3	DY4 – 3025 – 000 000	E	1	ARM ASS'Y, PINCH PRESS
4	DY4 – 2688 – 000 000	F	5	WASHER
5	DY4 – 3056 – 000 000	E	1	SLEEVE, EJECT
6	DY4 – 3053 – 000 000	E	1	LEVER, EJECT
7	DY4 – 3055 – 000 000	F	1	SPRING, COMPRESSION
8	DY4 – 3022 – 000 000	E	1	GEAR ASS'Y, CHANGE
9	DY4 – 3045 – 000 000	E	1	BELT, RELAY
10	DY4 – 3047 – 000 000	E	1	PULLEY, RELAY
11	DY4 – 3026 – 000 000	E	1	SLIDER ASS'Y, M
12	DY4 – 3048 – 000 000	E	1	CAM
13	DY4 – 3024 – 000 000	E	1	ARM ASS'Y, GL
14	DY4 – 3044 – 000 000	F	1	SCREW
15	DY4 – 3075 – 000 000	E	4	SCREW
16	DY4 – 3054 – 000 000	E	1	RETAINER, GEAR
17	DY4 – 3023 – 000 000	E	1	ARM ASS'Y, FF
18	DY4 – 3049 – 000 000	E	1	GEAR(B), L
19	DY4 – 3050 – 000 000	E	1	GEAR(A), L
20	DY4 – 3017 – 000 000	E	1	PRINTED CORD ASS'Y, FP444
21	DY4 – 3063 – 000 000	F	1	SCREW
22	DY4 – 3012 – 000 000	E	1	MAIN CHASSIS ASS'Y
23	DY4 – 3042 – 000 000	E	1	SWITCH, ROTARY(ENCORDER)

■ **9-20B** *Part symbols and numbers of the mechanical section of Canon ES1000 of Fig. 9-20A.*

position at this time, the capstan motor torque will pass through the slip mechanisms in both reel disks, causing the torque to become weak. Setting the center gear assembly in the low position transmits torque directly to both reel disks.

Realistic 150 (VHS-C) loading mechanism

The loading motor provided on the right side of the chassis is the source of power for loading operations. During loading, the tape is drawn from the supply reel disk and wound around the cylinder (figure 9-22). The rotation of the loading motor is reduced by two worm gears and transmitted to the control cam gear. The rotation of the control cam gear is conveyed to the adjacent cam gear, the ring gear, and the lower supply loading ring, which is one of the loading rings located around the cylinder. The supply loading ring

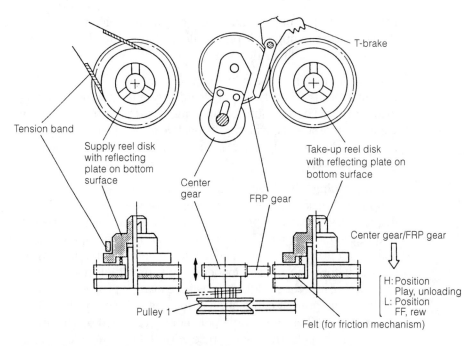

■ 9-21 *Reel disk drive mechanism of Pentax 8-mm camcorder.* Pentax Corp.

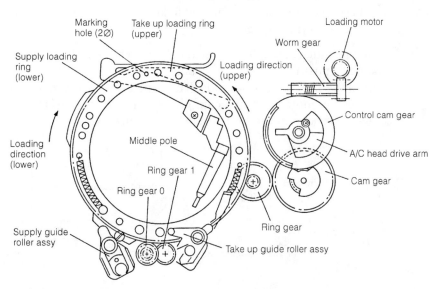

■ 9-22 *Loading mechanism in the Realistic VHS-C camcorder.* Radio Shack

is fitted with the supply guide roller assembly, which will be set in the supply arm stopper (V block) along the guiding groove on the chassis as the loading ring rotates.

The supply loading ring is linked with ring gears 0 and 1, which transmit torque from the supply loading ring to the upper take-up loading ring. The take-up loading ring is fitted with the take-up guide roller assembly, which will advance along the guiding groove in the chassis as the loading ring rotates until it is set in the take-up arm stopper.

During loading, clutch gear S and the SC gear are linked with the supply reel disk to apply weak reverse torque to the supply reel disk to prevent slack tape. The T-brake pressing against the bottom of the clutch gear T applies brake so that the tape does not come out of the take-up reel. The middle pole is horizontal on the chassis before the tape is loaded. A pin provided in the supply loading ring lifts the middle pole as tape loading proceeds, and immediately before the completion of loading, it is set on the middle pole stopper. Then the middle pole holder provided on the arm of the A/C head locks the middle pole with the middle pole stopper. The A/C head is initially located under the mechanism state switch. As loading proceeds, the A/C head drive arm screwed to the control cam gear moves the A/C head to the play position. The pressure roller comes into contact with the capstan shaft, driven by the P-operation lever, which is linked with a groove provided under the control cam gear.

When loading is completed, the mechanism state switch detects the sixth position so that the loading motor stops and the VTR enters the play or record mode. The control cam gear driven by the loading motor has two cam grooves in the top surface and one cam groove in the bottom surface (figure 9-23). The B cam

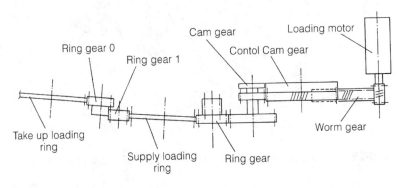

■ **9-23** *Realistic 150 loading mechanism.* Radio Shack

lever is linked with the outer of the two top-side cam grooves and drives main brake S. The TE lever is linked with the inner groove and drives the T-brake and eject arm on the take-up side through a rod.

Pentax PV-C850A 8-mm loading mechanism

The loading motor located in the upper left hand side rotates the worm gear at the left front of the chassis. There are cam grooves in both the top and bottom surface of the drive gear, which is meshed with the worm gear (figure 9-24). The pin of the L gear fits into the groove on the top side and the force from the L gear

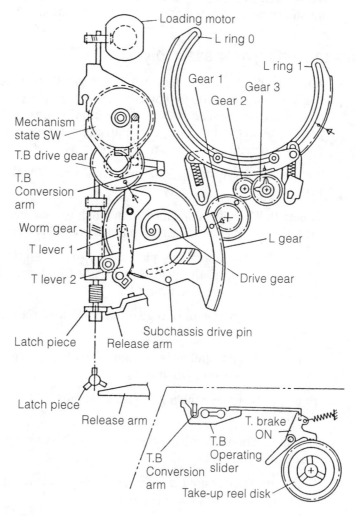

■ 9-24 *Pentax 8-mm VTR unit loading mechanism.* Pentax Corp.

goes through gears 1, 2, and 3, to the L rings 1 and 0. The pins of the guide roller assemblies for the supplied side and take-up side are inserted into the L rings 1 and 0, and when the L ring 1 moves counterclockwise and L ring 0 moves clockwise, the pins are pulled in the loading direction and placed into the catchers on the supply and take-up sides. The compression force at this time is applied by the tension spring, which is attached to the guide roller assembly tension mechanism built into the tips of the L ring 1 and L ring 0.

At the moment that loading ends, the TB drive gear (take-up reel disk T-brake drive arm), which meshes with the drive gear, drives the mechanism state switch, which stops the rotation of the loading motor when it detects the play mode position.

Samsung timing gear assembly

After repairs in the sub-deck or to assemble the sub-deck, timing points should be made for correct camcorder operation. The gear train must be installed in A, B, C, D, and E in order. If the install points (timing points) of gear train are mismatched, the camcorder can malfunction or part damage can occur.

Timing A: Align install hole of gear cam pinch 7 with hole in the main base.

Timing B: When installing lever cam pinch to gear cam pinch, timing "B" point of cam as described in (figure 9-25).

Timing C: After assembling plate slides (6), when installing gear main cam (4), pull the plate slider ass'y (6), toward arrow and then install the gear cam main (4).

Timing D: Align hole of cam gear main (4) with the large hole on main base.

Timing E: When installing lever cam (5) to gear cam main (4), timing "E" point of cam as in drawing.

Timing F: When assembling the gear cam main (4) and the mode switch assembly (3).

Timing G: When assembling the mode switch assembly (3) and the gear cam tension (1).

Timing H: When installing lever gear tension (2) to gear cam tension (1), timing "H" point of cam as illustrated.

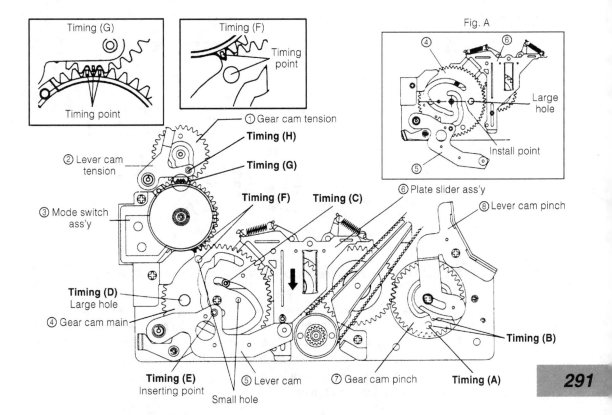

Timing (G)

Timing point

Timing (F)

Timing point

Fig. A

④ ⑥

Large hole

Install point

⑤

① Gear cam tension

Timing (H)

② Lever cam tension

Timing (G)

③ Mode switch ass'y

Timing (F) Timing (C)

⑥ Plate slider ass'y

⑧ Lever cam pinch

Timing (D)
Large hole

④ Gear cam main

Timing (E)
Inserting point

⑤ Lever cam

Small hole

⑦ Gear cam pinch

Timing (A)

Timing (B)

■ **9-25** *Samsung SXC854 8-mm timing gear assembly.* Samsung Electronics Co.

Pentax PV-C850A 8-mm main brake drive mechanism

The main brake engages the reel disks only in L. stop mode. Since L. stop mode is in the standby status in the camera mode, turn power off when stopped in this mode for a long period of time during camera recording to engage and hold the main brake on both reel disks (figure 9-26).

When switching from the fast-forward or rewind mode to the L. stop mode, the main brake is applied in quick operation. Braking must be applied quickly in the fast-forward and rewind modes. Braking is applied at the normal speed in the record and play modes while the cam arm is turning.

In switching from the fast-forward or rewind mode to the L. stop mode, the latch piece turns and the release arm lifts up simultaneously. This operation disengages the release arm and B-slider 2 and the force of the spring at the right-hand side of the chart

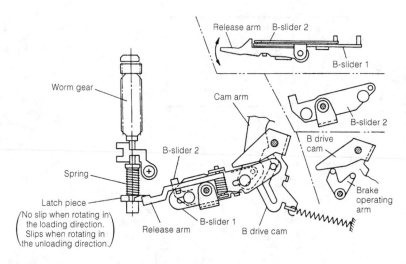

■ 9-26 *Main drive mechanism of Pentax 8-mm camcorder.* Pentax Corp.

rapidly pulls the release arm and B-slider 1, which is the pedestal for the release arm. Because the pin caulked to the right edge of B-slider 1 fits into the groove in the B drive cam, the B drive cam turns counterclockwise when B-slider 1 moves to the right. This operation turns the brake operating arm clockwise to engage the main brake on both reel disks.

Now when the loading motor turns in the loading direction, the mechanism moves from L.STOP mode to PLAY (REC) mode, the drive gear turns, and the cam arm turns clockwise, pushing B-slider 1 to the left. This operation turns the B drive cam clockwise and disengages the main brakes from both reel disks.

When in the PLAY mode and the STOP button is pressed, the loading motor will turn in the unloading direction to turn the cam arm clockwise and turn the B-slider counterclockwise, which turns the B drive cam counterclockwise and turns the brake operating arm clockwise to engage the main brake on both reel disks. When in the L.STOP mode and the FF or REW button is pressed, the cam arm and the B drive cam both turn clockwise to release the main brake.

RCA 8-mm idler gear/T-reel base operation

The capstan motor rotates in the forward direction. The capstan pulley rotates. The timing belt transmits the rotation to the idler pulley. The idler pulley rotates. The idler gear swings to the right, engages with the T-reel base and then rotates the T-reel (figure 9-27). The T-brake gear begins to rotate.

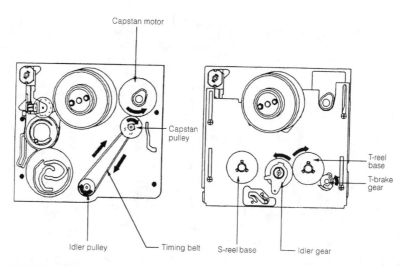

Samsung 8-mm playback (PB) tension adjustment

Remove cover housing, holder-AV and case top, case front and case-left assembly. Set the torque cassette. Place in play mode, and confirm that reel disk S torque value is less than 4.5+ or −1 g/1 cm. If the torque value does not meet the specification, adjust the tension band. To increase the torque value, move tension band upward. To decrease the torque value, move tension band downward (figure 9-28).

RCA PRO845 play-to-fast forward operation

The fast-forward button is pressed. The head drum continues rotating. The loading motor remains stopped. The capstan motor and the pinch roller rotate in the forward direction at high speed (figure 9-29). The idler gear rotates at high speed. The T-reel base rotates at high speed. The T-brake gear rotates at high speed.

Realistic 150 (VHS-C) pressure roller drive mechanism

The lower groove of the control cam gear is linked with the pin of the P-operation lever (pressure roller operation lever). As the control cam gear rotates counterclockwise, the P-operation lever also turns counterclockwise (figure 9-30). The lower end of the P-operation lever has teeth that engage with the teeth in the adjacent gear arm. When the P-operation lever turns counterclockwise, the gear arm rotates clockwise to cause the pressure roller lever to

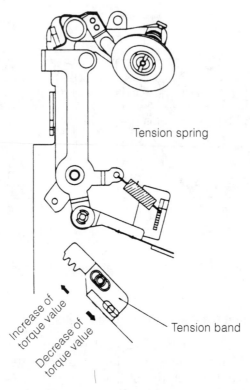

Tension spring

Increase of torque value

Decrease of torque value

Tension band

■ **9-28** *Samsung 8-mm playback tension band adjustment.* Samsung Electronics Co.

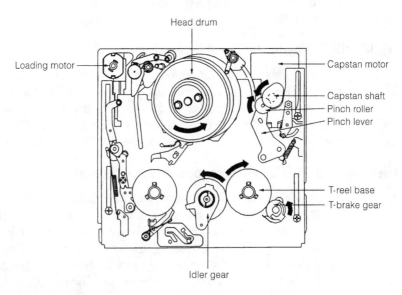

Head drum

Loading motor

Capstan motor

Capstan shaft
Pinch roller
Pinch lever

T-reel base
T-brake gear

Idler gear

■ **9-29** *RCA PRO845 play to fast forward operation.* Thomson Consumer Electronics

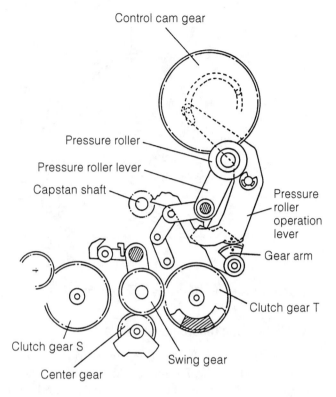

Control cam gear

Pressure roller

Pressure roller lever

Capstan shaft

Pressure roller operation lever

Gear arm

Clutch gear T

Clutch gear S

Swing gear

Center gear

■ **9-30** *Realistic 150 pressure drive mechanism.* Radio Shack

turn counterclockwise. This moves the pressure roller near the capstan shaft and the toggle mechanism brings the roller into contact with the shaft.

RCA 8-mm stop-to-rewind operation

The rewind button is pressed. The head drum rotates. The capstan motor rotates in the reverse high speed direction (figure 9-31). The idler gear swings to the left, engages with the S-reel base and rotates at high speed. The loading motor rotates to the reverse position. The T-reel base rotates in the high speed reverse direction. The T-brake gear rotates in the high speed direction. The T-brake lever moves across and engages with the lower gear of the T-reel to provide resistance on the T-reel base.

The BT lever first rotates toward the outside, and then rotates back toward the inside to its original position. The pinch roller is applied to the capstan shaft and then the pinch roller rotates in the high speed reverse direction.

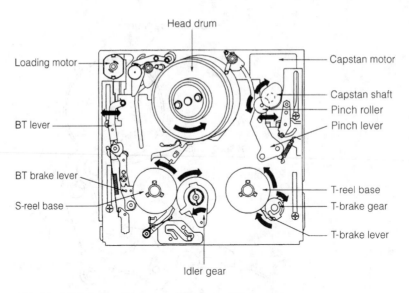

Head drum

Loading motor

Capstan motor

Capstan shaft
Pinch roller
Pinch lever

BT lever

BT brake lever

S-reel base

T-reel base
T-brake gear

T-brake lever

Idler gear

■ **9-31** *RCA 8-mm Stop to rewind operation.* Thomson Consumer Electronics

Pentax PV-C850A 8-mm record/pause mode

Pressing the PAUSE button during record moves the loading motor from the 6th to the 7th mode. This operation causes T lever 2 to move the T band AS, slacken the tension band, and aid the tape's reverse run. The capstan motor is operating in the reverse direction at this time to wind the tape on the supply reel disk.

The capstan motor is in stop state in either the record pause mode or the loading stop mode. When the pause mode is released during recording pause, the loading motor starts to rotate and performs the assemble operation while moving from the 7th to 6th mode.

The capstan motor turns in the forward direction in the assemble mode. Now the tape is played to match the phases between the new track and previously recorded track. However, monitor cut is performed and an EE picture appears in this period. The next record mode will be entered at one field before pause is turned on.

Conclusion

Because the VHS-C camcorder operates somewhat like the VHS modes, the Realistic 150 and the Pentax PV-C850A camcorders were chosen to illustrate operation of the VTR mechanism. Although the operation description can be lengthy in some areas, you should have some idea how the VTR or VCR section operates.

Always check with the manufacturer's service literature for detailed assembly charts and part location, especially when ordering the exact replacements.

Sluggish operation or camcorder malfunctions can result from bent or worn levers and arms, dry gear and pulley bearings. Tape can spill out with erratic, slow or no movement of the take-up reel. Belt and pulley areas can produce speed problems. Poor or no loading can result from a defective loading motor, gear and belt problems.

Remove and replace 10

BEFORE YOU ATTEMPT TO REPAIR THE CAMCORDER, YOU must get inside and locate the defective component. Cleaning and small-part removal can be done by first removing the cassette compartment cover. Sometimes you can locate the small parts on top of the VTR assembly. Try to locate the manufacturer's service manual on the camcorder you are servicing. This will save you a lot of time because most have different disassembly procedures.

Disassembly flowcharts provide certain steps to take in getting to the defective section of the camcorder (figure 10-1). If you do not follow some type of procedure, you can lose a lot of time and remove parts that are not necessary. Of course, after replacing the defective component, reverse the disassembly procedure. Remove the cabinet plastic covers, camera section, and VCR deck in that order.

Most camcorder manufacturers have a section in the service literature on how to remove the various sections of the camcorder. Although removal of all components is impossible to illustrate, you can remove different sections to get to the defective component. Always make a chart or rough sketch of the order in which sections and components are removed. Some parts such as the front cover might have small cover screws under rubber or plastic inserts (figure 10-2).

Write it down

If you do not have any method of removing the cabinet and components or no service literature, make drawings of components removed in step procedures. In step one, write down what you removed (covers and panels) and make rough drawings. Likewise, use the same procedure when removing any components. You might be called away from the bench and then forget where each part goes.

■ **10-1** *A typical disassembly flowchart.* Minolta Corp.

When removing the outside cabinet, place a cloth or soft material under the plastic cabinet so it does not get scratched. Lay cabinets out of the way after they are removed. Keep a cloth under the removed cabinet side to prevent PC board or component damage. Be careful not to break locking tabs or plastic inserts in removal. Remember where certain cable and wires lay if they stick to the cabinet panels.

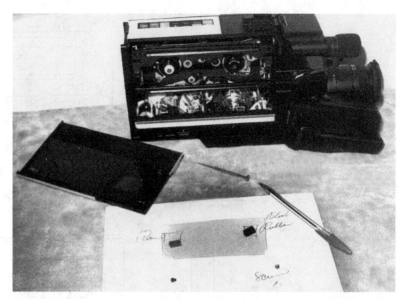

■ **10-2** *Remove rubber stops and two small screws to remove front cover on RCA CPR300.*

When installing the new part or component, follow the manufacturer's cleanup and lubrication of the moving part. Clean off all around the area for loose dust or dirt. Do it very carefully, so not to disturb other components. Make sure that all connectors and electrical connections are made with correct polarity. Push the connectors and plugs in tight. Do not apply power or insert the battery while removing or replacing defective parts. Check for wires that might be misplaced keeping the covers from closing.

Too many screws

Several hundred different sizes of screws are used in the camcorder. Place the screws in a certain area or write down the length and where they belong. In the service literature, many manufacturers list the size, color, and length of the screws that hold the components in position. Be especially careful with the cabinet screws. Keep the correct pressure on such screws so not to strip or scar the top surface. If one or two are difficult to remove and replace, place black enamel paint over the screw head after the camcorder is fully tested. Make sure no loose screws are left over.

In the Canon ES1000 camcorder, the list of various sizes of screws are given with their location (figure 10-3). For instance, in one side of the plastic camcorder case there are several different sizes

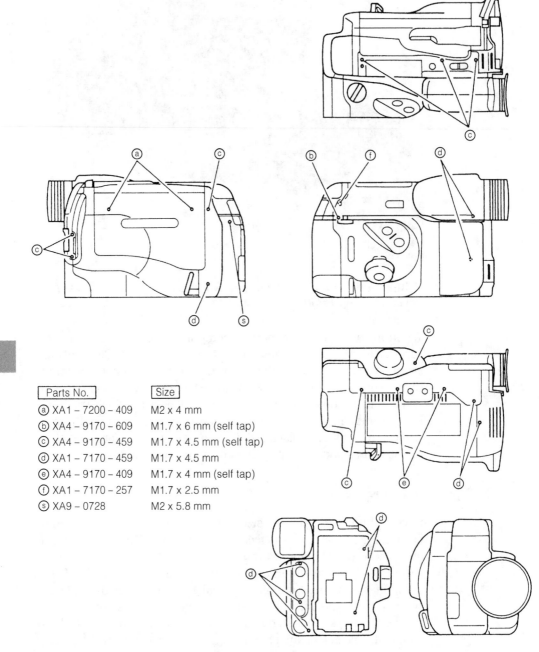

Parts No.	Size
ⓐ XA1 – 7200 – 409	M2 x 4 mm
ⓑ XA4 – 9170 – 609	M1.7 x 6 mm (self tap)
ⓒ XA4 – 9170 – 459	M1.7 x 4.5 mm (self tap)
ⓓ XA1 – 7170 – 459	M1.7 x 4.5 mm
ⓔ XA4 – 9170 – 409	M1.7 x 4 mm (self tap)
ⓕ XA1 – 7170 – 257	M1.7 x 2.5 mm
ⓢ XA9 – 0728	M2 x 5.8 mm

■ **10-3** *List of external screws in the Canon ES1000 camcorder.* Canon, Inc.

of screws. Two M 2-x-4 mm (A) screws at the top, self tap ml.7-x-4.5-mm (C) at top and towards the front area, with one 1.7-x-4.5-mm screw (D) at the bottom edge and M 2-x-5.8-mm (S) screw towards the top back area of camera case.

Here three different types of screws are used with different lengths. It's best to place screws from one section in a separate container with a sketch of where they came from for easy replacement. If not, the screw holes can be damaged and can end up too long, possibly damaging a component inside the camcorder.

General Electric 9-9605 (VHS) disassembly flowchart

This flowchart indicates disassembly steps for the cabinet parts and the PC boards in order to find the items necessary for servicing (figure 10-4). When reassembling, perform the steps in the reverse order.

Follow the following procedures to prevent breakage:

☐ When removing the cabinet, work with care so as not to break the locking tabs.

☐ Place a cloth or some soft material under the PC boards or unit to prevent damage.

☐ When reinstalling, ensure that the connectors are connected and electrical components have not been damaged.

☐ Do not supply power to the unit during disassembly.

☐ Use a wrist strap to provide ESD protection while disassembling and when operating the unit while disassembled.

Cassette cover removal

In some models, you can easily remove the cassette cover to clean or remove any tape stuck. Remove two rubber inserts (one white and one black) and the two screws under the inserts to remove the cassette panel from the VHS RCA CPR300 camcorder. While in others, the two top screws holding the cassette cover are removed and the cassette comes off. In many smaller camcorders, the side cabinet must be removed to get at the front components.

Samsung ES1000 cover housing removal

Remove 2 screws BH:M1.7 × 5 to remove the front cover over loading area (1) and remove the cover housing in the direction of arrow A. To remove the holder A/V assembly, remove 2 screws BH:M2 × 7 (3) and one screw BH:M2 × 4 to pull the cover away

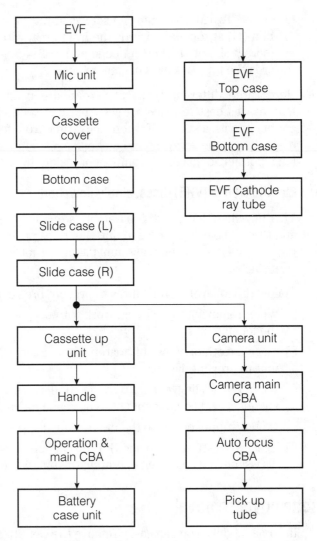

■ 10-4 *General Electric 9-9605 (VHS) camcorder flowchart.* Thomson Consumer Electronics

(4). Now remove the case top assembly in direction of arrow C. Note: Remove case top assembly while pushing two locking tabs using precision screwdriver (figure 10-5).

Canon ES1000 rear cover removal

1. Loosen two screws (C) and six screws (D).
2. Remove the rear cover (figure 10-6).
3. Before removing the rear cover, be sure to take out the lithium battery.

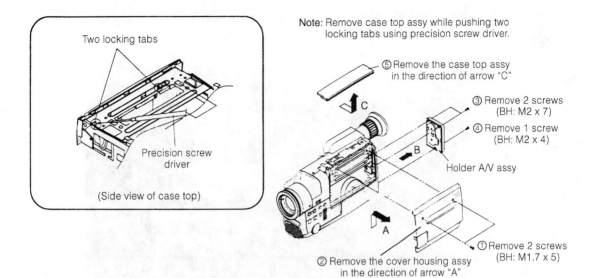

Two locking tabs

Precision screw driver

(Side view of case top)

Note: Remove case top assy while pushing two locking tabs using precision screw driver.

⑤ Remove the case top assy in the direction of arrow "C"

③ Remove 2 screws (BH: M2 x 7)

④ Remove 1 screw (BH: M2 x 4)

Holder A/V assy

② Remove the cover housing assy in the direction of arrow "A"

① Remove 2 screws (BH: M1.7 x 5)

■ **10-5** *Removal of cover housing in Samsung SCX845 camcorder.* Samsung Electronics Co.

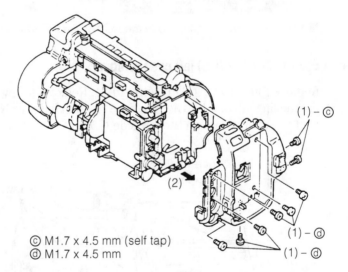

(1) – ⓒ

(2)

(1) – ⓓ

(1) – ⓓ

ⓒ M1.7 x 4.5 mm (self tap)
ⓓ M1.7 x 4.5 mm

■ **10-6** *How to remove rear cover in Canon ES1000 camcorder.* Canon, Inc.

Case removal

To remove the outside plastic case to get at the components, simply remove the cassette lid. If the battery case is in the way, remove the cover. Now remove the left case or cover and then the

right case or cover (figure 10-7). Remove the VTR block or chassis if trouble exists in the movement of tape.

■ **10-7** *Both covers removed in the RCA VHS CPR300 camcorder.*

General Electric 9-9605 (VHS) left case removal

Remove four screws (D) (figure 10-8). Remove screw E. Release the locking tab and lift the side case (L) unit slightly. Now disconnect the connectors on the left side (L) unit.

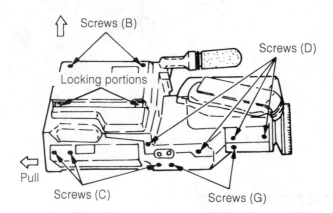

■ **10-8** *Remove two screws of left case in the General Electric VHS camcorder.* Thomson Consumer Electronics

Samsung 8-mm case front assembly removal

Remove 1 screw (BH:M2 × 7) at the top of camcorder case (figure 10-9). Remove 1 screw (BH-M2 × 7) at the left side of lens assembly (3). Remove final 1 screw (BH-M2 × 7) from underneath lens assembly (4). Remove the front-case assembly from the lens assembly in the direction of the arrow. Disconnect 1 connector (CN451) from the mic board (6).

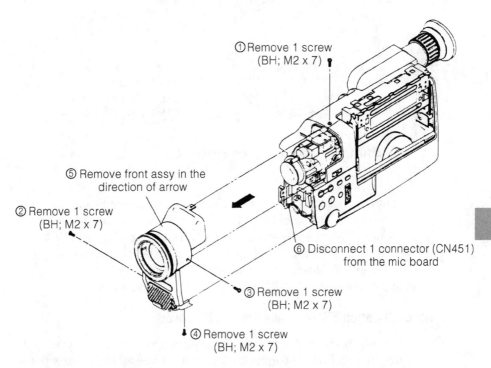

① Remove 1 screw (BH; M2 x 7)

⑤ Remove front assy in the direction of arrow

② Remove 1 screw (BH; M2 x 7)

⑥ Disconnect 1 connector (CN451) from the mic board

③ Remove 1 screw (BH; M2 x 7)

④ Remove 1 screw (BH; M2 x 7)

■ **10-9** *Removing front case assembly in Samsung 8-mm model.* Samsung Electronics Co.

Canon 8-mm front cover and left cover removal

Loosen screw (C), one screw (D) and one screw (F) (figure 10-10). Screw C is a self tap of M1.7 × 4.5 mm, while D and F are M1.7 × 4.5 mm and M1.7 × 2.5 mm, respectively. Disconnect connector CN001, and remove the front cover. Detach the tripod screw hole part (3). Now, disconnect connector CN003, and remove the left cover.

VCR section removal

To repair or replace any component in the tape path, the video cassette record and playback assembly must be removed from the

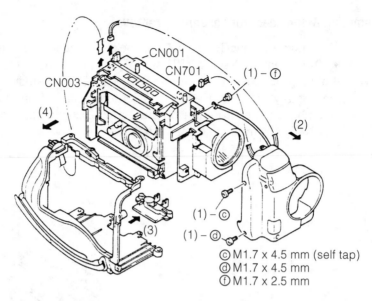

CN001
CN701
CN003
(1) – ①
(4)
(2)
(1) – ©
(3)
(1) – ⓓ

© M1.7 x 4.5 mm (self tap)
ⓓ M1.7 x 4.5 mm
① M1.7 x 2.5 mm

■ **10-10** *Removal of Canon ES1000 front and left covers.* Canon, Inc.

cabinet. In some camcorders, a lot of components must be removed, while in others it's a breeze to remove the cabinet and VCR section. The cassette-up unit can be removed in some VHS camcorders to get at the VCR components, while in the smaller units, the whole VCR section is removed. Keep all loose screws in a separate container. Check off the removed components.

Removal Of Canon ES1000 cassette and LS cover

Loosen two screws (A), and remove the front cassette cover (figure 10-11). Press the eject button. Insert tweezers into the gap under part -A leaf spring. While lifting it up, unclamp the LS cover. For part -B (circled), take the same step as mentioned above to remove the LS cover. Make sure when assembling, attach the LS cover in the eject state.

NEC V500 (VHS) cassette compartment removal

After all side panels are removed, the cassette compartment can be pulled up after removing four corner screws (M) (figure 10-12). Now remove the cassette-up unit. When installing the cassette-up unit, make sure the cassette is in the closed (down) position. Check for correct seating of the cassette unit before replacing the screws.

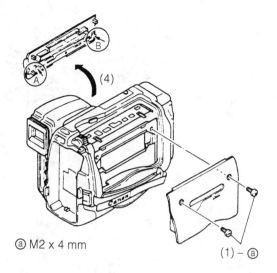

ⓐ M2 x 4 mm

(1) – ⓐ

■ **10-11** *Removal of Canon ES1000 cassette and LS cover.* Canon, Inc.

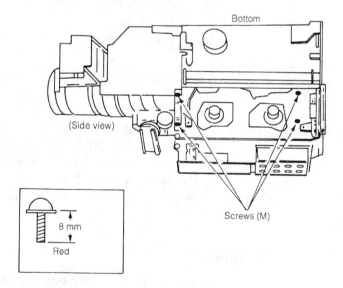

Bottom

(Side view)

Screws (M)

8 mm

Red

■ **10-12** *In some camcorders, take out four screws to remove cassette assembly.*

Samsung 8-mm VCR and camera block removal

Remove 1 screw (BH:M2 × 4) to remove the camera block assembly (figure 10-13). Remove 1 screw (BH:TAP 1.7 × 6) in the left side of camera area (2). Pull and remove the camera block in direction of the arrow.

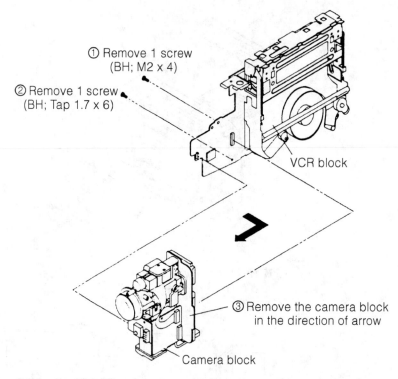

① Remove 1 screw (BH; M2 x 4)

② Remove 1 screw (BH; Tap 1.7 x 6)

VCR block

③ Remove the camera block in the direction of arrow

Camera block

■ **10-13** *Samsung 8-mm VCR and camera block removal.* Samsung Electronics Co.

Remove 4 screws (BH:M2 × 3) at the top of the VCR assembly (1). Disconnect 6 different connectors (W101, W501) two connectors, and (W502) three connectors. Mark down where each plug is connected to the VCR chassis. Remove the main board upward in the direction of the arrow so the full deck VCR assembly is free (figure 10-14).

Camera section removal

The camera section often comes out with one side of the cabinet. Then the camera unit must be separated from the cabinet. The EVF, microphone, and small accessories must be removed before the cabinet or case screws are removed. In smaller camcorders, the camera (front section) is removed from the camcorder body. A full size view of all cabinet parts of a small Zenith VM6150 camcorder is shown in figure 10-15.

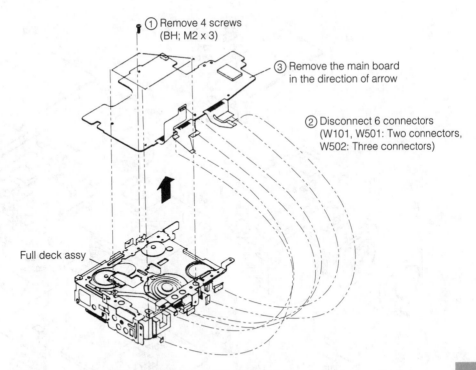

① Remove 4 screws
 (BH; M2 x 3)

③ Remove the main board
 in the direction of arrow

② Disconnect 6 connectors
 (W101, W501: Two connectors,
 W502: Three connectors)

Full deck assy

■ **10-14** *Removal of Samsung SCX854 VCR block removal.* Samsung Electronics Co.

Removal of Canon ES1000 camera PCB

The camera PCB, power supply PCB, and recorder PCB can be re-moved at the same time. Loosen 1 screw (F), disconnect CN1401 (board to board connector), and remove the camera PCB (figure 10-16). Loosen two screws (F), disconnect the CN002 (board to board connector), and remove the power supply PCB. Disconnect the CN101, CN102, CN103, CN104, CN105, and CN2001 connectors. Loosen 1 screw (F), and remove the recorder PCB, while dis-engaging the claw A.

Samsung camera block removal

To remove the camera block assembly, remove 1 screw (BH-TAP 1.7 × 6) to remove the remote module board (1). Disconnect con-nector (CNA01) from the auto board (figure 10-17). Remove 1 screw (BH-TAP 17 × 6) to remove auto board (3). Remove 1 screw at the left side of lens assembly (BH-TAP1.7 × 6) (4). Remove two (BH-TAP1.7 × 6) screws on right side of camera assembly to re-move the tripod chassis. Remove two screws (BH-TAP1.7 × 6) to remove the process board.

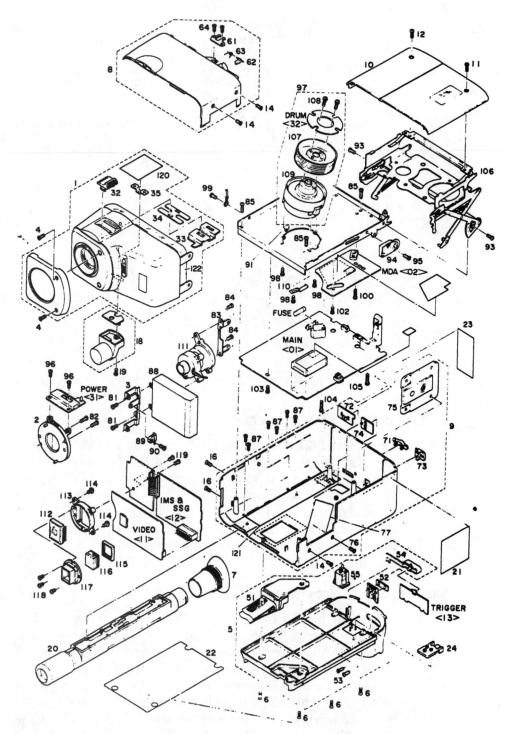

312

■ **10-15** *Complete cabinet and part layout in Zenith VM6150 camcorder.* Zenith Corp.

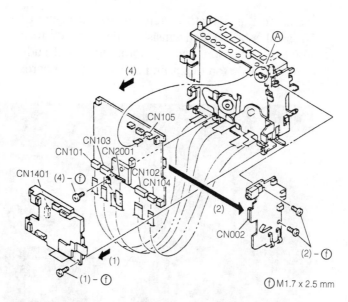

(4)

CN105
CN103
CN101 CN2001
CN1401 (4) – ⓕ
CN102
CN104

(2)

CN002

(1)

(2) – ⓕ

(1) – ⓕ

ⓕ M1.7 x 2.5 mm

■ **10-16** *Removal of Canon ES1000 camera PCB.* Canon, Inc.

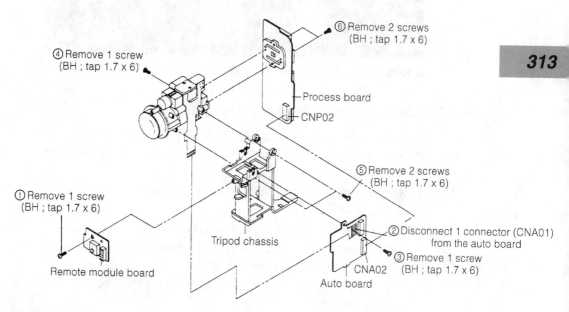

⑥ Remove 2 screws
(BH ; tap 1.7 x 6)

④ Remove 1 screw
(BH ; tap 1.7 x 6)

Process board

CNP02

⑤ Remove 2 screws
(BH ; tap 1.7 x 6)

① Remove 1 screw
(BH ; tap 1.7 x 6)

② Disconnect 1 connector (CNA01)
from the auto board

③ Remove 1 screw
(BH ; tap 1.7 x 6)

Tripod chassis

Remote module board

CNA02

Auto board

■ **10-17** *Samsung 8-mm camera block removal.* Samsung Electronics Co.

Circuit board removal

You will probably find several circuit boards in the camcorder
called the luminance/chrominance, main circuit, interface process,
regulator, and control circuit boards. These are little boards con-

nected to the operating components throughout the camcorder. The smaller boards can consist of the input key, fuse circuit, sensor, autofocus, function switch, motor drive and audio circuit board (figure 10-18). You might find only two large boards in some units.

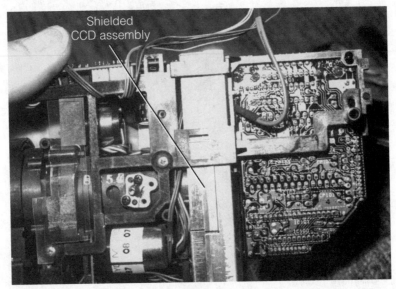

■ **10-18** *Shielded CCD sensor assembly in an RCA VHS camcorder.*

RCA CPR100 (VHS-C) main circuit board removal

(See figure 10-19.) Remove the EVF, microphone, left case, cassette cover, left cover, VCR section, and luminance/chrominance circuit boards.

1. Remove one screw (1) holding the VCR board and the main circuit board.
2. Remove one tab on the VCR board holder.
3. Disconnect eight connectors (CN16, CN603, CN604, CN902, CN903, CN904, CN906, and CN908).
4. Disconnect the following four connectors (CN16, CN551, CN905, and CN214).
5. Remove the main circuit board from the head switch and function switch circuit board in the direction of the arrow.

Samsung 8-mm function board removal

Remove 4 screws (BH:TAP2 × 4) to remove the function board from the left case assembly (figure 10-20).

Main
circuit board

Disconnect
four connectors

■ **10-19** *Disconnect four connectors to remove the main circuit board in RCA CPR100.* Thomson Consumer Electronics

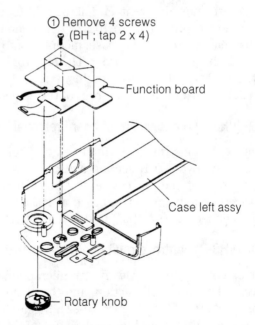

① Remove 4 screws
(BH ; tap 2 x 4)

Function board

Case left assy

Rotary knob

■ **10-20** *Removal of Samsung 8-mm function board assembly.* Samsung Electronics Co.

Pentax PV-C850A 8-mm process board removal

Remove three screws (1) holding the process circuit board in place (figure 10-21). Lift up the process board in the direction of the arrows. Now disconnect ten connectors.

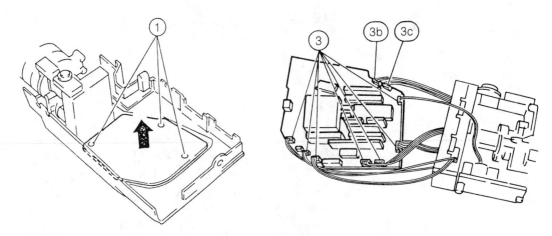

■ **10-21** *Pentax 8-mm camcorder process board removal.* Pentax Corp.

Samsung 8-mm circuit board location

There are nine different circuit boards found in the Samsung SCX854 camcorder (figure 10-22). The main board is the largest, with a mic board at end of case, module board and function board towards the front of camcorder. The electronic viewfinder board is at the EVF eye piece, with a battery terminal board, process board and auto board towards the front of the camcorder case.

RCA CPR100 (VHS-C) process circuit board removal

Remove the electronic viewfinder, microphone, left case, cassette cover, left cover, VCR section and camera section. Remove two screws holding the process circuit board (figure 10-23). Open the process circuit board in the direction of the arrow. Now disconnect three connectors (CN1001, CN1002, and CN1103).

RCA CPR100 (VHS-C) control circuit board removal

Remove the electronic viewfinder, microphone, left case, cassette cover, left cover, VCR section, and the camera section. Unsolder four points (CN1406) (figure 10-24). Release one tab and then remove the control board in the direction of the arrow.

Microphone removal

Some of the microphones are screwed to one side of the plastic case while others simply unplug from a mike jack. In the RCA CPR300 camcorder, the microphone unscrews from the electronic viewfinder (EVF) assembly. In small camcorders, the microphone

Main board

A/V jack board

Function board

Remote module board

Mic board

Process board

EVF board

Battery terminal board

Auto board

317

can be screwed to the top side of the camcorder with one or two mounting screws.

RCA CPR100 (VHS-C) microphone removal

Remove the electronic viewfinder (EVF). Remove one screw holding the microphone (figure 10-25). Remove the microphone in the direction of the arrow. Disconnect the connector CN51.

Sony CCD-M8E/M8U 8-mm removal of built-in microphone

Remove screw (1). Remove optical viewfinder (OVF) in the direction of the arrow (A) (figure 10-26). Now remove two more screws (3) and remove the built-in microphone (4) in the direction of the arrow (B).

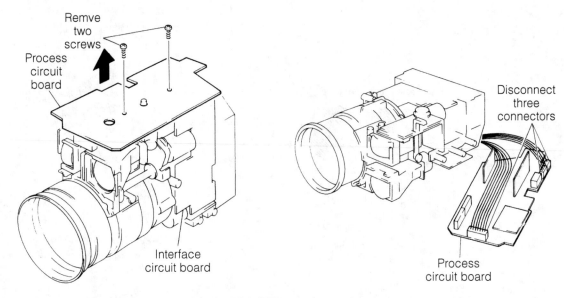

■ 10-23 *Removal of process board in RCA CPR100 camcorder.* Thomson Consumer Electronics

318

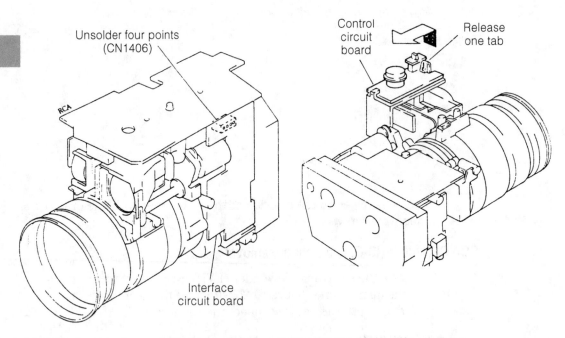

■ 10-24 *Unsolder four points to release tab on RCA CPR100.* Thomson Consumer Electronics

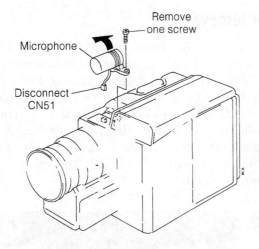

■ **10-25** *Remove one screw to remove microphone in RCA VHS-C camcorder.* Thomson Consumer Electronics

Remove one screw

Microphone

Disconnect CN51

1) Remove 1 screw ①.
2) Remove OVF ② in the direction of arrow Ⓐ.
3) Remove 2 screws ③, and remove the built-in microphone ④ in the direction of arrow Ⓑ.

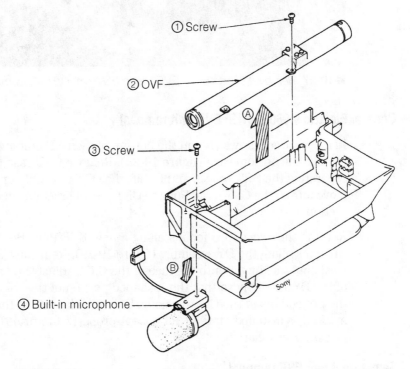

① Screw

② OVF

③ Screw

④ Built-in microphone

■ **10-26** *To remove microphone in Sony 8-mm camcorder, remove one screw (1).* Sony Corp.

Electronic viewfinder removal

Most camcorders have an electronic viewfinder (EVF) (figure 10-27). Smaller camcorders might not have one, or you might find the optical viewfinder (EVF) as in regular cameras. Many of the latest camcorders have a color viewfinder with an LCD screen. The Sharp 8-mm View Cam has a color LCD display screen on one side of the camcorder. A JVC VHSC GRSV3 model has an LCD screen at the rear with the optional tuner that allows it to operate as a TV set as well as a camcorder. The LCD picture can have a 3- or 4-inch LCD monitor screen.

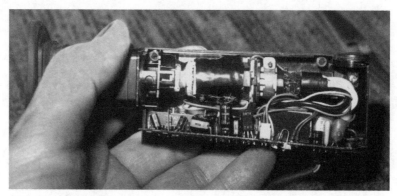

■ **10-27** *Removal of complete EVF assembly from a VHS-C camcorder.*

General Electric 9-9605 (VHS) EVF unit removal

Remove three screws (N) on the bottom of the EVF unit and then remove the bottom case (figure 10-28). Remove CRT case (B) by separating the CRT case A and B. Lift the CRT assembly up to remove it from the CRT case. Pull the CRT socket assembly in the direction of the arrows.

Reverse the procedure for installing a new EVF unit. Be careful when installing the DY assembly (figure 10-29). Reinstall the CRT masking by sliding it onto the face of the CRT. Adjust the position of the DY assembly so that the V-shaped portion of the coil meets the projections of the CRT masking. This will align when the CRT masking is installed on the CRT case A properly. Confirm the display after installation.

Samsung 8-mm EVF removal

Remove 2 screws (plain:TAP2 × 6) to remove the EVF assembly from the right case assembly (figure 10-30). Pull the EVF assem-

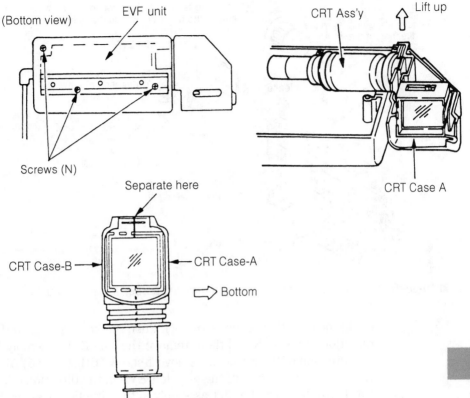

(Bottom view) EVF unit

CRT Ass'y ↑ Lift up

Screws (N)

CRT Case A

Separate here

CRT Case-B → ← CRT Case-A

⇨ Bottom

321

■ **10-28** *How to remove components on EVF in the General Electric VHS camcorder.*
Thomson Consumer Electronics

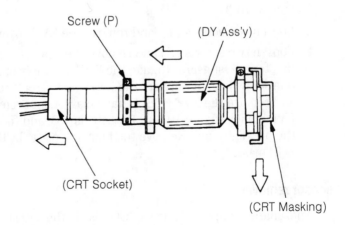

Screw (P) (DY Ass'y)

(CRT Socket)

(CRT Masking)

■ **10-29** *Reverse procedure to replace EVF tube in GE*
9-9605 camcorder. Thomson Consumer Electronics

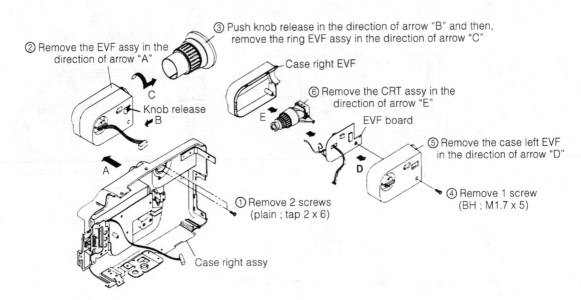

② Remove the EVF assy in the direction of arrow "A"

③ Push knob release in the direction of arrow "B" and then, remove the ring EVF assy in the direction of arrow "C"

Case right EVF

C

Knob release

B

A

⑥ Remove the CRT assy in the direction of arrow "E"

E

EVF board

⑤ Remove the case left EVF in the direction of arrow "D"

D

① Remove 2 screws (plain ; tap 2 x 6)

④ Remove 1 screw (BH ; M1.7 x 5)

Case right assy

■ **10-30** *Removal of EVF unit in Samsung 8-mm camcorder.* Samsung Electronics Co.

bly in the direction of the arrow (2). Push the knob release in the direction of arrow B and then, remove the ring EVF assembly in the direction of the arrow C. Remove 1 screw (BH:M1.7 × 5) from EVF plastic case. Pull off the case left EVF in the direction of arrow D (5). Remove the CRT assembly in the direction of arrow E.

Canon ES1000 EVF removal

1. Loosen two screws (C), and remove the eye cup holder (figure 10-31).
2. Loosen two screws (T), and remove the EVF cover.
3. Loosen two screws (E),and remove the gear base and three diopter adjust gears. To take the EVF assembly apart, loosen one screw (E), disconnect the CN1 and CN1502 connectors, and remove the EVF PCB. Detach claw A, and remove the EVF holder (figure 10-32). Detach claw B, and then remove the backlight unit. Remove the heatsink plate, LCD panel and LCD mask.

CCD sensor removal

The charge-coupled device (CCD) is in the latest camcorders, where the early models have small pickup tubes. The CCD sensor is subject to electrostatic breakdown like other C-MOS devices.

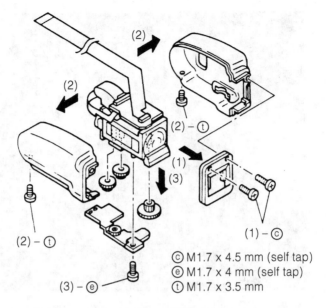

(2)

(2)

(2) – ⓣ

(1)

(3)

(2) – ⓣ

(1) – ⓒ

ⓒ M1.7 x 4.5 mm (self tap)
ⓔ M1.7 x 4 mm (self tap)
ⓣ M1.7 x 3.5 mm

(3) – ⓔ

■ **10-31** *Removal of Canon EVF unit.* Canon, Inc.

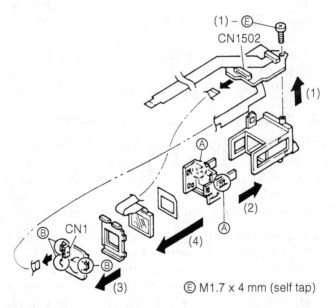

(1) – Ⓔ

CN1502

(1)

(2)

CN1

Ⓐ

Ⓐ

(4)

Ⓑ

Ⓑ

(3)

Ⓔ M1.7 x 4 mm (self tap)

■ **10-32** *Assembly of the EVF unit in the Canon ES1000 camcorder.* Canon, Inc.

Use extreme care when removing and installing the CCD sensor. Proper storage, handling and soldering must be performed to prevent damage (figure 10-33).

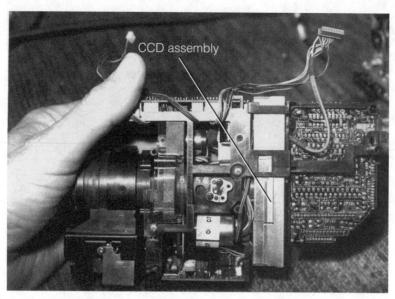

■ **10-33** *CCD sensor in the RCA VHS camcorder.*

Be careful not to soil the optical surface of the CCD image sensor with fingerprints or scratches. If soiled, wipe off and clean gently with a silicon lens tissue, chamois, etc. Sometimes a shield is placed over the CCD image sensor and should not be removed until ready to install. Quickly solder the sensor terminals. The optical filter of the CCD sensor can be discolored by excessive heat.

Mitsubishi HS-C20U (VHS-C) CCD image sensor removal

Take out two screws (A) and separate the optical block and imager board (figure 10-34). Remove three screws (B) from the filter holder (C) and remove the filter holder, filter (D) and rubber spacer (E). Take out two screws (F) from the image holder (C). Unsolder and remove the image sensor (H).

To install the CCD component, remove the protective seal from the CCD image sensor and place it on the image holder (C). Then atop these, place the rubber spacer, optical filter (D), and filter holder (C). Notice if the CCD image sensor is correctly oriented with respect to the image holder board. Also, check that the masking of the optical filter is positioned at the lower front. Secure the filter holder to the image holder with three screws (B). Now install the filter holder to the optical block with the two screws (A).

■ 10-34 *Exploded view of CCD sensor board in Mitsubishi HS-C20U camcorder.* Mitsubishi Corp.

Carefully insert the CCD image sensor pins protruding from the image holder into the holes of the image board and secure with two screws (F). Be careful when soldering the CCD image sensor pins.

Canon 8-mm CCD heatsink and VAP removal

Loosen one screw (F) and one screw (G). Then remove the CCD heatsink plates A and B (figure 10-35). Loosen another screw (H), and remove the VAP lock arm.

Pickup tube assembly removal

In the early video cameras and camcorders, the Vidicon, Newvicon, and Saticon tubes used image pickup tubes in the VHS camcorder. These tubes can be removed from the front, rear or with the yoke assembly. The lens and filter assemblies must be removed if it comes out of the front of the camcorder. Most of the

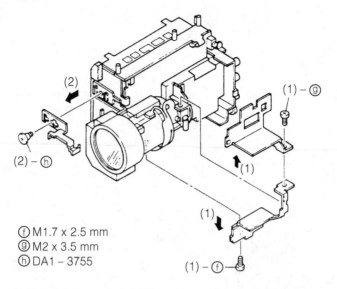

(2)

(1) – ⑨

(2) – ⓗ

↑(1)

(1)

ⓕ M1.7 x 2.5 mm
ⓖ M2 x 3.5 mm
ⓗ DA1 – 3755

(1) – ⓕ

■ **10-35** *Removal of CCD and heat sinks in Canon 8-mm camcorder.* Canon, Inc.

pickup tubes in the camcorder come out with the yoke assembly attached. Often, the front lens assembly is attached to the pickup tube holder.

Auto focus and power zoom assembly

Before leaving the camera section, a few words should be noted about the AF zoom lens assembly. (The auto focus and power zoom motors are discussed in Chapter 7.) These two motors are on the lens assembly. The auto focus (AF) is controlled by the AF motor. The power zoom of extending a wide or close-up scene is done with the zoom motor. The Macio lens may have a manual setting on most camcorders.

The Canon ES1000 lens group and IC meter are removed by loosening two screws (R) and three screws (Q). Then remove the front line unit (figure 10-36). Remove the V shift ring unit and two bars. Loosen two screws (N), and remove the IG meter (4). Remove the two bars and R shift ring unit.

Tape transport mechanism removal

Most of the mechanical problems are caused by the loading and tape transport mechanism. The VCR or VTR transport must often

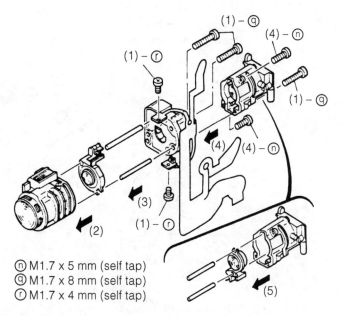

@ M1.7 x 5 mm (self tap)
@ M1.7 x 8 mm (self tap)
@ M1.7 x 4 mm (self tap)

■ **10-36** *Removal of lens group and 1G meter in a Canon 8-mm camcorder.* Canon, Inc.

be removed from the camcorder for normal component removal and replacement. The tape heads and guide assemblies are fixed components found on the VCR transport. Replacement of the cylinder, mode, loading, and capstan motors are discussed in Chapter 7. The many components found in the VTR and VCR assembly are shown in figure 10-37.

Video head removal

The video head (upper cylinder or drum) found in most camcorders is removed from the bottom section in replacement. The lower cylinder or drum is with the motor assembly. The drum or cylinder (video head) leads must be removed from the upper drum assembly. Be careful not to touch the video heads with your fingers. Often, drum adjustments are required after installing a new upper head assembly (figure 10-38).

Mitsubishi HS-C20U drum removal

Unsolder the lead wires of the upper drum relay pins (figure 10-39). Take out two screws and remove the upper drum in the upward direction. Install the new upper drum while using care not to touch the head tips or scratch the drum. After installing the new

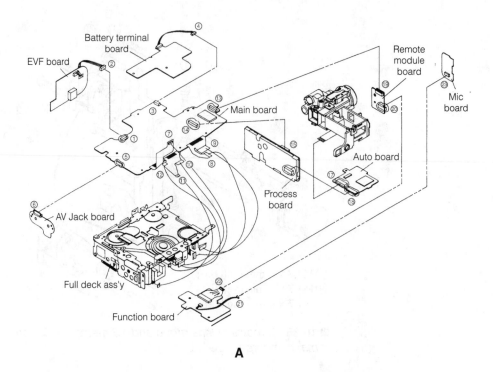

Battery terminal board

EVF board

④

②

Main board

Remote module board

Mic board

③

⑬

⑭

⑫

⑮

Auto board

⑦

⑨

⑪

⑧

①

⑤

⑩

⑯

⑰

⑱

Process board

⑥

AV Jack board

Full deck ass'y

⑳

㉒

㉑

Function board

A

No	Conn. Wafer Loca-No	Direction	Conn. Wafer Loca-No
1	CN301	From EVF ass'y	CNB01
2	CNB01	To main C.B.A.	CN301
3	CN901	From batt. term. C.B.A.	CN801
4	CN801	To main C.B.A.	CN901
5	CN201	From A/V jack C.B.A.	CN250
6	CN250	To main C.B.A.	CN201
7	W101	To full deck ass'y	D/motor
8	W501	To full deck ass'y	F.P.C.
9	W501	To full deck ass'y	C/motor
10	W502	To full deck ass'y	D/motor
11	W502	To full deck ass'y	L/motor
12	W502	To full deck ass'y	Prog. S/W
13	CN601	From remote M.C.B.A.	CN050
14	CN602	From process C.B.A.	CNP01
15	CNP01	To main C.B.A.	CN602
16	CNP02	From auto C.B.A.	CNA02
17	CNA01	From zoom lens ass'y	F.P.C.
18	CNA02	To process C.B.A.	CNP02
19	CN050	To main C.B.A.	CN601
20	CN051	From function C.B.A.	W960
21	CN961	From mic C.B.A.	CN451
22	W960	To remote mod. C.B.A.	CN051
23	CN451	To function C.B.A.	CN961

B

■ **10-37** *Schematic of Samsung SCX854 8-mm board connections.* Samsung Electronics Co.

■ **10-38** *The VHS-C cylinder can be seen after removing covers in RCA camcorder.*

■ **10-39** *Unsolder 8 leads before removing drum assembly in Mitsubishi HS-200 camcorder.* Mitsubishi Co.

drum, use the micro-checker with its probe 2 to 5 mm from the upper circumference of the upper drum. Point the probe toward the center of the drum. At the point the probe just contacts the upper drum, set the scale to zero. While taking care not to apply pres-

sure, use a drinking straw or similar tool to slowly turn the drum. Check for needle deflection within 4 microns. If greater than 4 microns, loosen the two screws and carefully readjust the upper drum position. Tighten the two screws in a balanced manner. Repeat this adjustment until the deflection is within 4 microns. After replacement, perform checks and adjustments for the playback switching point and FM waveform.

Samsung 8-mm drum removal

Be very careful when removing the drum assembly. Do not touch the head tip (11) during servicing (figure 10-40). First remove the housing assembly. Remove one screw (1), then remove the Guide Tape T (2). Remove two screws (4), (5), then remove the base drum (6). Remove one screw (7), then remove the earth brush (8). Remove two screws (9), then remove the drum assembly.

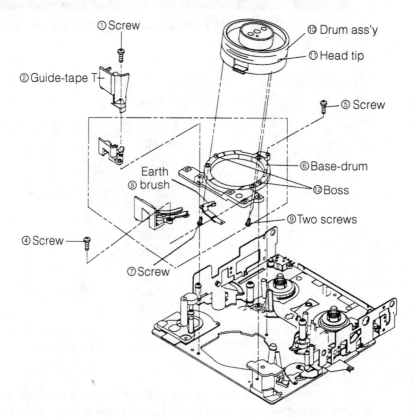

■ **10-40** *Samsung SCX854 8-mm drum removal.* Samsung Electronics Co.

Other transport parts removal

This section covers the miscellaneous tape transport parts in the various models.

Minolta C3300 audio/control (A/C) head removal

Remove the cassette housing. Disconnect connector CN13. Move the A/C head to the loading position (to the drum side). Remove the three screws holding the A/C head (figure 10-41). Take out the

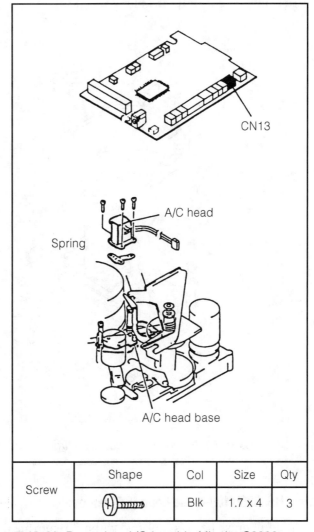

Screw	Shape	Col	Size	Qty
		Blk	1.7 x 4	3

■ **10-41** *Removing A/C head in Minolta C3300 camcorder.* Minolta Camera Co.

A/C head from the base mount. Be careful with the head spring in removing the A/C head. Adjust the A/C head after installation.

RCA CPR100 audio/control head removal

Remove the cassette holder. Disconnect connector CN15. Move the audio/control head toward the upper cylinder (operation position). Remove three screws holding the A/C head (figure 10-42). Now remove the A/C head from the base. The A/C head height adjustment spring is removed when removing the head. Perform the audio/control head rough, height/tilt/azimuth, and horizontal position adjustments after installing A/C head.

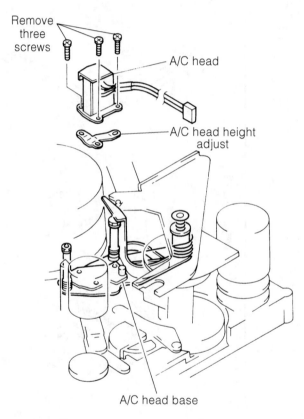

Remove three screws

A/C head

A/C head height adjust

A/C head base

■ **10-42** *Removal of audio/control head in RCA VHS-C camcorder.* Thomson Consumer Electronics

Mitsubishi HS-C20U full-erase head (FE) removal

The full-erase head is replaced without removing the supply guide pole. Remove the slit washer and spring, and then remove the

roller arm in the upward direction (figure 10-43). Gently press the erase head arm in the outward direction and remove the screw from the erase head arm and replace. Install the new full-erase head in the proper position. Use a spare cassette tape and observe the tape running in the area of the supply guide pole. If tape curling or wrinkling occurs, perform supply guide pole height and interchangeability adjustments.

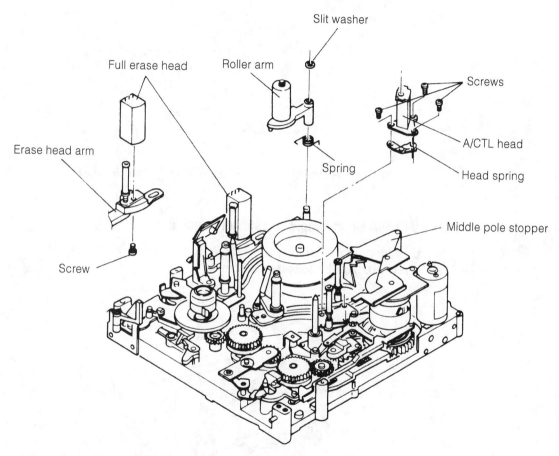

■ 10-43 *Removal of full-erase head in Mitsubishi camcorder.* Mitsubishi Co.

RCA CPR100 full-erase head (FE) removal

Remove the cassette holder. Disconnect connector CN16. Remove the washer holding the impedance roller and spring between the impedance roller and chassis (figure 10-44). Lift up the impedance roller and remove. Remove one screw holding the full-erase head.

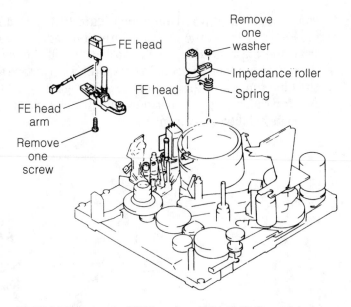

FE head

Remove one washer

Impedance roller

Spring

FE head

FE head arm

Remove one screw

■ **10-44** *Removal of FE head on RCA VHS-C model.* Thomson Consumer Electronics

Pentax PV-C850A 8-mm supply end sensor removal

Unsolder two points on the sensor (figure 10-45). Remove the screw holding the supply-end sensor.

■ **10-45** *Removing supply-end sensor in Pentax 8-mm camcorder.* Pentax Corp.

Pentax PV-C850A 8-mm dew sensor removal

Remove the lower cylinder (figure 10-46). Remove one screw holding the dew sensor. Disconnect the connector on the motor drive circuit board.

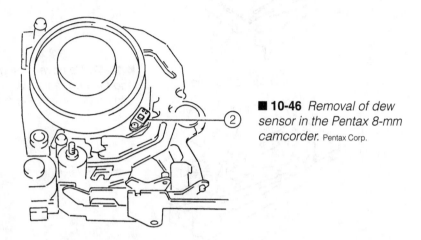

■ **10-46** *Removal of dew sensor in the Pentax 8-mm camcorder.* Pentax Corp.

Minolta C3300 (VHS-C) supply and take-up reel sensor

Remove the main PC board. Disconnect the connector CN-M1 on the MDA PC board. Remove two screws holding the MDA PC board (figure 10-47). Now remove the MDA PC board from the chassis. Remove the two screws—one holds the supply reel sensor and the other holds the take-up reel sensor. Lift up both sensors from the chassis.

Samsung SCX854 supply reel and take-up reel removal

Remove the tension band assembly. Remove the washer slit (1), and then remove lever brake S (2) and spring lever brake S (3). You might have to remove several pieces before getting to the reel assemblies (figure 10-48). Remove slit (4), and spring arm brake S (5), then remove the arm brake S (6). Lift up the supply reels S (7), and then take out the washer plane (3). Remove the washer slit (10), and then remove the lever T brake (11). Remove washer slit (12), and then remove the arm clutch assembly (13). Lift up the take-up T reel assembly.

Reverse order to reassemble all reel components. Mount the take-up T reel (9). Put arm clutch assembly (13) into the slit home (14) of the sub deck assembly, and then install it with slit washer (12).

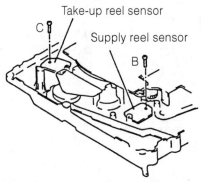

Take-up reel sensor

Supply reel sensor

C

B

A

■ **10-47** *Removal of supply and take-up reel in Minolta camcorder.* Minolta Camera Corp.

Put the T lever brake (11) into the home slit (15) of the sub deck assembly, and then install it with the slit washer (10). Place the plane washer (8) into shaft, and then mount the supply reel S (7) to the shaft.

Place in arm brake S (6), and install the spring arm brake S (5), and then install it with the slit washer (4). Put spring lever brake S (3), and install the lever brake S (2), and then install the slit washer (1). It's best to lay out each small part in a line as they are removed, so you know how they must be returned in the reverse order.

RCA CPR100 mechanism state (mode sensor) switch removal

Remove the cassette holder. Remove three screws holding the middle pole stopper (figure 10-49). Disconnect connector CN902 and remove the state switch.

Pentax PV-C850A 8-mm pressure roller arm assembly removal

Remove the E ring. Remove the spring hooked to the pressure roller. Lift the pressure roller arm assembly, taking care that it does not hit the guide pole, and pull out (figure 10-50).

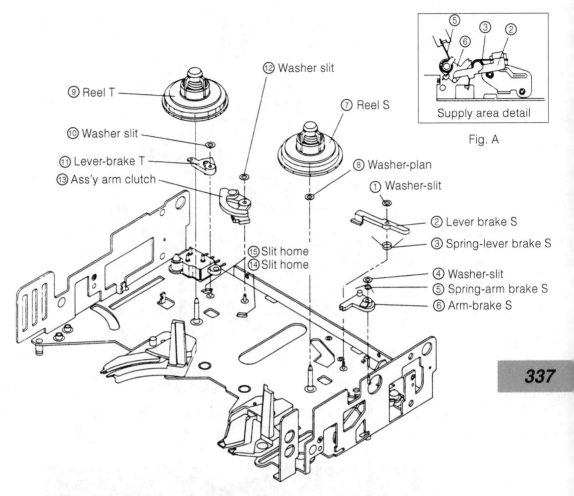

Washer slit ⑫
⑨ Reel T
⑦ Reel S
⑩ Washer slit
⑪ Lever-brake T
⑬ Ass'y arm clutch
⑧ Washer-plan
① Washer-slit
⑮ Slit home
⑭ Slit home
② Lever brake S
③ Spring-lever brake S
④ Washer-slit
⑤ Spring-arm brake S
⑥ Arm-brake S

⑤ ③ ②
⑥
Supply area detail
Fig. A

337

■ **10-48** *Removal of supply (S) and take-up (T) reels in Samsung 8-mm camcorder.* Samsung Electronics Co.

Samsung 8-mm pinch roller removal

Remove two slit washers (1), and then remove the Review Arm assembly (2) and Spring Review Arm (3). Take out the spring lever pinch (5) from the claw (4), then remove the Arm Pinch roller assembly (6) (figure 10-51).

To reassemble reverse the order. Place the pinch arm roller assembly in the bushing, and attach the spring lever pinch (5) on the claw (4). Install the slit washer (1). Put the spring review arm (3) in the bushing, and then hook it to the spring hanger area (8) of the arm review assembly (2) and to the notch of stud-slide (7). Finally, install the arm review assembly (2) with the slit washer (1).

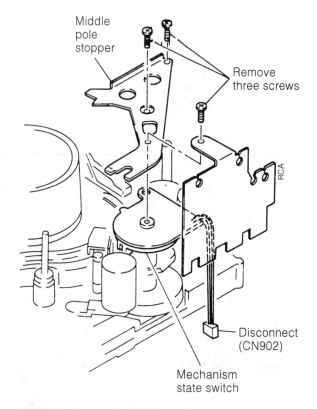

Middle pole stopper

Remove three screws

RCA

Disconnect (CN902)

Mechanism state switch

■ **10-49** *Removal of mechanism state switch in RCA VHS-C camcorder.* Thomson Consumer Electronics

Pinch roller

■ **10-50** *Pinch roller assembly in a VHS-C camcorder.*

Remove and replace

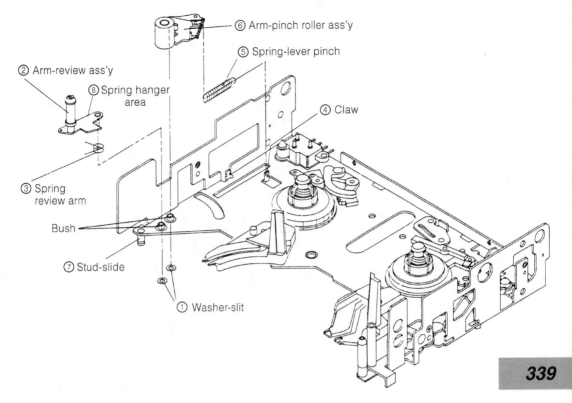

Arm-pinch roller ass'y ⑥

Spring-lever pinch ⑤

② Arm-review ass'y

⑧ Spring hanger area

④ Claw

③ Spring review arm

Bush

⑦ Stud-slide

① Washer-slit

■ **10-51** *Removal of pinch roller assembly in Samsung 8-mm camcorder.* Samsung Electronics Co.

RCA PRO845 impedance AM subassembly replacement and removal

Remove one washer (4). Lift up the impedance roller (2) to remove it from the impedance roller shaft (3). Remove one washer (7) (figure 10-52). Remove the head cleaner from the head cleaner shaft (6). Take care not to damage or scratch impedance roller in replacement. Clean up all parts. Reverse procedure for replacement.

Samsung 8-mm arm tension removal

To remove the arm tension assembly, remove slit washer (1) and then remove the screw (3) (figure 10-53). Remove the spring of the arm tension assembly from the claw (8), and then remove the arm tension assembly (5) from the bushing (2). Release the hook (13) of the arm tension assembly from the hole (12), and then remove the band tension assembly. Remove the lever guide assembly (6), and then remove the slide L. G. (7) from the sub deck assembly.

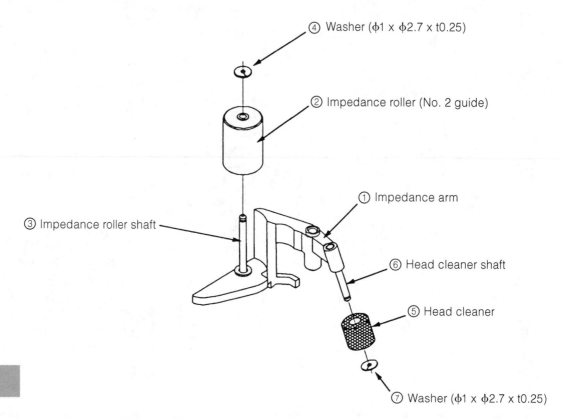

④ Washer (φ1 x φ2.7 x t0.25)

② Impedance roller (No. 2 guide)

① Impedance arm

③ Impedance roller shaft

⑥ Head cleaner shaft

⑤ Head cleaner

⑦ Washer (φ1 x φ2.7 x t0.25)

■ **10-52** *RCA PRO845 impedance arm replacement and removal.* Thomson Consumer Electronics

RCA 8-mm pinch lever assembly removal

Make sure the mechanism (deck) is in the standby position. Remove the cassette mechanism, the LED bracket, the idler gear assembly, and the reel chassis assembly. Remove the pinch lever spring (9) (figure 10-54). Slide the T-shuttle assembly to the front, turn the eject lever assembly clockwise, then turn the pinch lever assembly (6) in the direction of the arrow, and now lift up to remove it from the pinch lever assembly (7).

Mitsubishi HS-C20U (VHS-C) supply guide pole removal

The guide poles serve to improve tape transport stability between the cassette output and drum input by maintaining the required height. Adjust the supply guide rollers for smooth tape movement (figure 10-55). Remove the screw at the top of assembly and pull off the guide pole.

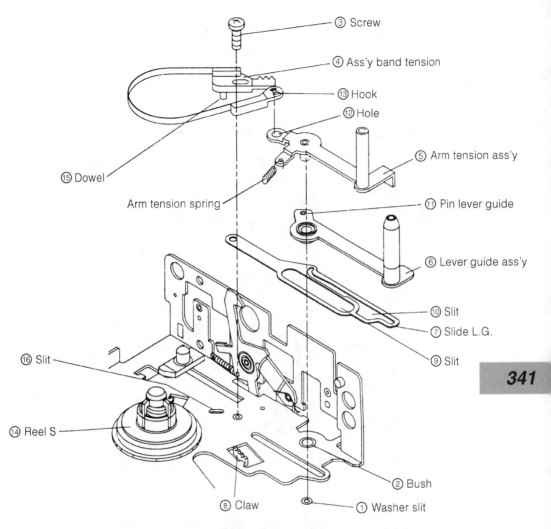

③ Screw

④ Ass'y band tension

⑬ Hook

⑫ Hole

⑤ Arm tension ass'y

⑪ Pin lever guide

⑮ Dowel

Arm tension spring

⑥ Lever guide ass'y

⑩ Slit

⑦ Slide L.G.

⑨ Slit

⑯ Slit

341

⑭ Reel S

② Bush

⑧ Claw

① Washer slit

■ **10-53** *Removal of arm tension assembly in Samsung 8-mm camcorder.* Samsung Electronics Co.

RCA CPR100 (VHS-C) supply loading ring and take-up loading ring removal

Remove the lower cylinder, wire clamp plate, flywheel FG circuit board, capstan flywheel, and middle pole lever. Remove one washer (1) holding the loading (4) and pull out loading gear (figure 10-56). Remove one washer (1) holding the ring idler gear (1) and pull out the ring idler gear. Take out the washer holding the ring idler gear (2) and pull off. Remove three E rings holding the supply and take-up loading ring.

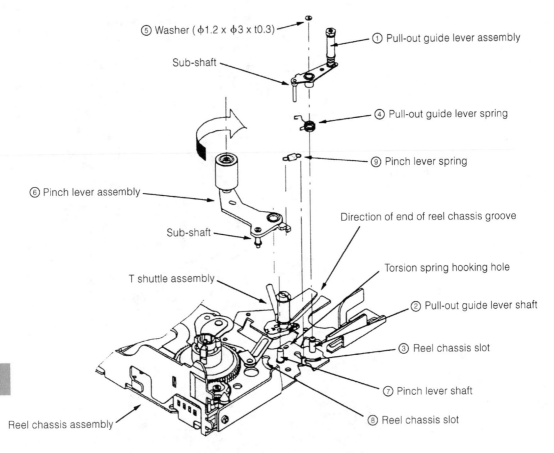

⑤ Washer (φ1.2 x φ3 x t0.3)

① Pull-out guide lever assembly

Sub-shaft

④ Pull-out guide lever spring

⑨ Pinch lever spring

⑥ Pinch lever assembly

Sub-shaft

Direction of end of reel chassis groove

T shuttle assembly

Torsion spring hooking hole

② Pull-out guide lever shaft

③ Reel chassis slot

⑦ Pinch lever shaft

⑧ Reel chassis slot

Reel chassis assembly

342

■ **10-54** *RCA 8-mm tape path slack confirmation.* Thomson Consumer Electronics

NG OK

■ **10-55** *Removal of guide poles in Mitsubishi VHS-C tape path.* Mitsubishi Co.

Samsung SCX854 arm pole base removal

Take out the pole base S (1) from Rail S (3) in the direction of arrow "B," and remove the Arm loading S (5) from sub deck. Take

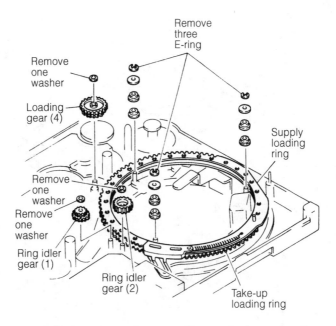

Remove
three
E-ring

Remove
one
washer

Loading
gear (4)

Remove
one
washer

Remove
one
washer

Ring idler
gear (1)

Ring idler
gear (2)

Supply
loading
ring

Take-up
loading ring

■ **10-56** *Removing supply loading and take-up loading
rings in RCA VHS-C transport.* Thomson Consumer Electronics

out the pole base T (4) in the direction of arrow "A," and remove
the arm loading T (6) from the sub deck. Reverse the order to re-
assemble the arm pole base assembly (figure 10-57).

RCA CPR100 (VHS-C) supply guide roller base removal

Remove the cassette holder, lower cylinder, wire clamp plate,
cylinder motor drive circuit board, flywheel FG circuit board and
the capstan flywheel. Now remove (1) screw holding the supply
guide roller base (figure 10-58).

Minolta C3300 (VHS-C) take-up guide roller base removal

Remove the main PC board, cassette housing, lower drum, wire
clamp, MDA PC board, FG PC board, and flywheel. Remove the
screw holding the take-up guide roller base (figure 10-59). Now re-
move the take-up guide roller base from the take-up loading ring.

Samsung 8-mm capstan motor removal

To remove capstan motor assembly, remove 2 screws (1) and one
screw (7). Remove the base capstan assembly (2) from two (2)
bushing (4), then remove the holder FPC (8) by releasing the hook
(figure 10-60). Remove the motor capstan (3) from the three bush-

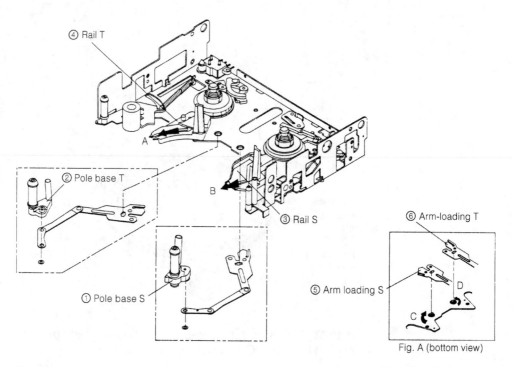

④ Rail T

② Pole base T

① Pole base S

A

B

③ Rail S

⑥ Arm-loading T

⑤ Arm loading S

C

D

Fig. A (bottom view)

■ **10-57** *Removal of arm pole base S assembly in Samsung 8-mm camcorder.* Samsung Electronics Co.

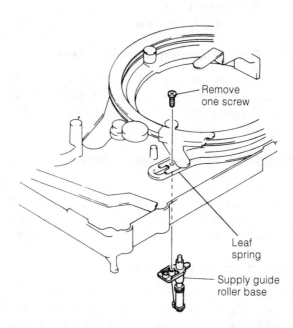

Remove
one screw

Leaf
spring

Supply guide
roller base

■ **10-58** *Removing supply guide roller base in RCA VHS-C camcorder.* Thomson Consumer Electronics

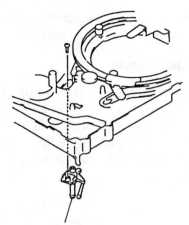

■ **10-59** *Take out one screw to remove the take-up roller in Minolta C3300 tape transport.* Minolta Camera Co.

Take-up guide roller base

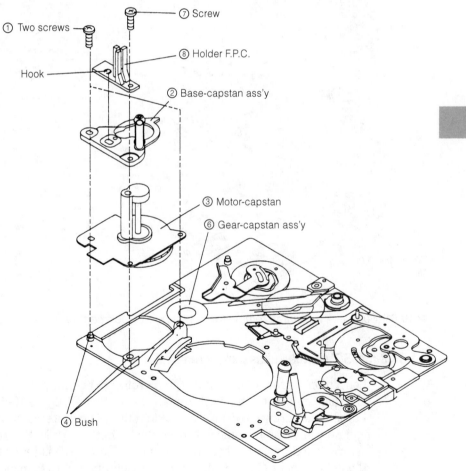

① Two screws

⑦ Screw

Hook

⑧ Holder F.P.C.

② Base-capstan ass'y

③ Motor-capstan

⑥ Gear-capstan ass'y

④ Bush

■ **10-60** *Samsung motor capstan removal.* Samsung Electronics Co.

ings (4). When reassembling, make sure that the gears of capstan motor (3) and the gear capstan assembly (6) are matched correctly.

Samsung 8-mm sub deck assembly removal

Be careful when removing components not to damage other parts. Remove sub deck assembly in the eject mode. To remove the sub deck assembly, remove idler assembly first. Take out the holder FPC (1) from the main deck assembly (3). Remove three screws (2) (figure 10-61). Remove the sub deck assembly (4) from the main deck assembly (3).

■ 10-61 *Sub deck assembly removal in Samsung SCX854 camcorder.* Samsung Electronics Co.

RCA 8-mm S/T shuttle subassembly removal

Loosen one screw (3). Turn the guide roller (1) counterclockwise and then lift it up to remove it from the S-shuttle (2) (figure 10-62). Loosen one screw (6). Turn the guide roller (4) counterclockwise and now lift it up to remove it from the T-shuttle (5). Notice that screws 3 and 6 need only to be loosened. If screw (3) is removed, the guide spacer (7) can fall out. Be very careful not to damage or scratch the guide rollers and tilt guides in replacement.

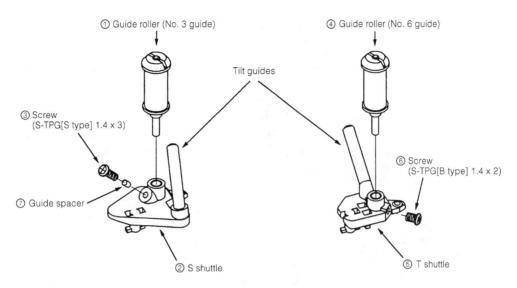

① Guide roller (No. 3 guide)

④ Guide roller (No. 6 guide)

Tilt guides

③ Screw
(S-TPG[S type] 1.4 x 3)

⑥ Screw
(S-TPG[B type] 1.4 x 2)

⑦ Guide spacer

② S shuttle

⑤ T shuttle

■ **10-62** *RCA 8-mm S/T shuttle sub-assembly removal.* Thomson Consumer Electronics

RCA 8-mm idler gear assembly removal

Make sure the mechanism (deck) is in the standby position. Remove the cassette mechanism. Remove the LED bracket. Remove one washer (figure 10-63). Remove the idler gear assembly (2) from the idler gear shaft (3). Reverse procedure for replacement.

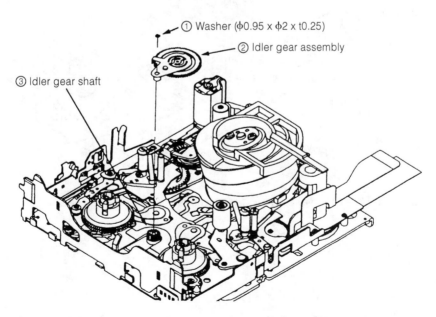

① Washer (φ0.95 x φ2 x t0.25)

② Idler gear assembly

③ Idler gear shaft

■ **10-63** *RCA 8-mm idler gear assembly removal.* Thomson Consumer Electronics

RCA PRO845 S/T reel base removal

Make sure the mechanism (deck) is in the standby position. Remove the cassette mechanism. Remove two (2) washers (8) (figure 10-64). While gently turning BT brake (5) clockwise, lift up the S-reel base (1) to remove it from the S-reel shaft. Lift up the T-reel base (2) to remove it from the T-reel shaft (4). Remove the two (2) washers (7) from the S-reel and T-reel shafts. Before installing the S-reel base and T-reel base, apply a drop of oil to both S-reel shaft and the T-reel shaft.

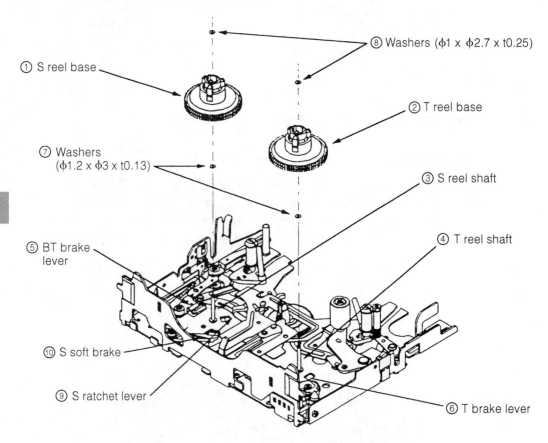

⑧ Washers (φ1 x φ2.7 x t0.25)

① S reel base

② T reel base

⑦ Washers
(φ1.2 x φ3 x t0.13)

③ S reel shaft

348

⑤ BT brake lever

④ T reel shaft

⑩ S soft brake

⑨ S ratchet lever

⑥ T brake lever

■ **10-64** *RCA PRO845 S/T reel base removal.* Thomson Consumer Electronics

Mechanical adjustments

THERE ARE FROM 10 TO 20 MECHANICAL ADJUSTMENTS TO be made in the camcorder after replacing certain parts and for better play/record operation. In the smaller camera, there are less mechanical adjustments to be made due to size. Some of the adjustments may be made with visual means. But in others, alignment tapes, operation fixtures, and critical test equipment must be used. Besides test equipment, several small special hand tools are required.

Important precautions

Always disconnect the camcorder from the power (battery or ac adapter) before removing or soldering components. Be careful when removing small screws, bolts, or washers so as not to drop them inside the unit's mechanical areas. Retrieve all loose parts. When removing a component, be careful not to damage or dislodge other parts (figure 11-1). Be careful when working around the tape guides and video head drum to prevent breaking or scratching the video head surface. Do not try to make important mechanical adjustments without the correct test equipment and alignment tapes. Always follow the manufacturer's alignment procedures. Remember, some manufacturers have made precise adjustments at the factory, like the tape transport mechanism, that ordinarily does not require adjustment.

Test equipment

Most manufacturers require the use of alignment and torque meter cassettes with mechanical adjustments (figure 11-2). Some manufacturers require that certain patch cords, adjustment plates, and fixtures be used. Besides the regular bench tools, special head drivers, torque gauge adapter tools, height jigs, and special screwdrivers are needed for correct adjustments.

Tape
guide

Pinch
roller

■ **11-1** *The mechanical parts found in the VTR or VCR transport of a VHS-C camcorder.*

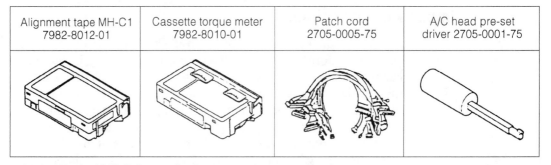

Alignment tape MH-C1 7982-8012-01	Cassette torque meter 7982-8010-01	Patch cord 2705-0005-75	A/C head pre-set driver 2705-0001-75

■ **11-2** *Minolta VHS-C jigs and adjustment components.* Minolta Camera Co.

Before starting maintenance and mechanical adjustments in the Samsung 8-mm camcorders, you should have an ac adapter (1), shoulder strap (2), RF unit (3), 6-V battery pack, 8-mm video cassette (6), lithium battery pack (5), cable dc/dc 7.5-V output (7), Remcon unit (8), and A/V cable (9) (figure 11-3). Check with the manufacturer's servicing tool list before attempting any electrical or mechanical adjustments.

Preliminary adjustment steps

After replacing or adjusting the tape guide posts, check the coarse adjustment of the guide posts' height to confirm the linearity envelope output on the scope.

Loca. No	Part No	Description & Specification	Remark
		Assy accessory; NTSC X12 zoom SC904	
1	A7008 – 0038	A apter; AC90/264 V 60Hz DC7.5 V 1.5 A UL/CSA EP2 NTSC	
2	67853 –600 –270	Shoulder – strap; SS E5 (new CI)	
3	67179 – 0104 – 00	Unit – RF; RMVN 13450 MO	
4	67223 – 0015 – 04	Battery pack; 220 V 1.2 A 6 V NB – E60A SEA	
5	64539 – 502 – 105	Lithum battery pack (55 x 30); EXP	
6	60101 – 700 – 102	8 mm Video cassette; P6 – 60/EXP	
7	66449 – 0029 – 00	Cable – dc; dc out 7.5 V 1.6 A dc – E1A	
8	67173 – 0182 – 00	Unit – Remocon (cardl); LI 3 V CR2025 CRM – E3A	
9	63054 – 402 – 040	A/V Cable; 2P A/V RCA cord 1.5MT	

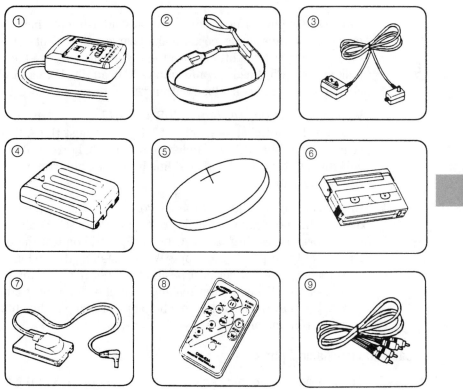

■ **11-3** *Samsung alignment equipment, adapter and battery pack.* Samsung Electronics Co.

351

When repairing or installing a new upper drum or complete cylin-
der unit, confirm the envelope output with the scope and make
fine adjustments of the A/C head in the horizontal position (VHS
and VHS-C models). Do not change the position of P1 and P4, tape
transport posts (figure 11-4).

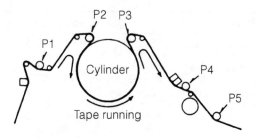

■ 11-4 *The loading post location with a VHS cylinder and tape running path.*

After reinstalling all new posts or if any adjustments have been made to the tape guide posts, make coarse adjustments of each tape guide post's height, confirm the tape transport, readjust the pullout post (P5) height, confirm the A/C head tilt (VHS and VHS-C), and confirm the envelope output with the scope (figure 11-5).

When installing the A/C head (VHS and VHS-C), confirm the A/C head tilt. Do not change height of P4 post. Adjust the A/C head coarse height, the A/C head height and azimuth, horizontal course adjustment of the A/C head, and fine horizontal adjustment of the A/C head position.

After installing or adjusting the P4 Post, make the coarse adjustment of the tape guide post heights (only P4 post), confirm the tape transport, confirm the A/C head tilt, and confirm the envelope linearity output on the scope. When installing the pullout post (P5) readjust the pullout post position. Do not readjust any other post after the P5 post. After making several of these post adjustments, you may need to only touch up one or two post heights for accurate running of the tape.

Samsung mechanical parts

The top side of the mechanical chassis in figure 11-5 of the Samsung SCX854 camcorder may need adjustment of, arm pole base T assembly (412), arm pole base S assembly (422), arm review (435), pink roller assembly (440), arm tension (445), lever guide assembly (449), arm clutch assembly (451), brake lever assembly (453), take-up reel assembly (456), supply reel assembly (458), brake lever (462), arm brake (456), guide rail take-up (474), and guide rail supply (477).

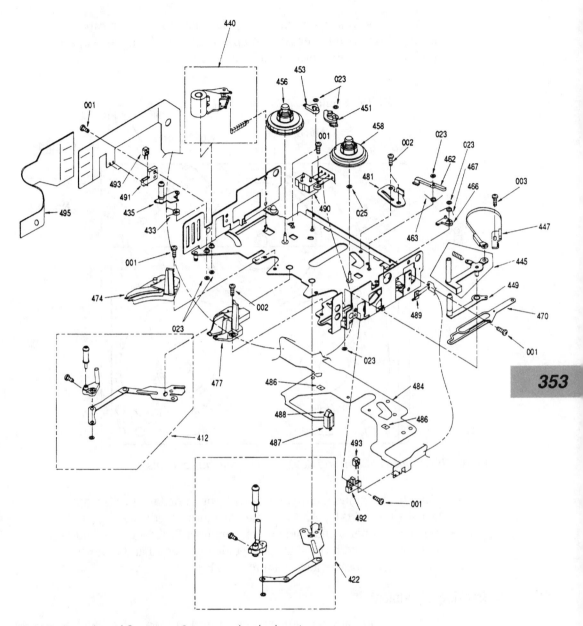

■ 11-5 *Location of Samsung 8-mm mechanical parts.* Samsung Electronics Co.

Samsung tape path adjustments

The tape path of the Samsung 8-mm transport starts at the supply reel, to the No. 1 guide, a roller lever guide number 2, slant pole guide number 3, impedance roller number 4, guide roller S number 5, number 6 the pole slant guide, pole slant guide 7 of take-up

reel T, guide roller T number 8, pole slant 9 guide for capstan, shaft pole guide number 10, the capstan shaft, and number 11 past review arm to enter into the take-up reel T (figure 11-6).

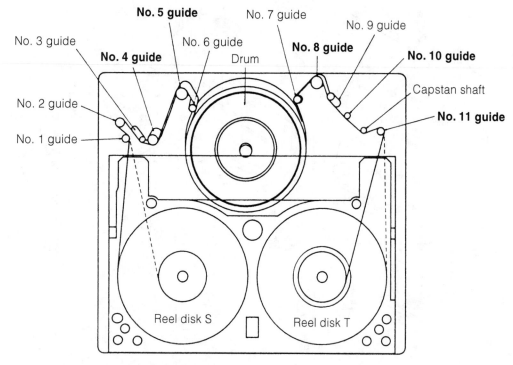

■ **11-6** *The location of Samsung SCX854 tape path adjustments.*

Tape height adjustment is made with the impedance roller, number 4 (Table 11-1). An envelope waveform is adjusted at guide roller S number 5 and guide roller T number 8. Tape guide adjustment is made with the shaft pole guide number 10 and tape wrinkle check at post review arm number 11.

Tracking adjustment

Before making any adjustments, clean up the tape paths, guides, rollers and drum or cylinder areas. In the Samsung SCX854 model, connect the oscilloscope connections to CTP101 for playback (PB) RF waveform and CTP102 for head switch and trigger waveforms (figure 11-7A). Insert alignment tape and playback for tracking adjustment. Confirm that both the entrance and exit side of RF waveforms of scope are flat (figure 11-7B). If not, go through the fine tracking adjustment.

■ Table 11-1 Layout of tape transport adjustments.

Guide no.	Component name	Adjustment purpose
No. 1	Tension pole	—
No. 2	Roller lever/G	—
No. 3	Slant pole SUB	—
No. 4	Impedance roller	Tape height
No. 5	Guide roller "S"	Envelope
No. 6	Pole slant "S"	—
No. 7	Pole slant "T"	—
No. 8	Guide roller "T"	Envelope
No. 9	Pole slant CAP	—
No. 10	Shaft pole guide	Tape guide
No. 11	Post review arm	Tape wrinkle

Samsung Electronics Co.

CTP102

CTP101

16

IC601

13 ◄━ PB RF

H'D Switching

(VCR Main PCB – Top Side)

■ 11-7A *The test point location on the main PCB in Samsung 8-mm camcorder.* Samsung Electronics Co.

Should be flat

■ 11-7B *The RF waveform for tracking adjustment should be flat.* Samsung Electronics Co.

Fine tracking adjustment

Play back the alignment tape. Confirm whether the waveform is flat or not. If it appears as A in figure 11-8, adjust guide roller number 5 clockwise to get the flat envelope waveform. If it appears as B, adjust guide number 5 counterclockwise to get the flat envelope waveform.

(a) (b) (c) (d)

Good

(e)

■ **11-8** *Samsung 8-mm drum entrance abnormal and good waveforms.* Samsung Electronics Co.

To adjust the drum exit side, confirm if waveform is flat or not. If waveform shows like C, adjust guide roller T (8), clockwise to get the flat envelope waveform. In case the waveform looks like D, adjust number 8 guide counterclockwise to get the flat envelope waveform. Reconfirm the envelope waveform that the envelope has not changed.

Tape guide adjustment

For guide adjustment number 4, play back the alignment tape. Inspect tape for bent area at the lower flange area. Simply, guide the tape to the lower flange. Cue/RPS the tape, then play it back and confirm that the RF waveform rises flat within 2.5 seconds (figure

11-9). Repeat the above adjustment of the tape until a normal waveform is obtained.

To adjust tape guide number 10, play back the alignment tape and guide the tape to the lower range. Cue/RPS the tape, then play it back and confirm that the RF waveform rises flat within 2.5 seconds in the playback mode. If waveform is not normal repeat adjustment of number 10 guide post (figure 11-10). If the tape is bent in the RPS mode, adjust guide number 11 until the tape is straightened.

For tape guide 11 post adjustment, play back the alignment tape. Make sure tape is not bent or out of line between guide number 10 and the capstan. Set the play mode again and confirm that the tape is not bent. Repeat number 10 and 11 adjustment if tape is bent.

■ **11-9** *Samsung SCX854 number 4 guide adjustment RPS and FPS normal and no good waveforms.* Samsung Electronics Co.

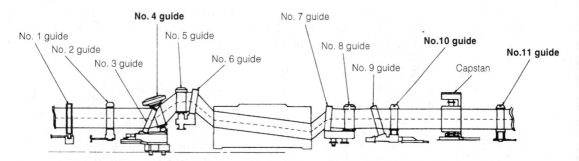

■ **11-10** *The tape travel diagram in the Samsung 8-mm camcorder.* Samsung Electronics Co.

Cue and RPS waveform check

Set the RPS mode and play back the alignment tape for tracking adjustment. Confirm that the waveform peaks maintain a constant pitch for 5 seconds or more. If not constant, do the fine tracking adjustment again at number 11 guide post. Now set the Cue mode and confirm that the waveform peaks maintain a constant pitch 5 seconds or more (figure 11-11). If not, readjust number 4 guide.

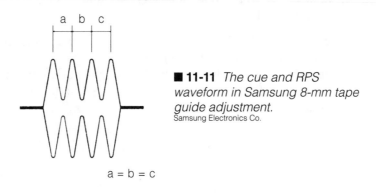

■ **11-11** *The cue and RPS waveform in Samsung 8-mm tape guide adjustment.*
Samsung Electronics Co.

Recheck after adjustment

Play back a tape and confirm that no tape rising and curling occurs at the lower flange of number 4 guide, the upper flange of number 8 guide, the lower flange guide of number 10 guide, and the number 11 guide upper and lower flanges. Check the tape again in the FPS, RPS, FF, and REW modes.

To check the envelope stability, play back the alignment tape, eject the tape, then load again. Confirm the envelope waveform.

In stop and play modes, set the play mode and confirm that the RF waveform rises flat within 2.5 seconds, also confirm that the tape is not bent around the pinch roller.

Cue/RPS and FF/REW the tape, then play it back and confirm that the RF waveform rises flat within 2.5 seconds. Also confirm that the tape is not bent around the pinch roller.

For a tracking check, play back the alignment tape. Confirm that the minimum amplitude value (E min) is 65% of the maximum value (E max) or larger (figure 11-12A). Confirm that no large fluctuations occur on the waveform, at figure 11-12B.

To make the self-recording envelope waveform check, set in SP mode play back tape and confirm the RF waveform with the spec-

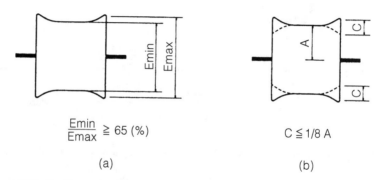

$$\frac{Emin}{Emax} \geq 65\ (\%)$$

(a)

$$C \leq 1/8\ A$$

(b)

■ **11-12** *The A and B tracking check of playback alignment tape in Samsung 8-mm camcorder.* Samsung Electronics Co.

ifications (figure 11-13). Also, check the level of amplitude value with the electronic specifications. In each mode, confirm that the difference of the amplitude (CH 1 and CH 2) is 65% or larger. If it does not meet these specifications, replace the drum assembly with a new drum original part number.

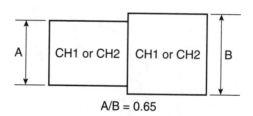

$$A/B = 0.65$$

■ **11-13** *Self-recording envelope wave-form check in Samsung SCX854 cam-corder.* Samsung Electronics Co.

Olympus VX 801 8-mm tape deck mechanism adjustment

This adjustment is necessary following the replacement of major parts in the tape running path, such as cylinder motor, posts, etc. The main purpose of this adjustment is to compensate for the large deviation in the components, which, taken together, consti-tute the tape drive mechanism. You may use a regular record/play test for this adjustment.

The adjustment points are posts T1, T2, T3, S6, and S7 (figure 11-14). The measurement points are the posts and cylinder. No tape warp or spillover should be noted on any of the posts. Place the VTR in playback mode. Use a driver post adjustment tool.

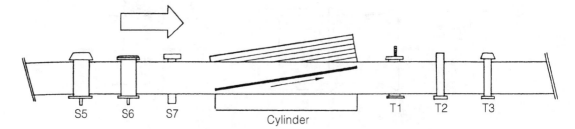

S5 S6 S7 Cylinder T1 T2 T3

■ **11-14** *Olympus 8-mm tape deck mechanism post and cylinder with respect to the tape.* Olympus Camera Co.

Play back a conventional record/play test tape. Check that the tape makes firm contact with the cylinder tape guide. If a gap exists between the tape and the cylinder head or tape spillover occurs, correct by adjusting S6 or T1, respectively. Visually inspect and check that the tape is not warped and no spillover occurs at posts S1 or S7 and T1 to T3. if warping and spillover occur, adjust S6, S7, T1, T2, and T3 (figure 11-15).

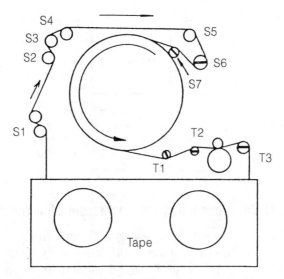

■ **11-15** *The various guides and posts in Olympus VX-801 tape path.* Olympus Camera Co.

Mitsubishi HS-C20U (VHS-C) supply guide pole adjustment

The guide supply poles serve to improve tape transport stability between the cassette output and drum input by maintaining the correct height. Adjust the supply guide roller to obtain smooth tape transport at the lower flange of the guide poles (figure 11-16).

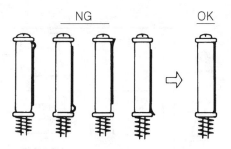

NG OK

■ **11-16** *Supply guide pole adjust-ment in Mitsubishi VHS-C camcorder.*
Mitsubishi Co.

Tape interchange ability adjustment

A quick check should be made after any service operation is performed that could adversely affect the tape, such as replacement of the cylinder or drum motor, tape guide, audio/control head, or any component in the tape path. Usually this adjustment is performed only after the tracking preset adjustment is completed. Often, no tape guide adjustments are needed if the unit passes this check.

General Electric 9-9605 (VHS) tape interchange ability adjustment

Before making these adjustments, make sure the tracking control is set into the detent (fixed) position. Connect CH 1 input of the scope to TP3501 and CH2 to TP2005, the head amp output (figure 11-17).

Loosen the hex screws on P2 and P3. Play back the monoscope portion of the alignment tape (VFKS 001H6) and adjust the height of posts P2 and P3 while watching the scope display so that the RF envelope on the scope becomes flat as possible. Now tighten the hex screws. (Remove the plastic piece on the slanted loading pin of P2 to make this adjustment. Replace after adjustment.)

If the scope display is as shown in (A) (figure 11-18), adjust the height of P2. Now adjust the height of P3 (B). If P2 and P3 posts are adjusted correctly, the scope display will become flat (C). Recheck post for normal tape travel.

RCA CPR100 (VHS-C) tape interchange ability confirmation

With a dual-trace scope, connect CH 1 probe to TP205. Connect CH 1 probe to TP209. Insert monoscope test tape and place in play mode. The tracking control should be set at the center of the FM envelope. Adjust the vertical gain for four divisions on the scope. Like-

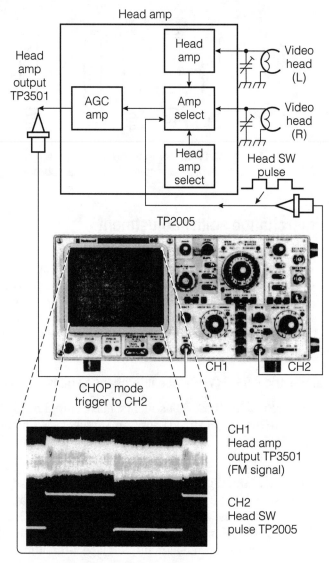

■ 11-17 *General Electric VHS tape interchange adjustment hookup.* Thomson Consumer Electronics

wise, set the tracking control for amplitude of three divisions. Confirm that the minimum envelope is 1.6 divisions or more. If the following adjustments are good, tape guide adjustment is not needed.

Audio/control (A/C) head adjustment

Incorrect position of the audio/control (A/C) head reduces the playback audio output, has poor signal-to-noise ratio (S/N) and

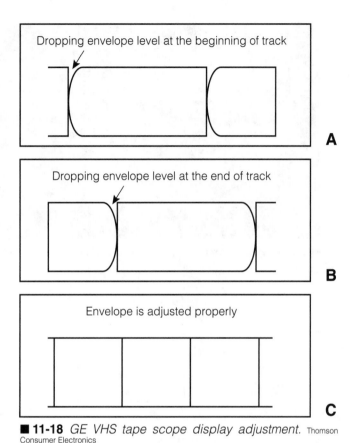

Dropping envelope level at the beginning of track

A

Dropping envelope level at the end of track

B

Envelope is adjusted properly

C

■ **11-18** *GE VHS tape scope display adjustment.* Thomson Consumer Electronics

may interfere with servo stability when the head cannot pick up the control signal. The audio/control coarse adjustment should be made before head height, tilt, azimuth, or horizontal position adjustments. The A/C control head is only in the VHS and VHS-C camcorders (figure 11-19).

Minolta C3300 (VHS-C) A/C head slant and height adjustment

For the rough adjustment, run the tape and then adjust the slant of the A/C head with screw B so that the tape runs smoothly along the bottom flange of takeup guide pole.

Connect the scope to TP302 on the main PC board (figure 11-20). Insert the stairstep signal on alignment tape MH-C1. Turn the azimuth screw C for maximum and flat by turning screws A, B, and C in the same direction. (Turn screws A, B, and C with the same angle for height adjustment.)

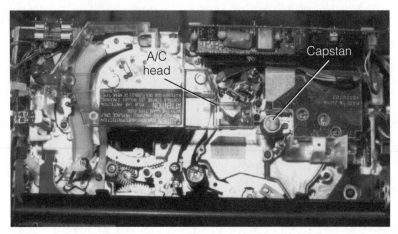

■ 11-19 *Location of the audio control (A/C) head in the RCA VHS cam-corder.*

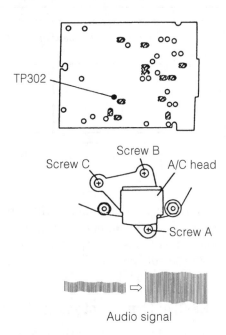

Audio signal

■ 11-20 *Minolta VHS-C A/C head slant and height adjustment.* Minolta Camera Co.

Confirming A/C head tilt

Make this adjustment after height adjustment of P4. Play back the tape and make sure the tape runs between the lower and top limits of Post P4 (figure 11-21). Notice the tape movement. If adjustment is needed, turn screw (C) clockwise so that the curling is

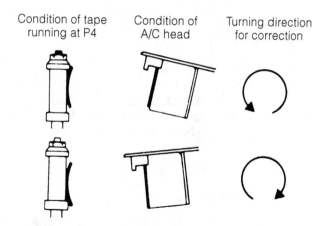

Condition of tape running at P4 Condition of A/C head Turning direction for correction

■ **11-21** *The VHS A/C head tilt in GE 9-9605 camcorder.* Thomson Consumer Electronics

apparent with the lower edge of P4. Now turn the screw (C) counterclockwise so the curling of tape smooths out.

The tape should be adjusted so it runs in the center of the guides and tape head. The revolving tape should catch the top part of control head (C) and bottom of audio tape (A). If the head is not properly adjusted, either the control or audio signals may appear erratic and intermittent. Remember the A/C head is found only in the VHS and VHS-C camcorders.

Adjustment of A/C head height and azimuth

Connect the scope to TP4001 on the audio CBA board. Play back the monoscope portion (6 kHz) of the alignment tape (VFM50001H6). Adjust screw (B) on the A/C head for maximum output (figure 11-22).

Horizontal position adjustment of A/C head

Set the tracking control to the detent (fixed) position. Connect the scope to TP3501 on the head amp section. Play back the monoscope portion of the alignment tape (VFM50001H6) and note the envelope that corresponds to the high period of the head switching signal at TP2005 (figure 11-23). Use this envelope for the following adjustments. Slowly turn the azimuth nut so the envelope is at maximum. Before finding the center of the maximum period of the envelope, rotate the adjustment nut back and forth slightly to confirm the limits on either side of the maximum period. Now determine the center point. Confirmation of the correct

365

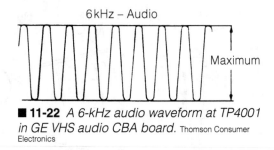

6 kHz – Audio

Maximum

■ **11-22** *A 6-kHz audio waveform at TP4001 in GE VHS audio CBA board.* Thomson Consumer Electronics

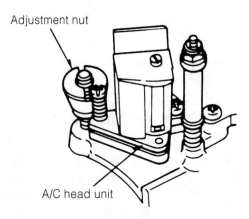

Adjustment nut

A/C head unit

■ **11-23** *General Electric VHS A/C head horizontal adjustment.* Thomson Consumer Electronics

adjustment can be made by turning the tracking control to the right and left to correspond with the envelope. The adjustment is okay when the envelope changes symmetrically.

Zenith VM6150 (VHS-C) audio/control head adjustment

Since this is a record-only camcorder, all tapes made with this unit are played back on another machine. Of course, the AC/CTL head must be correctly adjusted to ensure adequate audio output and S/N in addition to correct pickup of the control signal for servo operation.

Start by inserting play stairstep (audio, 7 kHz) section of the MY-C1 alignment tape. Turn screw 3 for maximum output on the scope. Turn screws 1, 2, and 3 by a small amount (about 45 degrees) in equal increments to adjust the head height for maximum audio signal (figure 11-24).

■ **11-24** *A/CTL head adjustment waveform in Zenith VHS-C camcorder.* Zenith Corp.

The control head phase (X value) effects the playback synchronization between sound and picture. It is more delicate in the EP mode than the SP mode. Use the operation fixture and set for observing the FM waveform with the scope. Set the tracking control to the OFF position. Now play the stairstep signal of MY-C1 alignment tape. Slightly loosen screws 4 and 5 (figure 11-25). Insert one prong of the tweezers into the notch (A) and the other prong into the hole (B). Twist to shift the head fully forward towards the capstan. Carefully shift the head in the opposite direction while observing the CH1 FM waveform and set to the maximum peak position. Now tighten screws 4 and 5. Check for maximum FM waveform.

For the final check, record a signal and confirm that the playback FM waveform meets the required performance in both SP and EP modes (figure 11-26). Now complete the different checks and adjustments in the electrical adjustment section, if needed.

367

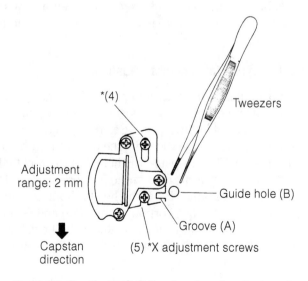

■ **11-25** *Zenith VHS-C-X-value head adjustment.*
Zenith Corp.

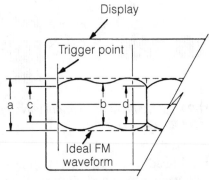

FM waveform relationships

$$\frac{b}{a} \gtrsim 0.8 \qquad \frac{c}{a} \gtrsim 0.7 \qquad \frac{d}{a} \gtrsim 0.7$$

(Video FM waveform specifications)

■ **11-26** *Zenith VHS-C FM waveform.*
Zenith Corp.

Reel table height adjustments

The supply and take-up reel tables should be the same height. Often the reel table heights are adjusted by changing the stack of washers under the reel assembly within the VHS camcorder (figure 11-27). A height fixture or reel jig is used for the correct height adjustment. If one of the reels is lower than the other, the adjustment is made by adding another washer. Usually, reel table height adjustment is only required when a new reel table is installed. If only one reel is replaced, compare the height with the original.

NEC V50U (VHS) reel table height adjustment

A post adjustment plate and reel table height gauge is needed for this adjustment. Place the post adjustment plate on the reels and put the gauge on the plate. Set the gauge to zero with the foot scraper of the gauge touching the cut-out portion of the plate (figure 11-28). Then measure the height of the reel table. Confirm the difference just performed in the former step (A). Do the same for the other reel table (B). If the height difference in measurements between the cut-out portion of the plate and reel tables are not 0 to 0.15 mm (higher or lower), adjust the height of the reel to obtain the specified height. Just add or reduce a washer.

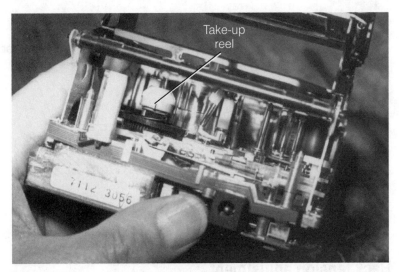

■ **11-27** *Close-up take-up reel in VHS-C camcorder.*

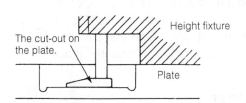
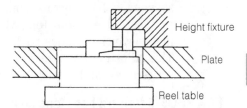

■ **11-28** *VHS reel table height adjustment.*

Samsung 8-mm reel torque check

Insert the torque cassette. Set camcorder to play mode, and confirm that the reel disk (T) torque value is 10.5 ± 3.5 g/cm. Set the RPS mode and confirm that reel disk S torque value is within 35 ± 5 g/cm. If the torque value does not meet this specification, replace corresponding reel disk.

Sony CCD-M8E/M8U 8-mm reel table height check

Make sure the height of the LS chassis to the supply reel table receptacle plate surface (2) and from the LS chassis to the take-up reel receptacle plate surface (3) should be the same as 6.85 ± 0.15 mm. Both A and B heights should be the same. If a case washer (T = 0.13) is inserted under the take-up reel table, it becomes 6.98 ± 0.15 mm (figure 11-29).

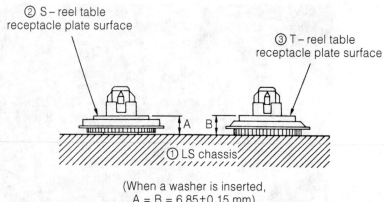

② S – reel table
receptacle plate surface

③ T – reel table
receptacle plate surface

① LS chassis

(When a washer is inserted,
A = B = 6.85±0.15 mm)

■ **11-29** *Sony 8-mm reel table height check.* Sony Corp.

Back tension adjustment

The back tension is done in play mode to take up tape slack and slippage with correct tension. Some manufacturers use a back tension meter (tentelometer), while others use a video cassette torque meter, which includes back tension and take-up in one cassette. This adjustment can be made with a regular video cassette, small screwdriver, and tension meter.

RCA PRO845 forward back tension adjustment

Load the camcorder with the torque cassette. Refer to the replacement parts list for the torque cassette stock number. Place the instrument in the play mode and confirm that the S-reel base is 6–12 gF/cm. If the torque reading is not within the specification, adjust the position of the B+ lever spring (figure 11-30). If the torque is lower than 6 gF/cm, relocate the BT lever in the direction of the arrow. If the torque is higher than 12 gF/CM, relocate the BT lever spring in the direction of the black arrow.

Samsung 8-mm playback tension adjustment

Supply an external 7.5-V source to the battery terminals. Insert torque cassette. Set in play mode, and confirm that reel disk S torque value is within 4.5 ± 1 g/cm. Readjust tension band if the torque value does not meet the above specifications (figure 11-31).

Pentax PV-C850A 8-mm tension pole position and tension adjustments

These adjustments should be made after the subchassis sliding mount adjustment is made. Check the position and tension and adjust the tension pole position simultaneously.

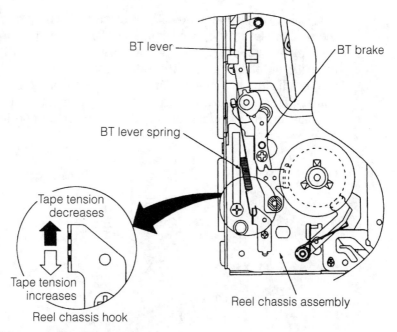

BT lever

BT brake

BT lever spring

Tape tension decreases

Tape tension increases

Reel chassis hook

Reel chassis assembly

■ **11-30** *RCA PRO845 back tension adjustment.* Thomson Consumer Electronics

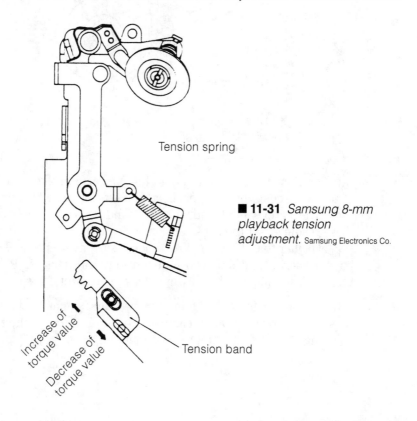

Tension spring

■ **11-31** *Samsung 8-mm playback tension adjustment.* Samsung Electronics Co.

Increase of torque value

Decrease of torque value

Tension band

For position adjustment, hook the tension spring to position (B) of the tension spring stopper (figure 11-32). Cover the supply end sensor light with paper so it does not pass light. Press the PLAY button without loading a cassette. Adjust the position of the tension torque adjustment plate so that the holes in the supply-side guide plate and tension arm are aligned. After adjustment, set the unit to the play and record modes and recheck tension arm position.

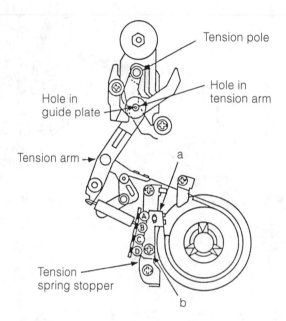

■ 11-32 *Tension pole position adjustment in a Pentax 8-mm transport.* Pentax Corp.

Now for tension adjustment, hook the tension spring to position B of the tension spring stopper. Load the tension cassette and play back. The meter should read between 9 and 12 g/cm. If not between these readings, set the back tension spring to position A if the tension is higher than 12 g/cm. When the tension is lower than 9 g/cm, hook the spring to position C of the tension spring stopper. Perform these measurements with the tape deck in horizontal position.

If the tension value has changed more than 2 g/cm, recheck the tension pole position and readjust if needed. Remove the paper covering after the adjustment is completed.

Other adjustments

RCA PRO845 tape path

The 8-mm video system uses an automatic track finding system (ATF) which automatically controls the tape speed and track finding system (AFT), eliminating the need for a manual tracking control (figure 11-33).

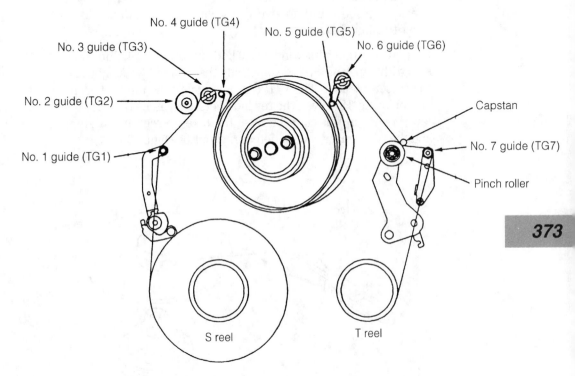

No. 4 guide (TG4)

No. 3 guide (TG3)

No. 5 guide (TG5)

No. 6 guide (TG6)

No. 2 guide (TG2)

Capstan

No. 1 guide (TG1)

No. 7 guide (TG7)

Pinch roller

S reel

T reel

■ 11-33 *RCA PRO845 tape path.* Thomson Consumer Electronics

When performing many of the tape adjustments, the automatic track finding system must be disabled. If the automatic track finding system is not disabled, and the tape path is adjusted, the automatic track finding system will constantly compensate for any adjustment made in the tape path, making accurate tape path alignment impossible.

To perform accurate tape path alignment, the mechanism must be placed in a mode that causes the video heads to read the tape in a slightly shifted mode. This mode is called the track shift mode. The mechanism can be placed in the track shift mode without the

use of any special tools or fixtures. To place the mechanism in the track shift mode, refer to tape path adjustment set-up.

Pentax PV-C850A 8-mm tension and torque checks

Always check the tension, torque, and compression force of the tape take-up section and moving section to smooth the tape transport and to satisfy the basic performance of the VTR. When the tape speed is abnormal, detect the defective sections by this check. Replace the defective parts with new ones and take another tension check.

Cover up the receiving windows of both supply and take-up end sensors with paper or tape or something that will not pass light. Lower the cassette holder. The VTR can now accept the input of each operation made. However, the rewind operation can be done for only a few seconds in this state because the take-up reel disk is stopped and the reel sensor cannot detect reel pulses (figure 11-34).

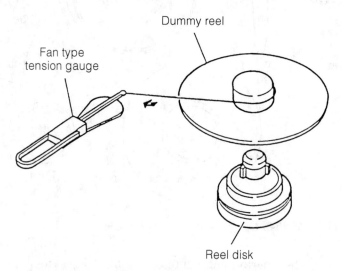

Dummy reel

Fan type
tension gauge

Reel disk

■ **11-34** *Pentax 8-mm tension and torque check.* Pentax Corp.

Table 11-2 shows the various adjustments to be made with the measured values. Note 1 are values measured using a dummy reel and fan-type tension gauge while pulling the take-up reel disk counterclockwise and the supply reel disk clockwise at a speed of 50 mm/s. Note 2 are values measured with an NTSC tension cassette.

■ Table 11-2 Pentax PV-C850A tension and torque adjustments.

Item	VTR mode	Measured reel	Measurement value	Remarks
Main brake torque	Stop	Supply	25 g or more	Note 1
		Take-up	7.5 g or more	Note 1
Slack removal torque	Unloading	Supply	20–30 g/cm	Note 2
Fast forward torque	Fast forward	Take-up	150 g or more	Note 1
Rewind torque	Rewind	Supply	150 g or more	Note 1
Take-up torque	Play	Take-up	6–24 g/cm	Note 2
Back-tension torque	Fast forward	Supply		
	Rewind	Take-up	0.2–6.2 g/cm	Note 1
Take-up back tension	Play	Supply	9–12 g/cm	Note 2
Reverse torque	Reverse play (reverse search)	Supply	20–30 g/cm	Note 2
Take-up brake torque	Play to stop	Take-up	6 g/cm or more	Note 2

Note 1: These are values measured using a dummy reel and fan type tension gauge while pulling the take-up reel disk counterclockwise and the supply reel disk clockwise at the speed of 50 mm/s.

Note 2: These are values measured using an NTSC tension cassette.

Pentax Corp.

Mitsubishi HS-C20U (VHS-C) loading gear and locking ring adjustment

Set the mechanical stop mode before removing or replacing the loading gear and loading ring assemblies. Turn the take-up and supply loading rings in the unloading direction. Be careful not to apply excessive force. Adjust to overlap the holes and teeth of the take-up and supply loading rings. Install the rings as shown in figure 11-35.

Mount the ring idler gear (1) with its markings at the 12 o'clock position. Now install idler gear (2). If it cannot be installed smoothly, turn the unloading ring slightly clockwise to permit installation.

Adjust the control cam for the STOP position. Set the larger wedge of loading gear (3) toward the loading ring. Make sure the edge of the smaller wedge contacts the edge of the control cam wedge. You may want to turn the mode control motor slightly clockwise to allow easy installation of the loading gear (3).

Loading motor gear
Loading gear (1)
Control cam
E-ring
Loading gear (3)
Loading gear (4)
Ring idler gear (2)

■ **11-35** *Mitsubishi VHS-C loading gear and locking ring adjustment.* Mitsubishi Corp.

Install the loading gear (4) with its teeth engaged with loading gear (3) and the take-up loading ring. Now the marked teeth of loading gear (4) should be roughly at the 3 o'clock position and engaged evenly with the take-up loading ring. Repeat the loading and unloading operations several times. Make sure the marked teeth of loading gear (4) comes to correct position with respect to the loading ring and mechanical operation is normal (figure 11-36). If the mechanical operation is not correct, assemble it once again.

Loading gear (4)
Take-up loading ring assembly

■ **11-36** *Mitsubishi VHS-C loading gear adjustment.*
Mitsubishi Corp.

RCA CPR100 (VHS-C) loading ring adjustment

This adjustment should be made after installing the loading gear, supply loading gear, take-up loading ring, and cam gear. Follow these steps.

Rotate the take-up and supply loading rings fully in the unloading direction. Gradually turn the take-up and loading rings in the loading direction. Match the inner empty holes of both rings (figure 11-37).

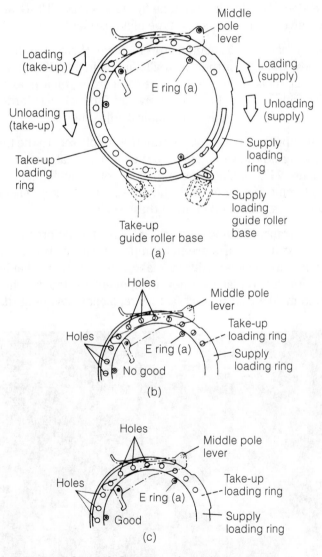

■ **11-37** *RCA VHS-C loading ring adjustment.* Thomson Consumer Electronics

Install E ring (A).

Install ring idler gear (1) with the markings facing the loading gear. Now reinstall the idler gear (2).

Conclusion

Most mechanical adjustments are only required after removing, installing or adjusting. Sometimes when the camcorder is dropped, denting or bending components, mechanical adjustments may be needed. Usually, all three tape formats—VHS, VHS-C, and 8 mm—are given within the same type of adjustment.

Many camcorder manufacturers have their own fixtures, test tapes, and jigs for their own VTR adjustments. You may find a few special tools are needed for the camcorder you are now repairing. Securing the exact service literature for each camcorder helps to make easier and quick mechanical adjustments.

The tape transport system from the supply reel to the take-up reel disk across the video heads is the most crucial section in the VTR (figure 11-38). The tape transport components, especially those that come in contact with the tape should be kept clean. Remove scratches, dust, and oil from these surfaces.

Most transport tape systems are adjusted before they leave the factory. If the parts are not tampered with or broken, no adjustments are needed. Always make the correct mechanical adjustments after replacing a new component to stabilize the transport system. Make sure exact factory replacements are used.

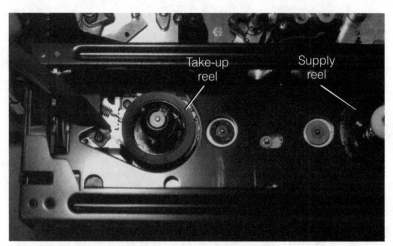

■ **11-38** *Reel take-up and supply reel tape path in RCA VHS VTR.*

RCA 8-mm tape path slack confirmation

Load the camcorder with blank tape and make a recording. Play back the recorded tape and confirm that the slack in the tape path between the capstan motor shaft and the number 7 guide (TG7) is 0.5 mm or less when in the cue mode. Confirm that the slack in the tape between the capstan shaft and the number 6 guide (TG6) is 0.5 mm or less when in the reverse mode (figure 11-39).

If the tape slack is not within the requirements specified as above, perform step 7 guide (TG7) height adjustment and then repeat the confirmation procedure.

After all of the tape path adjustment/confirmation procedures have been satisfactorily completed, apply a drop of lock paint to the number 7 guide (TG7). Take care not to get lock paint on any other portions of the transport mechanism.

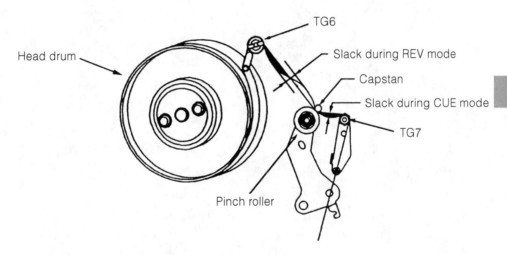

■ **11-39** *RCA 8-mm tape path slack confirmation.* Thomson Consumer Electronics

Electrical adjustments

ELECTRICAL ADJUSTMENTS ARE NECESSARY AFTER YOU replace critical components in the camera section. Electronic viewfinder (EVF) adjustments might be needed after the viewfinder has had rough treatment or the camera was accidentally dropped. Sometimes only a touch-up is needed. All electrical adjustments should be followed according to the manufacturer's specifications (figure 12-1). Basic adjustment charts are often found in the back of the service manuals.

■ **12-1** *Remove the top and bottom covers to get at the voltage and camcorder adjustments.*

List of maintenance tools and test equipment

Basically, seven or eight (minimum) test instruments are required for electrical adjustments. Other special tools and servicing jigs can be required by each manufacturer. Many of these test instruments are probably already on your electronic service bench. Basic instruments include:

☐ Oscilloscope

☐ Color TV monitor

- [] Signal generator
- [] Frequency counter
- [] Audio tester
- [] Regulated power supply
- [] Digital voltmeter (DVM)
- [] Blank video cassette for recording and playback
- [] Alignment tape
- [] Patch cords
- [] Camera jigs
- [] Electronic service tools

The Canon ES1000 camcorder maintenance tools and correct test equipment are listed in Table 12-1, with a list of supplies in Table 12-2.

■ Table 12-1 Canon ES1000 camcorder maintenance and alignment tools.

Description	Tool no.	Remarks
Alignment tape A (color bar)	DY9-1044-001	
Recording current adjusting jig	DY9-1056-000	
Y/C separator	DY9-1093-500	
V sweep master	DY9-1108-100	
Extension cable (12 pins)	DY9-1268-000	
Alignment tape (stereo)	DY9-1291-000	
Extension cable (20 pins)	DY9-1297-000	New
Extension cable (3 pins)	DY9-1298-000	New
Color bar chart	DY9-2002-000	
Gray scale chart	DY9-2005-000	
Color chart viewer (5600 K)	DY9-2039-100 100	
Viewer lamp (5600 K)	DY9-2040-000	
CCA12 filter	DY9-2046-000	

Canon, Inc.

■ Table 12-2 List of supplies of oil and grease for camcorders.

Description	Tool no.	Remarks
Floil G-902	DY9-3017-000	
Floil G-741B	DY9-3021-000	
Hanal 778	DY9-3026-000	New
Radiating grease KS609	DY9-3027-000	New
Grease GE-C9	DY9-8043-000	

Canon, Inc.

Each camcorder can have its own list of test instruments and tools for electrical adjustments (figure 12-2). Special jigs and harnesses are sometimes required for certain adjustments.

Ref. no.	Name	Part code
J-1	Color viewer 3,200K	
J-2	Gray scale ($\gamma = 0.45$)	VJ8-0009
J-3	Color bar chart	
J-4	Siemens star chart	
J-5	Color temperature conversion filter (Kenko MC C12; 58mm)	
J-6	Socket pull-out tool	VJ8-0030
J-7	Camera block fixing tool	VJ8-0128
J-8	Pan head	VJ8-0101
J-9	Circuit board connecting tool	VJ8-0140
J-10	Extension cord (CP1 to CP2)	VJ8-0139
J-11	Extension cord (CP2 to PW1)	VJ8-0129
J-12	Adjustment controller	VJ8-0141
J-13	Adjustment (−) screwdriver	VJ8-0104

Special tools and fixtures

Test Equipment

Vectorscope
Oscilloscope
Color monitor
Digital voltmeter
Frequency counter
Regulated DC power supply

383

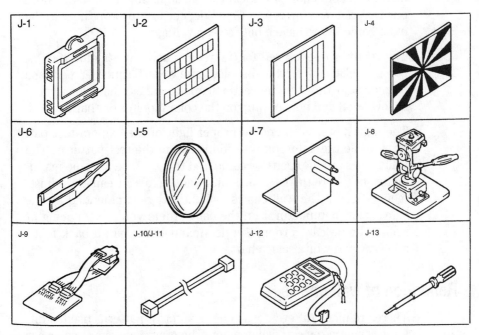

■ **12-2** *RCA PRO845 special camcorder tools for adjustments.* Thomson Consumer Electronics

List of maintenance tools and test equipment

Additional test instruments are:

☐ Vectorscope

☐ Light meter

☐ Tripod

☐ Light box

☐ Color viewer—3200 k

☐ Color bar chart

☐ Gray-scale chart

☐ Reflection charts and patterns

☐ Special screwdrivers

☐ Camera accessories

☐ Color temperature conversion filter

☐ Remote control card

☐ Special camera extension jigs and harnesses

The oscilloscope should be dual-trace with delayed sweep and a minimum bandwidth of 25 MHz. Most electronic technicians servicing the TV chassis already have a dual-trace scope on their work benches. The frequency counter should have a frequency of 20 MHz or greater. Most TV establishments have a digital voltmeter DVM or DMM for critical voltage adjustments. If not, choose one that can measure up to 1500 Vdc, because pickup tubes in the older camcorders have a high sweep voltage.

The vector scope is used for TV repairs and adjustments such as burst, black balance, white balance, auto white balance, and chroma balance adjustments. The vector scope can show the color level to be low or off and not show up on the color monitor or charts.

The light meter is to ensure proper light of the camera test patterns while the light box is used instead of the test patterns. The wall charts are inexpensive compared to light boxes. Some manufacturers use both the charts and light boxes in camera adjustments. Secure the wall charts or light box recommended by the camcorder manufacturer on the camcorders you are servicing or selling. Some camcorders' service manuals contain a back focus and gray and white scale chart.

Reflection of wall charts

There are many different wall charts and test patterns used in different camera tests and alignment. The gray scale chart, color bar

and back focus chart are recommended by most. The gray scale chart is used for troubleshooting, testing, and alignment. The gray scale chart is used when waveforms are presented by the service manual if by chart or a gray chart upon the light box. Besides the gray scale chart, there are several others including color bar chart, resolution chart, ball chart, white chart, black and white chart, gray and white chart, and the back focus chart. Since the white/black chart is reflective, a halogen lamp should be used with it.

The back focus adjustment using the back focus chart is to match the distance to the object with the index of the distance on the focus ring. Poor back focus adjustment can occur when the distance to the object and the index of the distance on the focus ring do not match. The back focus adjustment chart can be one with lines coming together at the end or a black solid line down the center (figure 12-3).

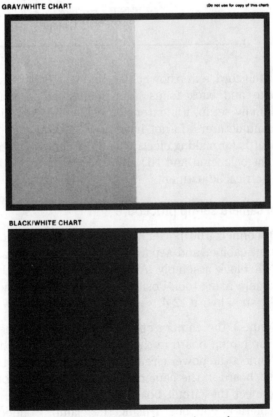

GRAY/WHITE CHART (Do not use for copy of this chart)

BLACK/WHITE CHART

■ 12-3 *Black and white focus charts for camcorder back focus set-up.*

Tools and fixtures

Most small tools on the TV service bench are all that is required to make electrical adjustments. A blank video cassette is used for recording and playback operations. The cassette alignment tape is used for color, audio, and servo alignment (Table 12-3).

■ **Table 12-3 Test cassette alignment tapes.**

Manufacturer	Type	Alignment	Part number
Canon	8 mm	Color bar	DY-1044-001
Minolta	VHS-C	M+C1	7892-8012-01
Mitsubishi	VHS-C	MH–C1	859C35909
Olympus	8 mm	Color bar	VFM9010P9D
		Monoscope	VFM9000P9N
RCA	VHS-C	3 kHz	156502
Pentax	8 mm	NTSC	20HSC-2
NEC	VHS	Alignment	79V40302
Samsung	8 mm	Lion pattern	
Zenith	VHS-C	Color	MY-C1
		EP mode	CY-CIL

Patch cord, extension cables, and test jig harnesses can be used in auto and back focus adjustments, color adjustments, camera dummy setup, iris extension cable and operation fixtures. Some manufacturers do not have any jig harnesses or external circuit boards for making electrical adjustments. Several camcorders use light balancing and ND and CCD filters over the lens in making electrical adjustments.

RCA 8-mm camera set-up procedure

Disconnect the power from the camcorder. Remove camcorder from cabinet and separate the camera block assembly from the VCR block assembly. Attach the camera block assembly to the camera fixing tool. Position the camera block and VCR section as shown in figure 12-4.

Connect the camera circuit board in the camera section to the main circuit board in the VCR section using extension cable J10. Connect the power circuit board in VCR section to the camera circuit board in the camera section with extension cable J11. Also, connect the circuit board connecting tool (J9) to J9001 on the camera circuit board using the clamp. Connect the adjustment controller to the circuit board connecting tool as in drawing.

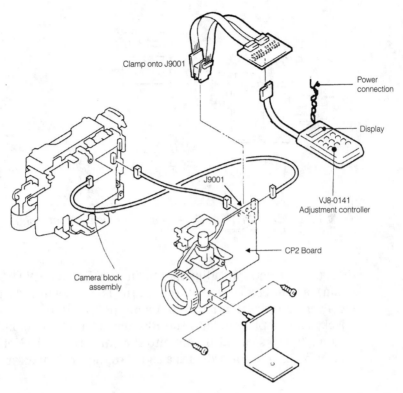

■ **12-4** *RCA camera adjustment set-up procedures.* Thomson Consumer Electronics

Apply a regulated dc power source (7.5 to 8.0 Vdc) to power the adjustment controller (black wire to positive). Turn on the dc power supply after powering up the camcorder. When all adjustments have been completed, turn off the adjustment controller first and then turn off the camcorder. Connect the color monitor to the video output.

Camera setup

For camera adjustments, the camcorder should be mounted on a solid work bench or a heavy duty tripod for accurate measurements. in the RCA CPR100 VHS-C camcorder, the unit is operated from the ac power supply with the audio/video (A/V) cable between camcorder and color video monitor. The video output cable must be matched with the RCA-BNC adapter to plug into the color monitor (figure 12-5).

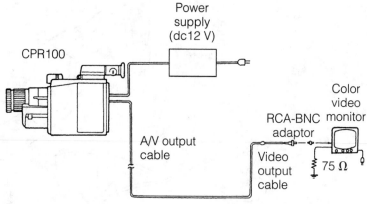

■ 12-5 *RCA CPR100 (VHS-C) camera adjustment connections.*
Thomson Consumer Electronics

To make electrical adjustments in the Pentax PV-C850A (8 mm), a light box is used in front of the lens assembly with an RF converter as distribution box. A monitor TV without audio/video jacks can be plugged into the RF converter, or the monitor TV with A/V jacks can also plug into the converter unit. Notice the color bar generator provides a signal to the RF converter (figure 12-6).

Canon ES1000 VAP/AF adjustment

Before attempting adjustment, warm up the instruments for at least three minutes. The standard view is obtained when the test chart is displayed over the entire screen of full scan monitor. Connect the test equipment as shown in figure 12-7. When checking on an oscilloscope, adjust the angle of view so that the gray scale section will be 36 µs or the color bar section will be 52 µs. When using the other chart, align the center at the standard angle of view that has been set with the gray scale or color bar chart. Shoot the chart from a distance of approximately 1.4 meters unless otherwise specified.

Camcorder breakdown

Often, both plastic sides of the camcorder must be removed for electrical adjustments (figure 12-8). Some adjustment boards are located on one side while others are on the other side and behind the camera lens assembly. Here boards 1 through 7 are located on the right side of RCA CPR100 camcorder, and the mike and interface circuit boards at the top of the lens assembly. The

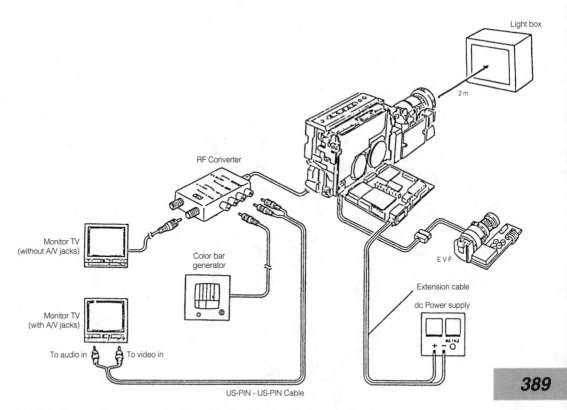

Light box

2 m

RF Converter

Monitor TV
(without A/V jacks)

Color bar
generator

EVF

Extension cable

dc Power supply

Monitor TV
(with A/V jacks)

To audio in To video in

US-PIN - US-PIN Cable

■ **12-6** *Pentax 8-mm connections for electrical adjustments.* Pentax Corp.

process circuit board (10) is at the front and underneath the lens assembly.

Besides containing critical circuits of the camcorder, the service manuals include test points and control board layout (figure 12-9). Most camcorder service manuals list the various test points and parts for easy camera adjustments. Like on any electronic product, alignment procedures are difficult at first, but after repairing several camcorders, each one becomes easier.

Power supply adjustments

Before attempting to make electrical adjustments, the output of the power supply voltage must be set correctly (figure 12-10). Incomplete adjustments can cause the signal-processing system to operate normally. Most dc power source adjustments are made with a digital voltmeter, blank tape, and dc power supply. These adjustments take only a few minutes, but they are very critical. Make sure the lens cap is on.

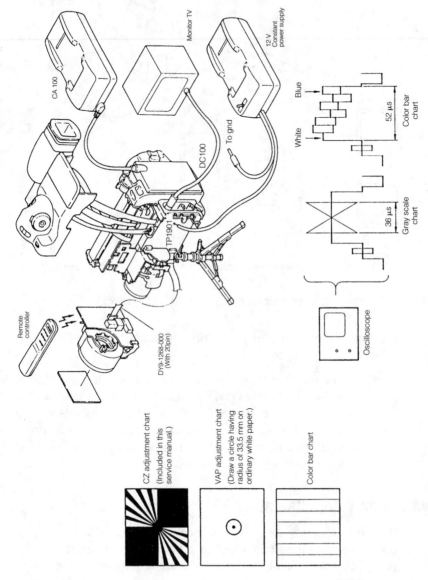

CA 100

Monitor TV

12 V
Constant
power supply

DC100

To gnd

TP1901

Remote
controller

DY9-1268-000
(With 20pin)

White

Blue

52 μs

Color bar
chart

36 μs

Gray scale
chart

Oscilloscope

CZ adjustment chart
(Included in this
service manual.)

VAP adjustment chart
(Draw a circle having
radius of 33.5 mm on
ordinary white paper.)

Color bar chart

■ **12-7** *Canon ES1000 VAP/AF adjustment connections.*

■ **12-8** *Remove both sides of camcorder for alignment and adjustment procedures.*

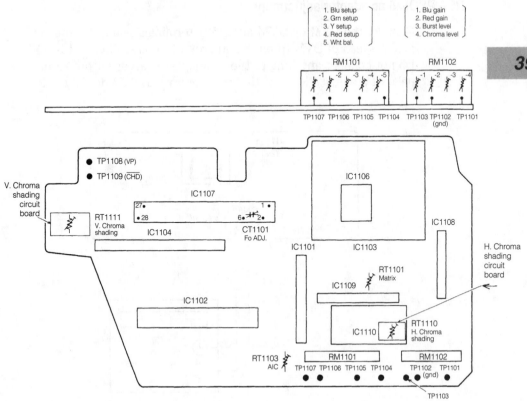

■ **12-9** *RCA VHS-C camcorder location of controls and test points for correct adjustments.*
Thomson Consumer Electronics

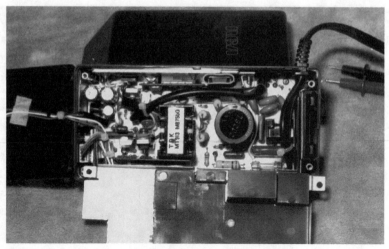

■ **12-10** *Inside view of RCA CPR300 power supply.*

RCA PRO845 ac adapter adjustment

Connect the DVM or DMM at CN521 terminals 1 and 3. Connect positive lead of DVM to pin 3 and ground to pin 1 (figure 12-11). Do not connect anything to the ac adapter charger output terminals. Now adjust VR251 so that the meter reads 6.7 Vdc ± 0.1 Vdc.

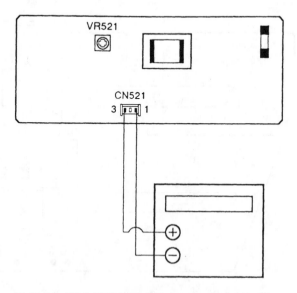

■ **12-11** *RCA PRO845 ac adapter charger adjustment.* Thomson Consumer Electronics

Canon ES1000 12-V power source

The preparation of the 12-V power supply must be modified. Remove the external housing of CA-100 power supply. Short-circuit across negative terminal (–) of dc jack (JK-1) and the control terminal C. Disconnect the battery terminal. Short-circuit across the negative terminal (–) of battery terminal land port and the control. Connect a lead wire with the positive terminal (+) of dc jack JK-1, and attach a clip to it with an intermediate switch (figure 12-12).

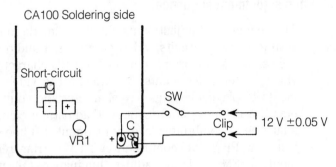

12-12 *Canon ES1000 12-V power source.* Canon, Inc.

Connect a lead wire with the negative terminal (–) of dc jack JK-1, and attach a clip to it. Insert ac plug of power outlet. Adjust VR1 so that a voltage of 12 V ± 0.05 V will appear at the top of clip when the switch is turned on. Use the 12-V constant voltage power supply as in the following list:

1. Switch OFF.
2. Insert the ac plug into power outlet.
3. Make connection to the camcorder.
4. Switch ON.
5. Write data.
6. Switch OFF.
7. Disconnect from the camcorder.
8. Remove the ac plug from power outlet.

Servo adjustments

After adjusting the power supply, check the system control, servo system, video, and audio adjustments—in that order. The system control adjustments can consist of the battery down and tape end adjustments, while the servo system adjustments can contain drum pulse, capstan sampling, PB switching, SP control delay MMV, EP tracking, and tracking preset.

RCA 8-mm adjustment sequence

The sequence of adjustments should be made in order of servo/system control circuits, video circuit, and audio circuits within the servo/system circuit to make the OSD character position and video center adjustments. Next make the video circuit adjustments of playback frequency characteristic confirmation, flying erase head confirmation, sync AGC adjustment, comb filter phase adjustment, comb filter level adjustment, PB line out Y level adjustment, PB Y level confirmation, Y FM carrier frequency adjustment, Y FM deviation adjust, luminance (Y) record current adjustment, chroma (C) record current level adjust, audio (AFM) FM record level confirmation, and ATF record current confirmation (figure 12-13A).

For the audio circuits, make the deviation confirmation, overall level confirmation, and overall signal-to-noise confirmation.

When performing the VCR section adjustment procedures, the video signal generator (pattern generator) is used as adjustment signal. It is important that the generator used produces a signal that meets specifications, as in figure 12-13B.

Before performing the VCR section adjustment procedures, disassemble the camcorder as shown in figure 12-13C. Convert the J9 adjustment CBA to J1005 on the (CP1) circuit board. When an external video signal is required, convert the video signal generator.

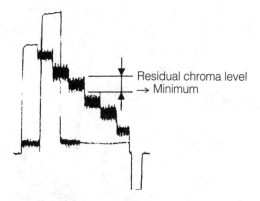

■ 12-13A *RCA 8-mm comb filter phase adjustment.* Thomson Consumer Electronics

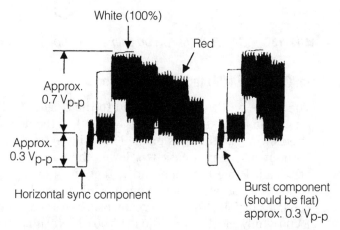

■ 12-13B *RCA video signal generator specifications.* Thomson Consumer Electronics

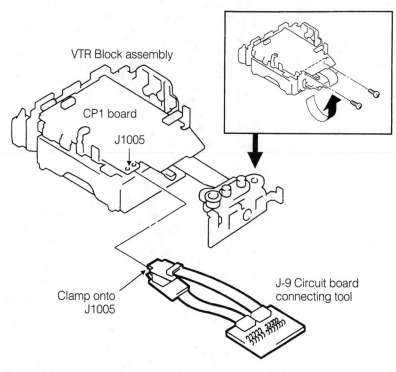

VTR Block assembly

CP1 board

J1005

Clamp onto
J1005

J-9 Circuit board
connecting tool

■ **12-13C** *RCA PRO845 VCR adjustment set-up.* Thomson Consumer Electronics

Sony 8-mm CCD-M8E/M8U tape end detection

The scope on CH 1 is connected to the base of Q118 on the ac range and CH 2 at the collector of Q119 on the dc range. Fix the erase switch so that it is pushed in with the tape (figure 12-14). Without inserting a cassette, lower the cassette compartment and load. Place the tape end detection filter in the space between the cassette compartment and the end sensor light receiving portion. Now place camcorder in record mode. Adjust RV001 fully clockwise. Adjust RV001 by turning counterclockwise so that the collector voltage of Q119 voltage (dc level) is more than 2 V and less than 3 V at the rising point of the light-up pulse.

If the voltage is less than 2 V at this time, end detection will operate and shut-off occurs. So in that case, turn RV001 slightly counterclockwise and put unit into recording mode again and readjust. Now remove the tape end detection filter and confirm that Q119 collector voltage is less than 0.2 V.

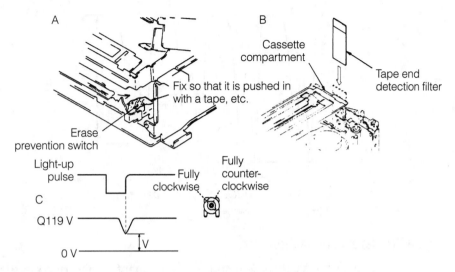

A

B

Cassette
compartment

Fix so that it is pushed in
with a tape, etc.

Tape end
detection filter

Erase
prevention switch

Light-up
pulse

Fully
clockwise

Fully
counter-
clockwise

C

Q119 V

0 V

V

■ **12-14** *Sony 8-mm tape end detection adjustment.* Sony Corp.

RCA PRO845 comb filter phase adjustment

Connect the CH 1 input of oscilloscope to test point TP101 on VCR section CP1-CBA and ground at point TP143. At the scope connect the external trigger terminal to TP105 on the same board. Connect the VCR section and test equipment as described in the VCR adjustment set-up procedure. Apply a color bar signal to camcorder as in VCR adjustment set-up procedure. Short pins 6, 11, and 14 of J1005 together. Place power switch in the VCR position. Adjust VR111 so that the amplitude of the residual chroma of the green signal is minimum.

RCA PRO 845 flying erase head adjustment

Connect the VCR section and test equipment as described in the VCR adjustment set-up procedure. Short pins 6, 11 and 14 of J1005 together. Place power switch in the CAM position and standby switch on. Connect scope to TP181 of CP1CBA and TP143 (ground). Confirm that the frequency is 6.5 to 9.5 MHz and that the oscillation voltage is 7.5 V_{P-P} to 10.5 V_{P-P} (figure 12-15). If the required voltage cannot be met, clean the flying erase head. Replace upper cylinder if the voltage cannot be met after cleaning the flying erase head.

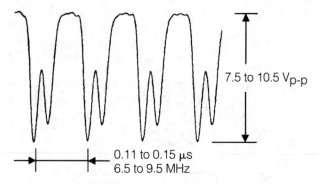

7.5 to 10.5 V_{p-p}

0.11 to 0.15 μs
6.5 to 9.5 MHz

■ **12-15** *RCA PRO845 flying erase head confirmation.* Thomson Consumer Electronics

RCA PBY level confirmation

Connect the VCR section and test equipment as described in the VCR adjustment set-up procedure. Place the power switch in the VCR position. Load the instrument with the alignment tape and play back the color bar portion of the tape. Connect scope to TP101 at CH 1 and external trigger to TP105 with ground at TP143. Confirm that the playback level is 0.52 V_{P-P} ± 0.05 V_{P-P} (figure 12-16).

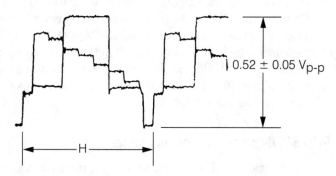

0.52 ± 0.05 V_{p-p}

H

■ **12-16** *RCA 8-mm playback (PB) Y level confirmations.*
Thomson Consumer Electronics

Canon ES1000 switching point adjustment

Insert color bar master alignment cassette DY9-1044-001. Set the VTR in playback mode. Scope the video out at TP101 (head switching pulse). Service mode 4C-bank 1 addresses 4C and 4A for adjustment. Adjust at 6.0 ± 1.0 H (figure 12-17).

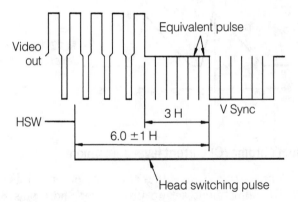

ment. Canon, Inc.

RCA 8-mm luminance (Y) record current level adjust

Connect the VCR section and test equipment as described in the VCR adjustment set-up procedure. Place POWER switch in the CAM position and place Standby switch in the on position. Short pins 6, 11, and 14 of J1005 together. With no video signal applied to the camcorder, load camcorder with MP type tape and place the unit in record mode. Connect scope to TP131 of CP1 CBA, and confirm that the record level is $250 \text{ mV}_{P-P} \pm 2U \text{ mV}_{P-P}$ (figure 12-18). If the Y record current is incorrect, clean video heads and check again. If level is not within the specifications, replace upper cylinder.

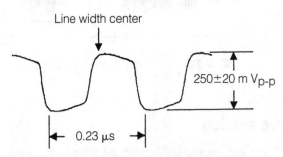

■ **12-18** *RCA 8-mm luminance (Y) record current level confirmation.* Thomson Consumer Electronics

Mitsubishi HS-C20U EP control delay adjust

Place in stop mode to connect scope to TP102 on main board. Short TP1 and TP103 together. Set for EP mode. Adjust R111 so that the period between the beginning of rising and the peak of the waveform is $a = 30 \pm 0.2 \text{ ms}$ (figure 12-19).

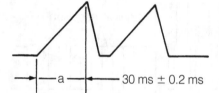

■ **12-19** *Samsung 8-mm iris level adjustment.* Samsung Electronics Co.

a — 30 ms ± 0.2 ms

RCA 8-mm chroma (C) current level adjustment

Connect the VCR section and test equipment as described in the VCR adjustment set-up procedure. Short pins 6, 11 and 14 of J1005 together. Connect scope to TP132 of CH 1 and trigger external to TP105. Ground scope lead to TP143. Place the power switch in the CAM position and place the standby switch in the on position. Apply a color bar signal as described in the VCR adjustment set-up procedure. Load the instrument with an MP type tape and place the camcorder in record mode. Adjust VR132 so that the chroma level is 200 V_{P-P}, ± 15 V_{P-P} (figure 12-20).

Burst

200 ± 15 mV$_{p-p}$

H

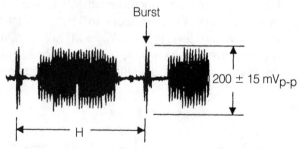

■ **12-20** *RCA 8-mm current level adjustment.* Thomson Consumer Electronics

CCD drive section

There are four or five important electrical adjustments to be made in the CCD drive section including focus, drive pulse frequency, PLL frequency, V-Sub or OFD, and CCD output adjustments. These adjustments are to ensure proper focus, set proper drive pulse frequency, to prevent blooming, and provide sufficient CCD or MOS outputs. The lens cap is removed with these tests. Be sure and make the FO/Q, VCO-PLL, AFC, and playback (PB) level adjustment after replacing heads or preamplifier.

Back focus adjustment

The purpose of the back focus adjustment is to ensure proper focus tracking throughout the zoom range or to match the distance to the object with the index of distance on the focus ring. Improper adjustment means the distance to the object and index of distance on the focus ring do not match. Many camcorder back focus adjustments are made with a back focus chart or light box with test patterns.

General Electric 9-9605 (VHS) focus adjustment

Aim the camera at the registration chart with lens cap off. Look in the viewfinder and adjust VR904 for best resolution.

Samsung 8-mm iris level adjustment

Set camera E-E, 3100 degrees K on gray-scale chart. Connect video output jack waveform monitor input jack and monitor TV jack respectively. Press the play (mode up) stop (mode down) button so OSD state is 02 iris XX XX. Dim the camera at the gray-scale chart evenly illuminated at 1500 to 200 lux (40 US) (figure 12-21). Adjust the self timer data up int. REC (data down) button so that Y level is 90 IRE +10/–5 IRE. Be sure to set start/stop (confirm) button to memorize setting. The OSD should show OK.

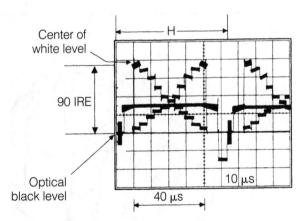

■ **12-21** *Samsung iris level adjustment.* Samsung Electronics Co.

Realistic 150 (VHS-C) back focus adjustment

Observe the back focus adjustment on the color monitor. Position the camera 3 meters (M) from the back focus chart and illuminate

the object with approximately 100 lux. Set the zoom ring to the wide-angle position and the focus ring to the three (3) meter position (figure 12-22). Loosen the hexagonal screw. Insert the back focus adjustment screwdriver point to adjust for optimum focus. Set the zoom ring to telephoto end and confirm that the chart is in focus. If not, return the zoom ring to the wide-angle end and readjust. Confirm that the chart is approximately in focus at both the wide-angle and telephoto ends with the focus ring set to the three (3) meter position. After this adjustment is completed, tighten the hexagonal screw and coat the screw with lock paint.

■ 12-22 *Realistic 150 VHS-C back focus adjustment.* Radio Shack

Olympus VX-801U PLL (VCO) frequency adjust

Connect the DVM to TP8003. Connect the VF-BA81 to the VX-801 camcorder and set the unit to VTR stop mode. Input the color bar signal through the VF-BA81. Adjust VR8001 to read 2.4 ± 0.1 V on the DVM.

Canon VM-E2NA 8-mm blooming (OFD or U-SUB)

The purpose is to set the antiblooming level, or blooming is likely to occur. Shoot the halogen lamp (300 W) wide-angled at 2 M and observe monitor TV. Place ND400 or ND800 filter on the camera lens. Adjust VR2002 on the sensor CBA board until blooming disappears (visually on monitor TV) (figure 12-23).

When the CCD or the REF module has been replaced, make the following adjustments (figure 12-24):

1. Ground pin 2 of CN2106 (with iris opened).

2. Prepare ND filter according to the type of halogen lamp used (300-V lamp—use ND400; 500-W lamp—use an ND800 filter lens).

3. Remember that excessive turning of VR2002 can cause the image to disappear.

403

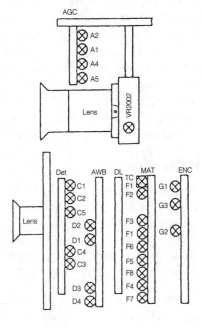

■ **12-23** *Canon 8-mm blooming OFD or V-sub adjustment.*
Canon, Inc.

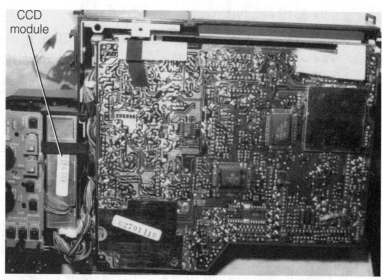

CCD
module

■ **12-24** *Location of CCD module in a VHS camcorder.*

Camera adjustments

The process section adjustments consist of AGC, brightness or luminance, white balance, auto white balance, color, and audio gain adjustments. Within these sections are several other adjustments. The real purpose is to set the brightness of the picture if the picture becomes extremely bright or dim. Set the white balance of the picture so the color reproduction does not deteriorate. Set the amplitude level of the burst signal so that the color does not become light or dense. Suppress the level differences between R, G, and B signals in standard illuminations due to color reproduction of poor white in the picture. Set the chroma level so the color reproduction does not deteriorate. Be sure and make the brightness (Y) adjustment before adjustments of the recording system.

RCA 8-mm iris auto level adjustments

Connect the camcorder and test equipment as described in the adjustment set-up procedure. Place the camera in the E-E mode with the focus set to the manual focus mode and aim the camcorder at the gray scale chart. Connect a jumper between pins 8 and 15 of J9001. Connect scope to J9001-18. Use J9001-15 as ground and trigger of oscilloscope at J9001-13 (figure 12-25).

Using the CH up and CH down buttons on the adjustment controller, set the channel display to Channel 3. Press the D. CENT. key to set data display to the center of the range and then use the data

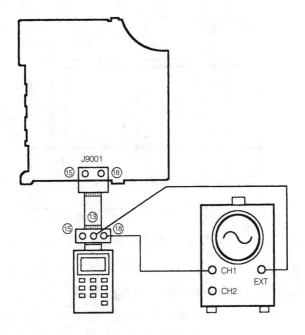

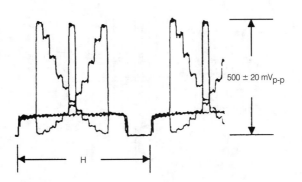

■ **12-25** *RCA PRO845 auto iris level adjustment.*
Thomson Consumer Electronics

up and data down keys to adjust the level to 500 + or – 20 m V_{P-P}.
Press the write key to store data.

Canon ES1000 REC AGC adjustment

Set camcorder to (camera EE) mode. Input signal is a white 100%
video signal. Connect scope at M.EQ, with trigger scope external
connection to FP2105. Adjust service mode, page 4 - bank 1 - ad-
dress 01. The specifications should be 500 + or – 10 mV_{P-P} (figure
12-26).

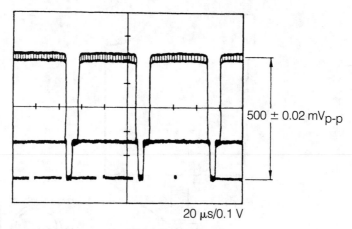

$500 \pm 0.02 \text{ mV}_{\text{p-p}}$

20 µs/0.1 V

■ **12-26** *Canon ES1000 record AGC adjustment.* Canon, Inc.

Sony CCD-M8E/M8U 8-mm iris setting adjust

Point camera at the color bar chart (in standard pattern frame). Connect the scope to TP681 on VC-4 board. Rotate RV722 so the signal level is set at 185 + or − 5 mV$_{\text{P-P}}$ (figure 12-27).

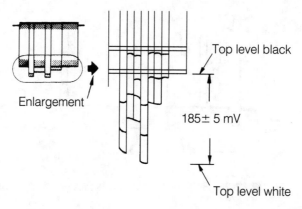

Top level black

Enlargement

185 ± 5 mV

Top level white

■ **12-27** *Sony 8-mm iris setting adjustment.* Sony Corp.

RCA 8-mm AGC level adjust

Connect the camcorder and test equipment as described in the adjustment set-up procedure. Place the camera in E-E mode and aim camcorder at the gray scale chart. Short pin 8 of J9001 to pin 15 of J9001 (figure 12-28). Connect the scope to J9001-18. Use J9001-15 as ground and the trigger of oscilloscope at J9001-13.

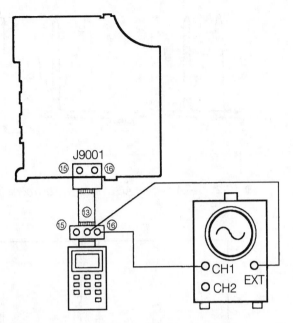

■ 12-28 *RCA 8-mm AGC level adjustment with scope and adjustment controller.* Thomson Consumer Electronics

Using the CH up and CH down buttons on the adjustment controller, set channel display to channel 4. Press the D. CENT key to set the data display to the center of the range and then use the data up and data down keys to adjust the level to 500 ± 20 MV$_{P-P}$ (figure 12-29). Press the write key to store the data.

Canon ES1000 Y/C separation adjustment

Insert signal of color bar generator. Set camera mode to E-E. Connect oscilloscope to M. EQ, with trigger of scope to FP2103. Adjust service mode 4-bank 1-addresses 02 and 03. Correct specifications to minimize residual chroma component (figure 12-30).

Samsung SCX854 auto white balance adjustment

Set camera to E-E, 3100-K/5100-K gray-scale chart. Press the play (make up/stop mode-down) button so that the OSD state is 55 AWB XX XX. Connect vectorscope input jack to video output jack. For white/balance indoor, arm camera at a 3100-degree K gray-scale chart, illuminated at 1500 to 2000 lux (40 µs). Press (start/stop confirm) button so that the white vector moves to the center of the vectorscope's screen.

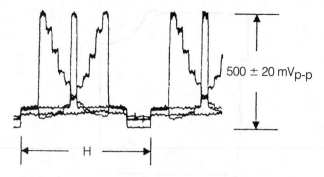

$500 \pm 20\,mV_{p\text{-}p}$

H

■ 12-29 *RCA 8-mm AGC level adjustment.* Thomson Consumer Electronics

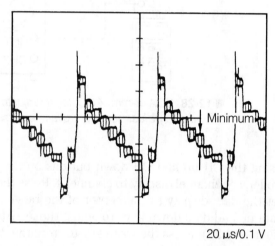

Minimum

20 μs/0.1 V

■ 12-30 *Canon ES1000 Y/C separation adjustment.* Canon, Inc.

With W/B outdoor, arm the camera at a 5100 OK gray-scale chart, illuminated at 1500 to 2000 lux (40 μs). Press (start/stop confirm) button so that the white vector moves to the center of the vectorscope's screen (figure 12-31). The OSD should then show OK.

Canon ES1000 Y record level adjust

Input signal 100% video signal with camera in E-E mode. Oscilloscope connected to M. EQ with scope external trigger at FP2101. Adjust service mode 4 - bank / 1 - address 04. Should be 500 + or – 10 mV$_{P\text{-}P}$ (figure 12-32).

Match the white luminance point with the black luminance point

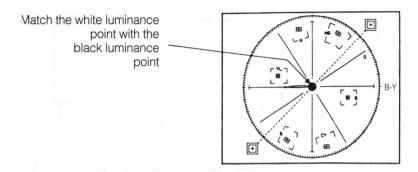

■ **12-31** *Samsung SCX854 auto white balance adjust.* Samsung Electronics Co.

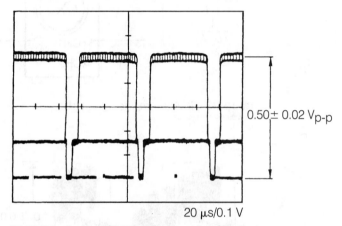

0.50 ± 0.02 V$_{p-p}$

20 µs/0.1 V

■ **12-32** *Canon ES1000 y record level adjust.* Canon, Inc.

RCA 8-mm line out Y level adjust

Connect the VCR section and test equipment as described in the VCR adjustment set-up procedure. Connect A/V cable and terminate the video output terminal in 75 Ω (figure 12-33). Place the power switch in the VCR position. Load camcorder with alignment tape and play back the color bar portion of tape. Connect scope to TP141 and external trigger at TP105. Adjust VR108 so that the signal level is 1.0 V$_{P-P}$ ± 0.02 V$_{P-P}$ (figure 12-34).

RCA PRO845 chroma balance adjustment

Connect the camcorder and equipment as described in the adjustment set-up procedure. Place a jumper between J9101-8 and J9001-15. Attach the C12 color conversion filter to the camcorder lens. Connect vectorscope to TP141 and terminate in 15 Ω. Use TP143 as ground (figure 12-35).

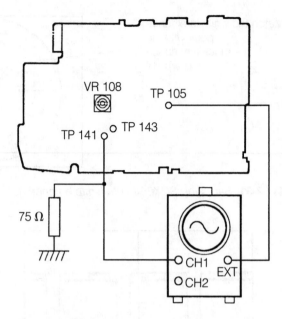

■ **12-33** *RCA 8-mm line out level adjust.* Thomson Consumer Electronics

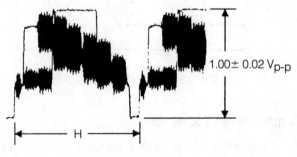

■ **12-34** *RCA PRO845 PB line out Y level adjust-ment.* Thomson Consumer Electronics

Set the camcorder to the E-E mode and the focus mode to manual focus. Adjust the gain and phase of the vectorscope so that the burst is set to the 75% mark on vectorscope screen. Using the CH up or the CH down buttons, set the channel indication on the adjustment controller to Channel 6. Using the D. CENT, the D. up and the data down button, to focus the luminance points of the color vectors (figure 12-36). Pay particular attention to the red vector. Press the write button to store the data.

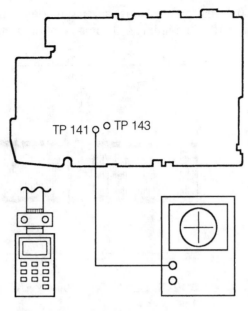

■ 12-35 *RCA 8-mm chroma balance adjustment.* Thomson Consumer Electronics

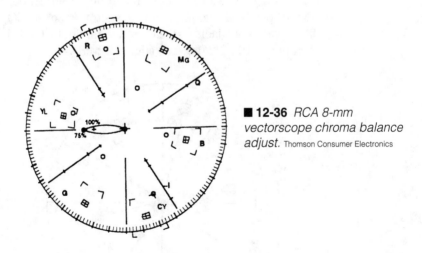

■ 12-36 *RCA 8-mm vectorscope chroma balance adjust.* Thomson Consumer Electronics

Canon ES1000 record C level adjust

Connect the red raster signal. Set camcorder in camera E-E mode. Connect scope at M. EQ with trigger external terminal of scope at

FP2009 test point. Adjust service mode 4 - bank 1 - address OB (figure 12-37). Minimize chroma component to specifications.

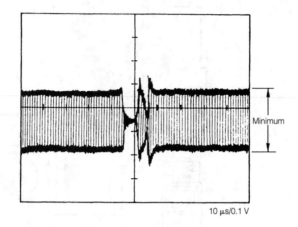

10 µs/0.1 V

■ **12-37** *Canon ES1000 record C level adjustment.* Canon, Inc.

Canon 8-mm PB chroma phase adjust

Use red raster signal recorder/reproduced on H18ME tape. Place camcorder in playback mode. Connect vectorscope M. EQ, with test point at video out jack. Adjust service mode 4 - bank 1 - address 45, R phase 104 ± 2 degrees (figure 12-38).

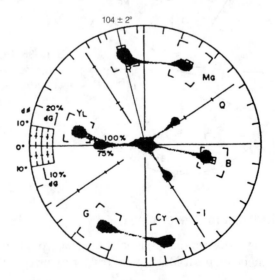

■ **12-38** *Canon ES1000 PB chroma phase adjust.* Canon, Inc.

RCA CPR100 (VHS-C) record chroma level adjust

This adjustment regulates the recorded color level. Sometimes if the color level is too high, diamond-shaped beats appear in the picture. Color can be degraded if too low. Apply the NTSC color bar signal $(1 / V_{p-p})$ to the EVF jack with audio/video adapter. Connect the scope probe to TP 201 on the head switch/function switch board (figure 12-39). Check the upper cylinder for an identification number (0 through 4) stamped on top. Rotate record luma level control (RT 201) fully counterclockwise. Load with blank tape and place in SP record mode. Adjust record chroma level control (RT 202) for correct value.

■ **12-39** *RCA CPR100 record chroma level adjustment.* Thomson Consumer Electronics

RCA 8-mm FM audio level adjust

Connect the VCR section and test equipment as described in the VCR adjustment. Place power switch in VCR position. Connect scope to TP201 on CP1 CBA board. Clip 22-kΩ resistor from TP201 to ground. Load camcorder with test tape and play back the FM audio signal. Adjust VR201 so that the amplitude of the lower frequencies and the amplitude of the higher frequencies are equal (figure 12-40).

Canon ES1000 Y-recording current adjust

No signal at input terminals. Set camcorder in camera E-E mode. Scope connected to M. EQ and trigger scope connected to FP2007. Adjust service mode 4 bank - 1 address OC with specification 210 ± 10 mV$_{P-P}$ (figure 12-41).

413

Same level

■ **12-40** *RCA 8-mm FM audio level adjust.* Thomson
Consumer Electronics

General Electric (VHS) audio back level adjust

Insert a blank tape and record a 1-kHz audio signal connected to
AUDIO IN with an ac adapter and an audio generator. After a few
minutes, play back the portion recorded. With scope connected to
TP 4001, adjust the playback level control (VR 4001) so the level
of playback waveform is equal to that of the recorded signal.

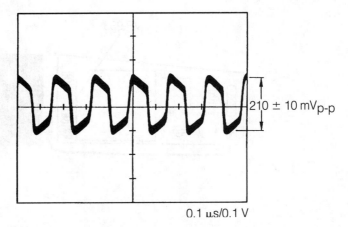

0.1 µs/0.1 V

■ **12-41** *Canon ES1000 Y recording circuit adjust.* Canon, Inc.

Sony CCD-M8E/M8U 8-mm audio distortion check

Input a 400-Hz, –66-dB signal to the microphone connecter pin (3) (white) and record for about one minute. Play back the recorded portion on VCR playback equipment. Make sure the playback distortion at audio output is less than 1 percent.

Electronic viewfinder (EVF) adjustments

Most of the EVF adjustments are made with the gray and resolution scale for best results. The deflection coil position adjustment is to provide correct tilt of the viewfinder. The centering adjustment is to match center of the TV and EVF pictures. Vertical size adjustment is to set vertical deflection size. Horizontal hold adjustment sets the horizontal frequency. Brightness adjustment optimizes the brightness of the picture, and the focus adjustment makes the EVF picture clear and distinct.

RCA PRO 848 EVR PLL lock adjust

Observe the electronic viewfinder. Connect VCR section and test equipment as described in VCR adjustment set-up procedure and apply monoscope signal to the camcorder video output jack. Place camcorder power switch in the VCR position. Adjust PLL lock control (VR 985) so that the monoscope pattern is centered on the horizontal scale (figure 12-42).

VR 983

Vertical size scale

Horizontal size scale

■ 12-42 *RCA PRO845 EVF PLL lock adjust.*
Thomson Consumer Electronics

Pentax PV-C850A 8-mm horizontal EVF tilt adjust

If the picture in the EVF screen is tilted, readjustment of the deflection coil is required. Loosen the deflection coil retaining screw (figure 12-43). Turn the deflection coil so the picture is parallel. Use a resolution chart and centering magnet to center the picture if off to the side.

RCA 8-mm EVF contrast adjust

Observe the EVF/video monitor. Place power switch in the CAM position and arm the camcorder at the gray scale chart. Connect the camcorder video output to a video monitor. Make sure camcorder is focused on chart. Adjust VR980 so that the contrast level displayed on the EVF screen matches that display on the video monitor (figure 12-44).

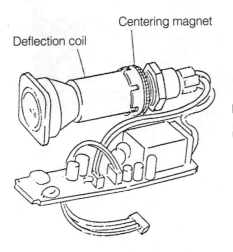

Deflection coil

Centering magnet

■ **12-43** *Pentax PV-C850A horizontal EVF tilt adjust.*
Pentax Corp.

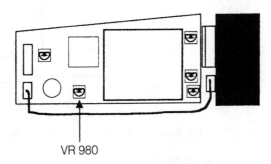

VR 980

■ **12-44** *RCA 8-mm EVF contrast adjust.*
Thomson Consumer Electronics

417

RCA PRO 848 EVF brightness adjust

Connect the VCR section and test equipment as described in the VCR adjustment set-up procedure. Place the camcorder power switch in the VCR position. Connect oscilloscope to CN973 pin 16 and use CN973 pin 5 as the ground connection. Adjust the brightness control (VR977) so that the pedestal level is 1.8 V_{P-P} ± 0.1 V_{P-P} (figure 12-45).

RCA 8-mm EVF color gain adjust

Observe the EVF/video monitor. Place the power switch to VCR position. Connect the VCR section and test equipment as described in the VCR adjustment set-up procedure. Apply a color bar

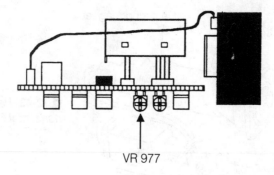

VR 977

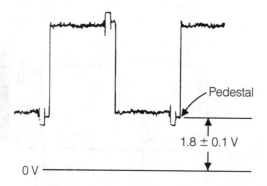

Pedestal

1.8 ± 0.1 V

0 V

■ **12-45** *RCA PRO845 EVF brightness adjust.*
Thomson Consumer Electronics

video signal to the camcorder video input jack and to the color video monitor. Adjust VR973 so that the color level displayed on the EVF screen matches that displayed on the color video monitor (figure 12-46).

RCA 8-mm OSD character position adjustment

Observe the EVF screen. Connect the VCR section and test equipment as described in the VCR adjustment set-up procedure. Place power switch in the CAM position. Push the standby switch in the on position. With camcorder in the record/pause mode, adjust the character display control C+321 (figure 12-47), so that the display is positioned as shown in figure 12-48.

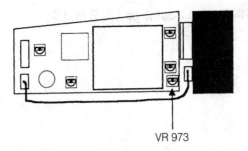

VR 973

■ **12-46** *RCA PRO845 color gain adjustment.* Thomson Consumer Electronics

CT 321

■ **12-47** *RCA 8-mm OSD character position adjust.* Thomson Consumer Electronics

A A=B B

Pause 0:00:00

■ **12-48** *RCA PRO845 OSD character position adjust.* Thomson Consumer Electronics

Canon ES1000 video trouble part A, B and C

PART A.

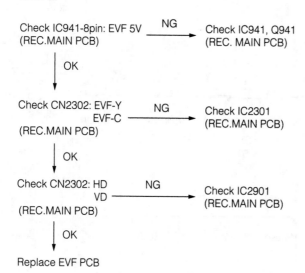

Check IC2101-2pin OK
(REC.MAIN PCB) ─────────────▶ Check JACK UNIT

│ NG
▼

Check IC201-36pin OK
(REC.MAIN PCB) ─────────────▶ Check C2129, R2119,2120
 (REC.MAIN PCB)
│ NG
▼

Replace IC2101
(REC.MAIN PCB)

PART B.

Check IC941-8pin: EVF 5V NG
(REC.MAIN PCB) ─────────────▶ Check IC941, Q941
 (REC. MAIN PCB)
│ OK
▼

Check CN2302: EVF-Y NG
 EVF-C ─────────────▶ Check IC2301
(REC.MAIN PCB) (REC.MAIN PCB)
│ OK
▼

Check CN2302: HD NG
 VD ─────────────▶ Check IC2901
(REC.MAIN PCB) (REC.MAIN PCB)
│ OK
▼

Replace EVF PCB

420

PART C.

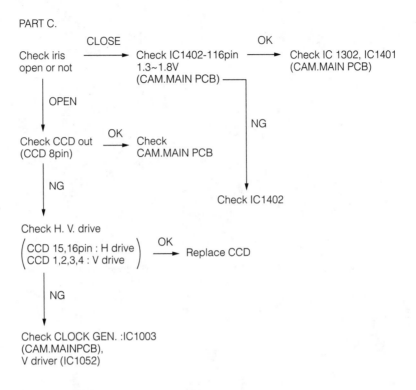

Adjustment notes

After replacing the heads and preamplifier, make the FO/Q, VCO-PLL, AFC, and playback (PB) level adjustments. If the drum assembly is replaced, the FO/Q adjustment is needed. Adjust the playback system prior to adjusting camera and deviation. Each manufacturer can have their own camcorder adjustment procedures.

Use a halogen lamp because most white/black charts are the reflective type. Adjust the chart surface temperature to approximately 1500 lux. The chart surface should be lit evenly. When the luminance cannot be reduced down to a specified value, use an ND filter. Wall chart adjustments are the cheapest and quickest way to go, except some manufacturers' adjustments are made with the light box.

Troubleshooting the camcorder

TROUBLESHOOTING THE CAMCORDER MIGHT NOT BE AS difficult as it seems. Try to match the most likely section on the block diagram with the defective symptom. Then, find the defective section on the regular schematic (figure 13-1). Most manufacturers have the schematics broken down into the various sections because one large schematic would be impossible to print.

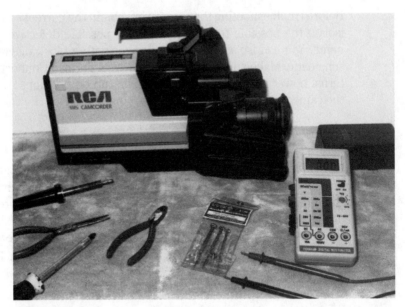

■ **13-1** *Choose small screwdrivers and tools to remove the various screws in the camcorder case.*

For instance, if the trouble symptom is no color and the camera section is normal in black and white operation, check the chroma circuits. Likewise, if the color picture is normal with no sound, you would check the audio circuits and microphone. If more than one

section is defective, check the power source. Although camcorder servicing methods on the different circuits might be the same as the one you are working on, they are serviced in the same manner.

Take critical voltages to locate the defective part. Scope the various circuits to locate missing or improper waveforms. After locating the suspected component, take critical continuity and resistance measurements. Remember that many of the symptoms found in any electronic product are simple part breakdown and mechanical operations.

Certain stages and circuits can be tested by simply taking an alignment test. If the circuit or component does not respond, suspect a defective stage. For instance, check the flying erase head by making the erase head adjustment. If voltage is not present, clean up flying erase head. If still low in voltage, replace upper cylinder or drum assembly.

Before troubleshooting

Before troubleshooting the camcorder, obtain the correct schematic, isolate the possible trouble, and list the possible defective components. You can isolate service symptoms with a block diagram and schematic. Make sure the battery voltage is normal. Connect an external power supply with all switches in the off position. Dismantle the camcorder to get at the defective components.

Voltage measurements

Critical voltage measurements with correct waveforms can solve critical service problems in the camcorder circuits. Only a few camcorder manufacturers place the actual voltage measurements on the schematic. Separate voltage charts are given in the back of the service manual. Several manufacturers break down the voltage charts with the camcorder in the various modes (stop, record, play, rewind, fast forward, review search, and forward search) (Table 13-1).

When the loading motor is not operating properly, check the voltages on the loading motor (1 and 2) terminals. If the motor does not unload or load, check voltages at pins 14 and 16 of IC391 (figure 13-2). Measure the dc voltage supply pin 15 of IC391. If low or no voltage, check low voltage power source or dc to dc converter. Remove pin 15 if voltage is low and determine if the loading motor drive IC is leaky. Check the load and unload signal at pins 39 and 40 of the micro processor (IC351).

■ Table 13-1 The various voltages found on the servo/system control IC601 in the Samsung 8-mm camcorder.

Pin no.	Play back	Record	Stop
1	0.0 V	0.0 V	0.0 V
2	4.3 V	0.0 V	0.0 V
3	0.0 V	0.0 V	0.0 V
4	4.6 V	4.6 V	4.6 V
5	0.0 V	0.0 V	4.7 V
6	0.0 V	0.0 V	0.0 V
7	4.1 V	4.1 V	4.8 V
8	0.0 V	0.0 V	0.0 V
9	4.6 V	4.6 V	4.8 V
10	4.6 V	4.6 V	0.0 V
11	4.6 V	4.6 V	4.6 V
12	0.0 V	0.0 V	0.0 V
13	0.0 V	0.0 V	0.0 V
14	0.0 V	0.0 V	0.0 V
15	0.0 V	0.0 V	0.0 V
16	4.7 V	4.7 V	4.7 V
17	0.0 V	0.0 V	0.0 V
18	4.7 V	4.7 V	4.7 V
19	4.7 V	4.7 V	4.7 V
20	4.8 V	4.8 V	4.8 V
21	4.8 V	4.8 V	4.8 V
22	4.8 V	4.8 V	4.8 V
23	4.8V	4.8 V	1.0 V
24	0.0 V	4.8 V	0.0 V
25	0.0 V	4.8 V	0.0 V
26	4.8 V	0.0 V	4.8 V
27	1.6 V	1.6 V	0.3 V
28	4.8 V	4.8 V	0.0 V
29	0.0 V	4.8 V	0.0 V
30	4.8 V	4.8 V	0.0 V
31	0.0 V	0.0 V	0.0 V
32	0.0 V	0.0 V	0.0 V
33	1.9 V	1.9 V	0.0 V
34	0.0 V	0.0 V	0.0 V
35	4.1 V	4.1 V	4.1 V
36	0.2 V	0.2 V	0.2 V
37	4.7 V	4.7 V	4.7 V
38	4.8 V	4.8 V	4.8 V
39	0.0 V	0.0 V	0.0 V
40	4.6 V	4.6 V	4.6 V
41	0.0 V	0.0 V	0.0 V
42	2.5 V	2.5 V	2.5 V

Pin no.	Play back	Record	Stop
43			
44	4.6 V	4.6 V	4.6 V
45	4.6 V	4.6 V	4.6 V
46	4.0 V	1.8 V	1.8 V
47	4.5 V	4.5 V	4.5 V
48	0.0 V	0.0 V	0.0 V
49	0.0 V	0.0 V	0.0 V
50	4.8 V	4.8 V	4.8 V
51	4.8 V	4.8 V	4.8 V
52	0.0 V	0.0 V	0.0 V
53	4.6 V	4.6 V	4.6 V
54	4.6 V	4.6 V	0.0 V
55	4.4 V	4.4 V	4.4 V
56	0.0 V	0.0 V	0.0 V
57	0.0 V	0.0 V	0.0 V
58	4.4 V	4.4 V	4.4 V
59	3.0 V	3.0 V	3.0 V
60	3.8 V	3.8 V	3.8 V
61	0.0 V	0.0 V	2.3 V
62	2.4 V	0.4 V	2.4 V
63			
64			
65	0.0 V	0.0 V	4.8 V
66	0.2 V	0.2 V	2.4 V
67	0.0 V	0.0 V	4.8 V
68	0.0 V	0.0 V	0.0 V
69	2.4 V	2.4 V	3.0 V
70	2.4 V	2.4 V	4.8 V
71	0.0 V	0.0 V	0.0 V
72	0.0 V	0.0 V	0.0 V
73	0.0 V	0.0 V	0.0 V
74	0.0 V	0.0 V	0.0 V
75	1.3 V	1.3 V	0.0 V
76	0.5 V	0.5 V	0.0 V
77	2.4 V	2.4 V	4.8 V
78	1.6 V	0.0 V	1.1 V
79	1.6 V	0.0 V	1.1 V
80	1.7 V	0.0 V	1.4 V
81	4.6 V	4.6 V	4.6 V
82	4.8 V	4.8 V	0.0 V
83	0.0 V	0.0 V	4.5 V
84	0.0 V	0.0 V	0.0 V
85	4.7 V	1.8 V	1.8 V
86	1.5 V	1.5 V	1.5 V

Pin no.	Play back	Record	Stop
87	2.4 V	2.4 V	2.4 V
88	0.0 V	0.0 V	0.0 V
89	4.7 V	4.7 V	4.7 V
90	4.7 V	4.7 V	4.7 V
91	0.0 V	0.0 V	0.0 V
92	0.0 V	0.0 V	0.0 V
93	4.6 V	4.6 V	2.4 V
94	4.6 V	4.6 V	4.6 V
95	4.6 V	4.6 V	0.0 V
96	2.3 V	2.3 V	0.0 V
97	2.0 V	2.6 V	0.0 V
98	2.3 V	2.3 V	0.0 V
99	4.6 V	4.6 V	0.0 V
100	4.6 V	4.6 V	0.0 V

Samsung Electronics Co.

427

■ 13-2 *Check the voltage applied to the loading motor pins 14 and 16 of IC391 in the RCA PRO845.*

Scope waveforms

There are many critical waveforms to be taken in the camcorder circuits. Critical waveforms can determine if the circuit is working or not. Waveforms taken throughout the camcorder signal paths can help you to locate the defective section or stage. Often, signal tracing with the scope and critical voltage measurements uncover

the defective component. Critical waveforms of the process, servo, sensor, luma/chroma, and the electronic viewfinder (EVF) circuits are given in the manufacturer's literature.

For instance, to determine if the encoder circuits are defective in the RCA PRO 845 camcorder, take critical waveforms of color in (18) and color out (16). The BFG waveform is taken at pin 36 of IC912 and the sync waveform off of pin 25 (figure 13-3). If input waveforms are normal and no output waveforms, suspect defective IC912 or improper dc supply voltage. Take a critical voltage test upon encoder supply voltage DVCC pin 3 (4.9 V).

Common failures

A "dead" camcorder can result from a blown fuse, poor battery voltage, or a bad ac power supply. Check the battery terminals for poor connections. Test the camcorder in both battery and ac operation to determine if the power source or the camcorder is defective. Sometimes the camera detection circuits shut the camcorder down if the battery is too low, although it's possible that the tape movement could continue to operate. Monitor the battery voltage with the camcorder operating to determine if the battery breaks down under load. In some models, the cassette must be loaded before any power comes on.

The fuse might be blown or intermittent. Intermittent operation can be caused with a loose fuse in the connector. Sometimes the fuse's metal ends have arced and cause a poor contact, resulting in intermittent operation. When checking the fuse in place, measure the voltage from metal clip to clip to determine if the fuse is open or has poor contact.

No picture

This can be caused with the lens cap on, showing nothing in the viewfinder. Check the white switch setting and brightness control. Recheck the manual iris setting. Determine if the tape is moving. Connect the camcorder to the TV set or monitor to determine if viewfinder is defective.

No picture in viewfinder

Can be caused by a defective or improper setting of the camera/playback switch. Make sure the switch is in playback mode. Make sure the EVF cable is plugged in tight. Check the EVF connection for bent or misaligned prongs. If no picture in the viewfinder,

428

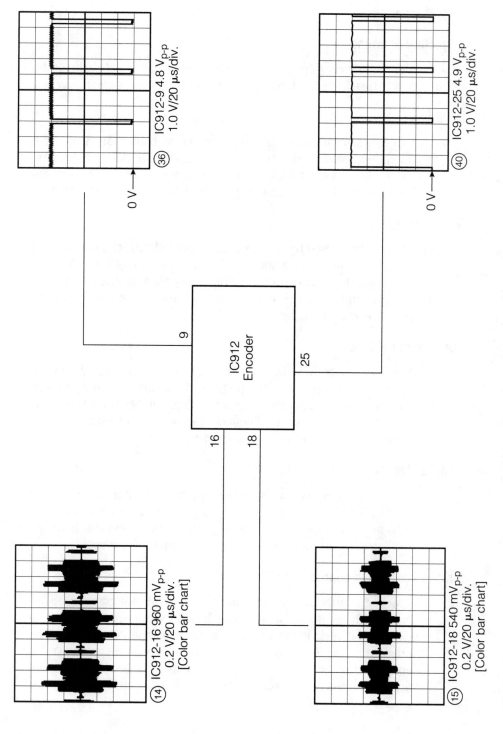

IC912-9 4.8 V$_{p-p}$
1.0 V/20 μs/div.

③⑥

0 V →

IC912-25 4.9 V$_{p-p}$
1.0 V/20 μs/div.

④⓪

0 V →

IC912
Encoder

9

25

16

18

IC912-16 960 mV$_{p-p}$
0.2 V/20 μs/div.
[Color bar chart]

⑭

IC912-18 540 mV$_{p-p}$
0.2 V/20 μs/div.
[Color bar chart]

⑮

■ **13-3** *The color, sync and drum waveforms found on 9, 16, 18, and 25 of IC912 encoder of RCA 8-mm camcorder.* Thomson
Consumer Electronics

connect camcorder to TV set monitor to make sure EVF is not operating.

No picture or sound

Make sure camera/playback switch is in playback mode. Check the power distribution source for a common defective power source.

No audio

Can result from a defective microphone or cables. Most of these microphones plug directly into the EVF assembly or camera. Clean mike controls. Make sure the ring tightener is snug. Try another external microphone. Next, check the VCR sound circuits.

No or improper color

This can be caused by poor or insufficient lighting. Check the camera with proper white set-up adjustments. Sometimes extreme light from the bright sun outdoors coming through the living room picture window causes poor color pictures. Check the color temperature switch setting.

Fuzzy or out of focus

This can result from improper focus of the zoom lens. When the zoom motor is operating the picture will naturally be out of focus for a few seconds. Sometimes changing quickly from scene far away to a close-up shot will cause the picture to be out of focus. Poor lighting can result in fuzzy pictures.

Damaged parts

Damage to parts is usually caused by the operator dropping the camcorder or rough treatment. If the camcorder uses a pickup tube as sensor, the glass tube might be broken. You can hear the rattling of pieces of glass, indicating pickup tube damage.

Cracked or broken boards

Cracked boards can produce dead or intermittent camcorder operation (figure 13-4). Make sure all board sockets are firmly pushed down. Look near heavy objects mounted on the PC board for the cracked areas. Sometimes the PC wiring can be repaired. Try to splice the cracked area. Do not run long wire leads. Be careful around multi-lead microprocessors and ICs, because the leads are

430

■ 13-4 *Locate the correct surface mounted (SMD) IC on the PC board for waveform and voltage measurements.*

close together and might be difficult to repair. Replace cracked boards.

Poor soldered joints

Poor soldering can cause intermittent or dead operations. Push down and pry up on a board at different areas to uncover a badly soldered connection. Sometimes poorly soldered connection can be solved by soldering all the joints in that area. Be very careful not to apply too much solder so that it doesn't run into another circuit.

You might find a lot of poor joints or broken boards in the camcorder. This is due to the fact it is carried around to many different places. Check for large parts or shields for poorly soldered connections. Sometimes cooling these joints with cooling solution helps to make it act up to aid in pinpointing the problem.

■ Table 13-2 The power supply flowchart in the RCA PR0845 camcorder.

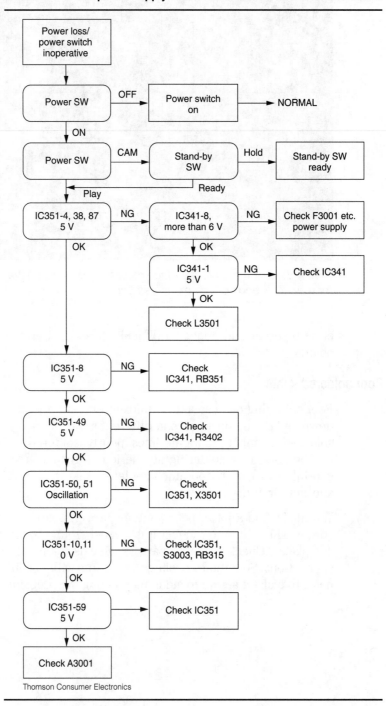

Thomson Consumer Electronics

432

Troubleshooting the various circuits

Many camcorder manufacturers provide a troubleshooting flow-chart of what components to check in the proper order. Besides critical waveform and voltage measurements, camera electrical adjustments can help to determine if a particular circuit is defective. Do not overlook doing accurate resistance measurements in difficult circuits.

No power

With no VCR or camera operation, go to the power input circuits. Try the camcorder in both battery and ac operation. A blinking green LED in the viewfinder can indicate a weak battery. If nothing, plug in the ac power supply. Check the fuse. Make sure battery or external jack is normal. If okay, measure the voltage at the fuse terminals. Proceed into the circuit and do not overlook an isolation polarity diode in the dc power line. Check the voltage going into the power circuits (figure 13-5). If it comes on and then shuts off, it could be that the end-of-reel detection circuit has activated.

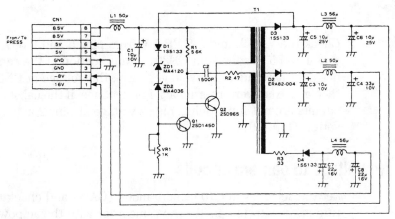

■ **13-5** *Minolta C3300 power supply circuits.* Minolta Camera Co.

Measure the input voltage of −8.5 V at CN302 pin converter, going to terminal 16 of the dc/dc converter (A3001). Check the 5 V (S) at pin 4 and 15 V at pin 5 that apply to pins 14 and 15 of converter, respectively (figure 13-6). Test the unregulated and regulated output voltage at connector CN301. Check C3003 (220 µF) and C3001 (470 µF) for possible leakage upon the input voltages.

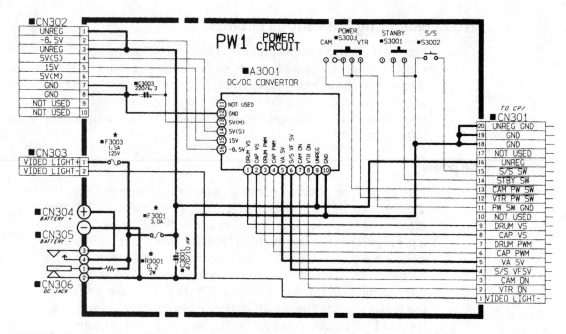

13-6 *Power circuit of RCA 8-mm dc/dc converter with input and output voltages.* Thomson Consumer Electronics

Check the VA 5 V and S/S VF 5 V from pins 5 and 6 of A3001 to pins 4 and 5 of connecter CN301. If any section of the camcorder does not have adequate voltage, check the voltage at CN301 and then at the converter terminals. For instance, if the capstan motor circuits are not functioning, check voltage at pins 2 and 4 of converter IC (A3001).

No voltage to camera circuits

Set the select switch to camera mode (CAM) and check the picture in the viewfinder. Try the camcorder with the ac power supply and required battery. If the camera or VCR circuits do not operate, suspect a defective power distribution circuit and dc/dc converter. Check the 5-V sources in the Samsung SXC854 camcorder dc/dc converter (figure 13-7).

The unregulated voltage comes from pins 1 and 2 of CN901. This voltage is fed through a low pass filter network (LPF) to the various switching circuits. The unregulated voltage from battery or external power supply is fed to switching transistors Q918 for camera (CAM 5 V) voltage source. Check the voltages on terminals of Q918 and pin 20 of IC901. Test transistors Q918 with a tran-

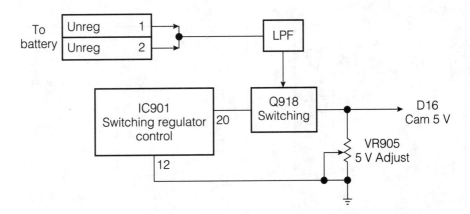

■ 13-7 *Samsung SCX854 switching regulator control circuits.* Samsung Electronics Co.

sistor tester or DMM diode tests. When the voltage will not vary with 5 V ADj control (VR905), suspect pin 12 of IC901. Check the other voltage sources of EVF 5 V, VTR 5 V, SS 5 V, Drum VS and Cap VS, to servo-syscon circuits, 20-V, 15-V, and –9-V sources. Check voltage flowchart Table 13-3 of Samsung 8-mm converter circuit.

Checking sensors

In some camcorders, you might have to deactivate a sensor in order to use the EMERGENCY ON mode for observing operation, waveforms, and locating the source of trouble. The REC safety left switch might have to be shorted together to supply power to the camcorder. In the Zenith VM 6150 VCR, cover the photosensor with tape so it will not be damaged with cassette switch on. Construct a jumper wire and connect it to pin 1 of CN1 and pin 3 of PH S301, the take-up reel sensor (figure 13-8 and figure 13-9). Use a small, stiff wire in the clip for inserting into PHS301 pin 3.

When operating the VCR without a cassette, the supply reel sensor must be deactivated in order to avoid emergency shutdown in the Zenith VM 6150 camcorder. This type of shorting arrangement is made to defeat both the supply and take-up reels. Sometimes the "tape remaining" indicator appears, but it does not affect the operation. Doublecheck the deactivating of sensors when not using a cassette in the machine. If power comes on and then goes off, it might mean that a battery charge is nearly completed.

■ Table 13-3 Samsung SCX854 DC/DC converter troubleshooting chart.

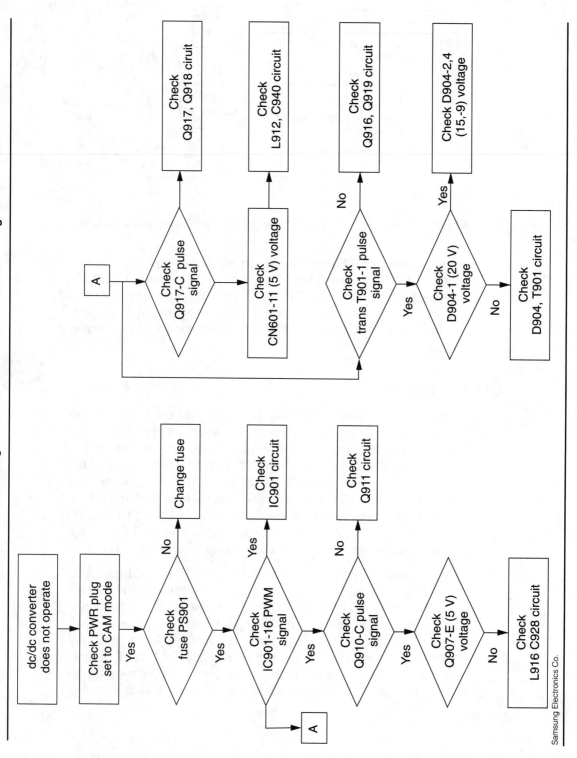

Samsung Electronics Co.

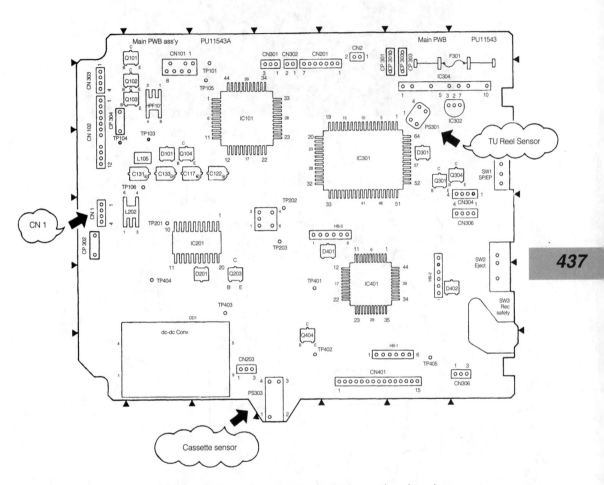

■ 13-9 *Zenith VHS-C location of CN1 and take-up reel sensor on the chassis.*

No auto focus

Try shifting the camera to different scenes to determine if the lens is changing back and forth in auto focus operation. Often the camera section must be torn down to get at the focus motor and circuits (figure 13-10). If no operation, check the voltage upon the

■ **13-10** *Autofocus assembly on lens assembly of the RCA VHS camcorder.*

focus motor and focus motor drive IC1336. Check the resistance or continuity of the focus motor in the Canon ES1000 camcorder.

The focus stop, focus power save, focus CW and CCW, focus pulse, and focus reset signals are fed from the camera/AF Mi-Com IC1402 (figure 13-11). A focus monitor signal is fed back from pin 27 to pin

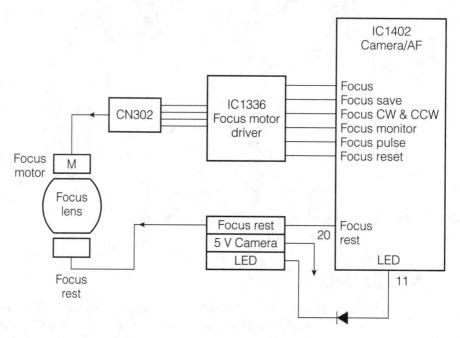

■ **13-11** *Canon ES1000 8-mm autofocus circuits.* Canon, Inc.

19 of IC1402. The camera 5-V source, focus reset and LED indicator is found fed to the focus reset circuits of camera lens assembly. Take critical voltages on focus motor drive IC and focus motor.

Pentax PV-C850A auto focus circuits

Before tearing into the camera, place auto focus switch on auto. Place a white cardboard a foot from the lens assembly and notice if the lens assembly moves. Take it away, and the assembly should move again. If not, check the infrared transmitting diode with the infrared diode tester. This diode, with the phototransistors, are located at the front and bottom of the lens assembly in most cameras.

Remove camera covers to get at the auto focus board and LED. Check the voltage (7.2 V) at the B+ switch Q2AF (figure 13-12). Measure the +5 V at pin 3 of the 5-V regulator (IC3AF). The 5-V reg-

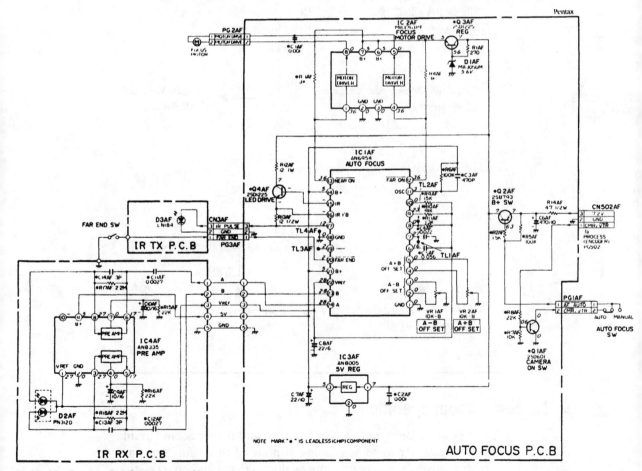

■ **13-12** *Pentax PV-C850A autofocus circuits.* Pentax Corp.

ulator could be leaky or open with low or no voltage at pin 3. Next, check the voltage applied to the auto focus IC1AF. Likewise, measure the voltage at LED driver Q4AF, preamp IC4AF and voltage at pins 2 and 13 of IC1AF (3.6 V). This voltage is sent to the focus motor drive IC2AF. Check the motor voltage at pins 5 and 8 of the focus motor. Remove motor plug and check the focus motor with low ohm-meter continuity resistance for open motor winding (Table 13-4).

■ **Table 13-4 Canon ES1000 image stabilizer troubleshooting chart.**

Canon, Inc.

No power zoom operation

The iris, auto focus, auto white balance, and power zoom circuits are tied together in some models. If none of these functions are working, suspect improper supply voltage. Press and hold the tele

440

(T) and wide (W) switches. Notice if the lens assembly moves out or in. Check the regulated voltage supplied to the zoom drive IC or transistors.

In the RCA PRO845 8-mm zoom operation, the zoom circuits operate from a 5-V source fed to a zoom position sensor. The zoom sensor is tied to pins 1, 2, and 3 of CN932, while the negative motor terminal at pin 3 and positive motor terminal at pin 5. The zoom motor is controlled by two zoom drivers Q9316 and Q9317 (figure 13-13).

■ **13-13** *RCA PRO845 8-mm zoom motor circuits.* Thomson Consumer Electronics

Check the voltage at the motor terminals and ground with the zoom tele or wide button pressed. Take continuity of motor terminals for open motor winding. With no or low voltage, measure the voltage on zoom drivers. Zoom drivers Q9316 and Q9317 have two digital transistors inside each component. Check the supply voltage pin of 5 V at terminal 4 of Q9316. If improper or no voltage, suspect power supply regulator transistor Q9313. Measure the input voltage (4.8 V) at pins 3 and 5 of Q9316. Suspect the micro processor IC932 with no output voltage at pins 57 and 58.

Iris control circuits

Usually the iris circuits are controlled from the AGC and ALC module. If the iris unit does not function, scope the AGC and iris detector waveforms entering the iris board module or IC (pins 13 and 19). Check the CLP3 waveform (pin 18) from the timing generator and the VD waveform (pin 9) of the iris driver IC721. Measure the

■ **13-14** *Sony 8-mm iris camera circuits.* Sony Corp.

supply voltage on IC721 (figure 13-14). Check the continuity of the iris motor drive and field coils.

The iris detector and AGC signals are applied at pins 2 and 12 of IC 1404 in the Realistic 150 iris circuits (figure 13-15). First check the B+ voltage (pin 1) with no iris movement. Notice the drive coil winding of the motor is supplied by +9 V and is tied to pin 9. Measure the damping voltage at pin 7 and 8 of IC 1404. Check the continuity of the damp and drive coils of the iris motor with the low ohmmeter scale. Low drive voltage can indicate a leaky iris drive IC.

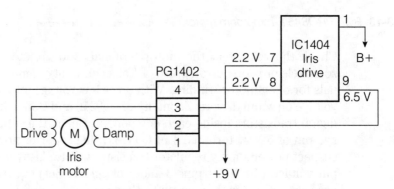

■ **13-15** *Radio Shack 150 VHS-C iris motor circuits.* Radio Shack

Capstan does not rotate

The following symptoms might occur in the Samsung SCX854: The tape is inserted and after a couple of seconds, it unloads and indicates drum or cylinder problems. There is no take-up action and the cassette is ejected. These symptoms can indicate that there is no drum or capstan motor rotation. Inspect the motor belt for

cracks, broken or slippage. If the motor is operating and no action, suspect a defective capstan motor belt.

Check the voltage applied to the motor terminals in the RCA PRO845. No voltage can indicate a defective driver or drive signal from microprocessor IC351 (figure 13-16). Measure the regulated voltage at pin 10 and 5 V at pin 15 of motor driver IC391. Suspect a defective voltage source or voltage regulator Q3901 with low or no applied supply voltage. Check the load and unload voltage at pins 11 and 12 of driver IC. Replace IC391 with correct drive, regulator and 5-V supply voltage.

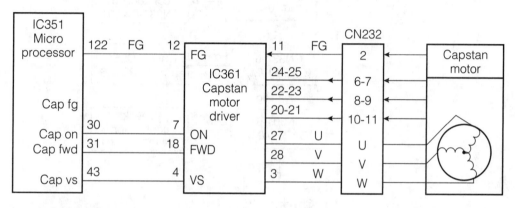

■ **13-16** *RCA PRO845 8-mm capstan motor circuits.* Thomson Consumer Electronics

RCA CPR100 capstan motor circuits

The capstan motor is controlled by IC driver IC604 (Table 13-5). If the FF/REW rotation is normal and there's no CW/CCW rotation, check the voltage at IC901. If no FF or REW, check the 12-V supply source at pin 7 of IC604. In play (or forward) mode, the capstan B+ voltage at pin 8 of IC604 is 2 V. With FF operation, the capstan B+ voltage at pin 8 of IC604 is 4.6 V (figure 13-17). Check motor coil continuity with voltage applied to the motor. Measure the forward and reverse motor voltage applied to the motor. Suspect capstan motor if voltages are present.

Does not eject or load

In the RCA CPP300 camcorder, when loading begins, the main brake releases both reels. The tape from the cassette is loaded by the guide roller. During unloading, the pressure roller is the first thing released. The main brake prevents the tape from fluctuating

■ Table 13-5 RCA 8-mm capstan motor flowchart.

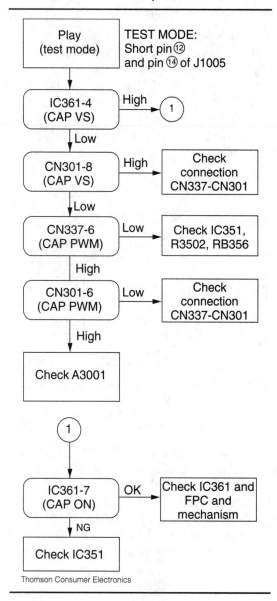

Thomson Consumer Electronics

and take-up brake is on to prevent tape from being pulled out of the take-up reel.

The loading motor in the Samsung SCX854 camcorder is operated by a signal voltage from IC601 Mi-Com, loading motor driver IC504, and the loading motor (figure 13-18). The Mi-Com IC601 controls the load and unload signal to the loading motor driver IC.

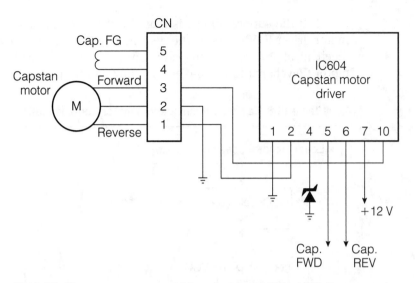

■ **13-17** *The capstan motor drive circuits of RCA VHS-C camcorder.*
Thomson Consumer Electronics

445

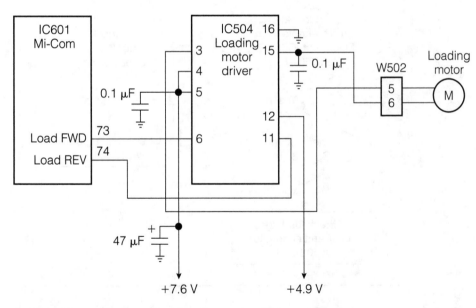

■ **13-18** *Samsung 8-mm loading motor circuits.* Samsung Electronics Co.

Notice if loading motor is rotating, when the eject or load circuits are energized. Check the supply voltage at pins 4 and 5, and also pin 12 of IC504. Check the voltages on pin 15 for load and pin 3 for unload at the motor terminals. No voltage can indicate a defective

IC504. If the supply voltage is real low at pin 12, suspect a leaky motor driver IC504. Check the door mechanism for bent levers or mechanical problems when loading motor operates. Check loading motor flowchart (Table 13-6) for loading motor operations.

■ Table 13-6 Samsung 8-mm loading motor troubleshooting chart.

```
┌─────────────────────────────────┐
│  Loading motor does not operate │
└─────────────────────────────────┘
                │
                ▼
        ┌───────────────┐          TS-3
        │   Check fuse  │
        │     PS901     │
        └───────────────┘
                │
                ▼
      ┌───────────────────┐
      │ Check GND and VCC │
      │ of loading driver │
      │       IC504       │
      └───────────────────┘
                │
                ▼
          ╱ Check ╲              ╱ Check ╲
         ╱ drive enable ╲   No  ╱ IC601(Mi-Com) ╲
        ⟨ Mi-com at IC601-71, ⟩──▶⟨   operation   ⟩
         ╲ 72 IC504-6, 11 ╱       ╲             ╱
                │ Yes                    │ Yes
                ▼                        ▼
          ╱ Check drive ╲   No   ┌──────────────────┐
         ⟨ IC504-3, 14  ⟩───────▶│ Check loading drive │
          ╲            ╱         │       IC504       │
                │ Yes            └──────────────────┘
                ▼
      ┌───────────────────┐
      │   Check loading   │
      │ motor and connector│
      │     W502-5, 6     │
      └───────────────────┘
```

Samsung Electronics Co.

Cylinder of drum motor does not operate

In many camcorders, the drum or cylinder and capstan motors operate from the servo or Syscon circuits. A problem symptom might be that when the tape is inserted, it loads for a few seconds and then unloads. There is no drum or cylinder rotation. Check the regulated and unregulated 5 V at pins 5 and 14 of the drum motor driver IC180 in the Canon ES1000 (figure 13-19). Real low voltage

446

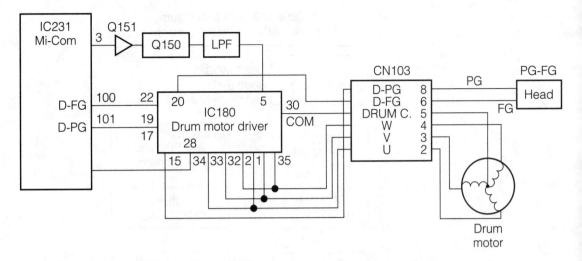

■ **13-19** *Canon ES1000 8-mm drum motor circuits.* Canon, Inc.

can indicate a defective dc/dc connector, battery source, or leaky IC180.

Check the drum FG and PG waveforms at pins 100 and 101 (IC231). These waveforms are present when drum motor is operating. Scope the D - PWM signal at pin 3 of servo Mi-Com IC231. Check continuity of windings V, W, and U of drum motor when voltage is found at motor terminals. Do not overload Q151 and Q150 of the PWM power drive applied to pin 5 of IC180. Check Table 13-7 for RCA PRO845 drum rotation.

Poor rotation of drum motor

When the drum or cylinder does not rotate properly during recording, check the servo speed control circuits in the Samsung SCX854 camcorder. IC502 provides drive control for the drum motor terminals, U, V, and W. Check the drum drive motor IC for correct supply voltage and input drive. Check the input and output terminals of dc/dc converter of drum PWM circuits. Scope the motor output FG and PG pulses at terminals 68 and 69 of IC601 Mi-Com. Check Table 13-8 for additional troubleshooting data.

Sensors not working

When none of the trouble detection indicators work, suspect a defective system control IC. Check the voltage supply source of the Mi-Com IC. If no end lamp, check the end lamp voltage and sensor

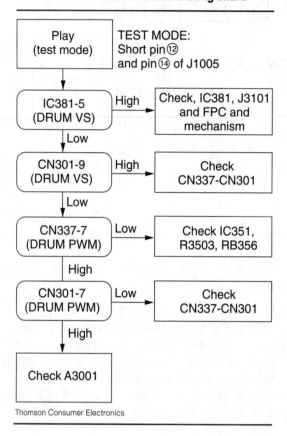

■ **Table 13-7 RCA 8-mm drum does not rotate troubleshooting chart.**

| Play (test mode) | TEST MODE: Short pin⑫ and pin⑭ of J1005 |

IC381-5 (DRUM VS) → High → Check, IC381, J3101 and FPC and mechanism

↓ Low

CN301-9 (DRUM VS) → High → Check CN337-CN301

↓ Low

CN337-7 (DRUM PWM) → Low → Check IC351, R3503, RB356

↓ High

CN301-7 (DRUM PWM) → Low → Check CN337-CN301

↓ High

Check A3001

Thomson Consumer Electronics

at pin 41 of IC501 (figure 13-20). Measure the voltage or end sense transistor and LED. Suspect poor cable and socket contacts, no applied voltage from sensor detectors of Samsung 8-mm indicator circuits. Do not overlook the LED drive transistor.

If there is no supply reel or take-up reel indication, check both reel sensor indicators. Measure the +5 V applied to pin 3 of each device. Check all sensor connections. Do not overlook a defective sensor. Review troubleshooting chart (Table 13-9).

Detectors not working

The VCR will not operate with a flashing dew test LED. The drum does not rotate during loading. Sometimes in unloading, the system stops for 5 minutes or so or shuts off. Check for a defective dew sensor or IC controlling the dew sensor circuits. Sometimes,

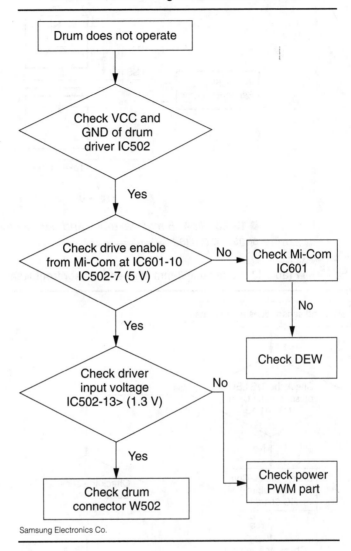

■ Table 13-8 Samsung SCX854 drum flowchart.

Drum does not operate

Check VCC and GND of drum driver IC502

Yes

Check drive enable from Mi-Com at IC601-10 IC502-7 (5 V)

No → Check Mi-Com IC601

No

Check DEW

Yes

Check driver input voltage IC502-13> (1.3 V)

No

Yes

Check power PWM part

Check drum connector W502

Samsung Electronics Co.

449

when all LEDs flash, that indicates dew warning. When only some LEDs flash with no operation, that indicates an emergency mode, which requires service.

The intermittent dew sensor operation can result from poor connector or ground contacts. Measure the resistance of the dew sensor. Then measure the resistance where the dew sensor is connected to the sensor IC terminal (figure 13-21). If there is a difference in resistance, suspect poor contacts at the socket connector.

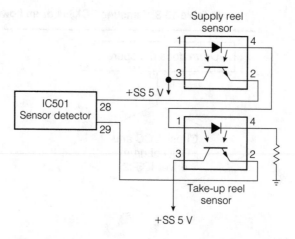

■ **13-20** *RCA 8-mm take-up and supply-reel sensor circuits.* Thomson Consumer Electronics

■ **Table 13-9 Samsung 8-mm start-end sensor troubleshooting chart.**

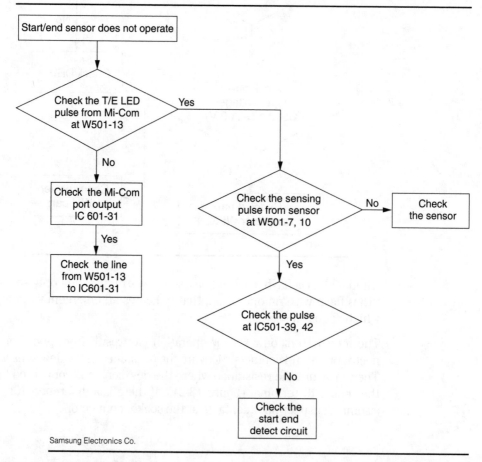

Samsung Electronics Co.

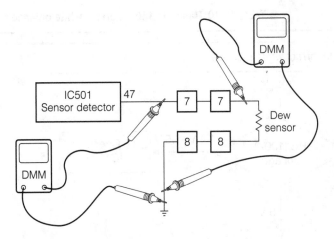

■ 13-21 *Measuring the resistance of the dew sensor and possible poor connections.*

Improper white balance

Check the incorrect white balance flowchart (Table 13-10). In the RCA CPR100 process video circuits, measure the voltage at TP1107 off of pin 4 of IC1102 (1.4 V to 1.5 V). If no voltage, check supply voltage to IC1102 (B+, 9 V) pin 11 (figure 13-22). IC1102 might be defective with normal supply voltage and no voltage at TP1107.

Measure the voltage pin 15 of IC1104 (auto white balance IC). Check the voltage at pin 5 (2.9 V) of IC1104. If voltage is zero, inspect RM1101 (setup control). IC1104 could be defective if voltage is on pin 5 (2.9 V) and not on pin 15. Recheck voltages on pin 18 (0.3 V) and pin 19 (0.2 V). If no voltages are measured here, test voltages on IC1107.

No on-screen display

Check to see if any of the screen display lights are on. If not, inspect battery display, apply dc voltage to external battery jack, or exchange the battery. Does the display light up (E—F) with any tape rotation? Readjust the battery circuits. Make sure the camcorder is set to camera and record mode. If no display, check the 9- or 5-V supply voltage. Measure voltages on power switches, over discharge transistors, and regulators in the power distribution.

You can check the on-screen display, by setting up the on-screen display character position adjustment. Connect the VCR section and

■ **Table 13-10 Realistic 150 incorrect white balance flowchart.**

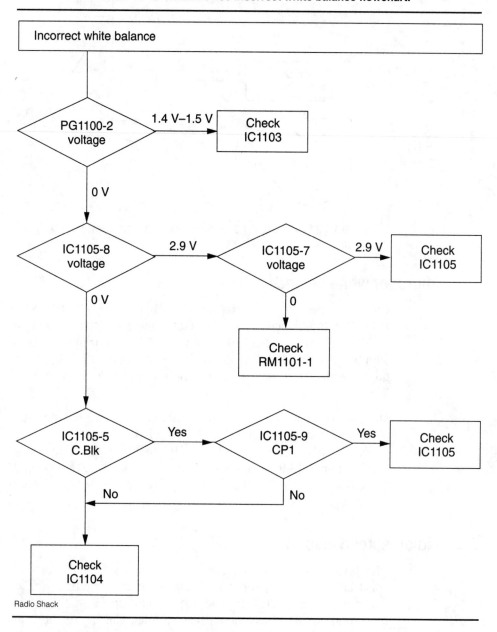

Radio Shack

test equipment in the VCR set-up adjustment in the RCA PRO845 (figure 13-23). Place the power switch in the CAM and standby switch in the on position. With the camcorder in record/pause mode,

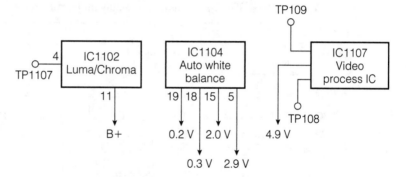

■ 13-22 *RCA VHS-C voltage and waveform test points in the white balance circuits.*

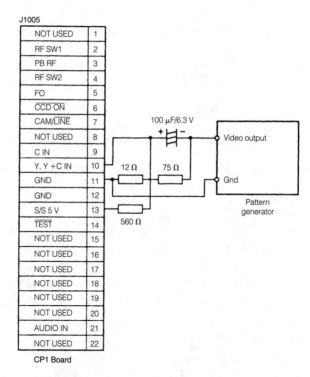

■ 13-23 *The VCR setup adjustment in the RCA PRO845 camcorder.* Thomson Consumer Electronics

check the character display adjust CT321 so that the display is centered. If the adjustment cannot be made, troubleshoot the on-display flowchart (Table 13-11).

■ Table 13-11 RCA 8-mm on-screen dislay inoperative flowchart.

```
┌──────────────┐   NG   ┌──────────────┐
│  EE-video    │───────▶│ Refer to "no │
│  monitor     │        │   EE-video   │
└──────────────┘        │   monitor"   │
       │                └──────────────┘
       │ OK
       ▼
┌──────────────┐   NG   ┌──────────────┐   NG   ┌──────────────┐
│ IC101-26 SIG │───────▶│ IC321-13 SIG │───────▶│ Check IC321  │
└──────────────┘        └──────────────┘        └──────────────┘
       │                       │ OK
       │ OK                    ▼
       │                ┌──────────────┐
       │                │ Check OS data│
       │                │    block     │
       │                └──────────────┘
       ▼
┌──────────────┐   NG   ┌──────────────┐
│ IC321-16 SIG │───────▶│ Check IC321  │
└──────────────┘        └──────────────┘
       │
       │ OK
       ▼
┌──────────────┐
│ Check IC101  │
└──────────────┘
```

Thomson Consumer Electronics

No video monitor

To test for lack of video monitor, check voltages and waveforms on the main video amp, A/V output, and luma process IC. Set select switch to camera mode. Aim the camera at the color bar chart. If EVF monitor not good, check IC301 and EVF circuits. Check video at A/V output, pins 1 and 8. Check pins 10 and 12 of IC301 for video signal (figure 13-24). If no signal, measure B+ voltage on IC301 and suspect IC301.

With no video on TV set or color monitor, check the video at pin 19 of IC201 (1 V_{p-p}). With no video, measure the voltage at pin 25 of IC201 (5 V). If no voltage, check the 5-V supply line source. If no voltage, check pin 24 of IC201 (video 210M p-1). Proceed to pin 15 of IC201 to look for video signal (1 V_{p-p}). Suspect IC201 if video waveform is at pin 15.

No video recording

The Y RF output at pin 39 of Y/C process IC201 in the Samsung 8-mm camcorder is sent to the RF amp IC101. A recording C output is

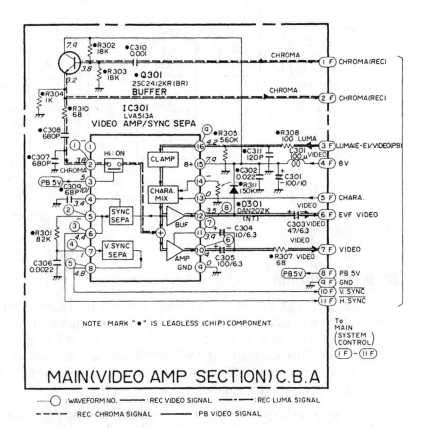

NOTE: MARK "●" IS LEADLESS (CHIP) COMPONENT.

To MAIN (SYSTEM CONTROL)
(1 F)-(11 F)

MAIN(VIDEO AMP SECTION)C.B.A

─○ :WAVEFORM NO. ──── :REC VIDEO SIGNAL ─ ─ ─ :REC LUMA SIGNAL
─ ─ ─ :REC CHROMA SIGNAL ──── :PB VIDEO SIGNAL

455

■ **13-24** *Realistic 150 (VHS-C) video signals on main video IC301.*
Radio Shack

fed from pin 8 to pin 6 of IC101. The chroma (C), luminance (Y), AFM and AFT are mixed inside the head amp IC101. The output of record amp is fed to CH 1 cylinder head from pin 29 and CH 2 from pin 32 (figure 13-25). The FE head erase oscillator signal is fed through the FE amp to the head cylinder.

Check the video signal at pin 30 of IC201 in the Samsung SCX854 camcorder in VCR mode. If the signal is normal, go to pin 4 of IC301. Proceed to pin 47, 48, and 49 of IC201 if no signal is present at pin 4. Check the sycon/servo circuit Mi-Com, VCC voltage, and IC201 circuit (Table 13-12). If the signal is present at pin 4 of IC301, precede to pin 21 of IC201. In CAM mode, check the CAM Y signal at pin 28 of IC201 and pin 1 of IC605 if no Y signal at pin 28 of IC301. Check the Y RF and Y FM signal to the head amp IC101. Likewise check the chroma (C) signal at the head amplifier.

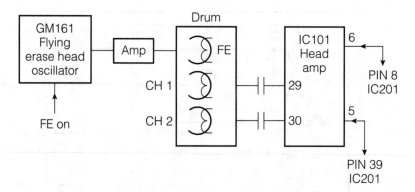

■ **13-25** *Block diagram of Samsung 8-mm record amp circuits.* Samsung Electronics Co.

No record chroma

Set the RCA PRO845 camcorder in record mode and scope the chroma signal at pin 53 of IC101. Proceed to pin 8 or TP132 of IC101 if the chroma signal is normal. Check the color signal at pin 8 of IC191 (figure 13-26). Proceed to head amp output terminals 28 and 33 of IC191. This chroma signal can be traced right up to the J1003 head terminals 5 and 9.

When the chroma signal is low or missing at any point in the head amp circuits, check that circuit for possible improper supply voltage or defective components. If the chroma signal is not found at pin 8, check the color signal at pin 57 and 59 of IC101. Measure the VCC supply voltage of IC101. If the voltage is normal with input chroma on IC101 and no output at pin 8, suspect defective IC101 (Table 13-13).

No color playback

To test for chroma playback, check the signal waveforms and voltages on the luma process and chroma process ICs. Check the color playback signal at pin 45 of IC201 of Y/C process IC in Samsung 8-mm camcorder (figure 13-27). If signal normal, proceed to chroma signal at pin 64 of IC201. Proceed to GM141 network and pin 6 of IC101. If playback chroma signal is still missing, check the color playback at CH 1 and CH 2 heads at pins 29 and 32 of IC101. Do not overlook a defective IC101 or supply voltage in IC101 with no playback color recording (Table 13-14).

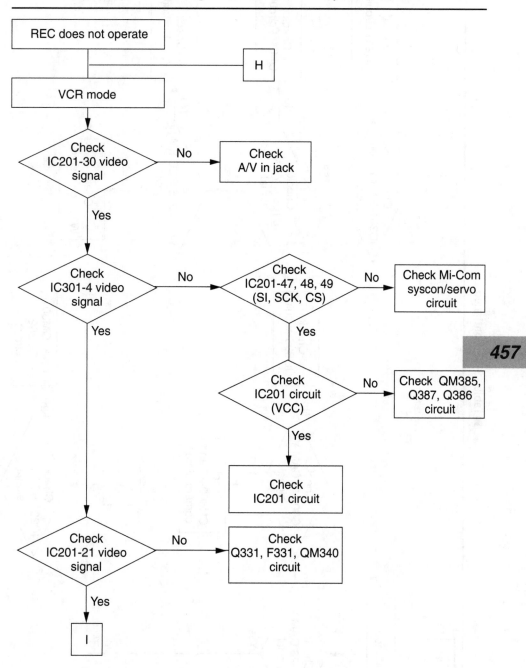

457

```
                                                    No      Check
                                              ┌─────────→  IC201 circuit
                                              │
                                        Check IC201-39
                                    J ──→  Y RF out signal
                                              │ Yes
                                              ↓
                                        Check IC106-6      No      Check
                                        Y FM signal  ─────────→  QM224 circuit
                                              │ Yes
                                              ↓
                                        Check W101-2, 5     No      Check
                                        REC FM signal ─────────→  IC101 circuit
                                              │ Yes
                                              ↓
                                        Check W101 connector
```

```
                                          No      Check
                                    ┌─────────→  IC605 circuit
                                    │
        H ──→ CAM mode ──→ Check IC201-28 CAM Y signal
                                    │ No
                                    ↓
                              Check IC605-1, CAM Y signal
                                    │ Yes
                                    ↓
                              Check CN602-29 and camera circuit
```

```
              Yes
        (from IC201-28) ──────────→ I

        I ──→ Check IC201-5       No      Check QM301,
              EMPH out signal ─────────→  QM302 circuit
                    │ Yes
                    ↓
                    J
```

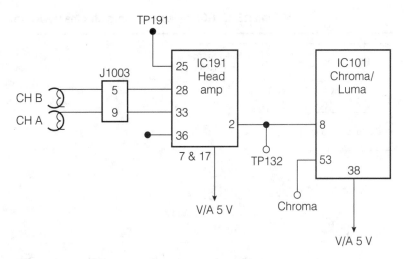

■ **13-26** *RCA PRO845 chroma and head amp circuits.* Thomson Consumer Electronics

No video playback

The lack of a video playback signal is checked from the tape heads back through luminance/chroma and luminance circuits. Turn on power switch and place in play mode. Test by the numbers (figure 13-28). Check for FM signal at TP204. Check the 5-V power source (pin 25) of IC203 with no FM signal. Test for FM signal at pin 21 of IC 203. If no signal, check waveform at TP202 (SW 15 Hz). Check for SW30Hz signal at TP203. Run continuity test on video heads. Inspect for clogged areas. Now suspect IC601.

Go to pin 28 of luma process (IC201) if FM signal is found at TP204 and no video playback. Test supply source on pin 25 of IC201 and suspect leaky IC201 or power source for low voltage. Check for luma signals at pins 23 and 11 of IC201. If no luma signal at pin 11, check for FM signal at pin 2 and 4 of IC201. Suspect the luma process IC201 with no FM or video playback signal. A defective or dirty video head can produce rainbow color effects in the recording.

No picture in playback mode

Set power switch to camera mode. Check for random noise in EVF or monitor. If no noise in picture, check pin 14 of CN933 and then check no record video and incorrect auto iris tests. Proceed to CCD out at pins 37 and 38 of IC917 (figure 13-28). If okay, proceed

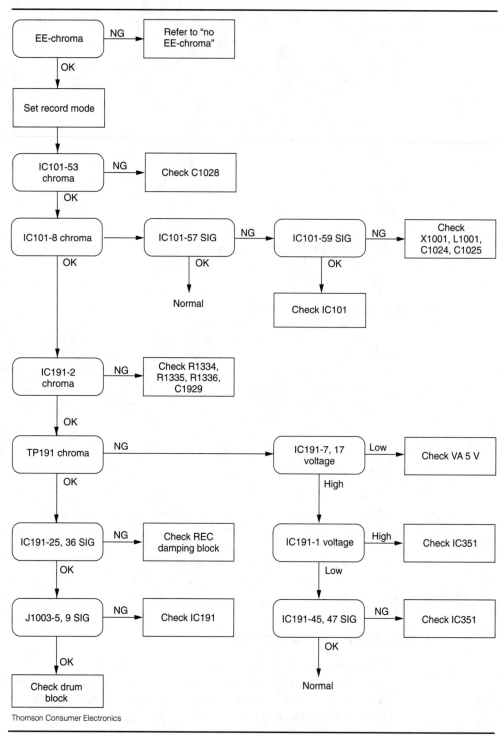

460

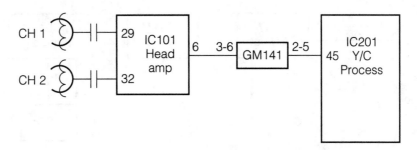

■ **13-27** *Samsung 8-mm P/B Y/C process and head amp circuits.* Samsung Electronics Co.

■ **Table 13-14 Samsung SCX854
color does not operate troubleshooting chart.**

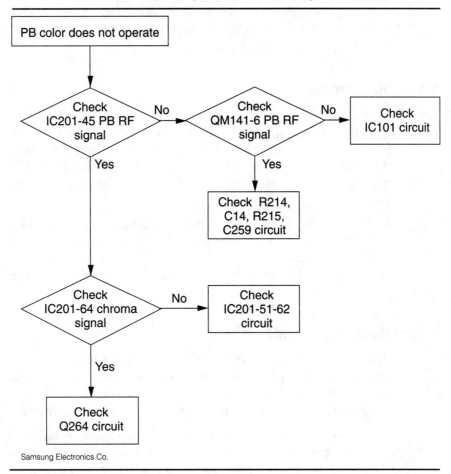

Samsung Electronics Co.

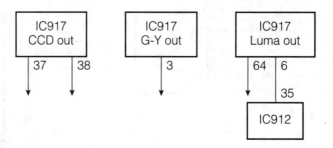

to IC917 pin 3, 64, 6, and 35, in that order. Then check supply voltage on IC912. For no signal at pin 3, check IC916 and IC917. Test the LPF block that consists of Q9165, Q9166, L9190, L9191, C9211, C9256, C9257, C9258, C9261, R9182, R9191, R9192, R9216, R9217, R9218, R9256, and R9257 (Table 13-15).

No record chroma

If a color flowchart is handy, check off the following IC stages to locate the defective component (Table 13-16). Check the CAM C at pin 12 of the connector CN933. If no good, go to C out at pin 16 of IC912. Proceed to terminals 19 and 20 of IC914 to check R-Y/B-Y out signal. Check IC914 for no color signals and supply voltage (figure 13-29).

With normal R-Y and B-Y out signals, check terminals 46 and 48 of IC914. If okay, proceed to pins 4 and 5 of IC917. Proceed to pin 4 of IC912 and pins 9, 10 and 11 for BFG, BF and C BLK signals. If okay at pins 9, 10 and 11 of IC912, check for a defective IC912 for no color signal.

Sound does not operate

Check the audio block diagram and schematic for audio problems. Inspect the microphone. Sub the external microphone to eliminate the regular mike. Most camcorder microphones are condenser types. Can you hear the audio in the earphone monitor?

The audio system can be checked by injecting a 1-kHz audio signal at the microphone jack. Then signal trace the audio record circuits with scope or external power amplifier. Check the audio signal at

■ Table 13-15 RCA PRO845 no picture troubleshooting chart.

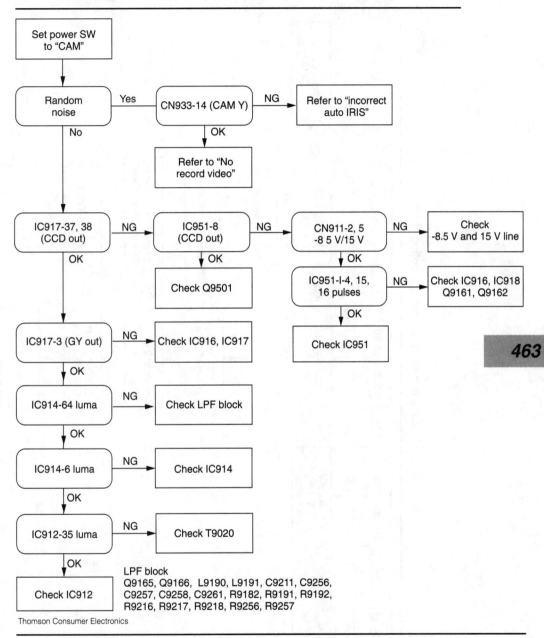

Thomson Consumer Electronics

pin 38 of IC401 in the Samsung SCX854 camcorder. Proceed to pin 31 of audio amp IC401 (figure 13-30). Check the audio at pin 8 of IC401. Check the microphone if audio injected signal is okay.

■ Table 13-16 RCA 8-mm no color troubleshooting chart.

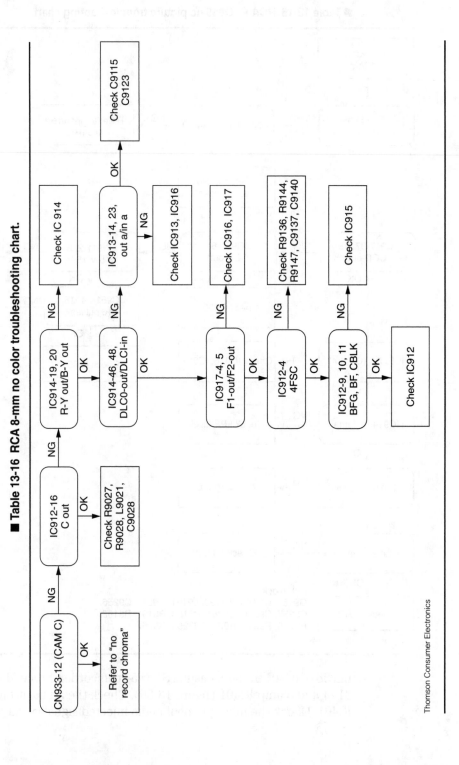

Thomson Consumer Electronics

■ **13-29** *Check the following IC terminals for no color in the picture.*

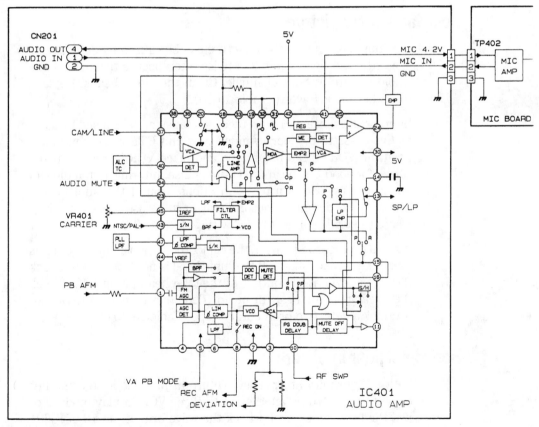

■ **13-30** *Samsung 8-mm audio amp circuits.* Samsung Electronics Co.

If no output AFM signal at pin 8, check IC401 and supply voltage at pin 42 (5 V). Proceed to record AFM RF at pin 4 of tape head preamp IC101. The audio signal is amplified by IC101 and applied to CH 1 and CH 2 of head cylinder (Table 13-17).

No audio playback

Set the select switch to playback mode (PB). The playback signal from the tape head can be scoped at pin 2 of IC201. Check the amplified signal on pin 8 of IC201. If a signal is going in and not out, suspect IC401 or the power source (B+ 5 V, pin 20). Some audio circuits have a playback level control. Make sure it's adjusted properly. Signal trace the audio out (AV1) to the video circuits. Check the signal with proper waveforms on the audio schematic.

Noisy and jittery picture

Random noise in the whole picture can be caused by defective or clogged video heads. Random noise often occurs throughout the whole picture in both channels. Clean the video heads. Replace the video heads if worn (Table 13-18).

Intermittent noise in the prerecorded tape can be caused by a defective cassette or poor cylinder sync and CTL recording pulse. Load the VCR with a blank tape and place VCR in record mode. Check for good C sync and CTL-Rec pulse. Intermittent audio can be caused by poor wiring connections around the audio head. Check the lead connections of flying or full erase head, especially where the leads connect to PC wiring (figure 13-31).

Insert a prerecorded tape in the camcorder when a noisy picture is found in playback mode. If the luma level is no good or low, check the signal level at the output of the tape head preamp IC. Check the preamp IC or head drum for defective component. Do not overlook a defective prerecorded tape (Table 13-19).

Horizontal jitter in picture

With an intermittent or noisy picture in play mode, try another cassette recorded by another VCR. Place VCR in play mode. Adjust the tracking control. Check the waveform at pin 12 of IC601 (figure 13-32). Check the CYL phase waveform at pin 17. If no waveform, check the cylinder motor. If there's a normal waveform,

■ **Table 13-17 Samsung SCX854 sound does not operate troubleshooting chart.**

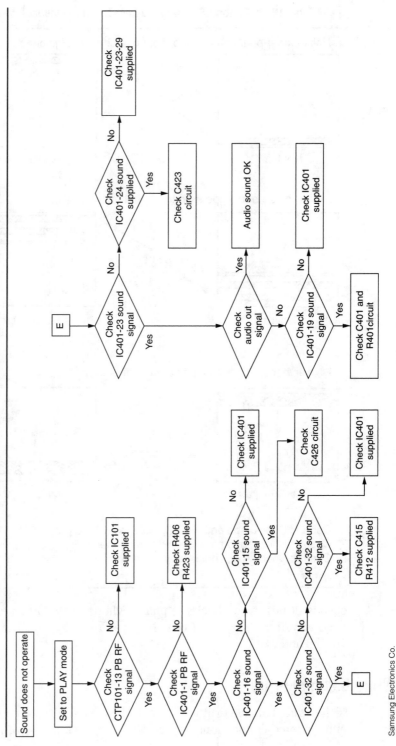

Samsung Electronics Co.

Horizontal jitter in picture

■ Table 13-18 Canon ES1000 noise bars in video playback chart.

1. Noise-bar appears on top or bottom of picture, or V jittering

Noise bar

Monitor TV Monitor TV

2. A few noise-bars appear on top or bottom of screen

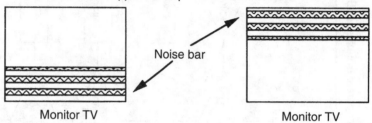

Noise bar

Monitor TV Monitor TV

3. Noise bar rolling from top to bottom or bottom to top

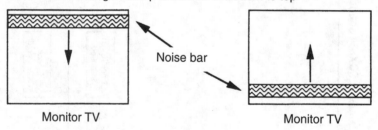

Noise bar

Monitor TV Monitor TV

Case 1: Check tape path (TG-3, TG-6) switching point.
Case 2: Check tape path, check loading mech.
Case 3: Check ATF, check capstan motor.

Canon, Inc.

suspect IC601. Now check the phase cylinder waveform at pin 64. If no waveform, suspect IC601. If waveform okay, suspect IC605 (pins 5 and 7).

White balance drifts

If the white balance drifts off, check the close-up switch contacts and soldered connections (figure 13-33). Check pin 10 of IC4 for

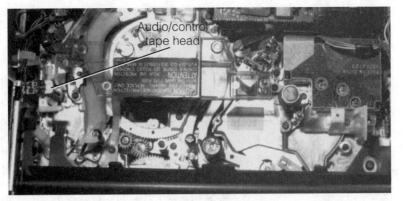

■ **13-31** *Location of audio tape head in the RCA VHS camcorder.*

■ **Table 13-19 RCA PRO845 no luma troubleshooting chart.**

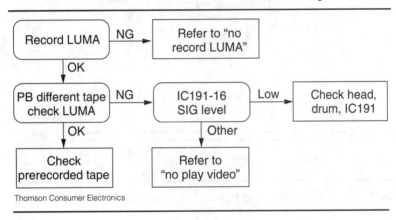

Thomson Consumer Electronics

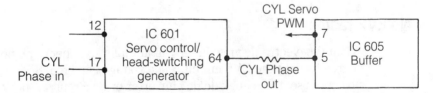

■ **13-32** *Check the tracking control and waveform at pin 12 of IC601 for horizontal jitter noise.*

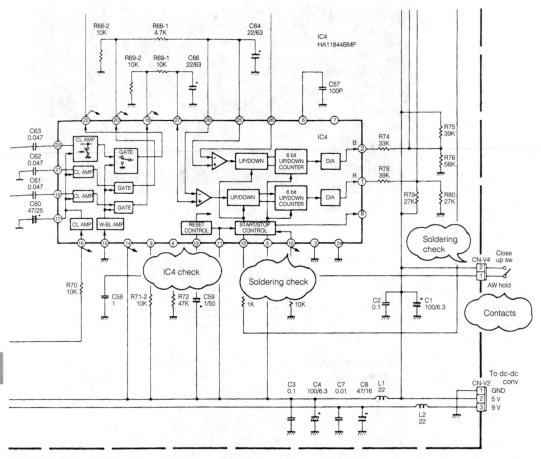

■ **13-33** *Check IC4 when white balance drifts and close-up switch connections.*

poor soldered connections. Suspect IC4 if switch and contacts appear normal.

No EVF raster

When the electronic viewfinder will not light up, check the power source feeding the EVF circuits. The voltage can be 5, 8, or 9 V. If no supply source, check dc/dc converter or dc circuits. Check the anode voltage on small CRT from 2 to 3 kV (2.7 kV), pin 2 at 370 V, and pin 3 at 330 V.

The camcorder with color viewfinder includes a back light, LCD, IC972 and IC971 in the RCA PRO845 model (figure 13-34). The

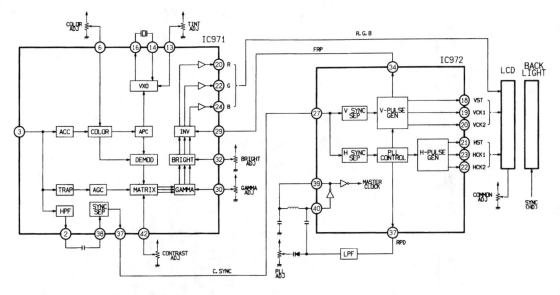

13-34 *RCA PRO845 EVF block diagram.* Thomson Consumer Electronics

video input is found at pin 3 of the color, demodulator, matrix, brightness and colors R, G, and B fed to the LCD from IC971. A brightness, gamma and contrast adjustment are found at pins 32, 30 and 42, respectively. Color sync is fed from pin 37 of IC971 to pin 27 of IC972.

IC972 provides vertical and horizontal sweep to the LCD block. Check the 5, 6, 12, and 7.5 V supplied to the EVF circuits from the dc/dc converter for no EVF raster. Scope the sync at pin 1 of connector CN972. For no EVF video, check waveform pins at 3, 20, 22 and 24 of IC971. Check pin 27 and 36 of IC972 for correct sync (Table 13-20).

No EVF horizontal deflection

Suspect the horizontal circuit with no CRT voltage. Check for input line voltage at pin 5 of output transformer T801 (figure 13-35). The heater voltage across pins 3 and 7 is 16.3 V. The horizontal circuit must operate before the voltage is developed. Check for collector voltage on horizontal driver transistor Q803. Fuse can be open (TF801). Suspect a leaky horizontal drive transistor (Q803) or improper drive voltage at the base terminal. Check the horizontal oscillator waveform at pin 2 of deflection IC801. If no deflection waveform, suspect IC801 or the supply voltage (pin 4, 5.3 V).

■ Table 13-20 RCA 8-mm color electronic viewfinder no raster symptom chart.

No EVF raster

CN971-1 5.0 V	→ OK →	Check backlight

CN971-1 5.0 V —NG→ Check V/A 5 V

CN971-5 6.0 V (unreg) —NG→ Check unreg

A9701-3 13.5 Vp-p —NG→ Check dc/dc converter

A9701-4 -12.0 Vp-p —NG→ Check dc/dc converter

A9701-5 7.5 V —NG→ Check dc/dc converter

CN972-1 SYNC —NG→ Check IC972

CN971-1 5.0 V —OK→ CN971-5 6.0 V (unreg) —OK→ A9701-3 13.5 Vp-p —OK→ A9701-4 -12.0 Vp-p —OK→ A9701-5 7.5 V —OK→ CN972-1 SYNC —OK→ Check backlight

No EVF video

IC971-3 video —NG→ Check VF video line

IC971-3 0.8 Vp-p —NG→ Check VF video line

IC971-20, 22, 24 R.G.B. —NG→ IC971-32 2.2 V —NG→ Check bright adj

IC972-27 SYNC —NG→ Check IC971

IC972-36 SYNC —NG→ Check IC972

VR983 ADJ —NG→ Check IC972

IC971-3 video —OK→ IC971-3 0.8 Vp-p —OK→ IC971-20, 22, 24 R.G.B. —OK→ IC972-27 SYNC —OK→ IC972-36 SYNC —OK→ VR983 ADJ —OK→ Check LCD

IC971-32 2.2 V —OK→ Check IC971

Thomson Consumer Electronics

■ 13-35 *Samsung B & W EVF horizontal circuits.* Samsung Electronics Co.

No EVF vertical deflection

Check the vertical circuits for a horizontal white line or insufficient vertical sweep. The vertical circuits within Samsung SCX854 model consist of one large vertical and horizontal sweep ICB01 (figure 13-36). Just about any component within the vertical circuits can cause no vertical sweep. Check the vertical drive circuits for insufficient vertical sweep. Measure the supply voltage on pin 2. Scope the vertical input and output at yoke winding. Check all

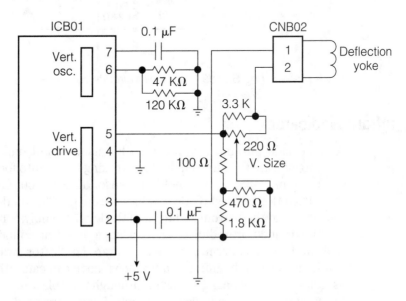

■ 13-36 *Samsung 8-mm EVF vertical circuits.* Samsung Electronics Co.

vertical drive voltages on pins 1, 3, and 5. Do not overlook ICB01 for no vertical sweep.

No EVF or weak video

Scope the video waveform at pin 3 of CNB01 and pin 11 of ICB01 (figure 13-37). Check waveform at output pin 13 of ICB01 that is fed to the base of video amp QB01, through 4.7 K and C809 (10 µF). The video amp transistor feeds the amplifier video signal to G1 of CRT. If video is found at base terminal of QB01 and not at the collector terminal, take voltage measurements upon QB01. Suspect QB01 with fairly normal voltages and no video output. Do not overlook CB02 (1 µF), CB09 (10 µF), and C811 (3.3 µF) for weak video to G1 of B & W CRT in Samsung 8-mm EVF circuits.

474

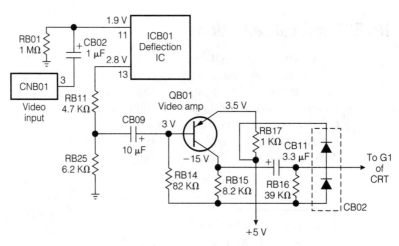

■ **13-37** *Samsung SCX854 EVF video circuits.* Samsung Electronics Co.

Infrared indicator

A homemade infrared indicator can be made out of only a few parts to indicate the infrared diode is working in the auto focus circuits (figure 13-38). Simply hold the sensor device about one inch away from the infrared diode inside the camera. This diode is often located at the bottom and front of the lens assembly. When the auto focus and infrared diode is working, a pulsating sound is audible in the piezo buzzer. Moving the infrared indicator away from and then close to the infrared auto focus diode can cause the lens assembly to rotate back and forth. Although the pulsating sound is not very loud, it does indicate the auto focus infrared diode and

■ 13-38 *Infrared autofocus sensor indicator schematic.*

driver circuits are ok. No sound indicates a defective infrared LED or auto focus circuits.

Servo/system control waveforms

Important waveforms are found throughout the camcorder circuits. Critical waveforms are very important in signal tracing or locating defective circuits in the various camcorder circuits. The most important waveforms are those found in the servo system control circuits. The servo microprocessor (IC351) waveforms found in the RCA PRO845 model can determine if the servo circuits are performing correctly (figure 13-39).

```
     (8)   (7)   (6)                    (5)

     122   121   120                    108
     Cap  Drum  Drum                    AFT
     FG    FG    PG

(9)──  2 Cap PWM

(10)── 3 Drum YWM           IC351
                        Micro processor    T. Reel  99 ──(4)
(11)── 14 RF SW
                                           S. Reel  98 ──(3)

                                           Main SCK  84 ──(2)

                                           Main SO.  82 ──(1)
```

■ 13-39 *Waveforms taken around the microprocessor IC351 in the RCA 8-mm camcorder.*

Waveforms 3 and 4 indicate if the take-up reel and supply reel are rotating at pins 98 and 99 of IC351. The capstan FG, drum FG and drum PG waveforms indicate if the capstan and drum assemblies are rotating at pins 122, 121, and 120. The capstan PWM and drum PWM are found at pins 9 and 10 of IC351 in both rec/play modes. Check the various waveforms found upon the servo control IC351 in Table 13-21.

■ **Table 13-21 RCA PRO845 servo/system waveforms on servo IC351**

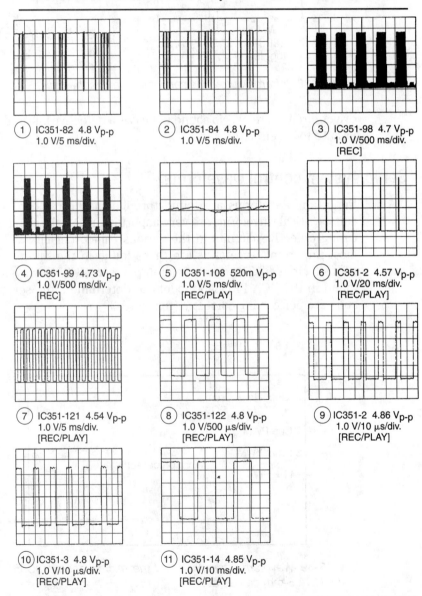

1. IC351-82 4.8 V_{p-p}
 1.0 V/5 ms/div.

2. IC351-84 4.8 V_{p-p}
 1.0 V/5 ms/div.

3. IC351-98 4.7 V_{p-p}
 1.0 V/500 ms/div.
 [REC]

4. IC351-99 4.73 V_{p-p}
 1.0 V/500 ms/div.
 [REC]

5. IC351-108 520m V_{p-p}
 1.0 V/5 ms/div.
 [REC/PLAY]

6. IC351-2 4.57 V_{p-p}
 1.0 V/20 ms/div.
 [REC/PLAY]

7. IC351-121 4.54 V_{p-p}
 1.0 V/5 ms/div.
 [REC/PLAY]

8. IC351-122 4.8 V_{p-p}
 1.0 V/500 μs/div.
 [REC/PLAY]

9. IC351-2 4.86 V_{p-p}
 1.0 V/10 μs/div.
 [REC/PLAY]

10. IC351-3 4.8 V_{p-p}
 1.0 V/10 μs/div.
 [REC/PLAY]

11. IC351-14 4.85 V_{p-p}
 1.0 V/10 ms/div.
 [REC/PLAY]

476

Power supplies

THERE IS A LOT MORE TO THE CAMCORDER POWER SUPPLY than a battery. The camcorder can be operated from a battery or ac power source. The ac power supply can consist of switching, constant voltage, constant current, voltage protection, and voltage regulation circuits. Besides supplying a dc voltage for operating the camcorder, the batteries can be charged (figure 14-1). Also, inside the camcorder you can find battery discharge and alarm circuits with power circuit control.

ac power supply

There are several different types of ac power packs or supplies of 5, 6, 7.2, 9, and 12 V. The Canon ES1000 is supplied with 5 V, RCA PRO845 at 6 V, and Samsung SCX854 at 6 V with a 7.5-V ac adapter. In the RCA 8-mm camcorder the ac adapter charger consists of a rectifier circuit that includes ac input, filters, and primary rectifiers. The primary side has a switching element (Q5101), PWM control circuit, and a P/S regulator transformer (figure 14-2).

The secondary side circuits consist of a P/S insulator or photocoupler, secondary rectifier (D5201), smoothing circuit, error amplification circuit (IC521), and VCR output. A charge circuit contains the charge/discharge control circuit (IC523), charge selector circuit (Q5202), battery output, and discharge circuit (Q5205).

Samsung SCX854 ac adapter

The ac input circuits are isolated from the secondary circuits with photo-coupler (IC102). The primary circuits are at ground potential, while the secondary circuits have a floating or hot ground. Note when taking voltages within the ac adapter, make sure of the correct ground (figure 14-3). The ac circuit consists of fullwave bridge rectifiers, filters, controller IC104, switching Q101 (2SK904), and primary windings of power transformer (T101).

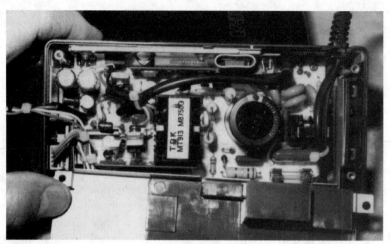

■ **14-1** *The ac power supply or adapter provides a charging voltage for the camcorder battery.*

AC ADAPTER/CHARGER (CPS801A) EXPLODED VIEW

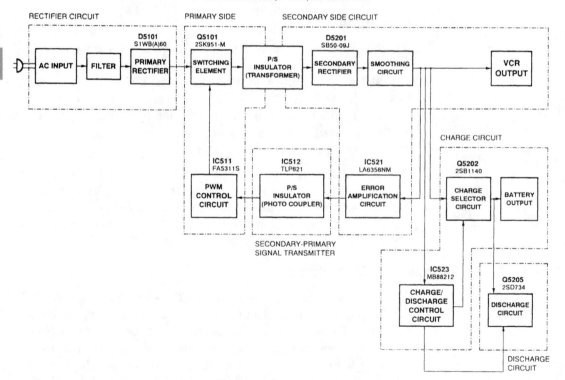

■ **14-2** *Block diagram of the RCA PRO845 adapter circuits.* Thomson Consumer Electronics

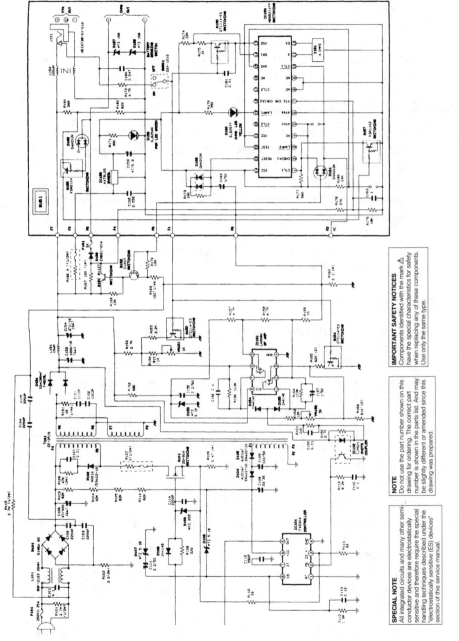

479

■ **14-3** *The Samsung SCX854 ac adapter circuits.* Samsung Electronics Co.

The secondary circuit consists of the secondary winding of T101, op amp IC151, switching Q154, digital switching Q153, and dual switching of Q152 and Q151, and F151 (2A) fuse.

A sub 1 chassis contains digital switching Q156, with dual diodes (D152), to the VTR output and charge jack. IC152 regulator is connected to the green LED (D156), digital switching transistor (Q155), Q157, and switching IC153. D157 and D158 zener diodes are found in the battery charging output terminals.

Inside the RCA CPR300 ac adapter

A load must be replaced across the ac adapter output terminals, so very little voltage is measured (figure 14-4). By placing a battery or 20-Ω load across the battery output terminals, the charger circuits can be serviced. Like most adapter circuits, a power transformer with diode rectifiers and filter capacitors are located. First, inspect and check continuity of ac fuse. Measure the voltage across the primary and secondary circuits to determine if ac voltage is obtained. Suspect leaky IC and transistor regulators with no charging voltage.

Battery charging

Many small batteries last an hour or less with constant camcorder operation. The battery can last longer with intermittent operation. As the battery becomes older and is charged many times, the charged time becomes less than one hour. Most camcorders have a flashing light, indicating the battery is getting weak. In the RCA CPR300, the green recording light in the viewfinder begins to blink. If left on too long, the camcorder circuits will shut down, leaving the camcorder inoperative. You can either insert a new battery or use the ac adapter unit to provide camera operation. Always take at least two batteries when you are out shooting scenes away from the power receptacles.

Most camcorders have Ni-cad batteries with lithium battery for memory circuits. Remove the battery from camcorder if you do not plan to use it for any length of time. You can discharge the battery with a 10-W, 10-Ω resistor with a pan of alligator clips. Likewise, a 100-W bulb can be connected across the Ni-cad battery for complete discharge.

Charge up the Ni-cad battery when indicator on camcorder display indicates the battery is low. Most present-day ac adapters shut off when the battery is fully charged, with LED indicator, pre-

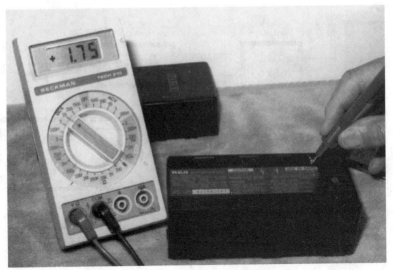

■ **14-4** *The RCA ac adapter will not show normal voltage unless a battery load is placed across charging terminals.*

venting overcharging of the battery. Most batteries charge up within one hour.

Battery detection circuits

Although the battery detection circuits are found in the camcorder and not in the ac adapter/charger, these circuits are discussed here because the detector is activated by battery shutdown. Many of the camcorders (large or small) have some indicating device when the batteries are getting weak. It's usually located in the electronic viewfinder (EVF). Either the recording, battery indicator, or battery lines flash when the battery is getting low. In some camcorders, the unit shuts down within a few seconds. Sometimes you can still eject the cassette, but in some models, you must insert a new battery or apply the ac adapter for any type of operation.

Canon ES1000 battery detection

When the unregulated battery of 6 V drops rapidly to cause EVER 5 V to become less than 4.5 V, the ES Det L signal is output at pin 3 of IC230. This places the Main Mi-Com (IC231) in the sleep mode and shuts down power to the camcorder (figure 14-5). The 6-V battery must be replaced or charged before the camcorder can be operated.

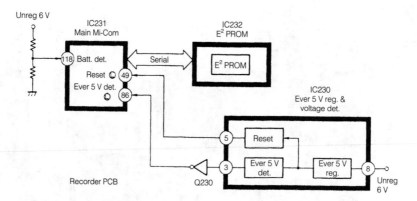

■ **14-5** *The battery detection circuit in Canon ES1000 camcorder.*
Canon, Inc.

Realistic 150 battery overdischarge detection circuits

The battery overdischarge detection (ODC) circuit monitors the battery terminal voltage, detects overdischarge, displays characters in the EVF screen to indicate discharge, and if the voltage is less than normal, it turns the power off. In the VTR mode, "power-off" corresponds to "stop." If in the camera mode, "power-off" corresponds to "record pause."

Battery power (12 V) passes through the fuse (F970) and a latch relay (RL901) to a zener diode (ZD903, 7.5 V), which causes a voltage drop of about 7.5 V (figure 14-6). It is then applied through RT901 (overcharge level) to the emitter of the comparator (Q905). Q905 compares the voltage with the reference voltage.

The reference voltage is generated by the digital-to-analog converter controlled by BATT outputs (2 bits of data—Batt 1 and Batt 0) from the IC901 and is applied to the base (inverting type) of the comparator (IC905). When the Batt output of the system microprocessor (IC901) is high, the resistors connected to the output pins are connected in parallel with R967 (8.2 Ω), and the reference voltage is changed, depending on the battery output as shown in Table 14-1.

When the battery voltage is applied to the emitter (noninverting input) of the comparator (Q905), it becomes lower than the reference voltage applied to the base of Q905. The output of the switch (Q906) goes high, and IC901 detects battery voltage and judges whether the battery is discharged. The results of this judgment make the output of IC901 as shown in Table 14-2.

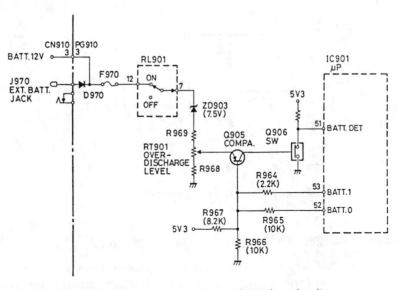

■ 14-6 *Realistic 150 battery overcharge detection circuits.* Radio Shack

■ Table 14-1 Reference and battery terminal and voltages (Realistic 150).

Outputs		Reference voltage	Battery terminal voltage
BATT.1	**BATT.0**		
1	0	4.26 V	12.3 V
0	1	3.45 V	11.6 V
0	0	2.75 V	10.9 V

Radio Shack

■ Table 14-2 Battery and voltage display in Radio Shack 150.

Battery voltage	μP Output mode	Display in EVF screen
More than 12.3 V	No change	"E---F"
12.3 V to 11.66 V	No change	"E--"
11.65 V to 10.9 V	No change	"E-" ("-": blinks)
Less than 10.9 V	Power off	

Radio Shack

■ 14-7 *Sony 8-mm battery detection circuits.* Sony Corp.

Sony CCD-M8E/M8U 8-mm battery detection circuit

The battery-down circuit indicates when the battery is low in the camcorder (figure 14-7). When the BAT DWN signal becomes low (L), the voltage drops to more than the rated voltage in the circuit where the unregulated 6-V level is detected. The time of detection began when the POWER signal is low (L) and the loading motor does not operate.

The off period begins when the low battery is detected during battery insertion operation in the TAPE RUN and the BAT DOWN LED (REC LED) flashes for 30 seconds and the key acceptance as the machine operation stops. When either EJECT, REC, STBY or CCD-SW is pressed after the LED turns off, the LED starts flashing for 30 seconds.

When the battery down detection is noted during the REC period, the TAPE RUN/BAT DOWN (REC LED) flashes for one second. This informs the operator that only one second of recording is possible before shutdown. After the one-second time interval, the mode changes to the READY Mode and the keys other than the eject key cannot work. Now only the loading and unloading operations are working until the battery is replaced.

If the battery down is detected in the STBY period, the mode changes to the READY mode and the TAPE RUN/BATT DOWN (REC LED) flashes at 4 Hz. Again, only the unloading and loading functions operate until the battery is replaced.

ac adapter/charger circuit adjustments

The ac adapter and charger output voltage must be properly adjusted for accurate and safe voltages in operating the camcorder

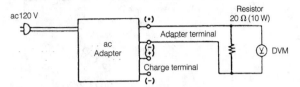

■ 14-8 *Realistic adapter voltage adjustment hook-up.* Radio Shack

or charging the batteries. First determine the battery operating voltage and adjust the output of the adapter voltage accordingly. Although each manufacturer has their own adjustments, the following methods indicate how it is done. Adjustments should also be made for required correct current charging.

Radio Shack 150 adapter voltage adjustment

The adapter voltage adjustment is made with a DVM or DMM. Measure the voltage at the adapter terminals (figure 14-8). Place a 20-Ω, 10-W resistor across the voltage adapter terminals as a load. Locate the voltage adapter control VR201. Now set the camera/charge switch to the camera position. Connect the DVM across the 10-W resister. Adjust VR201 for 13.95 V ± 0.05 V.

Minolta C3300 battery alarm adjustment

This adjustment is made to set the battery alarm lamp so that it starts blinking at 9.2 V. The oscilloscope and digital voltmeter is used with the alarm adjustment. Locate test point pin 6 of IC404 (figure 14-9). Place camcorder in the record mode with 9.2 Vdc to the battery terminals. Rotate R436 to the position that potential charges from low to high (oscillation is observed at the changing point). Now check that the battery alarm display of the tape counter starts blinking.

Other battery connections

Besides connecting the small battery or ac adapter to the camcorder, the reset can be operated with the outside battery pack or auto car battery adapter/charger. Many camcorders have a separate jack where the external power can be plugged in (figure 14-10). Some camcorders have a car battery charger that plugs into the cigarette lighter.

IC404 R436

Main board adjustments location

■ **14-9** *Minolta C3300 battery alarm adjustment.* Minolta Camera Co.

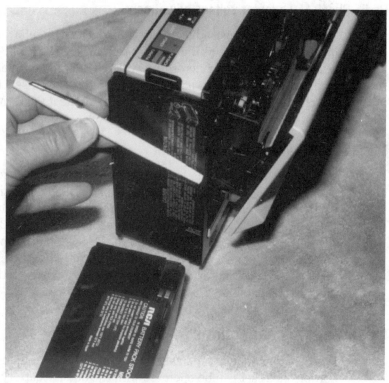

■ **14-10** *The battery jack is found at the rear of camcorder.*

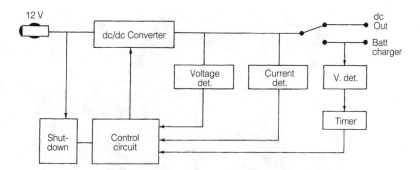

■ 14-11 *Block diagram of a car battery voltage/charger adapter.*

The camcorder can be operated from the car battery adapter or the unit will charge up those batteries while shooting pictures in remote areas. The 12-V car battery voltage is lowered or raised according to the camcorder operating voltage. The car battery charger can have a shutdown, voltage detector, current detector, and detection timer circuits like the ac adapter (figure 14-11). Follow the manufacturer's service literature for correct output voltage and charging current adjustments of the car battery charger adapter.

Troubleshooting the power adapter

Before tearing into the ac adapter, check all cords and plugs. Most ac adapter units fit on the backside of the camcorder in place of the battery. Clean all slip-pressure-type contacts with cleaning fluid. Inspect the dc output cord for breaks or poor connections. Place a load (20-Ω, 10-W resistor) across the charging output terminals and measure the output voltages.

Determine if the ac adapter is dead in both voltage and charge. If the unit supplies voltage but no charging of batteries, suspect a dirty voltage/charge switch. If the adapter is entirely dead, remove the top cover and inspect the fuse (figure 14-12). Replace the blown fuse with exact amperage. Take a close look—sometimes there is more than one fuse in these adapters.

To check the output voltage of ac adapter, place a 20- or 10-W low resistor across adapter battery terminals or a 100-W bulb. It's best to solder alligator clips and leads to resistor or bulb so it can be easily clipped across the battery jack terminals. Make sure there are no sense or interlock switches that must be jumped. Do not forget to remove jumpers or clips after adapter has been repaired or tested.

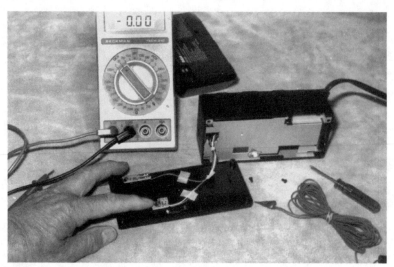

■ **14-12** *Remove cover of ac adapter to check fuse and components.*

Keeps blowing fuses

Suspect a shorted bridge rectifier if the main line fuse keeps opening. Check across each diode for leakage. Sometimes one or two diodes become shorted inside the bridge rectifier component. If only one is found leaky, replace the whole component. These fuses are 2- or 3-A types. Do not fret if the adapter unit operates with fuse replacement. Sometimes a power line overload or lightning charge can cause the fuse to open.

Check the main filter capacitor and diodes in the primary of the transformer if the main fuse still blows. Check terminal 3 of IC1 for leakage to ground (See figure 14-13). Notice if IC1 is oscillating. Sometimes you can hear the oscillations. Check all components in the primary circuits of T1 for leakage. Usually the oscillator or dc/dc converter shuts down with overloading circuits.

Voltage tests

Measure the voltage at the cathode terminal of diode (D8). No voltage here indicates an overload, or the primary oscillator circuits are not operating.

Remove S2 lead of the secondary from T1 to isolate the secondary circuits. Now take voltage measurements on IC1 and Q1. Very low voltage at pin 3 of IC1 can indicate a leaky IC. Higher-than-normal voltage at pin 3 can show that IC1 is open or not oscillating. Pro-

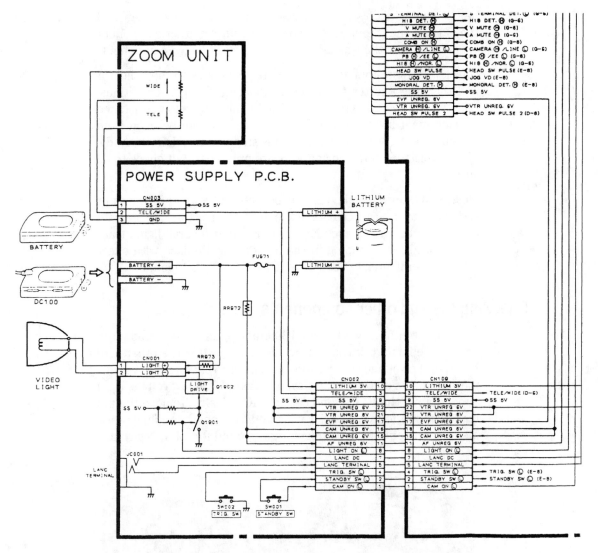

■ 14-13 *The Canon ES1000 power supply PCB.* Canon, Inc.

ceed to the secondary circuits if dc voltage is at the collector terminal of D8.

Random transistor and diode tests

A quick method of checking for a leaky or shorted diode or transistor is to make a random check with each semiconductor on the board. Place the DMM to diode or transistor test and check the resistance across each diode. All diodes, including zener types, can

be checked with this method. Double-check components around the diode if one is found leaky so you are sure another component is not indicating the leakage instead of the suspected component.

Check the transistors with a common base check to the collector and then the emitter terminals for leakage or open conditions. Like the diode, a good transistor should only have a low resistance measurement in one direction. The transistor can be open if no measurement. Use the regular transistor tester if one is handy. Most transistors in the ac adapters are npn types, but check to be sure.

Most transistors and diodes can be checked with the transistor tester (figure 14-14). Of course the digital transistors can indicate an open or high resistance joint. You will find several digital transistors used for switching in the ac adapter. Replace with exact part number if a digital transistor is found leaky or open.

Checking ICs and other components

You will often find two to four IC components in the ac adapter. One is used as a primary control oscillator, while the others are found in the voltage control and charging current circuits. Voltage measurements on the IC can turn up a leaky IC. A low voltage (V_{cc}) supply pin of the IC may indicate the IC is leaky. Remove the pin lead from the foil with solder wick and take another voltage test. Measure the pin of the IC to common ground for a low resistance

■ **14-14** *Check those suspected transistors with the transistor tester.*

■ 14-15 *Checking the photocoupler found in the ac adapter isolation circuits.*

(under 1 kΩ). Replace the leaky IC with the low-resistance measurement of the supply voltage pin terminal.

The photocoupler enclosed in one component can be checked with the diode test of the DMM (figure 14-15). Check the diode like the regular fixed diode with the DMM diode test. Now check the phototransistor side in the same manner. The diode should have a low measurement in one direction and no measurement across the emitter and collector terminals on the transistor side. Very low measurement indicates a leaky photocoupler.

Lithium batteries

The lithium battery is used in some camcorders for backup memory or quartz circuits. Usually, the lithium battery is a 3-V type. Lithium battery 3-V power is supplied when the regular camcorder battery is removed. The lithium battery can have a battery voltage detection and indicator circuit (figure 14-16). When the terminal voltage of lithium battery decreases below 2.7 V, the LITHIUM BATTERY MARK warning indication flashes on the viewfinder screen in the Canon ES1000.

Battery will not charge

The battery might be used up or the battery charger is defective. If other batteries charge on the adapter/charger, suspect a defective battery. Try completely discharging the battery. Now try to recharge it. After a couple of hours, if the battery does not charge up, discard it. (Do not place it in a fire to destroy it.)

491

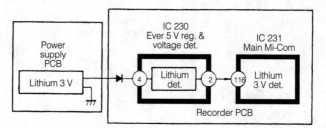

■ **14-16** *Canon ES1000 lithium battery detection and indication circuit.* Canon, Inc.

Check the voltage output of the charger with a load made up of resistors across the battery charge output terminals. Very low voltage output can indicate a defective charging circuit or charge/voltage switch. Notice if the adapter provides operating voltage for the camcorder. Inspect the charge/voltage switch for poor contacts. Shunt the switch contacts with alligator clips. Suspect a defective IC charge circuit with no charge voltage. Inspect the diode in series with the voltage and charge lead terminal for open or burned conditions. Measure all voltages on the IC (power switch) terminals and compare with the schematic.

Abbreviations

SOMETIMES ONLY AN ABBREVIATION IS USED ON THE manufacturer's schematic diagram or service literature. Here is an alphabetical list of the most-used abbreviations to help you understand the various camcorder circuits.

ac	alternating current
ACC	automatic color control
A/CTL	audio control
ADC	analog to digital converter
ADD	addler
ADJ	adjusting
ADUB	audio dubbing
AE	audio erase
AEF	automatic editing function
AFC	automatic frequency control
AFT	automatic fine tuning
AGT	automatic gain control
AH	audio head
AHD	audio high-density disc
AL	after loading
ALC	automatic level control
ALM	alarm
ALU	arithmetic logic unit
AM	amplitude modulation
AMP	amplifier
ANT	antenna
APC	automatic phase control
APL	average picture level
A/S/M	audio/servo/mechacon
ASSY	assembly
ATT	attenuator
AUD	audio
AW	automatic white

AUX	auxiliary
B	base or blue
BAL	balance
BATT	battery
BBD	bucket brigade device
BCD	binary-coded decimal
BEG	beginning
BF	behind focus or burst flag
BFP	burst flag pulse
BIT	binary digit
BLK	black or blanking
BLU	blue
BNC	bayonet connector
BOT	beginning of tape
BPF	bandpass filter
BRK	brake
BRN	brown
BRT	brightness
BT	band tuning
BUFF	buffer
B/W or BW	black and white
C	color, capacitance, or collector
CAL	calibration
CAP	capstan or capacitor
CAR	carrier
CRR	carrier
CASS	cassette
CC	cassette compartment
CCD	charge-coupled device
CCT	circuit
CDS	cadmium sulphite
CD	count down
CE	chip enable
CF	ceramic filter, correct focus, or color frame
CFG	capstan frequency generator
CFVSEL	capstan frequency-to-voltage converter select
CH	channel
CHG	charge
CHROMA	color
CLK	clock
CLR	clear
CMD	command
CMOS	complementary metal-oxide semiconductor
CNT	count or counter

COL	color
COM	common
COMB	combination or comb filter
COMP	comparator, composite, or compensation
CONN	connector
CONV	converter
CP	circuit protector or clamp pulse
CPC	capstan phase control
CPU	central processing unit
CTC	crosstalk channel
CTL	control
D	drum, digital, diode, or drain
D/A	digital-to-analog
DAC	digital-to-analog converter
dB	decibel
dc	direct current
DD	direct drive
DEC	decoder
DEMOD	demodulator
DET	detector
DEV	deviation
DFRS	drum free-running stop
DG	differential/gain
DISCR	discriminator
DL	delay line
DLY	delay
DOC	dropout compensator
DOD	dropout detector
DP	differential phase
DPC	drum phase control
DYAC	dynamic aperture control
E	edit or emitter
EDP	electronic data processing
E-E	electric to electric
EF	emitter follower
EMP	emphasis
EN	enable
ENC	encoder
ENV	envelope
EO	error out
EOP	end of play
EP	extended play
EQ	equalizer
ES	electronic switch

ESNS	end sensor
EXP	expander
EXT	external
F	farad or fuse
FADV	frame advance
FDP	fluorescent display panel
FE	full erase
FET	field-effect transistor
FF	fast-forward, flip-flop, or front focus
FG	frequency generator
FI	field index
FIX	fixed
FM	frequency modulation
FMA	FM audio
FR	field recording, frame, or rusible resistor
FREQ	frequency
F-V CONV	frequency-to-voltage converter
FWD	forward
FWDS	forward search
G	green or gate grid
GCA	gain control amplifier
GEN	generator
GND	ground
GRN	green
GRY	gray
H	horizontal, high, henry, or hour
HB	high bridge
HBF	horizontal burst flag
HD	horizontal drive
HG	hall generator
HPF	high-pass filter
Hz	hertz
IC	integrated circuit
ID	identification pulse
IF	intermediate frequency
EFR	infrared
IFT	intermediate frequency transformer
IMS	images
IND	indicator
INH	inhibit
INS	insert
INT	internal or interrupt
INV	inverter
I/O	input/output

IR	infrared
L	low or left
LCD	liquid-crystal display
LED	light-emitting diode
LIM	limiter
LIN	linearity
LL	low light
LLD	low-light detector
LOAD	loading cassette
LP	long play
LPF	low-pass filter
LSB	lower sideband
M	motor
MAX	maximum
MDA	motor drive amplifier
MECHACON	mechanism control
MIC	microphone
MIN	minimum
MIX	mix or mixing
MM or MMV	monstable multivibrator
MNOS	metal nitride-oxide semiconductor
MOD	modulator or modulation
MOS	metal-oxide semiconductor
MPX	multiplex or multiplexer
MR	magnetic resistor
MS	mode select
MUT	muting
MUX	multiplex or multiplexer
NAND	not AND
NC	not connected
NFB	negative feedback
NLN	nonlinear
NO	normally open
NOR	normal, or not OR
NR	noise reduction
OP	operation
OPAMP	operational amplifier
ORN	orange
OSC	oscillator
PB	playback
PBLK	preblanking
PC	pulse counter or photocoupler
PCM	pulse-code modulation
PD	phase detector

497

PG	pulse generator
PGM	program
PHS	photosensor
PI	photointerrupter
PIF	picture intermediate frequency
PLA	programmable logic array
PLL	phase-locked loop
PLS	pulse
P or POS	position or positive
p-p	peak-to-peak
PR	pinch roller
PREAMP	preamplifier
P/S	pause/still
P.SET	reset
PSC	pulse-swallowing control
PU	pickup
PUT	programmable unijunction transistor
PWB	printing wiring board
PWM	pulse width modulation
PW or PWR	power
Q	quality factor
R	red
RA	resistor array
RAM	random-access memory
R/B	red and blue
REC	recording
REF	reference
REG	regulator or regulated
REM	remote
REMOCON	remote control unit
REV	reverse
RF	radio frequency
R/P	record/playback
RPT	repeat
RS FF	RS flip-flop
RST	reset
RT	rotary transformer
RUN	running
RY	relay
SAW	sawtooth or surface acoustic wave
SC	subcarrier or simulcast
SCH	search
SEL	select
S or SENS	sensor

SEP	separator
SF	source follower
SFF	short fast follower
S/H	sample and hold
SIF	sound intermediate frequency
SN	signal-to-noise ratio
SOL	solenoid
SOS	sound on sound
SP	standard play
S PLS	sampling pulse
REV S	reverse switch
REW	rewind
S/S	slow/still
SSG	sync signal generator
SSNS	start sensor
STD	standard
SUP	supply
SW	switch
SWD	switched
SYNC	synchronization
SYNCON	system control
T	target
TAL	tally
TBC	time base connector
TC	time code or tension control
TEN	tension
TF	thermal fuse
TIM	timing
Tk or TRK	tracking
TNR	tuner
TP	test point
TR	transistor, trimmer, or transformer
SR	supply reel
SREW	short rewind
UL	unloading
UNREG	unregulated
UNSW	unswitched
V	volt or vertical
VACT	video action
VCO	voltage-controlled oscillator
VCXO	variable-control crystal oscillator
VD	vertical drive
VF	viewfinder
VIF	video intermediate frequency

499

VLT	violet
VR	variable resistor
VS	video and sync
VSCH	variable search
V/T	video/television
VXO	variable crystal oscillator
W	watt
WARN	warning
W & D	white and dark
W BLK	wide blanking
WHT	white
TRANS	transformer
T/T	tuner/timer
TU	take-up
YEL	yellow
WV	working voltage
XTAL or X.TAL	crystal
Y	luminance
ZFE	zero frame editing

500

Camcorder manufacturers

AIWA
35 Oxford Dr.
Moonachie, NJ 07074

Canon
One Canon Plaza
Lake Success, NY 11042

Chinon
43 Fadem Rd.
Springfield, NJ 07081

Curtis Mathes
2855 Marquis Dr.
Garland, TX 75042

Elmo
70 New Hyde Park
New Hyde Park, NY 11040

Fisher
1200 West Walnut St.
P.O. Box 9038
Compton, CA 90224

General Electric
Box 1976
Indianapolis, IN 46206

Goldstar
1000 Sylvan Ave.
Englewood Cliffs, NJ 07632

Hitachi
3890 Steve Reynolds Blvd.
Norcross, GA 30093

Instant Replay
2951 South Bay Shore Dr.
Coconut Grove, FL 33133

J C Penney
National Parts Center
6840 Barton Rd.
Morrow, GA 30260

JVC
41 Stater Dr.
Elmwood Park, NJ 07407

Kodak
343 State St.
Rochester, NY 14650

Kyocera
411 Sette Dr.
Paramus, NJ 07652

Magnavox
Phillips Consumer Electronicss
(Philco) and Sylvania
P.O. Box 967
Greenville, TN 37944-0967

Minolta
101 Williams Dr.
Ramsey, NJ 07446

Mitsubishi
5757 Plaza Dr.
Box 6007
Cypress, CA 90630

NEC
1255 Mechael Dr.
Wooddale, IL 60191

Nikon
623 Stewart Ave.
Garden City, NY 11530

Olympus
Crossways Park
Woodbury, NY 11797

Panasonic
One Panasonic Way
Secaucus, NJ 07094

Pentax
35 Muerness Drive East
Englewood, CO 80112

Quasar
1707 N. Randall Rd.
Elgin, IL 60123

Radio Shack
National Parts Center
700 One Tandy Center
Fort Worth, TX 76102

RCA
Thomson Consumer Electronic
600 N. Sherman Dr.
Indianapolis, IN 46201

Ricoh
5 Didrick Place
West Caldwell, NJ 07006

Sanyo Fisher
SFS Corporation
21350 Lasser St.
Chatsworth, CA 91311

Sears
Sears Tower
Chicago, IL 60684

Sharp
Sharp Plaza
Mahwah, NJ 07430

Sony
Sony Dr.
Park Ridge, NJ 07656

Teknika
353 Route 46 W.
Fairfield, NJ 07006

Toshiba
82 Totowa Rd.
Wayne, NJ 07470

Vivitar
1630 Steward St.
Santa Monica, CA 90406

Zenith
1900 Austin Ave.
Chicago, IL 60639

Glossary

ac Alternating current, which is supplied from the ac wall plug or outlet. The camcorder can be operated from the power line with the ac adapter or power pack.

ACC Automatic color control. A switch that sets the color level on many TV receivers and video monitors.

AFC Automatic frequency control. The AFC circuit locks the TV or FM receiver to a station with the strongest signal.

AFM Audio frequency modulation, a method that provides a wide range of sound recording in both Beta and VHS systems.

AGC Automatic gain control. Like the auto or home radio, a certain signal level must be maintained. The camcorder AGC controls the signal level at all times.

AM Amplitude modulation. On the regular broadcast band, 550 to 1600 kHz are AM stations.

antenna A device to pick up the signal for best TV reception.

APC Automatic phase control. A circuit that keeps the color and luminance signals in phase to prevent jittery or wavy pictures.

aperture The opening in the camera that permits light to enter. The size of this opening is controlled by an adjustable setting called the iris. The smaller the number that corresponds to the aperture, the larger the size of the "hole."

aspect ratio The ratio of height to length.

audio Audible sound. In camcorder recording, the sound is recorded at the top of the video tape.

automatic rewind A process that automatically brings the videocassette back to the beginning (found in some VCRs and camcorders).

automation Automatic operations performed by the camcorder.

A/V Audio/video systems or jacks.

azimuth The angle of the tape head with the tape. The tape must run in a straight line with the tape head to prevent poor-quality recording or playback. An adjuster for the tape head is usually located at the side of the tape head.

band A band of broadcast frequencies, such as the AM band (550 to 1500 kHz) or the FM band (88 to 108 MHz).

barrel distortion Lines that bend in the picture that appears like you are looking through a barrel.

Beta One of the first tape formats provided by Sony Corporation. The Beta cassette will not play on a VHS VCR, nor will a VHS cassette play with the Beta VCR machine.

bias A bias voltage is applied to the audio tape when recording to reproduce higher frequencies.

black and white A picture with no color—only black, white, and gray shades.

block matrix A picture tube with black surrounding each bead color upon the face of the CRT, used to bring out a brighter, clearer picture.

boom A long arm or pole that holds a microphone suspended over the subject.

burn A permanent image on the front of a CRT. To avoid this, keep the lens cover over the camera at all times when using a video camera that has a tube as pickup device.

cable The TV signal is brought through a cable system instead of the TV antenna. Cables are used to tie the camcorder, VCR, and TV receiver together to play back the recorded cassette.

camcorder A separate camera and recorder were used in the early video days. Now both are available in one unit.

camera The part of a camcorder made up of a lens and pickup device that is either a tube or solid-state component (CCD or MOS) that views the subject, transforms it into electronic signals, and places the images on tape to be replayed by a camcorder or video cassette player.

camera cap A device to place over the lens opening to protect the lens and pickup device when the camcorder is not operating.

capstan The capstan is a shaft that revolves at certain speeds to move the tape from the cassette across the tape head. Usually, the tape is held against the capstan with a rubber pinch roller, like in the audio cassette player.

capstan servo The electronic control circuit that controls the capstan motor with proper speed in relation to the video drum tape and drive capstan.

cassette A two-reel holder that contains video or audio tape. The video tape comes in three different formats: VHS, Beta, and 8-mm.

cassette cleaner A cassette with dry or liquid material that cleans the heads and tape paths of a VCR or audio cassette player.

CATV Color TV signals that come through a cable to your house from a cable company are called cable TV or CATV. You must pay for these TV signals instead of using your own outside antenna.

CCD Charge-coupled device. A solid-state chip that usually detects a subject as the vidicon tube in the early cameras.

character generator A small device that generates titles and numbers on the video tape electronically.

chroma Chrominance or color. The three primary colors are red, green, and blue.

chromium dioxide A component used in making video and audio tapes.

closed circuit A TV system with a camera and receiver are connected together by microwave or cable. Production broadcasting uses closed circuit methods.

coaxial A shielded cable with a solid conductor in the center of the cable. The shielded cable prevents outside spurious signals from entering the TV or recorded picture.

color burst sensor A color burst sensor can be found in the VCR to tell when the burst signals are present and can be edited out of the old black-and-white movies.

color system The National Television Standards Committee (NTSC) system for American Television uses 525 lines and a 60 field, while the United Kingdom supports a phase alteration line (PAL) and the French (SE CAM) system uses a 625-line, 50-field format. The European system is not compatible with the U.S. system.

color temperature Kelvin is the unit of color temperature, which is the degree of heat needed for a perfect black body to emit light. The higher the temperature, the bluer the light; the lower the temperature, the redder the light.

comet-tailing When the camera or object moves, red or blue streaks can tail a bright object.

common A common ground, found in most electronic circuits, is a common point to return the electronic circuit.

consistency The variation in quality among different batches of tapes.

continuous loop A tape system in which the endless loop is repeated, such as the early telephone answering machines.

contrast Comparing the bright and dark areas of the picture. Too much contrast can result in a dark picture while very little contrast can be washed out.

control track The cue or sync track at the bottom of the tape. The control signal is recorded to automatically correct the tape speed.

convergence Positioning the three colored beams to shine through a shadow mask and onto each color bead (pixel) for the best picture.

counter A means of pinpointing a starting and stopping point on the tape.

crosstalk Audible or visible interference in the audio or video cassette player. Improper adjustment of tape head in the audio cassette can produce crosstalk.

CRT Cathode ray tube. A picture in the TV receiver. The electronic viewfinder of the camcorder can have a tube for viewing the scene.

cue To start and stop the tape at a certain position on the tape.

dB Decibels. A measurement of sound.

dc Direct current. A dc battery is used to power the camcorder.

degausser An electromagnetic ring of wires to clean up color impurities of the shadow mask of the picture tube. The magnetic poles of the earth and man-made devices such as a carpet sweeper or speaker can magnetize the shadow mask, producing impurities in the color picture.

depth of field The range of focus at the desired lens opening. The higher number of the camera provides a great depth of field. The lower number provides a wide opening, producing a narrow depth of field.

dew sensor A device with circuitry that automatically tells you the dangerous level of moisture in the camera. The camcorder should not be used while the dew sensor is flashing or on.

diffusion filter A filter applied to the front of the lens that gives a soft appearance.

digital A digital VCR has special effects such as freeze frame, picture in picture, and solarization.

diode A semiconductor that prevents current from flowing in only one direction. Also called a rectifier.

dipole "Rabbit ears" antennas are simple dipole. The dipole element of the TV antenna is the rod where the cable or flat lead-in wire is attached.

dropout Little white streaks across the picture as the recorded tape is played. Dropouts often occur at the beginning and end of the tape. Dropouts can be caused by poor or contaminated tape.

drum A cylindrical component with heads that records the video picture.

dub To transfer the image and sound from one tape to another or to change various sections of the recording. Sound can be dubbed upon the tape at a later date.

dynamic range The range from the softest to the loudest sound that can be recorded. The larger the number, the wider the dynamic range.

edit To add or take away scenes from a tape.

eject To release the videocassette from the VCR, camcorder, or audio cassette player.

EP Extended play. Refers to the speed where six hours of recording can be done on a T120 VHS cassette.

erase To remove material or scenes from the audio or video cassette.

erase head The erase head removes all previously recorded material from the tape as the camcorder, camera, or VCR is recording new material.

EVF Electronic viewfinder. Actually, the tube and circuits are similar to a small TV set. Some camcorders have the electronic viewfinder, while others have an optical viewfinder.

fast forward A means to make the tape move faster in a forward mode.

fast search The VCR or camcorder is operated at a faster speed so you can see the recorded material.

ferri chrome A compound of chromium and iron dioxide material that produces high-quality video and audio tapes.

ferric oxide An iron compound used in manufacturing video and audio tapes.

flagging Bending of the picture at the top or bottom. In the TV camera, flagging occurs most often at the top of the picture.

flutter Uneven speeds in tape that causes a wavy picture or sound.

flyback The horizontal transformer in the TV receiver or electronic viewfinder.

flywheel A large wheel found on the end of the capstan drive assembly. Most flywheels are rotated with a drive belt.

FM Frequency modulation. FM modulation removes most of the pickup static in radio reception.

foot candle The amount of light provided by a candle at the distance of one foot. The unit of light intensity.

foot-lambert The unit of measurement of brightness. One foot-lambert is equal to 3.426 candelas per square meter.

formulation tape The actual magnetic compound deposited upon the recording tape.

frame A single picture. The VCR can have a device to stop the tape to view certain frames.

frequency response The dynamic range that a medium can record (in decibels). The normal frequency response of audio cassette tape is from 20 to 20,000 Hz, while the average frequency response of video cassette tape is from 45 to 12,000 Hz.

F-stop The setting of the lens opening. The larger the number, the smaller the opening, and the smaller the F-stop, the larger the lens opening.

fuse The fuse protects the circuits inside the TV set, VCR, audio cassette, and camcorder. Most fuses are in a small, round, glass enclosure.

generation The master tape is the first-generation recording.

ghost Another or several images alongside the original. TV signals bouncing off of various subjects produce ghosts in the picture. Improper cable hookup can produce lines in the pictures.

glitch Interference malfunction that can flash on the screen of a video or audio recording.

ground Earth or a common reference point in the circuit.

ground plug A three-prong ac plug in which the large prong is grounded to protect the operator.

hardware The VCR is referred to as the hardware, and software is the cassette that plays in the VCR.

harmonic distortion Unwanted sounds or overtones in music.

head The electromagnetic device that records, erases, or plays back tapes in the VCR, camcorder, or audio cassette player.

helical scan The diagonal playback or recording system that places video frequencies on the tape. The tape spins at an angle to the cassette tape.

hertz (Hz) The measurement of frequency equal to one vibration. 1000 cycles per second (Hz), or 1 kHz.

high Z High impedance. A crystal microphone can have high impedance, while a dynamic mike can have low impedance output.

horizontal resolution The more horizontal lines there are, the sharper the picture. European scanning lines are 625, while the U.S. standard contains 525 lines.

HQ High quality. Usually, a camcorder or VCR with HQ specifications produces a higher quality image in chrominance and luminance noise reduction and white-clip circuits.

hue The tint of a color picture. The tint control in a TV receiver varies the hue of the colored picture.

IC Integrated circuit. A chip with many different components in one body, used extensively in the camcorder, VCR, and other consumer electronic products.

IF Intermediate frequency. The IF transformer in the radio or TV receiver is between the tuner and detector circuits.

image lag When the camera is moved quickly from one subject to another, it produces a ghost or streak on the screen.

impedance The unit of ac resistance. The output impedance of the amplifier must match the speaker impedance. The cables used to connect the TV antenna and VCR to the TV receiver have 75-Ω and 300-Ω impedances. The shielded cable is 75 Ω, while the flat wire is 300 Ω.

index An electronic marker on a tape (a point for fast rewind, record, or play).

infrared remote A hand-held remote control unit that controls the TV, VCR, video disc, and audio disc players. The infrared remote transmits infrared beams of light, which are picked up by a receiver and control circuit.

interference Static or noisy unwanted signals.

IPS Inches per second. The speed of the tape during recording and playback.

iris Controls the size of the opening of the lens assembly (aperture), which determines the amount of light entering the camera.

kinescope Refers to the TV picture tube. Also called a CRT.

L-125 Beta cassette with 15 to 45 minutes playing time.

L-250 Beta cassette with 1 to 1½ hours playing time.

L-500 Beta cassette with 2 to 3 hours playing time.

L-750 Beta cassette with 3 to 4 hours playing time.

L-830 Beta cassette with up to 5 hours of recording.

lag A trace of light behind a moving object or when the camera is moved quickly from one scene to another.

laser A concentrated beam of high-frequency light. A laser beam is in compact disc players for reading an audio disc.

LCD Liquid-crystal display. Found in audio and video products.

lead-in The flat wire or cable that brings in the TV signal to the back of the TV receiver.

LED Light-emitting diodes. Found throughout the camcorder and VCR as indicators.

lens A piece of curved glass that lets light pass through it, striking the film in a camera, pickup tube, or solid-state device in the video camera or camcorder.

load To place a videocassette into the VCR or camcorder.

low Z Low impedance. The speaker can have a low impedance of 4, 8, or 10 Ω.

LP Long play. The T-120 video cassette will play four hours of program material.

luminance Brightness. The luminance circuits are in camcorder, VCR, and TV receivers.

lux Measurement of light sensitivity. A camcorder with a 7 lux is more sensitive than one with a 20-lux setting.

macro The macro lens is used to take close-up pictures.

MDS Multipoint distribution system. A cable TV system with scrambled signals.

ME Metal evaporated tape. Metal tape is in the 8-mm video cassette.

microwaves Electromagnetic waves with a small wavelength, such as in satellite transmission and those in the microwave ovens used for cooking.

M loading The tape from a VHS format is wound around the heads in an M-like fashion.

monitor The television set can be called a TV monitor when connected to the VCR. A monitor can resemble a TV set without a tuner but has direct hookup to input video signals.

MOS Metal-oxide semiconductor. The electronic solid-state chip used to pick up the picture instead of a tube. Pentax, Radio Shack, and RCA have MOS pickup devices in their camcorders.

MP Metal particle. Found in the 8-mm video cassette tape.

MTS Multichannel television sound. The TV or VCR with MTS decoder will allow you to hear stereophonic broadcast format.

muting A circuit that blanks out video or audio signals in recording or playback.

newvicon A tube pickup device used in the early home video cameras.

nicad Nickel-cadmium. The battery made up of nickel-cadmium material can be charged over and over again.

noise A distorted, unwanted signal in audio and video systems. Noise can appear intermittently or all the time in a poor recording.

NTSC National Television Standards Committee. The committee who sets standards in the TV industry.

ohm Unit of electrical resistance. Resistors are rated in ohms.

oscilloscope An electronic testing device used to observe waveforms in electronic circuits.

overscan Portions of the picture you do not see at the edges of the picture tube.

PAL Phase alteration line. The 625-line color TV system found in Great Britain.

pause control The pause control is used to stop the recording or playback of an unwanted program.

PCM Pulse code modulation. The method used in 8-mm video or stereo systems.

PET Polyethylene tesphalate (Mylar). The plastic base used for recording tape.

pixel Picture element. Thousands of tiny light-sensitive spots on the CCD pickup device.

play The play button is pushed when you want to watch what was recorded.

power The amplifier can have 100 W of power to drive several speakers. The power plug can be referred to as the ac outlet.

513

power supply A voltage source that supplies power to the VCR or camcorder. Often, the power supply circuitry changes ac to dc voltage.

probe The DMM or VOM has test probes to check voltage or resistance in the various circuits.

programming The VCR can be programmed for hours or days of monitoring the TV signal.

rainbow effect Wiggly color lines found in the picture from poor erasure of the previous program.

random excess Provision to use the tuner in a scan mode (to go through the channels at random).

record To put audio or video material onto the tape or disc.

resolution The clarity of the picture. The higher the number in horizontal lines, the better the resolution. The American system has 525 lines.

rewind To bring back the tape to a starting position.

RF Radio frequency. The frequency at which radio and television frequencies are broadcast. External RF energy in the picture or sound can be caused by a strong unwanted signal feeding into the radio or television receiver.

saticon A popular pickup device used in home video cameras.

scanning There are 525 scanning lines in the U.S. system and 625 scanning lines in the United Kingdom broadcast system.

search The video cassette or video disc player can have speed search, cue, and review functions to enable the operator to quickly locate a special segment of the recording.

se cam The 625-line color system used in France.

sensitivity The degree of input signal in RF or audio signal.

sensor light A lamp bulb that indicates the unit is ready to operate. A dew sensor light in the camcorder indicates when moisture is inside the head area.

separation The degree the right and left channels are apart.

servo A control circuit that regulates the speed for the rotating drum or motors inside the VCR, disc player, or camcorder.

shotgun mike A highly directional microphone used to pick up audio at a great distance.

sine wave Fundamental wave used in testing audio and video consumer products.

skewing Bent visual distortion of the upper portion of the picture caused by rapid fluctuation of signal on the tape. Also, the angled motion of the tape.

SLP Super long play. The slowest speed found in VHS, VCR, and camcorders.

S/N Signal-to-noise ratio. The comparison of good signal with unwanted signal. The audio amp with the highest signal-to-noise ratio produces the least noisy sound.

snow Black and white specks on the TV screen due to weak or poor reception.

software The video cassette is referred to as software. The VCR is referred to as hardware.

SP Standard play. A two-hour T-120 VHS tape rotates at SP speed.

speed The rate the tape passes the tape head. Often rated in inches.

splice Connecting two pieces of tape. Sometimes used in editing material.

stereo Two separate channels of audio. The stereo amp has a left and right audio channel.

sync Synchronizing signals. The recordings at the bottom of the tape are synchronizing signals. Sync pulses are in the TV set or monitor to keep the picture from going horizontally or vertically.

tape A narrow, plastic-coated material with oxide compounds with magnetic quality. Both audio and video are recorded on tape.

tape head A coil with a magnetic core that makes and takes off magnetic impressions of audio and video.

tint Sometimes referred to as the hue control. The tint control of a TV receiver varies the color of a person's face.

tracking There are audio and video tracks on the recording tape. The tape head can be adjusted for optional tracking of the tape.

tracking control A control that slightly changes the alignment of the tape head so it will accurately align with the video tracks on the tape.

transistor A semiconductor device that operates somewhat like a tube. Many transistors can be found in the IC component.

tuner The front end of the VCR, radio, or TV set that picks up and tunes in each station.

515

UHF Ultra high frequency. The stations found in the TV set from 14 to 83 channels. A special antenna is needed to pick up UHF channels.

U loading The loading pattern of the tape in the Beta system.

VCR Video cassette recorder.

VHF Very high frequency. The VHF channels of the TV set are from 2 through 13.

VHS Video home system. The most popular video format, developed by JVC.

VHS-C A small cartridge using the VHS format. The VHS-C cassette must be placed in the adapter to play into the VCR.

video disc A flat disc used to record audio and video information.

video disc player A large unit that plays the video disc through the TV set.

vidicon The early popular video pickup tube found in commercial and home cameras.

VIR Vertical internal reference. A system used in some TV receivers for automatic hue control.

VTR Video tape recorder.

white balance The primary video colors, red, blue, and green, must be blended correctly for a white rendition.

white balance control This control sets the colors for the camera by a switch or automatically.

wow and flutter A variation of tape speed can produce wow and flutter in the sound or video of a recording.

zoom A wide angle lens that can take a picture far away. Manual or motorized power zooming can be found in the camcorder. Often, the consumer home video cameras have a zoom ratio of 3:1 or 6:1.

Index

1

12-V power supply, 393, **393**

8

8-mm, 2, 12, 17-19, **18**

A

A/C head adjustments, 364-366, **366**
ac
 adapter adjustment, 392, **392**
 power supply, 477-480, **478-480**
adapter
 RF, 14, **15**
 VHS-C playback mode, 4
adjustment sequence, 394, **395-396**
AF circuits, 23-24
AGC
 adjustment, 405-407, **406-407**
 circuits, 113, **114**, 125-127
arm
 pole base, 342-343, **343**
 tension, 339, **341**
audio
 back level adjust, 414
 circuits, 241-261, **242-245**, **247-251**, **253**
 control heads, 258-260, **259-260**, 362-368, **364-368**
 distortion check, 415
 dubbing, 11
 output jacks, 260-261, **261**
 recording/playback circuits, **250**
 signal-processing circuits, **250**
 tracks, 25-30, **27**, **29**
 troubleshooting, 462-463, 466, **467-469**
automatic
 focus, 2, 7, **8**, 23, 87-90, **88-90**, 228-233, **228-233**
 iris, 9, 22, 83-85, **84-86**
 white balance, 7-8, 22
AV (audio/video) circuits, 23

B

back
 focus adjustment, 401-402, **402**
 tension adjustments, 370-372, **371**
batteries, 25, 480-486, **481-486**
 camcorders, 12
 lithium, 491
 terminal circuits, 148, **149**
belts, 58
Beta, 2, **3**
block diagram
 8-mm, 17-19, **18**
 audio circuits, **242**
 audio recording/playback circuits, **250**
 audio signal-processing circuits, **250**
 auto iris circuits, **234**
 autofocus, 88, **90**
 Canon ES1000, **248**
 capstan motor, **208**
 FM audio noise reduction circuit, **249**
 motors, **202**
 Pentax PV-C850A, **249-250**
 Samsung 8-mm, **186**, 188, **189**
 Samsung SCX854, 17, **18**
 servo circuits, **188**
 stereo sound circuits, **248**
 system control circuits, **138**
 VHS, 15-17, **18**
 VHS-C, 17
blooming, 403, **403-404**
brake drive mechanism, 291-292, **292**
breakdowns, 388-389, **391**
brightness adjust, 417, **418**

C

C level adjust, 411-412, **412**
camcorders
 8-mm, 2, 5-6, **7**
 audio tracks, 25-30, **27**, **29**

Boldface numbers indicate illustrations.

camcorders *continued*
 Beta, 2
 block diagrams, 14-19, **16, 18,**
 camera section, 19-20, **19,** 65-97, **66**
 cleaning, 54-58, **56-57, 59**
 history, 1
 Hitachi, 2
 hookups, 12, **13-15**
 new features, 2
 older, 12
 power requirements, 12
 S-VHS, 3
 size of, 2
 VHS, 65
 VHS-C, 2-5, **4-6,** 12, 65
 video
 home systems (VHS), 3
 tape recorder (VCR), 3
 weight, 12-13
camera
 adjustments, 404-415, **405-415**
 section, 19-20, **19,** 65-97, **66,** 310-313,
 312-313
 setup, 387-389, **388-389**
capacitors
 leadless, 50, **51-53**
 tatalum, 50
 trimmer, 53, **54**
capstan
 assembly, 277, **278-279**
 belt, 58
 motor drive circuits, 184-185, **186**
 motor pulley, 58
 motors, 208-217, **208-217,** 343, **345**
 shaft, 58
 troubleshooting, 442-443, **443**
case removal, 305-307, **306-307**
cassette
 over removal, 303-305, **305**
 holder sensor, 177, **177**
CCD, 8-9, **9,** 19
 drive circuits, 24
 drive section, 400-404, **401, 404**
 pickups, 66-69, **69**
 removal, 322-325, **324-326**
 unit, 2
center
 gears, 280
 pulley, 58
character position adjustment, 418, **419**
chips
 digital transistor, 45-46, **47-48**

diodes, 46, **48**
 filters, 50
 IC, 44
 leadless
 resistor, 46, 48, 50, **50**
 transistor, 44-45, **46**
 tatalum capacitors, 50
 trimmer capacitors, 53, **54**
 types of, 44-54, **45-53**
chroma
 balance adjustment, 409-411, **411**
 level adjust, 413, **413**
 phase adjust, 412, **412**
 playback process, 29-30
 processing, 22
 processing circuits, 80-83, **81-82, 84**
 signal playback, 128-135, **128-135**
 signal recording circuits, 120-123, **122-123**
circuits
 AF, 23-24
 AGC, 113, **114,** 125-127
 audio, 241-261, **242-245, 247-251, 253-261**
 automatic
 focus, 23
 iris control, 22, 83-85, **84-86**
 white balance, 22
 AV (audio/video), 23
 battery terminal, 148, **149**
 board removal, 313-316, **314-318**
 capstan motor drive, 184-185, **186,** 442-
 443, **443**
 CCD drive, 24
 chroma
 playback, 29-30
 processing, 80-83, **81-82, 84**
 signal playback, 128-135, **128-135**
 signal recording, 120-121, **122-123**
 clamping, 114
 cylinder lock, 176-178, **177-179**
 dark/white clipping, 117, **118**
 Digital 4-V, 25
 EE video signal output, 118-119, **118**
 encoder, 22
 end-sensor, 169, **170**
 EVF (electronic viewfinder) circuits, 23,
 95-97
 focus, 88, **90**
 function switch key input, 143-148, **146**
 head-switching, 102-104, **103**
 image
 drive, 73-75, **74**
 stabilization, 95, **96**

518

input/output, 99-102, **100-102**
loading motor drive, 181-184, **183-185**
luma process, 78-80, **80**
luminance
 playback process, 124-128, **126**
 record process, 120, **121**
 signal recording, 111-113, **113**
main deemphasis, 127
matrix color, 21
Mi-Com 4-V, 25
motor, 201-240, **201-240**
on-screen display, 160-162, **161-162**
PB (play/back), 23
power
 control, 148-160, **149**, **151-157**, **159-160**
 distribution, 23-25, **24**
preamp, 266-267, **268**
preamplifier, 21, 77, **78**
preemphasis, 117
reel sensor, 178, **179**
safety tab sensor, 177, **178**
servo, 185-199, **187-199**
signal processing, 21, 65-66, **68**, 75-77, **76**, **78**
SS (Syscon-Servo), 23
sync generator, 21, 72-73, **73**, 128
system control, 139-143, **140-142**, **144-145**
test points, 54, **55**
trouble
 detection, 28
 stop, 180-181, **182**
troubleshooting, 95-97, **95**
video recording, 105-108, **106-109**
Y & C record, 123-124, **124-125**
clamping circuits, 114
cleaning
 camcorders, 54-58, **56-57**, **59**
 tape transport, 58, **59-61**
 video heads, 56-57, **56-57**
cloth, service, 32
clutch gear, 280-281
cold current leakage tests, 34
color
 gain adjust, 417-418, **419**
 playback, lack of, 456, **460-461**
comb filter, 115, 397
common failures
 boards, 430-431, **431**
 damaged parts, 430
 focus, 430
 no color, 430
 no picture, 428-430

no sound, 430
 soldered joints, 431
component connections, 41, **42-43**
connections, component, 41, **42-43**
contrast adjust, 416, **417**
control delay adjust, 399-400, **400**
Cue and RPS waveform check, 358, **358**
current level adjustment, 400, **400**
cylinder, 176-178, **177-179**, 273-276, **275**

D

dark/white clipping circuits, 117, **118**
delay line trim, 116
depletion region, 68, **69**
detectors, troubleshooting, 448-451, **450-451**
dew sensor, 173-176, **174-175**, 335, **335**
Digital
 4-V, 25
 signal process, 20-25, **20**, **22**, **24**
 transistor chips, 45-46, **47-49**
diode tests, 489
drive pulse, 19
drum
 assembly, 276-277, **276**,
 capstan assembly, 277, **278-279**
 motors, 217-228, **217-228**, 446-448, **447-449**
dubbing, 11

E

earphones, 256
EE video signal output circuits, 118-119, **118**
ejection, 443-446, **445-446**
electronic viewfinder (EVF), 10, **11**, (*see also* viewfinder)
electrostatic-sensitive devices, 34-35, **35**
encoder, 22
equalizer
 phase, 127
 playback, 127
 video, 116, **116**
EVF (electronic viewfinder) circuits, 23, (*see also* viewfinder)
extended play (EP), 3

F

features
 audio dubbing, 11
 automatic, 9
 automatic focus, 2, 7, **8**, 87-90, **88-90**
 automatic iris, 83-85, **84-86**

519

features *continued*
 automatic white balance, 7-8, 85-87, **86-87**
 CCD (charge-coupled device), 8-9, **9**, 19-20
 drive pulse, 20
 electronic viewfinder (EVF), 10, **11**
 flying erase head, 2, 5, 119-120, **119-120**,
 266, **266**
 fuzzy logic, 2
 high-speed shutter operation, 9, **10**
 HQ technology, 11-12
 image sensor, 19
 image stabilizations, 2
 MOS, 8-9, 19-20
 viewfinder, 2, 91-95, **91-95**
 zoom,
 lens, 10
 power, **1**
filters
 comb, 115
 chips, 50
fine tracking adjustment, 356, **356**
Fisher model FVC73U, 12
flying erase head, 2, 5, 119-120, **119-120**,
 266, **266**
FM audio noise reduction circuits, **249**
FM modulator, 117
FM audio level adjust, 413, **414**
focus
 removing assembly, 326, **327**
 troubleshooting, 437-440, **438-440**
foil repair, 38
formats, camcorders and video cassettes, 1-32
frequency counter, 62-63
FRP gears, 280
Fuji FUJIX-H18 H12SW, 68
functions
 play mode, 108-111, **110**, **112**
 record mode, 104-105, **104**, **106-109**
 switches, 143-150, **146-149**
fuzzy logic, 2

G

gear
 assemblies, 58
 center, 280
 clutch, 280-281
 FRP, 280
 idler, 292, **293**, 347, **347**
 loading, 375-376, **376**
guide
 poles, 280-296, **281-296**
 posts, 58

H

head switching, 28
head tilt, 364-365, **364**
head-switching circuits, 102-104, **103**
high-speed shutter operation, 9, **10**
history
 camcorders, 1
 video cameras, 1
Hitachi
 camcorders, 2
 MOS, 8
hookups
 camcorders, 12, **13-15**
horizontal
 EVF tilt adjust, 416, **417**
 switching transistors, 71
hot current leakage tests, 34, **35**
HQ
 recording system, 3
 technology, 11-12

I

IC chips
 installing, 38
 precautions, 41, 44
 removing, 36-37, **37**
 tools for replacement of, 37-38
 types of, 36, **36**
idler
 gear, 292, **293**, 347, **347**
 wheels, 58
image
 drive circuits, 73-75, **74**
 sensor, 19
image stabilization circuits, 2, 95, **96**
impedance roller, 58, 272
infrared indicator, 474-475, **475**
iris
 auto level adjustments, 404-405, **405**
 automatic, 83-85, **84-86**
 control, 22, 441-442, **442**
 level adjustment, 401, **401**
 motor drives, 233-236, **233-236**
 setting adjust, 406, **406**

J

JC Penney Model 5115, 12
joints, soldered, 431

L

leadless
 capacitors, 50, **51-53**

resistor chips, 46, 48, 50, **50**
transistor chips, 44-45, **46**
leakage tests, 34, **35**
light
 boxes, 61, 63
 meters, 62
literature, service, 32
lithium batteries, 12, 25, 491
loading
 drive mechanisms, 282-296, **283-296**
 gear, 375-376, **376**
 motor drive circuits, 181-184, **183-185**, 201-208, **202-207**
 ring, 177-179, **377**
locking gear, 375-376, **376**
lubrication, 59-61, **60-61**
luma process circuits, 78-80, **80**
luminance
 playback process, 29, 124-128, **126**
 record current level, 399, **399**
 record process, 28-29, **29**, 120, **121**
 signal processing, 21-22, 77-80, **79-80**
 signal recording circuits, 111-113, **113**
 signal separator, 115, **115**
lux, 2

M

main deemphasis circuit, 127
maintenance chart, **60-61**
matrix color circuits, 21
measurements
 automatic focusing system, **229**
 voltage, 39, **40**, 424, **425-427**
mechanical tape operations, 267-296
meters
 digital voltmeter or mulitmeter, 62-63
 light, 62
Mi-Com 4-V, 25
microphone, 254-258, **255-258**, 316-317, **319**
middle pole and stopper, 277
mixer, 16-18
monitor, 62
MOS, 8-9, 69-71, **70-71**
motor circuits, 201-240, **201-240**
 autofocus motors, 228-233, **228-233**
 block diagram, **202**
 capstan motors, 208-217, **208-217**
 drum motors, 217-228, **217-228**
 iris motor drives, 233-236, **233-236**
 zoom motors, 237-240, **237-240**

N

NEC
 V500, 308, **309**
 V5OU, 368, **369**
noise canceler circuits, 127

O

off/on sequences, 156-159, **157**, **159**
Olympus
 VX 801, 359-360, **360**
 VX-801U, 216
on-screen display, 28, 160-162, **161-162**, 451-454, **453-455**
oscilloscope, 62-63
OSD character position adjustment, 418, **419**

P

Panasonic VHS PV-900, 13
PB
 chroma phase adjust, 412, **412**
 (play/back) circuits
PBY level confirmation, 396, **396**
Pentax PV-C850A, 291-292, **292**
phase equalizer, 127
pickup tube assembly removal, 325-326
pickups
 CCD, 66-69, **69**
 MOS, 69-71, **70-71**
pinch
 level assembly, 340, **342**
 roller operation, 272, **273**, 337, **338**
play mode, 108-111, **110**, **112**
playback
 equalizer, 127
 tension adjustment, 293, **294**
PLL
 frequency chart, 403
 lock adjust, 415, **416**
potential well, 68, **69**
power
 camcorders, 12
 control circuits, 148-160, **149**, **151-157**, **159**
 distribution circuits, 23-25, **24**
power supplies, 477-491
 ac power, 477-480, **478-480**
 adjustments, 389-393, **392-394**
 batteries, 480-486, **481-486**
 troubleshooting, 486-491, **487-491**
preamp circuits, 21, 77, **78**, 266-267, **268**
precautions
 IC chips, 44
 service, 33-34, **34**

521

preemphasis circuits, 117
pressure roller, 58, 293, 295, **295**
problems
 trouble detection circuits, 28
 video cassettes, 6-7
pulley belt, 58

R

record chroma
 level adjust, 413
 lack of, 462, **464-465**
recording
 mode, 104-108, **104**, **106-109**
 order of dissembling, 31
reels, 58
 control module, 163-164, **164**
 disk drive mechanism, 284, 286, **287**
 reel sensor circuits, 178, **179**
 S/T, 348, **348**
 T, 292, **293**
 table height adjustments, 368-370, **369-370**
 take-up and supply, 281-282, **281**
removing and replacing, 299-348
 auto focus and power zoom assembly, 326, **327**
 camera section, 310-313, **312-313**
 case removal, 305-307, **306-307**
 cassette cover, 303-305, **305**
 CCD sensors, 322-325, **324-326**
 circuit board, 313-316, **314-318**
 electronic viewfinders, 320-325, **320-325**
 extra screws, 301-303, **302**
 microphones, 316-317, **319**
 pickup tube assembly, 325-326
 transport mechanisms, 326-348, **328-348**
 VCR section, 307-310, **308-311**
 writing down steps, 299-301, **300**
resampling process, 21
RF adapter, 14, **15**
ring, loading, 375-378, **376-377**
rollers, 58
 arm, 336, **338**
 impedance, 272
 pinch, 337, **338**

S

S-VHS camcorders, 3
S/T reel, 348, **348**
safety tab sensor circuits, 177, **178**
scope waveforms, 427-428, **429**
screw, extra, 301-302, **302**
SDMC components, 53-54

separation adjustment, y/c, 407, **408**
sequence, adjustment, 394, **395-396**
service data, 38
servicing, 30-32, **31**
servo
 adjustments, 394-400, **395-400**
 circuits, 185-199, **187-199**
 system, 28, 475-476, **475-476**
set-up procedures, 386-387, **387**
shutter operation, 9, **10**
shuttle subassembly, 346-347
signal
 circuits, 65-66, **68**
 processing, 21, 75-77, **76**, **78**
slant and guide poles, 280-296, **281-296**
solder
 joints, 431
 techniques, 36
speed, tape, 3
SS (Syscon-Servo) circuits, 23
standard play (SP), 3
stop-to play tape path, 269, **272**
supply
 end sensor, 334, **334**
 guide poles, 340, **342**
 reel, 58, 267, 269, **271**, 281-282, **281**
 take-up reel sensor, 335, **336**, 341, **343**
surface mounted components, 44
switch removal, 336, **338**
switching point adjustment, 398, **399**
sync
 generator, 21, 72-73, **73**
 separator, 113, 128
system control, 28, 137-165, **137-138**, **140-142**, **144-145**

T

T-reel base operation, 292, **293**
tab lock, 30
take-up
 reels, 172-173, **173**, 281-282, **281**
 rings, 341, **343**
tape
 end detection, 396, **397**
 end sensor, 167-168, **168-172**
 guides, 356-357, **357**
 interchange ability adjustment, 361-362, **362-363**
 operations, 263-296, **263-296**
 flying erase head, 266, **266**
 head descriptions, 264-267, **264-267**
 mechanical, 267-296

path, 269, **272**, 373-374, **373**
thickness sensor, 177, **178**
transport, 58, **59-61**, 326-348, **328-348**
tatalum capacitors, 50
tension
 adjustment, 293, **294**
 checks, 374, **374-375**
tests
 cassettes, 64, **64**
 cold current leakage, 34
 diode, 489
 equipment, 61-64, **62-63**, 349-350, **350**,
 381-384, **382-383**
 hot current leakage, 34, **35**
 points, 54, **55**
 transistor, 489, 490
 voltage, 489
tools, 381-384, **382-383**
 fixtures, 386-393, **386-393**
 troubleshooting, **423**
torque checks, 374, **374-375**
transistor tests, 489, **490**
transport mechanism, 282, **284**
trimmer
 capacitors, 53, **54**
 delay line, 116
tripods, 62
trouble
 detection circuits, 28
 stop circuits, 180-181, **182**
troubleshooting
 audio, 462-463, 466, **467-469**
 boards, 430-431, **431**
 capstan, 442-443, **443**
 cassette holder sensor, 177, **177**
 no color, 430
 color playback, 456, **460-461**
 common failures, 428-431, **431-432**
 damaged parts, 430
 detectors, 448-451, **450-451**
 dew sensor, 173-176, **174-175**
 ejection, 443-446, **445-446**
 EVF circuits, 95-97
 focus, 430, 437-440, **438-440**
 infrared indicator, 474-475, **475**
 iris control circuits, 441-442, **442**
 loading motor drive circuits, 181-184, **183-
 185**
 mode switches, 178-181, **180-182**
 on-screen display, 451-454, **453-455**
 no picture, 428-430
 power, **165**

power, lack of, 433-434, **433-434**
power supplies, 486-491, **487-491**
record chroma, 462, **464-465**
recording, 454-456, **456-458**
reel sensor circuits, 178, **179**
safety tab sensor circuits, 177, **178**
scope waveforms, 427-428, **429**
sensors, 435, **437**
servo/system control, 475-476, **475-476**
soldered joints, 431
no sound, 430
take-up reel detection, 172-173, **173**
tape thickness sensor, 177, **178**
tape-end sensor, 167-172, **168-172**
tools, **423**
trouble stop circuits, 180-181, **182**
video playback, 459-462, **462-463**
viewfinder, 470-474, **471-474**
voltage
 lack of, 434-435, **435-436**
 measurements, 424, **425-427**
white balance, 451, **452-453**, 468-470,
 470
zoom, power, 440-441, **441**

V

VAP/AF adjustment, 388
VCR section, 25, **26-27**, 307-310, **308-311**
vectoroscope, 62-63
viewfinder, 320-325, **320-325**
vertical switching transistors, 71
VHS camera circuits, 65-66, **67**
VHS-C, 2-5, **4-6**, 12, 17
 camera circuits, 65-66
video cameras history, 1
video cassettes
 8-mm, 5-6, **7**
 adapter for playback mode for VHS-C
 tapes, 4-5, **5**
 audio tracks, 25-30, **27**, **29**
 Beta, 2, **3**
 problems with, 6-7
 standard play (SP)
 test, 64, **64**
 VHS-C, 3-5, **4-6**
 video tape recorder (VCR), 3
video equalizer, 116, **116**
video heads, 25, 56-57, **56-57**
video light, 162, **163**
video playback, troubleshooting, 459-462,
 462-463
video signal output circuits, 118-119, **118**

viewfinders, 91-95, **91-95**
 adjustments, 415-420, **416-419**
 color electronic, 2
 electronic, 10, **11**
 troubleshooting, 470-474, **471-474**
voltage
 measurements, 39, **40**, 424, **425-427**
 tests, 489
VTR section (*see* VCR section), 25

W

wall charts, 384-385, **385**
warm-up time, 30
waveforms
 scope, 427-428, **429**
 servo/system control, 475-476, **475-476**
weight of camcorders, 12-13
white balance, 7-8, 85-87, **86-87**
 adjustment, 407-408, **409**

troubleshooting, 451, **452-453**, 468-470, **470**
wrist strap, 32
writing down steps in repairs, 299-301, **300**

Y

Y & C record circuits, 123-124, **124-125**
y record
 current adjust, 413, **414**
 level adjust, 408-409, **409-410**

Z

zoom,
 increased, 2
 lens, 10
 motors, 237-240, **237-240**
 power, **1**, 440-441, **441**
 removing assembly, 326, **327**

About the Author

One of the best-known names in the troubleshooting and repair business, Homer L. Davidson is the author of more than 900 magazine articles and numerous technical servicing books, including *Camcorder Maintenance and Repair* and *Troubleshooting and Repairing Compact Disc Players.*